The Diaries of Paul Klee,
1898-1918

The Diaries of

1898-1918

Edited, *with an Introduction, by* FELIX KLEE

University of California Press
Berkeley, Los Angeles, London

English translation from the German, authorized by Felix Klee
© 1964 by The Regents of the University of California
University of California Press, Berkeley and Los Angeles, California
University of California Press, Ltd., London, England
ISBN: 0-520-00653-4
Library of Congress Catalog Card Number: 64-20993

Tagebücher von Paul Klee 1898–1918, *herausgegeben und eingeleitet von Felix Klee*
First German edition *published in Cologne by Verlag M. DuMont Schauberg, 1957*
(Nachdruck verboten. Alle Rechte vorbehalten
© Verlag M. DuMont Schauberg, Köln, 57)

First California Paper-bound printing 1968

Manufactured in the United States of America

4 5 6 7 8 9 0

Note on the Text

This first complete English-language version of Paul Klee's *Tagebücher* is based upon the text of the German hardcover edition, published by M. Du Mont Schauberg, Cologne, in 1957. Certain Klee drawings and several of the minor textual changes in the paperback edition, also issued in 1957 by the same publisher, have been taken over. Like the German original, the translation has no scholarly paraphernalia. The reader who requires precise identification of persons or fuller information on other points should consult Will Grohmann's large-scale study of the artist's life and work, *Paul Klee* (New York: H. N. Abrams, Inc., n.d.) and Felix Klee's memoir, *Paul Klee: His Life and Work in Documents* (New York: George Braziller, 1962).

Swiss German occurs fairly often in the *Tagebücher*. Much of the pungency of such entries as 414, 428, 586, 608, and 721 evaporates in translation; the same is true of the erratic German of Jean de Castella, in entry 464, and the mock-Japanese German of 570/72.

Paul Klee had the habit of noting down sets of rhyme-words, which were to be used in poems. The sense of these rhymes has here been translated—in order to show something of Klee's association of ideas—but no attempt has been made to capture the sound (see entries 184, 286, 292, 296, 306, 325, 330.)

Grateful acknowledgment is made to several persons who have provided information: Dr. Norbert Raymond, Los Angeles, and Professors Robert R. Heitner and Marcel Rothlisberger, University of California, Los Angeles—for advice on points of language and history; Professor Fritz Faiss, San Fernando Valley State College, a former student of Klee's at the Bauhaus—for clarifying certain technical passages; Mrs. Kate T. Steinitz, the Belt Library of Vinciana, for the benefit of her acquaintance with the "Blue Four" and her shrewd insight.

The translation was a combined effort. Pierre B. Schneider of Paris, France, prepared a draft version of the main text. R. Y. Zachary and Max Knight of the University of California Press made the final translation of the entire volume.

<div align="right">R. Y. Z.</div>

Preface

The reader of the four diaries of Paul Klee in this volume will be initiated—
being presumably an outsider—into a mysterious, rare, individual, and watch-
ful world, that of Paul Klee the "painter." Indeed, the entries in his diaries
were not originally intended for publication, but merely for his own reflec-
tion. During his lifetime my father allowed no one, not even myself, access
to his most personal confession.

Shortly after the First World War Paul Klee moved into the limelight of
public notice, and after the Second World War he attracted the attention
of the whole western world. Along with this great interest, partly critical in
character, partly full of the most positive praise, went naturally a growing
curiosity about his life. In the recently published book by Dr. Will Grohman
we find a wealth of biographical material and much instructive information,
but this most personal confession of Paul Klee will have a far more com-
pelling effect on the observer.

So far as I know, Paul Klee, who was always a fanatic about orderliness,
kept a diary from the year 1898, when he was nineteen years old. He gave
each chapter a running number and date. However, in the course of 1,134
numbers Klee skipped several figures in the series. About 1911, my father
began to make a clean copy of these very diverse notes in two notebooks,
which were to be followed later by two more, final, copies.

With great pleasure, and with a full appreciation of my responsibility, I
gave my consent in the summer of 1955 to the plan to publish the diaries
of my father, Paul Klee. For quite a while many art lovers, who knew of the
diary from excerpts that had appeared in several books about my father, had
expressed their strong interest in a separate edition of the unabridged text.
My first task was to decide whether the many private and personal notes of
Klee could be of value to outsiders. After a detailed examination I felt that
I could assume this responsibility and undertook a review of the whole text.
I should now like to transmit some comments to the reader based on this
work:

1. Various parts of the text were written by Klee in Swiss German, the

dialect my father always used with the family. I have kept to the original version.

2. Following the usual practice, several passages in the original text of Klee were adapted to what is accepted style at present. Mistakes, misspellings, and obscurities in the text were corrected.

3. In several places proper names were replaced by initials. This precaution was necessary in order to avoid subjecting some still living friends of my father's to the glare of publicity.

4. I happened to find several rough drafts of diary entries in my possession; these I added to the text I edited. (My father would often cut out pieces from the first version and paste them into the final diary at the proper places.)

5. In the archives of the Paul-Klee-Stiftung there turned up a notebook of my father's covered in black oilcloth. Besides notes and some poems, it contained an essay on "graphic art," a first version of his *Creative Confession*, and, in the form of extracts, under the respective numbers, some noteworthy variants of the diary text. The publisher and the editor have refrained from publishing both versions side by side or one after the other. Rather, we agreed to accept only the more essential statement in one version or the other.

Otherwise it was possible to publish everything without demur, and without too much offense to Klee's original intention to keep his diaries secret.

After Klee's death, on June 29, 1940, the four diaries were faithfully guarded by my mother, Lily, in her apartment in Bern. After the death of my mother, on September 22, 1946, the notebooks came into the possession of the newly formed Klee-Gesellschaft. Upon my return from Germany to Bern on November 13, 1948, I presented a claim under my copyright, which I had never waived. After a vigorous dispute our opposing attorneys, in the spring of 1953, entered into an agreement that was satisfactory to me. The Klee-Gesellschaft was dissolved. The possessions and copyrights it had laid claim to were returned to me. In a further agreement I granted recognition to the Paul-Klee-Stiftung, which was founded in the year 1947. Its holdings, apart from a rich collection of paintings, were augmented by the diaries, the catalogue of the complete artistic works, the literary remains consisting of theoretical writings, a Klee library, and a collection of documents. The foun-

dation has its headquarters in the Berner Kunstmuseum and is administered by it. The reproduction rights for the paintings of Paul Klee which are in its possession belong to it, while the reproduction rights for the remaining pictures, as well as the literary copyright, remain with me and my family.

The encompassing world of Paul Klee, which was alluded to at the start, is impressively thrown open to the younger generation in this way: By reading the diaries we are introduced to his life and into the realm of all the arts— music, painting, and literature. We witness in their true sequence the inner growth and the struggle of the young Paul Klee. A struggle with human and with artistic problems, as they confront every developing and serious artist. We recognize today the source of Klee's distinctive, philosophically humorous picture titles; they grew out of his formally perfect and strongly pictorial knowledge of the German language, here amply documented, and far surpassing what is ordinarily met with in diaries. Apart from his solid musical background, we observe a literary creativity and mastery marked by true genius, whether in written dialogue, aphorisms, letters, critical remarks, observations, travel impressions, his humor often edged with sarcasm, or his astounding assurance in the appraisal of his own personal fate. Thus we recognize in this document Paul Klee's strong attachment to all the events of daily life, as a part of the whole of and with nature. Reading and studying the following four diaries will open another unexpected and marvelous blossom to the friend and observer of Klee's art. Be it the spirit of this first publication to carry us off for ample time to distant worlds, on this side and beyond.

Bern, summer 1956 FELIX KLEE

Contents

List of
Illustrations

DRAWINGS

PHOTOGRAPHS

Following page 42

Lebenslauf

Ich bin am 18 Dezember 1879 zu München=
=buchsee geboren. Mein Vater war Musik=
lehrer am Kantonalen Lehrer seminar Hofwyl,
und meine Mutter war Schweizerin. Als ich im Frühjahr
1886 in die Schule kam, wohnten wir in der
Länggasse in Bern. Ich besuchte die ersten vier
Klassen der dortigen Primarschule. Dann
schickten mich meine Eltern aus Städtische
Progymnasium, dessen vier Klassen ich absolvierte,
um dann in die Literarschule derselben Anstalt
einzutreten. Den Abschluss meiner allgemeinen
Bildung bildete das Kantonale Maturitätsexamen,
das ich im Herbst 1898 bestand

Die Berufswahl ging äusserlich glatt
von Statten. Obwohl mir durch das Maturitäts-
zeugnis alles offen stand, wollte ich es wagen,
mich in der Malerei auszubilden und die Kunst=
malerei als Lebensaufgabe zu wählen. Die
Realisierung führte damals — wie teilweise auch
heute noch — auf den Weg ins Ausland.
Man musste sich nur entscheiden zwischen Paris
oder Deutschland. Mir kam Deutschland

A BRIEF AUTOBIOGRAPHY,
BERN, JANUARY 7, 1940

Gefühlsmässig mehr entgegen.

Und so begab ich mich dann auf den Weg nach der bayrischen Metropole, wo mich die Kunstakademie zunächst an die private Vorschule Knirr verwies. Hier übte ich Zeichnen und Malen, um dann in die Klasse Franz Stuck der Kunstakademie einzutreten

Die drei Jahre meines Münchner Studiums erweiterte ich dann durch eine einjährige Studien = reise nach Italien (hauptsächlich Rom)

Und nun galt es, in stiller Arbeit das Gewonnene zu verwerten und zu fördern. Dazu eignete sich die Stadt meiner Jugend, Bern, auf das beste, und ich kann heute noch als Früchte dieses Aufenthaltes eine Reihe von Radierungen aus den Jahren 1903 bis 1906 nachweisen, die schon damals nicht unbeachtet blieben.

Mannigfache Beziehungen, die ich in München angeknüpft hatte, führten auch zur ehelichen Verbindung mit meiner jetzigen Frau. Dass sie in München beruflich tätig war, war für uns ein wichtiger Grund, ein zweites Mal dorthin zu übersiedeln (Herbst 1906) Nach aussen setzte ich mich als Künstler langsam durch und jeder Schritt vorwärts
war

war an diesem damals kunstzentralen Platze
von Bedeutung

Mit einer Unterbrechung von drei Jahren
während des Weltkrieges durch Garnisonsdienst
in Landshut, Schleissheim und Gersthofen, blieb
ich in München niedergelassen bis zum Jahr 1920.
Die Beziehungen zu Bern brachen schon äusserlich
nicht ab, weil ich alljährlich die Ferienzeit
von 2-3 Monaten daselbst im Elternhaus ver-
brachte.

Das Jahr 1920 brachte mir die Berufung
als Lehrer an das staatliche Bauhaus zu Weimar.
Hier wirkte ich bis zur Übersiedlung dieser
Kunsthochschule nach Dessau im Jahre 1926.
Endlich erreichte mich im Jahr 1930 ein Ruf zum
Leiter einer Malklasse an der preussischen Kunst-
akademie zu Düsseldorf. Dieses kam meinem
Wunsch entgegen, die Lehrtätigkeit ganz auf
das mir eigentümliche Gebiet zu beschränken,
und so lehrte ich dort an dieser Kunsthochschule
während der Jahre 1931 bis 1933.

Die neuen politischen Verhältnisse Deutschlands
erstreckten ihre Wirkung auch auf das Gebiet
der bildenden Kunst und hemmten nicht nur
die Lehrfreiheit, sondern auch die Auswirkung
des privaten künstlerischen Schaffens. Mein
Ruf als Maler hatte im Laufe der Zeit sich

über die staatlichen, ja auch über die continentalen Grenzen hinaus ausgebreitet, so dass ich mich stark genug fühlte, ohne Amt im freien Beruf zu existieren.

Die Frage von welchem Orte aus das geschehen würde, beantwortete sich eigentlich ganz von selber. Dadurch, dass die guten Beziehungen zu Bern nie abgebrochen waren, spürte ich zu deutlich und zu stark die Anziehung dieses eigentlichen Heimatortes. Seitdem lebe ich wieder hier und es bleibt nur noch ein Wunsch offen, Bürger freier Stadt zu sein.

Bern den 7 Januar 1940

Paul Klee

A Brief
Autobiography

[*The following is a translation of Paul Klee's autograph letter, reproduced on the preceding pages. The letter accompanied his application for Swiss citizenship, which was not offered to him until May 1940, the month of his death. By this time he was in a sanatorium at Ticino and remained a German citizen until he died.—Trans. note.*]

I was born on December 18, 1879, in Münchenbuchsee. My father was a music teacher at the Cantonal Teachers' College at Hofwyl, and my mother was Swiss. When I started school in the spring of 1886, we lived in the Länggasse in Bern. I attended the first four grades of the local primary school; then my parents sent me to the municipal *Progymnasium*. I then entered the *Literarschule* of the *Gymnasium*. After I passed the cantonal examinations and was graduated in the fall of 1898, I had concluded my general education.

Although every career was open to me by reason of my graduation certificate, I decided to study painting and to devote my life to art, despite the risk of such a career. In order to realize my aim, I had to go abroad (the same would be true of many young Swiss artists today), either to Paris or to Germany. I felt more strongly drawn to Germany, and decided to go there.

That is how I came to the Bavarian capital, where on the advice of the Art Academy I went to Knirr's preparatory school. Here I practiced drawing and painting, and before long was able to enter the class of Franz Stuck at the Academy. After three years of study in Munich, I broadened my experience by a year of travel in Italy (principally in Rome). Then I had to settle down to evaluate what I had learned and to use it for my future development. To carry out this intention I returned to Bern, the city of my youth; the fruits of my stay there were a number of etchings done between 1903 and 1906, which even then attracted some notice.

During my Munich years I made many friendships, including that of the woman who is now my wife. Since she was professionally active in Munich, I decided—for what seemed to me an important reason—to move back there

(fall, 1906). I was slowly making a name for myself as an artist; and Munich, a center of art and artists at that time, offered significant prospects of artistic advancement. Except for three years of military service, when I was stationed at Landshut, Schleissheim, and Gersthofen, I maintained my residence in Munich until the year 1920. At the same time, I did not sever my connection with Bern, returning every year to the home of my parents for a summer holiday of 2-3 months.

In 1920 I was appointed to the faculty of the Bauhaus in Weimar. I taught there until this institution was moved to Dessau in the year 1926. Finally, in 1930, I received a call to the Prussian Art Academy at Düsseldorf, to be in charge of a painting class. I welcomed this appointment; it permitted me to confine my teaching to the field that was genuinely my own, and thus I taught at the Academy from 1931 to 1933.

The political turmoil in Germany affected the fine arts too, constricting not only my freedom to teach but the free exercise of my creative talent. Since I had by then achieved an international reputation as a painter, I felt confident enough to give up my post and make my livelihood by my own creative work.

The question of where to settle down for this new phase of my life answered itself. Since my close ties with Bern had never been broken, I was now strongly attracted to it again as my real home. I have lived here ever since, and my one remaining wish is to be a citizen of this city.

Bern, January 7, 1940

(signed) PAUL KLEE

Diary I

1. I shall preface my childhood memories with the remark that I was supposed to have been born in the schoolhouse at Münchenbuchsee, near Bern, on December 18, 1879. I was a few months old when my father, who in his capacity of teacher of music at Hofwyl Teachers' College, was granted permission to live permanently in Bern. At first, we settled, so it is said, in a rather poor, all too-common little street called Aarbergergasse; but soon we moved to 32 Hallerstrasse, a big and grander street. I can't remember this flat any more than the preceding, but only the next one, at 26 Hallestrasse. From my third to my tenth year. We then moved to the Kirchenfeld (8 Marienstrasse), where I spent the later and less innocent part of my childhood. During my last years in the Gymnasium we lived at the family estate on the Obstberg.

Memories of Childhood
(Bern in the Eighties)

2. I developed very early an aesthetic sensibility; while I was still wearing skirts I was made to put on underwear that was too long for me, so that even I could see the grey flannel with the wavy red trimmings. When the doorbell rang I hid to keep the visitor from seeing me in this state (two to three years).

3. When grownups were talking, my mother and a friend, for example, I wasn't able to catch individual words out of the swift flow of sentences. Endless sentences without meaning, like a foreign language (very early memory; two to three years).

4. On one occasion my mother came home and found her beautiful lamp broken. Her hysterical tears made a deep impression (three years).

3

5. My grandmother, Frau Frick, taught me very early to draw with crayons. She used a particularly soft kind of toilet-paper on me, so-called silk paper! She wouldn't take a bite of her apple, nor would she put slices of it in her mouth; instead she would first scrape them into a sort of pulp with a pen-knife. From her stomach sour breath rose periodically (three to four years).

6. My first impressions of the beauty of little girls were very precocious yet extremely intense. I was sorry I was not a girl myself so I could wear ravishing, lace-trimmed white panties (three to four years).

7. For a long time I trusted my Papa implicitly and regarded his words (Papa can do anything) as pure truth. The only thing I couldn't bear was the old man's teasing. On one occasion, thinking I was alone, I indulged in some playful mummery. A sudden amused "pf!" interrupted and wounded me. Even in later life, this "pf!" was heard occasionally.

8. In a dream I saw the maid's sexual organs; they consisted of four male (infantile) parts and looked something like a cow's udder (two to three years).

9. When my parents went out at night the maid took command of the house. On such occasions a room would usually be cleaned, and when it came time to scour the floor, we were allowed to sit on the brush and ride back and forth. But there was one unfortunate thing that was distinctly unfavorable to me: my sister always had special privileges. Unhappy moments, which called the value of entire evenings into question.

10. Evil spirits that I had drawn (three to four years) suddenly acquired real presence. I ran to my mother for protection and complained to her that little devils had peeked in through the window (four years).

11. I didn't believe in God; other little boys were always saying, parrotlike, that God was constantly watching us. I was persuaded of the inferior nature of such a belief. One day a very old grandmother died in our barracklike

apartment house. The little boys claimed that she was now an angel; I wasn't in the least convinced (five years).

12. The dead body of my grandmother made a deep impression on me. No resemblance could be detected. We weren't allowed to come close. And Aunt Mathilda's tears flowed like a quiet brook. For a long time I shuddered whenever I passed the door leading down to the cellar of the hospital, where the corpse had been kept for a while. That the dead could terrify us, I had thus learned myself; but shedding tears appeared to me a custom reserved for adults (five years).

13. My father once described a spinster as a dry girl. I thought this referred to her oddly shrunken lower lip (six years).

14. From time to time, I played tricks on a little girl who was not pretty and who wore braces to correct her crooked legs. I regarded her whole family, and in particular the mother, as very inferior people. I would present myself at the high court, pretending to be a good boy, and beg to be allowed to take the little darling for a walk. For a while we'd walk peaceably hand in hand; then, perhaps in the nearby field where potatoes were blooming and june bugs were all over, or perhaps even sooner, we would start walking single file. At the right moment I'd give my protégée a slight push. The poor thing would fall, and I'd bring it back in tears to its mother, explaining with an innocent air: "It tumbled." I played this trick more than once, without Frau Enger's ever suspecting the truth. I must have gauged her correctly (five or six years).

15. I imagined that everything adult was naturally different. When my mother had been at the opera and next day praised the tenor, what I pictured in my mind was this: of course, no play-acting, no costume—that was for children; but instead, a man in tails, with the score in his hands. At most, a little scenery, maybe an ordinary room (six to seven years).

16. Tramps often attacked me in my dreams. But, I always managed to escape by claiming to be a tramp myself. This ruse always helped me with my fellow students (about seven years).

17. I frequently drew at Frick's house—he was my uncle, the fat restaurant owner; I used to look at the *Fliegende Blätter* there. A guest watched me as I drew a horse and buggy. When it was done, he said: "Do you know what you have forgotten?" I thought he might be alluding to a certain organ possessed by stallions, and answered this man who was trying to embarrass me with stubborn silence. At last he named it: "The yoke" (six to seven years).

18. My fat Uncle Frick was good at imitating the voices of animals. He once fooled a little boy by meowing. The little fellow searched the entire restaurant for the cat, until my uncle put an end to the affair by uttering a trumpetlike noise. But the boy kept up the idea and, with a mixture of stupidity and shrewdness, said: "The nasty kitten has sh. . . ." Hearing this, I had feelings of social revulsion. I would never have used such words in good society (seven to eight years).

19. I was told that tailors sat on the table. Deep down I took this for a fib. But when I actually encountered one of these gentry on his table, I was startled, as by a vision become flesh (seven years).

20. Two little boys, four or five years old (I myself was seven), were supposed to obey me, in every thing, because I was the strongest. One of them, Richard, was a gentle soul and easy to influence—it excited me to play on this weakness as well. I reproached him for his sinful way of life, told him that God (in whom I didn't believe) would punish him, and kept on until he burst into tears. Whereupon I relented and comforted him, telling him it wasn't true. Several times I allowed myself to be tempted by this experiment.

The other one, Otto Eicher, spoke in lovely cadences, which at first strongly appealed to me. But later this sugary tone began to irritate me to the point of nausea. I started to hate the boy and to persecute him. Simply because of that. To this day, I can hear his way of reiterating his questions: "Whatcha doing there, wh-aat??" (seven years).

21. In the second year of grammar school I already harbored very special feelings toward Hermine, the girl who sat next to me. I still remember a

moment during class, as we sat on the desks, with our feet on the bench, and looked at the picture posters hung on the rear wall. The child had a rather silly way of continually smiling with her nostrils: lost to the world, she would pick glass beads from her lap. I cast many glances to the left—feeling at home in this world (seven years).

22. This didn't keep me from busying myself concurrently with a girl from the Suisse romande. I was her favorite playmate, because I understood her language and could even speak a bit of French. But in due course the little tyrant was no longer content with this and started questioning me about vocabulary. A sprightly little thing, red-brown velvet cap with a pert white feather (seven years).

23. While I was in charge of distributing the new books in school, a girl showed a preference for a cover of a certain color. I was in a position to fulfill her wish, and pushed the book toward her. This started the rumor that she was my sweetheart, a supposition that wounded me because she wasn't beautiful and lived in Felsenau (eight years).

24. For a long time I stayed faithful, with a few interruptions, to little Camille. This little lady was beautiful, I could swear to it even today. It was a strong but secret love. Whenever we met unexpectedly my heart quivered. Still, we greeted each other briefly and timidly; before witnesses we acted as if we didn't know each other. At one of our meetings she wore a pale red dress and a big red hat (in Hotelgasse). Another time she walked backward along the Kirchenfeld Bridge, and I was barely able to avoid a collision; that time, she had on a short, dark blue velvet dress and a little cap. Her braid was abundant and loosely bound. Her father was a German Swiss and her mother from Geneva. There were five sisters, each one more beautiful than the other (seven to twelve years).

25. Through a gap in the garden fence, I stole a bulb from a dahlia and transplanted it into my own miniature garden. I hoped for pretty leaves and perhaps a friendly flower. But a whole bush grew up, covered with countless deep red blossoms. This awakened a certain fear in me, and I played with the thought of renouncing my possession by giving it away (eight years).

26. I won a victory over Frau Scheurer, though it was not complete. While sliding down the banister I had broken the metal stand of the cil lamp with my foot. I was terrified, but no witness was present. So it hadn't been me. Suspicion settled on me anyway. Now it was just a matter of consistently denying the crime. I even went so far as to broach the subject myself without any urging, again stressing my innocence. Finally Frau Scheurer at least became unsure (eight to nine years).

27. In the restaurant run by my uncle, the fattest man in Switzerland, were tables topped with polished marble slabs, whose surface displayed a maze of petrified layers. In this labyrinth of lines one could pick out human grotesques and capture them with a pencil. I was fascinated with this pastime; my "bent for the bizarre" announced itself (nine years).

28. One night my mother returned at night from a trip, after an absence of about three weeks; I had long since gone to bed and was supposed to be asleep. I pretended to be, and her homecoming was only celebrated the next morning (eight years).

29. "His sister consoles him," read the illustrated passage in a poem. But I didn't put any high value on the sister's consolation, because she looked unaesthetic (six to eight years).

30. I clearly recall a stay in Marly, near Fribourg. At least, the second one: the first lived on in my mind only through the expression "Marly-skirts," which we applied to a certain kind of children's clothes we wore at the time. The second visit took me for the first time to a strange town, without arcades, on a small river greener than the Aare. Marvelous drawbridges. A horse carriage which was said to contain fleas. The catholicism of the region. A procession. The sisters Küenlin, who ran the boardinghouse. Their French dialect. The hefty lady-director. Gentle Eugenie in the kitchen. The flies there. The poultry yard. The killing of these animals. The squirrel in the wheel. Downstairs, the water with its ticking mechanism. Coffee outside in the afternoon. The cosmopolitan children. Some from Alexandria, who had already traveled on

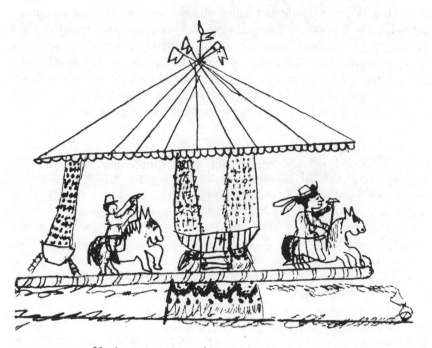

THE CAROUSEL, 1889 (TEN YEARS OF AGE)

the sea in ships as large as a house (this I didn't completely believe). A fat, brutal Russian boy. The walks in the surrounding countryside. The small, swaying foot-bridges. The grownups' fright on these bridges. The man who, at the other end, said *"Dieu soit béni."* The terrible thunderstorm, during which we found shelter in an aristocratic country house. The various bowling alleys. Swimming in the brook. The high reeds. Swimming with a couple of gentlemen near a threshold-like waterfall. The sad farewell to this paradise.

A third stay, which confirmed and strengthened the impressions gathered during the second. The fat, merry young priest who played "musical chairs" with our parents and us (about six to eight years).

31. Herr Winter's daughters smelled of groceries. One of them was in my class. On the first day of the fourth grade it was discovered that this child should really have been kept back in the third. The mistake was corrected by a written statement that was handed to me together with the job of escorting the girl (like a policeman) to her right classroom. I did this with the necessary discretion, and although I didn't like her family and even though all the girls had bad teeth, I never said anything about it in our street (nine years).

32. When I was ten I went to the opera for the first time. They were playing *Il Trovatore*, and I was struck by the fact that these people suffered so much and that they were never calm and seldom gay. But I quickly felt at home in the pathetic style. I began to like the raving Leonora, and when her hands fumbled wildly about her mouth, I thought I recognized in this gesture a desperate grab at her denture; I even saw the glitter of a few outflung teeth. In the Bible people used to rend their garments: why shouldn't pulling out your teeth be a beautiful and moving expression of despair? (ten years).

33. One day, while I was in the lowest class of the Progymnasium [preparatory school], I saw the primary school teacher, whom I'd now got by, approaching me. An inexplicable impulse drove me to go out of the man's way, in order to elude the whole business. During class I saw a fellow student sitting in front of me masturbating in the shadow of his desk (eleven years).

34. By a stroke of bad luck some pornographic drawings fell into my mother's hands. A woman with a belly full of children, another extremely *décolleté*. My mother was unjust enough to take a moral view of this and scold me. The *décolleté* was the consequence of a ballet performance at the theater. A rather plump elf bent over to pluck a strawberry, and you could gaze into the deep valley pinched between swelling hills. I was scared to death (eleven to twelve years).

35. I imagined face and genitals to be the corresponding poles of the female sex, when girls wept I thought of *pudenda* weeping in unison.

36. The first girl I approached with any carnal passion was little nine-year-old Helene from Neuchâtel, a delicate beauty. I met her twice over a stretch of a few weeks during summer vacation, in my uncle's hotel in Beatenberg. A favorable moment came, and I drew her violently against me and would have covered her with kisses, if she had not fought me off madly.

This young lady being very capricious, I suffered much on account of her. Every moment she was *fâchée*: "You're bad."

A young Russian intruded on my hunting grounds. But he was inclined to sadism and couldn't refrain from giving the lady's tiny bare legs a good going-over with some thin rods, until I threw myself on him (only after I had reached the peak of anger) and put an end to the affair. A cold stare was his only reply.

On another occasion my victory was less easy. A young boy from Bern joined us as a third party, and during one of the *"fâché"* periods, ousted me altogether. These were my first torments of that sort. Once I unexpectedly met the girl with her aunt in Bern, near the main police station. I had been strolling through the town with Thiessing. Shortly before, he had bought some candy, and just then my mouth was stuffed and I could hardly speak. He witnessed the whole occurrence. Afterward, he felt as if he had discovered something. His words, "That's your sweetheart!" sank in deeply and painfully. How cruel boys are, even when they are fond of each other (eleven to twelve years).

Our last encounter took place on board a steamer on the Thunersee. I had already sated my curiosity about sexual matters in Munich and felt rather soiled. She was like an angel, and seventeen. The impression, however, was no more than relative, resting as it did on memories.

37. A volume of short stories by Wilbrandt fell into my hands, and I read with special pleasure "Der Gast vom Abendstern." My father looked unfavorably on this; he was of the opinion that problematic characters weren't good at my age. I didn't know what to make of this point of view. What did "problems" mean? What one didn't understand now would doubtless be worked out at some later date. At least one could satisfy one's curiosity in part (fourteen to fifteen years).

Secretly, I had long since read "The Man in the Moon" in the volume of Hauff's *Tales*, which I took literally, not as satire. Like Clauren, in other words. It pleased me mightily (about twelve years).

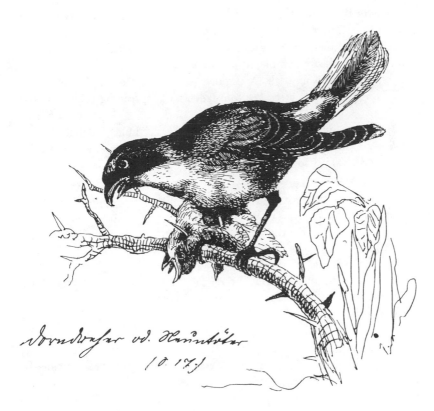

RED-BACKED SHRIKE, 1894

The Student at the Classical High School

50. A stay in Basel, autumn of 1897 and 1898, with my relatives. Great care was taken to entertain me. A certain admiration was shown for my talents. I felt well. My puberty also produced certain timid relations with my girl-cousin D., typical things, completely unconscious.

I took a splendid walk with D. through the vine-covered hills from Weil up to Tüllingen. I can still see the fruit-laden plain spreading broadly at our feet.

Many visits to the theater. Mainly opera. An evening of ballet. I composed many a quatrain to compensate for my too meager satisfactions. Art as authentic as it was bad. 4.24.1898.

51.. Bern. At a subscription concert I heard Brahms' Piano Concerto in D minor played by Frenné. It leaves me completely shattered. As a result, I stay up too late, far into the night. I arrive at school a quarter of an hour late, but this doesn't make up for the time lost.

A somewhat melancholy letter from Basel made me completely despondent. Dark, foggy weather fits this mood. I almost feel as if the best thing, now, would be to lie down for a long sleep, to wake up only on the return of spring. 1897.

52. Bern. 11.10.1897. As time passes I become more and more afraid of my growing love of music. I don't understand myself. I play solo sonatas by Bach: next to them, what is Böcklin? It makes me smile.

La Landi made a deep, unforgettable impression on me with old Italian songs. I sigh, Music! Music!

53. Bern. 12.12.1897. After a time I once again picked up some of my sketchbooks and leafed through them. In the process I felt something that seemed like hope reawaken in me. By chance I saw my mirror-image in the

windowpane and I thought about the man looking out at me. Quite likable, that fellow on the chair; his head resting against a white pillow, his legs on another chair. The gray book closed, the index finger of one hand inside it. He remained completely motionless, bathed in soft lamplight. Before this I had often observed him searchingly. Not always with success. But today I understood him.

54. Bern. 4.27.1898. "Sit down and learn it better!" So it went in the mathematics course; but all that is past and forgotten. Just now the year's first thunderstorm is raging outside. A fresh wind from the west grazes me, carrying the odor of thyme and the sound of train whistles, playing with my moist hair. Nature *does* love me! She consoles me and makes promises to me.

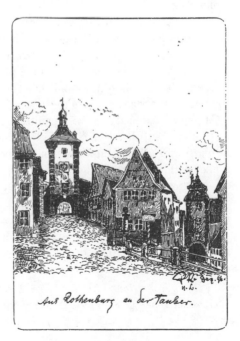

ROTHENBURG ON THE
TAUBER, DECEMBER 1896

On such days I am invulnerable. Outwardly smiling, inwardly laughing more freely, a song in my soul, a twittering whistle on my lips, I cast myself on the bed, stretch, and keep watch over my slumbering strength.

Westward, northward, let it drive me wherever it wishes: I have faith!

55. Bern. 1.19.1898. Brahms' Symphony in E minor stirs me more and more deeply. Even the variations in the last movement are beginning to entrance me.

In our circle, where everybody attends voluntarily, we read Sophocles' *Antigone*. There were also some ladies present, the wife of a *Bundesrat* and a matron clad in mauve! I wrote a long comic poem about her, and Bloesch read from Waldmeiser's *Brautfahrt*. These are the fruits.

56. 1.31.1898. The westwind is on the land. Headache above the right eye. At nine in the evening the temperature is still 41°F.; unable to tune the violin. Sick.

The landscape was just as sick, but magnificent. The woods a deep violet. In the Dählhölzli I lay down on the ground. For a long time I looked up at the swaying pine tops. There was a rustling, cracking, and rubbing in the branches. Music. One time I lay in the Elfenau and was refreshed by the birches. Their silver trunks, and behind them, the deep Gurten forest. By the forests, the meadows bare to the earth. No more snow.

At home I dabbled a bit with paints. It irritated me. Writing poetry didn't go well either. Just as on "that certain summer evening" I thrust my hand into a swarm of mosquitoes without catching a single one. And yet the air is filled with the hum of a thousand voices.

57. Bern. 3.3.1898. Feminine impression connected with yearning for artistic form.

3.5.1898. I even sang and wished I had a voice, as a bridge toward music. I had never wanted to become a violinist; for this, I felt I had too little of the virtuoso's temperament.

58. Bern. 3.6.1898. Gripping moment on a winter's day, with a warm wind blowing.

DRAWING FROM THE MATHEMATICS NOTEBOOK, ABOUT 1896

In the Egelgasse my emotion reached its climax. In the pond inverted clouds were mirrored. Secret pulsation of the still snow, like breathing in one's sleep. Old trees. The impression of a controlled passion. My portrait. Motion stirs an impulse to act in me, an impulse to experience first. My yearning to wander away, into a springtime. Far out into the land. Away. Ever onward.

Now back home in good spirits. Lamplight. Warmth. Assurance, strength, humor, faith.

59. 3.13.1898. Little erotic poems. A touch of frivolity in these things.

3.23.1898. Plan of a book of lyrical songs, before a single song had been completed.

6.17.1898. Last night I felt so well disposed I would have worked till dawn, if my eyes had allowed it. Now I'll work at night, sleep in the daytime. For a future painter this is not quite the right method.

The muse, a harlot dispensing solace for a botched job: but studious zeal doesn't please her at all, especially in mathematics.

60. I wrote a few short stories, but destroyed them all. Anno 1898. Nonetheless, I took myself under my own protection again.

The fact that the results are no good is still no proof of ungodly descent. In such a "classical" environment there is no reality to lean on. What nourishment does an elemental drive find in pallid humanism?: One is referred exclusively to the clouds. Drive without substance. Exceedingly high mountains with no base.

61. Recognized that the erotic energy in me was polygamous. My infatuation switches with every *soubrette at the Opera.*

> Contempt for chastity:
> Chaste are these four walls,
> If I may say so!
> Pure are these two hands,
> And how honestly I yawn! 2.13.1898.

62. When I was about fourteen I took a beautiful trip to Lucerne, Flüelen, and Altdorf with my father and Herr Pfyffer from Saint Imier. We walked

DRAWING FROM THE MATHEMATICS NOTEBOOK, ABOUT 1896

to Göschenen, spent the night there, then walked to Andermatt, Hospental, Gotthard, Airolo, Rodifiesso, and took the train to Bellinzona.

On the third day, to Lugano. Here we stayed with a relative of Herr Pfyffer's. After two or three days we moved to their country estate in San Mamette, where we remained about ten days, making many excursions during that time.

Finally we returned to Lugano and took the train back home.

When I was about twelve or thirteen I took a trip with my aunts. We left Beatenberg for Interlaken by carriage in the morning, then crossed the Brienzersee by boat, landed in Meiringen, thence to Alpnach and Lucerne by way of the Brünig Pass. On the next day, to Vitznau, and on the third, back to Lucerne and to Bern by way of Langnau.

When about fifteen, a student trip with Professor Tobler. I. Bern–Grimsel-hospiz; II. Grimselpass Glacier, by carriage to Fiesch, on foot to Hotel Eggishorn; III. Top of Mount Eggishorn, Riederalp, Belalp, down to Brig. Train to Leuk, on foot to Leukerbad; IV. Gemmispass–Kandersteg; V. Öschinensee and back to Kandersteg. On foot to Frutigen. Train to Spiez–Bern.

When about seventeen I traveled with Siegerist to Spiez and thence walked to Kandersteg. Lower Öschinenalp. Spent the night in a shepherd's hut. Upper Öschinenalp, Hohtürli (hut of the Blümlisalp club). Here we were forced to remain two days, because of the fog, and to manage as best we could. On the first clear morning we walked down to Bundalp, Kienthal, Reichenbach, and took the train to Bern.

Shortly before my graduation finals, in the summer of 1898, my work in school had sunk to a low point. I was forbidden to take part in the student trip. Instead I spent a short while alone on Saint Peter Island in the Bielersee (my first trip with my sketchbook and pencils). The days were ideally beautiful, and I worked very hard. I made the acquaintance of a Catholic priest and we visited the church in Ligerz, which had a handsome view. Beforehand we had drunk copiously of the wine from the lake region, and the pious man had become the best of companions. The fine stained-glass windows particularly held our attention. On the island I was attracted especially by the lower part around the once isolated Rabbit Island; some flowers called "crown imperial," which didn't open until evening, grew there.

I had no schoolbooks with me; I recovered thoroughly from my painful cramming, which was much more sensible. As usual I had faith in my lucky star, and at the examination I obtained four points more than the minimum. After all, it's rather difficult to achieve the exact minimum, and it also involves risks.

63. Backward glance. At first I was a child. Then I wrote nice essays and was also able to reckon (until about my eleventh or twelfth year). Then I developed a passion for girls. Then came the time when I wore my school cap tilted back on my head and only buttoned the lowest button of my coat (fifteen). Then I began to consider myself a landscapist and cursed humanism. I would gladly have left school before the next to the last year, but my parents' wishes prevented it. I now felt like a martyr. Only what was forbidden pleased me. Drawings and writing. After having barely passed my final examination, I began to paint in Munich.

Munich; First Year
of Study 1898–1899

65. Having passed my last examinations, I went to Munich in October 1898. My mother, worrying about me, remembered one of Frick's acquaintances named Otto Gack. These were honest people from Swabia, but pretty much working class and therefore hard to bear. As a result, I soon fell into the habit of repaying their kindness with harsh ingratitude, and gradually stayed away altogether. For a long time I felt sorry about it. Still, it was not my fault. I had been sent to this family without being asked for my opinion.

Herr Gack had come to fetch me at the railway station. His son, a farm worker jobless at the time, had helped me to find a room. Two daughters, one frustrated and overripe for marriage, the other a rather thin adolescent who went to handicraft school, showed me the sights in town. Two or three Sundays I was invited to dinner; the food tasted rather strange. And then I simply couldn't bring myself to go any more.

At first I lived on Amalienstrasse, in the home of a doctor's widow. My first business step was to go to see Herr Löfftz, who then directed the Academy, with my landscape sketches. He was a kindly man, praised my work, and sent me, as preparation for the Academy, to Knirr's private school. Knirr welcomed me with great joy. Upon Knirr's recommendation, a Herr Löh from Basel gave me some assistance and brought me to Dury's to buy paper and pencil. The atmosphere of the studio made a special impression on me. The ugly woman with the flabby flesh, bloated breasts, disgusting pubic hair—I was now to draw her with a sharp pencil!

I did my duty and set to work. Knirr remarked: "For the time being, I won't say anything," a comment which did not exactly encourage me. Then a certain First Lieutenant (Ret.) came over to me and explained the motion of the line and the tactile process to me. This I liked, and soon I produced works that earned me praise and applause. Now I began to enjoy Munich.

Soon I became one of Knirr's hopefuls, and he introduced me to his best students, Lichtenberger and Hondsik, with whom I immediately went to have lunch in a restaurant on Akademiestrasse. The new master, Slataper from

Trieste, a good, sweet man, joined us. In short, I was off to a career as a Knirr student. K. hardly thought about the Academy any longer. Rightly so.

66. After I had achieved success as a Knirr student, drawing nudes began to lose some of its glamour, and other matters, problems of existence, became more important than glory in Knirr's school. Occasionally I even played hooky. Then too, I didn't in the least see (and I was right) how art could ever come from diligent studies of the nude. This insight, however, was an unconscious one. Life, of which I knew so little, attracted me more than anything else: still, I regarded this as a kind of scampishness on my part. It seemed to me that I had no strength of character whenever I heeded the inner voice more than orders from the outside.

In short, I had first of all to become a man: art would then follow inevitably. And, naturally, relations with women were part of it. One of my first acquaintances was Fräulein N., from Halle on the Saale. I considered her—by mistake, to be sure—free and fitted to introduce me to those mysteries around which the world, "life," for better or worse revolves. Much later, when she was no longer important to me, I learned about her unhappy love for a singer. Perhaps this was a good thing for me: this way, the lady couldn't get her hooks into me.

I had met her in a (mixed) evening course in nude drawing. A daughter of Professor V. in Bern, who knew me by sight from there, suddenly spoke to me. I went over into the ladies' camp, where the nude model, a mulatto who was sexually very excitable, could be seen from the back. The Swiss girl introduced me to a girl from East Prussia. I pondered whether she was the right subject for me to study. But the stimulus was too weak. The right one was to be introduced to me on the following evening; it was the N. previously mentioned. A blonde, blue-eyed thing, with a soprano voice and more elegant. I stayed near her without further ado and walked next to her on the way home. We admired the wintery beauty of the Leopoldstrasse, whose trees were heavy with snow, glittering in the light cast by magic arc lamps. I carried a bag of apples for her, and when we took leave in the Schellingstrasse, she gave me one. At the church fair, which was soon to be held, I hoped to take a further step toward the Holy of Holies. Hummel, a Swiss fellow from Gottlieben, was enormously amused at seeing me in love. Perhaps I really was, but certainly

only because I wanted to be in love. After the feast I sought to maintain what little intimacy I had obtained and to meet her more often. During a walk to the Isartal with some fellow students, I vowed never to waste such a landscape again on idiots. When I saw Munich lying in the distance, I thought: if only she were here and those boors there! Fräulein N., however, was there; in fact, she was sick in bed.

I didn't fail to send her a note with good wishes for a prompt recovery. When she turned up at the drawing course again, she thanked me emotionally and expressed her gratitude by presenting me with her photograph in the Dutch costume she had worn at the peasant ball; it was quite charming, even though her hands might have been smaller. When she went so far as to utter a word of praise about one of my nude studies, it was time to make a move. I steered the conversation to the subject of the Isartal and how beautiful it was there. She pounced on the hint at once: "Do you plan to go there some time? Then I'll come along." I was delighted, and on one of the first days of spring we carried out the project, and of course went out to Grosshesselohe. The next rendezvous was in Starnberg. Fräulein N. had been visiting there for two weeks. We had decided to meet at the railway station, but there was no trace of her. Relying solely on my instinct, I went out to look for her. After a while I saw a lady who resembled her strolling in the distance. If it was she, what a lucky chance in this huge place! Impatience made me quicken my step. She thought she was being pursued by an adventurer and started running too. But I ran faster and was able to persuade the frightened creature that it was I and that I had a good reason to chase her. And so the day was saved. We sailed around the lake on the steamer. There I had the satisfaction of hearing the remark made by a Frenchman—"la jolie petite blondine"—with which he called the attention of the other members of his party to my companion. By recounting it to her, I was able to pay her a fine, objective compliment. I also remember that we enjoyed a thunderstorm, just as in *Werther*, and this delicate miss was inclined to shiver in the evening.

As our friendship became warmer, I realized that she didn't guess my real intentions. We strayed along a thousand side streets, but never where I really wanted to go. Of course I was powerless because my lady no longer felt herself free, but since I was not aware of the fact, I sometimes got the feeling that I had some defect or other that kept me from being successful with women.

PENCIL STUDY AT KNIRR'S SCHOOL, 1899

The maternal tone that she sometimes assumed with me bore out the false-ness of my position. She even scolded me for my slightly stooped posture.

Nonetheless, the interruption of our relations by a visit that absorbed me for weeks was unpleasant to me. When I was again free, the invitation of my friend to visit her once more filled me with expectations. I spruced up to have tea with her in the best bourgeois fashion. Then we strolled about most properly in the English Garden and, on the way back, dropped into a bar for beer. We took an ironic pleasure in this conventional side of the affair.

Again in May we went out to the Starnbergersee and walked a way along the right shore. At a particularly beautiful spot she took off her shoes and stockings and waded out some distance in the water. I sketched her then on my pad, with a humorous emphasis.

My young lady finally moved to the landscape school in Worpswede. After we had drunk a last cup of tea in an idyllic garden pavilion, in the presence of a third girl who hung cherries around my ears, we shook hands with comradely vigor. Later as I walked alone down the road, I said "phew!" and spat. How dishonest it all had been, not in the least like the new, unknown experience I had looked for.

Still, in the period that followed immediately, I felt bothered by not having a girl friend. I suffered especially from it in Burghausen, where I went at the end of the year at Knirr's school. I was yet to receive a maternal letter and a landscape from her. I gave this study, in a carved frame, to my parents.

Two years later I saw my girl friend again briefly. For the first time, she came to my room in the Catholic Casino. She was now free of her singer, and I had just started a new relationship. Her protracted sadness hadn't made her more beautiful; her delicate face was just a touch faded, a hint that she wouldn't marry, that she would give lessons in watercoloring to adolescent boys and girls.

67. Music, for me, is a love bewitched.
Fame as a painter?
Writer, modern poet? Bad joke.
So I have no calling, and loaf.

68. Many paradoxes, Nietzsche in the air. Glorification of the self and of the drives. Boundless sexual drive. Neo-ethics.

69. Force demands forceful expression. Obscenity as expression of fullness and fertility.

BURGHAUSEN 1899

70. In Burghausen I wanted to start painting. Therefore I went with Hondsik to buy paints and a box. I left for the trip loaded with luggage. In Mühldorf at the River Inn, the little train went off without me. I didn't mind. I didn't care whether I spent the night in Burghausen or here. Mühldorf sur-

prised me with its southern architecture. The evening was enchanting. The great Inn nearby. The next morning I pushed on to Burghausen. I immediately rented a splendid room for a month. Painting was difficult, but I soon attained a certain manual dexterity and brought off bold studies. Besides, one idled, drank beer, and over in Austrian Ach, good red wine. But there was a great shortage of girls.

Among my colleagues, I shall mention Blittersdorf, whose accounts of Sicily impressed me, and who more than once deplored the fact that I wasn't a girl, but later found a substitute in the horrible Lorenz. Trapp, a good fellow from Darmstadt, who was always raving about Schmoll, whom I got to know quite well later in Rome. Karfunkle, who wanted to work hard and often actually started at five in the morning. An American Jew whose line had a certain fire in it. Regarded Lenbach as his mortal enemy because he had had a portrait refused by the Artists' Society.

Naturally we constituted a kind of locust plague for the town of Burghausen. However, it depended on the tourist trade and shut an eye. None of the high-school professors we insulted ever frowned on us.

Once in the early morning hours we visited a very queer dive. Blittersdorf led the way, after asking the night watchman for the address. It was obvious we weren't wanted there, and sinister faces soon admonished us to clear out.

A Herr Granichstätten showed up and had himself trumpeted as a musical genius. Frau Knirr believed in him. He was a handsome, stout Jew. Later he tried to compose operettas, after an attempt to sing his own serious songs had earned him catcalls in Munich. (Frau Knirr fled from the concert hall.) As fruits of my labor, besides the lightning oil sketches, I brought a humorous sketchbook back to Bern. In order not to have to go back to Munich, I chose the following itinerary: Salzburg–Innsbruck–Buchs–Sargans–Zurich–Bern.

BURGHAUSEN–SALZBURG 1899

71. Before leaving I accepted the invitation of Ziegler the engraver to visit him in his little castle nearby. When I rang the bell I was deafened by the barks of a monstrous dog. I liked it better upstairs. Ziegler showed me his material for the book he was planning on engraving. There was something at-

tractive about his laboratory. Less attractive was his attempt to separate me from Knirr, even though he may have intended to be objective.

I departed in old-fashioned style, by mailcoach. I climbed on the coachman's seat, my arms filled with an enormous bouquet of flowers. We trotted through charming countryside, as far as Tittmoning if I'm not mistaken. Here a funny little train stood waiting. As far as Freilassing, a Herr W., who was going to Reichenhall, entertained me with pleasant conversation; here I transferred to an express train and in no time I reached my first goal.

Now for the first time I was in a strange land, abroad, completely on my own. My arrival was greeted by an extraordinary rainstorm for which I was quite unprepared. As a result, my arrival at the Hotel "Blue Goose" was not very brilliant. I was given the last room; the window opened on the staircase. This idyllic arrangement suited me quite well, since I was constantly on the move, drank in the wonderful city in deep drafts, and dutifully inspected the noteworthy sights in the vicinity with the help of a small guidebook. I recall mainly the Mozarteum, the Mönchsberg, the Cathedral, the great fountain, a restaurant up on the hill where there were foreigners and music, the cemetery, the off-pitch chimes.

But when after a few days my money started melting away, I first cautiously purchased my ticket to Bern. Then I paid my hotel. After that, not much remained, but it was probably enough for a good lunch somewhere. Fate, however, had ordered that in Austria, too, good trains were more expensive, and I was glad that my financial reserves proved sufficient. A Swiss fifty-centimes coin was my last possession.

On the other hand, I was full of good humor; it even stood the test of seeing a man next to me having a tempting meal served to him. The weather was superb. It's pleasant to see places like Zell-am-see, Kitzbühel, Innsbruck, Landeck, Vaduz speeding by your window. On the whole, I was, as a "Swiss," slightly disappointed in this part of the Alps.

Buchs came as a kind of salvation in that I was able to exchange my fifty centimes for a ham sandwich and a glass of lukewarm Swiss beer. After the Wallensee, darkness came and I gradually fell asleep with only one last little worm gnawing at me: would I find a connection to Bern in Zurich? It was so fine to manage from Salzburg to Bern on fifty centimes, it really had to work.

And work it did: at 2 a.m. I arrived in my hometown. I awakened my

mother by whistling the Mime-motif and soon lay again in my own bed for the first time in many months.

72. With Siegerist, a mountain-climbing friend, I made a fine trip into the region of the Faulhorn, which then took a rather unexpected turn. We went by train to Thun, Interlaken, Brienz, Meiringen, then walked to the waterfalls of Reichenbach and the pass of the Grosse Scheidegg. Here we turned northward in the direction of the Schwarzhorn. We spent the night in a mountain hut, lying on the straw above some quarrelsome pigs. II. Departure for the summit of the Schwarzhorn. Then down the other side, over a pathless stretch of loose stones; in a dale we took the direction of the Faulhorn. We disagreed as to which direction to follow. My companion was stubborn; besides, he felt responsible for me and demanded that I obey him. I didn't see his point, and my strong sense of direction made me feel sure that I could find my way alone. He followed his own direction, thinking that I'd soon be unable to proceed any further. But he had to turn back, whereas I went so quickly along my own route that he soon lost sight of me. I felt right, free and alone on heavenly heights, and I easily reached the top of the Faulhorn. There I asked for a cup of coffee and a piece of white bread; afterward I lay down in the grass and for hours contemplated the clouds and the high peaks. When the familiar tiredness seized me I found the inn bustling with newcomers, a group of Englishmen with a pretty girl, not of the delicate sort. Of my friend, not a trace. What a splendid route he must have found! When the party of Englishmen started I followed them at some distance, constantly keeping the light creature in sight, as if I were a huntsman and she the game. When I clearly saw Grindelwald below I thought of the hotel prices there and preferred to spend the night in a hut 3,000 feet above sea level. A young fellow took me in and we slept close to each other. When it was already dark a couple of girls' voices called him and begged him, in singing tones, to escort them because they were late. The youth showed himself chivalrous, for he got up without protest; I didn't object, because he took along his feet, which didn't exactly sweeten my sleep. III. When I woke up he had not only re-

turned but had long since arisen. I paid and went down to Grindelwald. I made my first pause in Zweilütschinen, where I downed many glasses of milk, at least five in a row. In Interlaken I drank beer and ate ham sandwiches. Then I whiled away the time in that town until the last train left. In Scherzligen I met my comrade again. He was still quite excited and related his adventures. After he had failed to find me at the place where we had parted, he became obsessed with the idea that I had had a fall somewhere. When the people in the "Hotel" Faulhorn claimed they had not seen me, my friend, who was exhausted from having searched the district, regarded the case as settled beyond the shadow of a doubt. He spent the night up there while people hired by him continued the search. Of course, without result. However, we decided not to be mad at each other any longer, shook hands, and shared the extra costs in brotherly fashion.

73. On August 25, 1899, I received a letter from Worpswede. She wrote me a motherly letter that cooled me off for good, in spite of my fondest fancies. Enough of mothers.

Once in the course of a conversation she said to me: "I believe you don't actually love anyone from the bottom of your heart?" My answer was a brash "No," which struck me, falsely, as a bit dishonest when I uttered it. It was the truth. I only wished to find out the mystery. Within certain limits the personality of the woman was of no importance.

I compared myself to a rock that was cold at night and on overcast days, but that could become burning hot under the sun.

BERN, 1899

74. Often I had cheerful drinking sessions with my father at home. Once he uttered this beautiful sentence: "There is no more beer. Under the circumstances nothing remains for us but to show consideration for *die Alte*." And we went to bed.

75. A comparison: The sun brews vapors that rise and struggle against it.

76. On September 25, 1899, I went to Neuchâtel and from there by train to Areuse near Colombier to visit a young man named Bovet, who lived there with his parents. I had met him at Knirr's and taken pity on his dreadful German. His parents' house was very handsome; it had something aristocratically patriarchal about it. After a prayer one sat around a gigantic circular table and ate great quantities of excellent food. Then to the wine, until one could no longer stand. In the afternoon the two of us drove to town in the father's horse-carriage and visited the museum. Poor Bovet had a tendency to *kitsch*. Imagine having such wealthy parents and not even being allowed to paint what he wants to paint! He had already had to finish an animal painting to bring it to the exhibition in Neuchâtel.

Later he served in the dragoons in Bern. Unfortunately, he never returned my visit.

77. A short sample of the way I used, in those days, to rhyme in the popular vein:

I. Now Death has taken thee,
The rosy red tone
Is thrown on falsely.
Curtains magic in their delicacy
Colored my love who was dead,
Dead never to wake.

II. Tell me, you people, what shall I do, O people?
My heart burns so,
Now I have no sweetheart more
To kiss and kiss once more.
Oh, if I were a little bird,
A little bird would know,
I would fly to the distant seas that roar
And cool my heart in the sea.

78. I am like the slope where the resin boils in the sun, where the flowers burn. Only the witches' sabbath can cool me; I fly to it in the shape of a firefly and immediately know where a little lantern is lit.

MUNICH I, ADDENDUM

79. How we talked with one another. For instance: one of us imitates a goat successfully. Response: "Look what you can do." Or: "What will you do once you have nothing left but your bare body?" "Pose in the nude." "Come to think of it, the day after tomorrow is a holiday, let's have a last one!"—When both of us were broke, there was always something nice about it; but when only one was broke, then the continuous borrowing only made things worse for the one who still had money. —When one of us, at night, wanted to leave the tavern: "Stay a half hour more, I'll buy you a half pint, and if you stay a whole hour I'll buy you a cake to boot." —"Man, be satisfied! Aren't you alive! That in itself is quite wonderful!" —"You've got time to rest only while you're alive." —"So, now we shall celebrate your birthday; what else were you born for?" —When Karfunkle put on his socks: "Now he puts on a hole again." (Presuhn.)

Munich II, 1899–1900

80. Haller now also came to Munich; he had his way, instead of becoming an architect in Stuttgart. He entered Knirr's school, and when I came, he already felt very much at home there. As a matter of fact, his friendship with "the best student in ten years" had been quite useful to him; he made good use of it when he introduced himself. Besides this, there was his fresh, enterprising nature, which even then could be quite irresistible. His laughter made the studio all the more congenial. Now a group of talented young people, including some Swiss, formed around us; they felt free to take every liberty, particularly that of venting their sarcasm and irony on outsiders.

81. What gives this joke its point, for instance, is that it really happened:
Chief I (85 years): "I believe that I am more destined to be a landscapist, after all."
Chief II (84 years): "Bah! How can you be sure of that yet?"

82.

> I sank most deeply in the arms of dream
> When I kissed you under the willow-tree.
> It was a burning kiss,
> And my temples hammered,
> A cloud pack chased
> Over everything below.
> O power of night!
> O deep splendor of this burning joy!

83. Retrospect. Inspection of my complete self, said goodbye to literature and music. My efforts to attain more refined sexual experience, abandoned in that one single instance. I hardly think about art, I only want to work at my personality. In this I must be consistent and avoid all public attention.

33

That I'll eventually express myself through the medium of art is still the most likely outcome.

A little "Leporello catalogue" of all the sweethearts whom I didn't possess provides an ironical reminder of the great sexual question. The list ends on the initial of the name "Lily" with the remark "wait and see."

I met the lady who was to become my wife in the autumn of 1899, while I was playing music.

84. You have started a fierce fire in my soul, from which sonorous flames rise (music as a way of sublimation).

85. Fear of the beginner's stage. You who approach me and will someday understand, I tell you that, if I should pass on too soon, you would lose much in me.

86. Flower of fire, at night you replace the sun for me and shine deeply into the silent human heart. February 1900.

87. I want to hold your head in my hands, tightly in both hands, and never allow you to turn away from me. For suffering would make my strength grow till it destroyed me.

88. I become clearer in the storm, and life fascinates me.

89. With the feeling that the development of my relation to Lily is inhibited: now I doubt the existence of love, it is turning to ordinary pity. Instead of adoring I analyze sharply and revealingly. Analysis turns ideal synthetic traits into shameful flaws. Nature toys with us. Love looks upon deceptive reflections. Distrust arises and slows down circulation. Nonetheless, I am filled with longing. I would call her Eveline.

90. By Eveline I meant accomplishment, the ideal. The reality was an overt or latent struggle to achieve this ideal with Lily, and besides, the satisfaction of my curiosity about the sexual mystery. In plain words, I had begun an affair with a girl who was my social inferior (after the New Year of 1900).

I felt well in "the storm of life." Some rest would be healthier, but impossible. The longing is gone, or else it assumes a more tranquil form.

Alcoholic excesses were an organic part of the whole process. Entries made in the state of drunkenness that followed long nightly parties must be deleted here, for they invariably turned out to be completely incomprehensible.

91. 3.6.1900. Lily is not all gaiety after all; she says that she is often sad. Why does she say this to me? Every time I feel more guilty toward her. I cannot tell her: "Once again I have sinned against what would be best and most beautiful—to have the right to seek and to find all my pleasure near you!" Sometimes I am really disgusted.

92. Sketch of a poem. After a May wine orgy. Everyone lies drunk. The spring night has grown dark, the first storm breaks. Thunder makes the glasses ring. Then mild rain comes down conciliatingly. All is forgiven.

93. The conviction that painting is the right profession grows stronger and stronger in me. Writing is the only other thing I still feel attracted to. Perhaps when I am mature I shall go back to it.

94. The Leporello catalogue turns up again. The name Lily is written down in full. Next comes Eveline, that is, the longing for complete happiness in love. The relationship is not stated.

95. My relationship to Fräulein Schiwago was very peculiar. I admired her greatly, but without losing control of myself. I probably already had within me too close an attachment to Lily to do so, without guarantees, without risk, just I myself.

Moreover, Schiwago at first seemed to be unattainable because it looked as if something existed, or was going on, between Haller and her. (I only learned in 1909 that she didn't approve of this reticence on my part.) Afterward we had taken leave of each other in April 1900 until the following autumn, on an evening at Schiwago's, strange because of the prevailing mood (Haller, Fräulein Wassiliew, Schiwago, and I were present); Haller later received a short letter from Schiwago. Among other things, she said:

"I have the honor to take leave of Herr Klee and the sad pleasure to take leave of you." From which I deduced that Haller was closer to her. At the end she quoted these words of mine: "Humor must help us get through anything."

96. The only extant alcoholic entry. I maintain. I know. I don't believe. I first want to see. I doubt very much. I beg! I do not envy. I do not turn back. I act. I oppose. I hate. I create in hatred. I must. While I admit. I weep. Nonetheless. I persist. I complete. I wager. Only quiet, only quiet!

97. A performance of Strauss' *Zarathustra* directed by the composer made a great impression on me. Read a brochure by Merian.

98. 4.26.1900. The most agitated days pleased me especially. I drew compositions in the morning ("Three Boys"). Then my mistress visited me and declared herself pregnant. In the afternoon I took my studies and compositions to Stuck, who accepted me in his autumn class at the Academy. In the evening I met Fräulein Schiwago at the Kaim concert. If I didn't sleep deeply and soundly that night!

MAY 1900, OBERHOFEN

99. To Eveline. I promised you much. To be a decent man. I want to prove myself to you. First, I must kneel before God. Then, Eveline, save me completely! I have no one but you!—I toyed with poison, I poisoned myself, why did I wish to be an outsider? I was basically too attached to the good for that. Woe to guilt, perhaps it is greater than I thought. Oh, to forget it near you! But you would first have to forgive it. If you can. I greet you from far off.

EXCURSION TO BEATENBERG WITH HALLER
AND SCHIWAGO

100. In Beatenberg, where I had experienced my first erotic sensations, I became clearly aware that a certain worm was gnawing at my soul after all.

The living presence of Schiwago, who had an ethical bent, provided even more incentive to indulge in moral considerations. The four of us, Haller, Fräulein K., Fräulein Schiwago, and I, had undertaken an excursion to Thun. In Sherzligen we rented a rather unwieldy boat from a fisherman and didn't get far with it. We returned it at once and appealed to the fisherman's competitor, who was able to rent us a marvelous keeled boat. The sweet course of the Aare along the Bächimatt made a tremendous impression on us. Then we rowed into the middle of the mirror-smooth lake as far as Merligen, amid idyllically friendly conversation and little pranks—Haller threw overboard our ladies' opened parasols. In Merligen we put in at a little slip—completely overgrown—of a brown and black farmhouse. Here we left our boat and climbed uphill toward St. Beatenberg. Once there we stopped at the Hotel Beau Séjour and ate an excellent lunch. Then we set up camp in the little wood and under my leadership followed the lovely path over the ladder down to the grotto of Saint Beatus and back, through the marvelous woods, to Merligen. In the coolness of evening we rowed back to Oberhofen, where my dear aunts served us dinner on the landing. My three comrades took the next steamer to Bern, but I stayed in Oberhofen. I brought the boat back to Scherzligen the next morning.

101. Tolstoy's *Resurrection* was introduced into our circle by Schiwago. It was too ethical for me, not only in relation to the artistic content, but in itself. From repeated observation I recognized that I was open to ethical matters only when the circumstances of my life were clear and hopeful. Later on, art absorbed all my morality, and, as a moral person, I was absolutely assured that I would end by being wholly absorbed by that world. Had I led a worldier life, I probably could not have avoided painful conflicts.

Once, in reply to Lotmar, I inveighed against the book: he defended it so nobly that he made a great impression on me and drew me, to some extent, under its influence. Still, he was not doing it with any definite intention, whereas Schiwago tried everything to save us. I made much of the fact that the book was lacking in humor. Later, when I became engaged, my ethical idealism rose up again and my opinion of this book along with it, and I gave it as a present to my fiancée.

102. In June, on the steamer *Bubenberg,* I met Fräulein Helene M., from Neuchâtel. This pretty damsel of seventeen had been as a child the object of my first great passion. I started thinking about all that had become of me since then, while she had remained fresh and pure as a forest brook.

103. Often I am possessed by the devil; my bad luck in the sexual realm, so fraught with problems, did not make me better. In Burghausen I had teased large snails in various ways. Now, in the region of the Thunersee, lovelier still if that is possible, I am exposed to similar temptations. Innocence irritates me. The birds' song gets on my nerves, I feel like trampling every worm.

104. Excursion by night from Bern to Solothurn, on foot, and up to the Weissenstein in the morning; by four in the afternoon, back again in Solothurn. The Bavarian beer-hall as sleeping quarters. Tired by the thirteen-hour walk, back home by train. Bloesch and a third fellow took it upon themselves to walk the additional stretch from Solothurn to Burgdorf.

105. I drew up the outline of a last will. In it I asked that all existing proofs of my artistic endeavors be destroyed. I well knew how meager and inconsequential it all was in comparison to the possibilities I sensed.

From time to time I collapsed completely into modesty, wished to produce illustrations for humor magazines. Later I might still find occasion to illustrate my own thoughts. The results of such modesty were more or less sophisticated technical-graphic experiments.

It is convenient to define a thwarted act of will as a crazy mistake.

OBERHOFEN, AUGUST 1900

106. Nowhere I wanted to stay; of what use, then, was a delightful landscape? The dryads' chatter bored me. The bells of the herds up in the mountains had sounded there before. On the water the despair of loneliness lurked around me. Unconsciousness was what I needed, not recreation. I felt drawn

to the city. I shall never be capable of entering a brothel, but I know the way to reach it.

I wrongly lead a vegetable life, like the blossoms of the flowers behind the iron fence in the castle at Oberhofen. I am a captive animal. For inner and outer bonds remain alike. How long shall my soul carry these chains? Can one ever find peace in love? . . . One can be afflicted without being unhappily in love. Even there.

During a heavy storm, men stand godless on the shore and moan for a few human lives, instead of sacrificing them in worship.

107. In a poem I sang a song to sorrow with such pathetic conviction that it personified itself in the desired woman, in whose embrace it was good to die.

108. This summer leaves me too much time for thinking. I have not got far enough to work without model and school. Finally evening came, and autumn. As if numbed by the day and its cares I awake and notice that leaves are already falling. And on this soil must I now sow? In winter am I to hope? It is going to be gloomy work. But work, anyway.

AUTUMN 1900

109. The comparison of my soul with the various moods of the countryside frequently returns as a motif. My poetic-personal idea of landscape lies at the root of this. "Autumn is here. The current of my soul is followed by stealthy fogs."

110. Eveline finally turns into the Muse of all my disconsolateness. This season is my low point. I look vainly toward the door. Salvation does not enter. Outside, too, there are no traces of any. Not a hint. At times all becomes empty. Only my brain, like a brown spot in this waste. Thus was born the poem. Surely its utterance brought me great relief. It also meant that the summer of 1900 had not been endured completely in vain. At least, one part of me had been cast into another form. I composed poetry at the

end of August. A tired song about Eveline. I was led astray, because of unconsciously successful work, into conceiving similar ones consciously and deliberately: this was a mistake that I was to make again and again, until I understood it and was able to avoid it.

111. I. I call Eveline a green dream under foliage, the dream of a naked child on the meadow.

But I was denied such happiness forever, when I came among people and could no longer leave them.

Once, I freed myself from the hold of pain experienced and fled into the noonday fields and lay on the burning mountain slope. There I found Eveline again; she was riper, but not aged. Only tired by a summer.

Now I know it. But see, I only surmised it, as I sang this. Be gentle to my gift. Do not frighten the nakedness in search of slumber.

II. March threatens us with summer; you threaten my soul with burning love, Eveline!

May still waxes green. These are still cradle songs.

I sharpened many a steely word. I wished to be a rock amidst the tide.

The edge was blunted. How I wish to kneel down, all humility. But before whom?

Worms wanted to console me. Am I so miserable? Then I am disgusted.

III. Ah, too much sun rose over me! Endless days without night. Forever singing light. I wanted to find again my early house in the green shade, my dream under the foliage. Where is it?

No crawling into hiding offers a delusion of evening to the dazzled one, he rubs flames into his eyes.

The awakened was not at all asleep. He speaks in a toneless voice: you tired song.

And this is it, the tired song.

IV. Hear the summer chirp in the fields
 hear the hoarse lark in the air
 Eveline. Queen in midday.
Only the smallest creatures are still zealously active, ants, flies, and beetles.

But me, the midday peace paralyses. I burn on a dry bed, I am all fire on the thin carpet of thyme and brier.

V. I still recall the moon's mildness. But now flies copulate on me, and I must look on it. The snow melts from the mountains; even there I shall not find coolness.

And I must stay. . . . Your glance bids me be silent, Eveline. We are saints, I became one through you.

VI. Do not flee from my proximity! Trust! Recognize! You have dried up the marshes of my soul, now you are hidden in clouds. Your victory shall be complete.

VII. When reality is no longer endurable, it seems like a dream dreamt with open eyes. Continue, dreadful dream, near Eveline. O deceptive illusion, that you yourself come down to find shelter and consolation near me.

VIII. This is the great day, all aglow with love. Shall there be an end here too, a twilight? Shall a goddess fall? Still it is day, still all is aglow with love.

112. Religious thoughts begin to appear. The natural is the power that maintains. The individual, which destructively rises above the general, falls into sin. There exists, however, something higher yet, which stands above the positive and the negative. It is the all-mighty power that contemplates and leads this struggle.

Before this all-mighty power I might stand the test, and to stand it ethically was my wish.

113. Relapse into the popular tone. My hope, alas, it is gone. I have waited long, through day and night, nothing can tempt me any more. No sweet whisper, no heaven and no paradise, my heart's flame is dying.

Munich III,
1900–1901

120. Poem III really was the only fruit fit for survival which I had produced until then. It is quite understandable that other poetic attempts should have followed. But it was no use to preserve these, which were in part only studies, exercises in style. I even dabbled in dramatic writing. A sequence of scenes was called:

1. The dancing Eve.
2. The suffering of men.
3. The Evil One and men.
4. The use of violence.
5. The liberating hero.
6. The poet.
7. Execution and resurrection.

121. Twenty-one years old! I never doubted my vital force. But how is it to fare with my chosen art? The recognition that at bottom I am a poet, after all, should be no hindrance in the plastic arts! And should I really have to be a poet, Lord knows what else I should desire. Certainly, a sea swells within me, for I feel. It is a hopeless state, to feel in such a way that the storm rages on all sides at once and that nowhere is a lord who commands the chaos.

122. To be a student of Stuck sounded good. In reality, however, it was not half so splendid. Instead of coming to him with a sound mind I brought a thousand pains and many prejudices. In the realm of color I found it hard to progress. Since the tone provided by mood predominated strongly in my mastery of form, I sought to find as much profit as possible here at least. And, in this respect, a great deal really was to be gained at Stuck's. Naturally I was not the only one, at this time, to be deficient in the realm of color. Later, in his monograph, Kandinsky passed a similar judgment on this school.
 Had this teacher made the nature of painting as clear to me as I was able to do later, once I had penetrated far deeper, I would not have found myself in such desperate straits. Then I reflected on what I might gain besides from

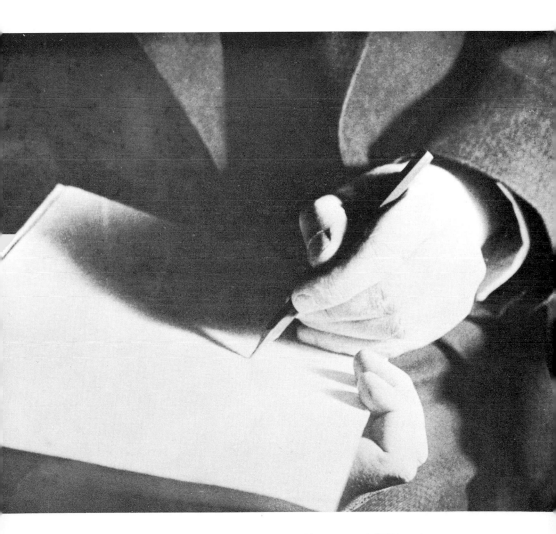

THE HANDS OF PAUL KLEE, DESSAU, 1931

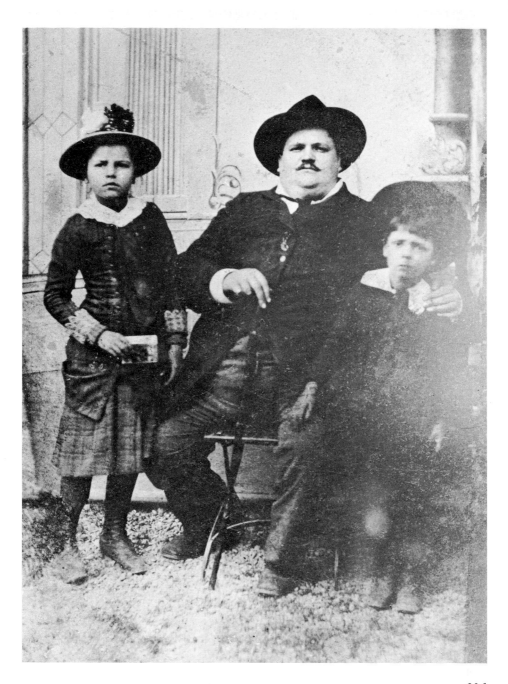

MATHILDE KLEE, ERNST FRICK, PAUL KLEE, BERN, 1886

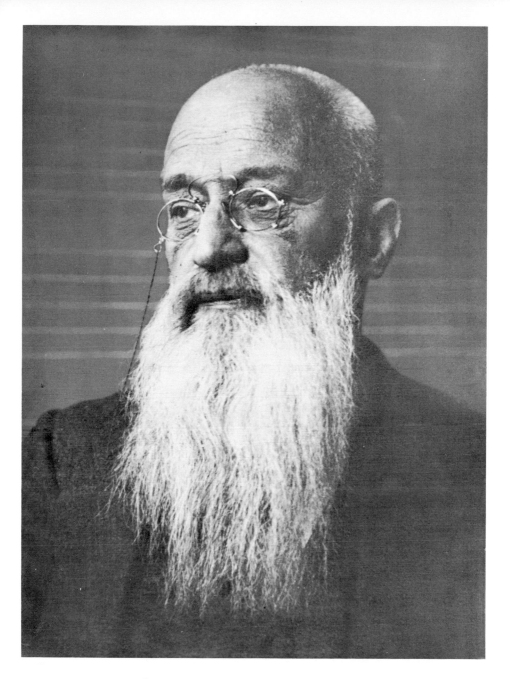

HANS KLEE, THE ARTIST'S FATHER, HOFWYL, 1925

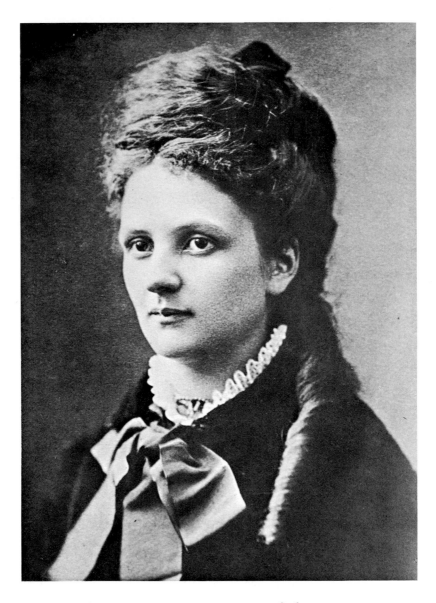

IDA KLEE, NÉE FRICK, MOTHER OF PAUL KLEE, 1876

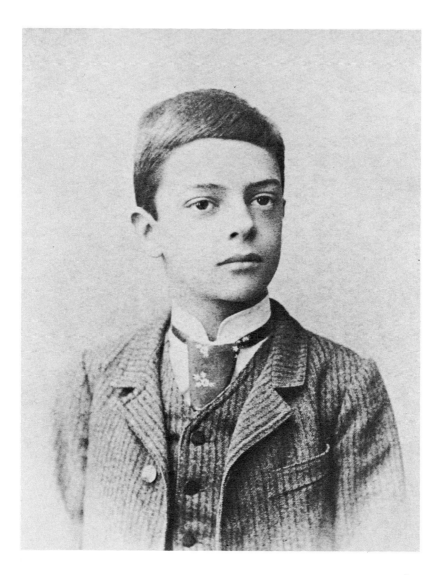

PAUL KLEE, BERN, 1892

LILY KLEE (WIFE OF PAUL KLEE), MUNICH, 1906. PHOTOGRAPH BY PAUL KLEE

PAUL KLEE, BERN, 1906

PAUL KLEE, LANDSHUT, 1916

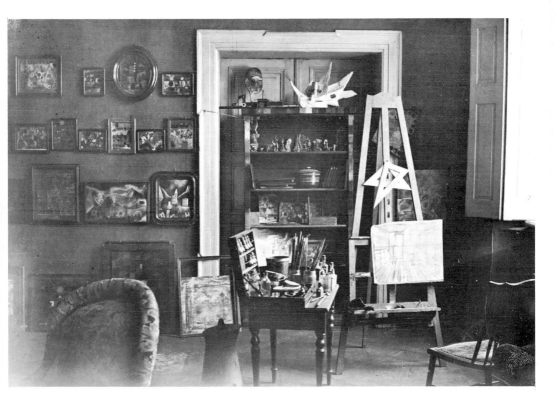

PAUL KLEE'S STUDIO IN MUNICH, WERNECKSTRASSE, SCHLÖSSCHEN "SURESNES," 1919.
PHOTOGRAPH BY PAUL KLEE.

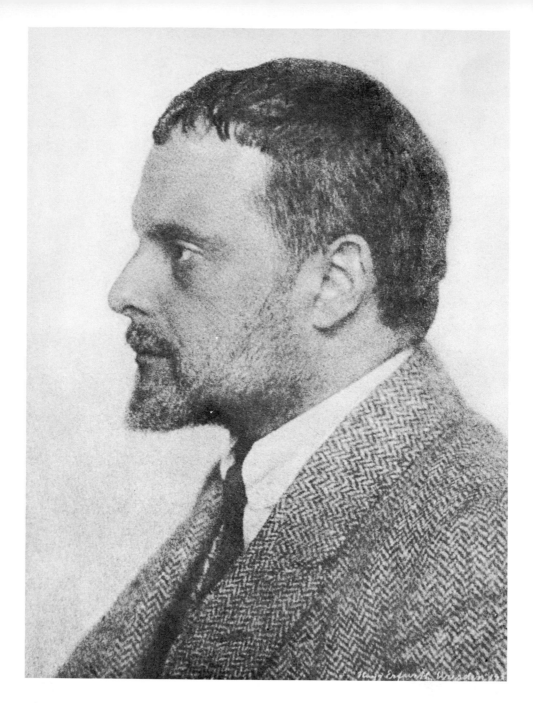

PAUL KLEE, WEIMAR, 1922

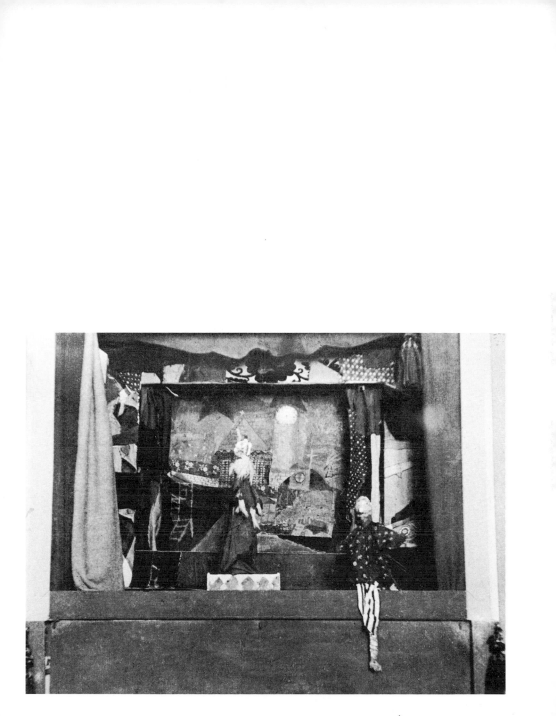

FELIX KLEE PUPPET THEATER; PUPPETS AND DECOR BY PAUL KLEE (KASPERLE AND THE
DEVIL IN THE MAGIC BOX), WEIMAR, 1922

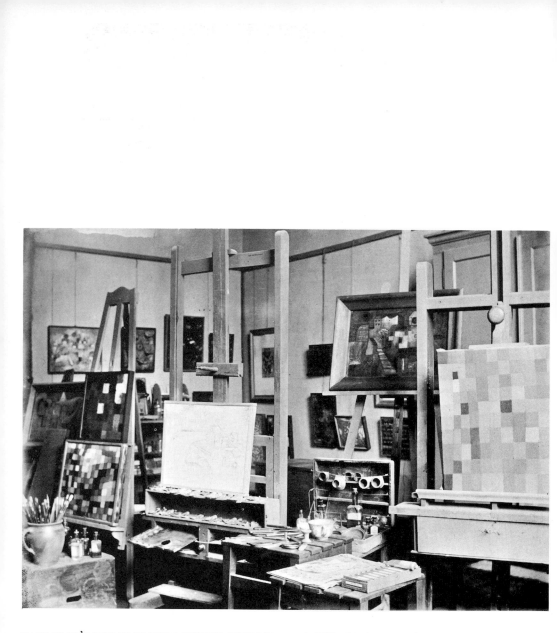

PAUL KLEE'S STUDIO IN THE BAUHAUS, WEIMAR, 1924. PHOTOGRAPH BY PAUL KLEE

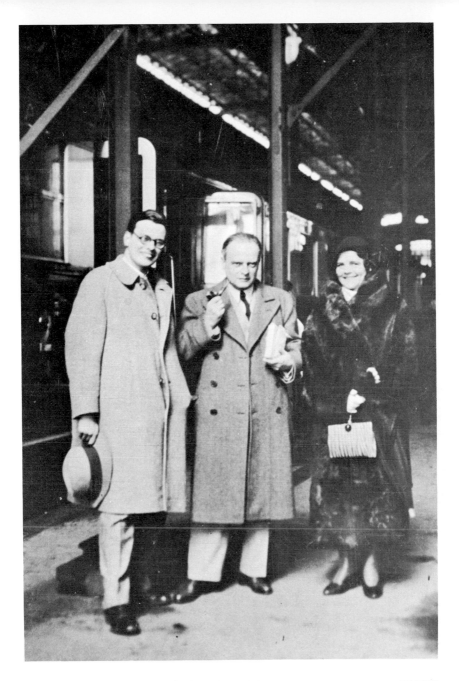

FROM LEFT TO RIGHT: FELIX, PAUL, AND EFROSSINA KLEE IN THE
RAILROAD STATION, BASEL, 1932

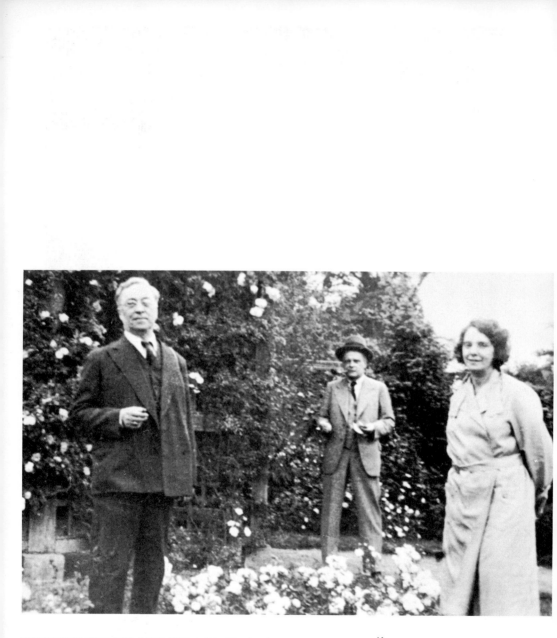

WASSILY KANDINSKY, PAUL KLEE, AND NINA KANDINSKY, DESSAU-WÖRLITZ, 1932

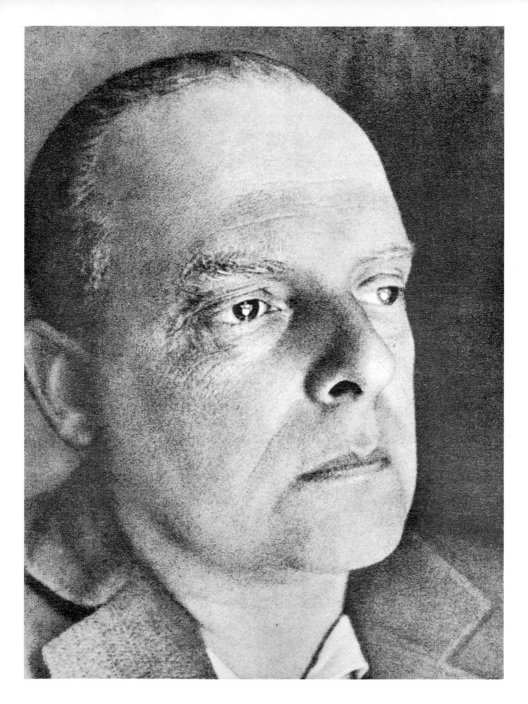

PAUL KLEE, DESSAU, 1933

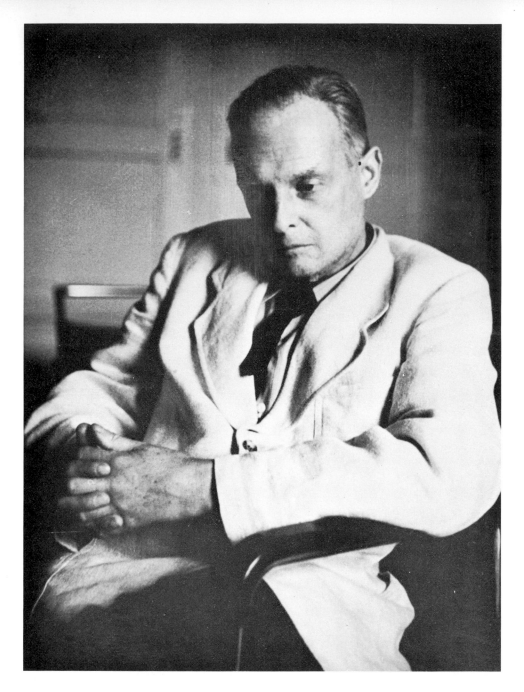

PAUL KLEE IN HIS STUDIO IN BERN, 1940

this influential man. I submitted illustrations for his appraisal, and he called them original. He advised me to try to sell them to the *Jugend*. But the *Jugend* was not interested in me.

123. December 24, 1900, an eventful day. I started it with a little more than ten marks and was invited to the Christmas-tree party by Lily's parents. First, I made a guest appearance at Knirr's, where I frequently came to draw in spite of my position as a student of Stuck, because the consideration that I enjoyed there stimulated me in my work. A surprising spectacle greeted me there. On the platform, instead of the model, stood a battery of wine bottles. The model, slightly tipsy, wandered from hand to hand, from knee to knee. I climbed on a ladder and worked on a mural beneath the skylight. When I returned in the afternoon things had developed even further. The sixteen-year-old Cenzi lay softly asleep in an upholstered armchair and was being sketched and painted. Red Berta, who had joined in, had dived quickly into the same giddying waters, soon fell into the loveliest fit of delirium, started babbling forth everything she knew, stamped her foot when anyone laughed, fell over when she tried to walk. Herr Kluge chose this moment to disappear and returned triumphantly with a bucket and a few bottles of champagne. This refreshed the girls and made us slightly drunk. As evening draws near, everybody gradually left for his Christmas party. Although I have an invitation too, I am the last to remain on the field of the orgy. This gives me little more than trouble, the two girls still don't want to leave alone. Cenzi's hair is undone and all the hairpins lost. Other trifles are missing, and are sought vainly in the dark. I go out to buy new hairpins. Some time passes again before the two of them are able to take my arm and venture out on the street. I lead them left and right. They are hungry. I prop them up against the wall, in a doorway, and buy food in the meantime. Then up to my room. They lie down and I have the proud feeling of holding two women in my power. The last moments pass in all kinds of daring pleasantries, but leave must be taken, and I show up at Lily's slightly befuddled.

124. Now I had achieved quite a good deal. I was a poet, I was a playboy, I was a satirist, an artist, a violinist. One thing only I was no longer: a father. My mistress' child had proved unfit for life.

Instead, there was the threat of debts, the threat of military service. The threat too of a fiasco in the longed-for ideal love.

It was a cross between the divine and the shabby.

125. Lily told me about her romance with a musician. A step forward, which rather perplexed me. That she felt strongly in this direction I sensed from the tone of her voice (12.26.1900).

126. The Christmas Eve with Cenzi and Berta was to have a little aftermath. On December 28th the four of us (Jean de Castella completed the foursome) went to a variety show. We aroused some attention there, for we were slightly conspicuous gentlemen, after all, and our ladies were not wearing full-length dresses. Later when we brought the girls home in a horribly cold night, swept by a northeastern storm, it turned out that Cenzi had no key to her house. She tried to arouse her people's attention by ringing, but no one reacted. Whereupon we brought Berta home. What now? We mumbled something or other about a hotel while we walked back to town. My apartment came first. When I opened the front door, Cenzi sneaked in without being invited. Jean sadly said goodbye. Thus, without actually trying, I had made a conquest. Added to this was the fact that Cenzi was said to be Herr N.'s mistress. I don't want to idealize matters, Cenzi was a Munich model who posed in the nude. But, being only sixteen, she didn't yet belong to the scum.

127. This affair with Cenzi lasted only until January 10, 1901. When her former friend came back from his Christmas holiday, she faithfully returned into his arms. At first this was quite painful to me, for the business had been quite to my taste. Cenzi demanded no lover's vows, she even addressed me in the polite plural. I used the intimate form of address with her, and always found her to be an even-tempered, reasonable creature. Not a trace of vulgarity in her. After the first night, she wrote me the following letter:

Munich, December 29, 1900

Dear Herr Klee,

Promised you to write you at once, which I am now doing. At home, everything went quite smoothly, only my father gave me a long sermon on morals, which I did not enjoy very much.

However, I had reason to be glad that there was no more to it. Now I must tell you something which I could not say to you by word of mouth. Above all, Herr Klee, I beg you to be very discreet, particularly with Herr N. You yourself must admit that it was not my fault; I just have my weak moments, like every woman, which, as a matter of fact, I now deeply regret.

And may you forget what took place that night; I am ashamed indeed to write you this, but I must call your attention to it.

And do not think badly of me, for both of us must bear the guilt together.

But let us remain good friends and forget the past. Your obedient Cenzi R. We shall see each other again next week. I shall visit you.

128. Beginning of January 1901. In the first place, the adventure with Cenzi diverted me a bit from Lily. It was a kind of relief from that unclearness. In the second place, I suddenly found myself totally incapable of maintaining relations with my former mistress any longer. This girl also had visited me from time to time during the winter to take a bit of money and a bit of love from me. She was entitled to the money because of the injury incurred through the clumsy childbirth. I already mentioned the fact that we were soon freed from this uncomfortable pressure. Neither spring, money, nor love could be said to be gushing forth generously. The love dried up first. The money went flowing just as long as I still owed something. I had planned to turn over to her a certain part of every sum received from home,

in order to be freed of my obligations by the time of the summer vacation. But now she suddenly left Munich to accept a job elsewhere. The idea was so pleasing to me that, by borrowing a considerable sum, I was able to satisfy her demands at once. The air was clear again after a year-long disturbance. Our last tête-à-tête, without love and hatred, left no thorns behind. We had, after all, lived some joyous hours.

129. Since Cenzi too now stayed away from me and only a few weak poems in the popular vein remained of that adventure, I was again completely available for the nobler sort of love. At the peasant ball, on February 5, 1901, I approached Lily again, or she me, until the distance between us was very small. But immediately afterward she drew back again, and called it a matter of mood. It was exciting, blows without grace, fisticuffs. I was sad and felt the urge to roam. But where?

130. Completely drunk one night, I filled my diary with fancies on the subject of Lily. How deeply everything that came from her sank into me. There was even a variation about jealousy in it. Sensuality ran amok. In the final variation words that we had exchanged appeared for the *cantus firmus*.

131. Ash Wednesday. The drunkenness is gone, but stronger than my misery is the power of your image, a charming face among masks.

Once again the English Garden is the scene of my feelings and confused emotions.

I swear, on my not-altogether-stainless honor, that I shall soon grow tired.

Lily and again Lily. Once more I feel strengthened in my feelings toward her, and shortly thereafter, again shaken. Neither path nor bridge. As for the effects on my studies, I shall say nothing.

She tells me, somewhat formally, that we will continue our duo-playing, the gracious young lady. Nonetheless, I think only of the woman. Nothing else can elicit a reaction from me.

132. My nights were not always good. Once, however, I really felt refreshed and strengthened in the morning. Spring was here, and I was confident I had the strength to enter its kingdom alone (I want to forget myself and

think of you beyond the mountains). It was already nested so deeply in me
that I preferred to flee myself than give up the thought of her entirely. This,
I thought, was the quickest way to regain my strength. And to triumph in
this muddled business through renunciation.

133. The doings at Saedt only half pleased me. Sometimes it downright
repelled me to move in this social sphere. The musical activity was, to be
sure, very stimulating at times. For instance, the evening with Straube, who
made me study Brahms' A-major Sonata, Opus 100, and was so enthusiastic
because I had understood so much in one hour. Long after, I kept hearing
his words: "But you play marvelously," which he spoke as we parted, drunk
and enthusiastic, after a nocturnal session at the Café Stefanie. Soon after,
he became very famous as an organ player and a conductor.

134. Jean de Castella praised the profundity of an English saying. Asked to
translate it, he produced the following:

> With right and knowing,
> With wish and will,
> Let knowing help right,
> And wish be quicker than will.

On March 2, 1901, in Starnberg, he inquired about the sexual act of plants.
Where did it take place—in the roots?

135. My restless life left a passing trace in my body. Nervous pains in the
heart bothered me, especially during my sleep. The heart became the theme
of my compositional exercises. Still, I did everything I could to rid myself of
this condition, and my future father-in-law achieved a medical triumph with
me.

136. Thoughts about the art of portraiture. Some will not recognize the
truthfulness of my mirror. Let them remember that I am not here to reflect
the surface (this can be done by the photographic plate), but must penetrate
inside. My mirror probes down to the heart. I write words on the forehead

and around the corners of the mouth. My human faces are truer than the real ones.

137. In the spring of 1901 I drew up the following program: First of all, the art of life; then, as ideal profession, poetry and philosophy; as real profession, the plastic arts; and finally, for lack of an income, drawing illustrations.

138. I. Why do men race on like storm-driven waves? Who blows on them, what wind? The wind of their desires blows on them. But their desires are vain.

I am a sailor afloat on them. My ship is strong and shall carry me to the goal. Shining hope rows me to the most beautiful island.

Alas, how roughly the surf breaks against it, my courage almost sinks. Is my best to be shattered here, tell me, you shining hope?

No, I am young and my arm is strong. I must reach the island, were it filled with the largest mountains, and were the highest of them called loneliness.

Forward, you free breeze up there. Forward, you foam of the breaking sea.

II. I can look still further. I have reached the island, I vanquished the breaking surf without extinguishing it. It is alive, it devours. My highest mountain shall totter.

The battlesong of the waves has subsided. The world is a wet grave, a wide waste.

The light goes out, dark must be the end. In day, life renews itself.

Night to us all! We will fight manfully before that night. Let life come first.

139. I have started a new life. And this time I'll succeed. I lay low on the ground. All was permitted me, I believed, my strength could be savored to the utmost.

I went to the fools' dance, a dirty knave. The maiden's love has freed me from such a figure.

I recognized my misery, and that half expelled it. Fright pulled me together.

I want to become serious and better. The kiss of the dearest woman has

taken all distress from me. I will work. I will become a good artist. Learn to sculpt. My aptitude is primarily formal in nature. Carry this recognition with me.

140. Stuck thought he could advise me to turn to sculpture; should I wish to paint again later, I would find good use for what I had learned. Proof of the fact that he understands nothing about the realm of color. And he advised me to go to Rümann. As a student of Stuck, I expected to be admitted there without difficulty.

However, the old man asked me to pass an entrance examination. I begged to be exempted from it, for the very fact that I should be asked to take one was tantamount in my eyes—and rightly so—to having flunked. But my request got him all excited: "I myself once had to pass an entrance examination." This had a royal sound. Then he submitted my drawing to sharp criticism; still, to a few of them he granted some merit. Finally I went away without accepting his position on the matter of the examination. Perhaps I did impress him a little after all. Maybe he expected to see me again?

The seven prophetic words of Rümann: I. I shall let no one tell me what to do; II. You are not, as I see, a draftsman of the very first rank; III. This is drawn quite nicely; IV. This head, however, deserves the adjective "bad"; V. Only those people are dispensed from a test who have modeled figures for years; VI. I myself once had to pass a test. (This is where I left.) VII. Good day, Herr Klee.

141. You seem to be of my own blood, so great is my love for you. This time I feel the strong god with me. I want to bow before his law and bring him an offering in sacrifice. I want to possess you, were it to mean your and my destruction. My god works great works on me. He sees me on the path of the law.

I love you as the woman who came to me with the friendly lamp, while I was brooding in the darkness.

142. Often I said that I served Beauty by drawing her enemies (caricature, satire). But that is not enough. I must shape her directly with the full strength of my conviction. A distant, noble aim. Half asleep, I already set out

on that path. When I am awake, it will have to be accomplished. Perhaps the road is longer than my life.

143. The term "self-criticism" turns up for the first time.

Then I philosophize about death that perfects what could not be completed in life. The longing for death, not as destruction, but as striving toward perfection.

On the whole, a stage between striving and despair.

144. He who strives will never enjoy this life peacefully. The first re-formations (moldings of the newly experienced world) offer a constant contrast with the fullness and freshness of impressions. Forward, toward mature works.

Childhood was a dream, some day all would be accomplished. The period of learning, a time for searching into everything, into the smallest, into the most hidden, into the good and the bad. Then a light is lit somewhere, and a single direction is followed (that stage I now enter; let us call it the time of wandering).

145. The awful thought of having deceived myself about Lily. I have already developed the habit of regarding this woman as mine. It would be a pity, considering the good influence worked on my psychic condition. For I at last lived a succession of calm days, days of ideal reflection, even though Berta and Kathi Bock visited me the other day and things took a rather dissolute turn. It runs off me. Even the thought of Cenzi, who lies in bed and talks nonsense, does not excite me at all. My distrust could turn into jealousy when I consider how many men are there where I should like to be alone.

Now she wants to come and have tea at my place.

Later she leaves me in the lurch after the St. Matthew's Passion.

Today she asks forgiveness for this. Thursday, April 4th, she is coming!

So much for the picture of my precarious position.

146. I would lie to a woman only out of pity. The woman, on the other hand, lies out of the falseness of her heart.

147. On Maundy Thursday Schiwago brought me back my compositions. She seems to have given up her satirical monograph on Klee. Perhaps she senses that I have become better now without her help. She talked with seriousness and friendliness. The devil whispered to me that I had passed by a pure spring unheedingly. "Are you taking leave forever, to speak so solemnly?" I asked in a joking way to create a diversion.

Then I took a walk with Lily to Grosshesselohe and back to Munich by way of the hills along the Isar. A strong, stormy wind pierced us. She spoke much of friendship.

I am so miserable I cannot speak. My misery is unspeakable.

148. Good Friday. I slept very badly and my imagination roamed as if I had a fever. The next morning I met Lily again in the English Garden. We often sit next to each other and say nothing. We are then like two happy people. It feels good, at least for a few moments. How one grows used to being with each other. I feel so at one with her that often I don't speak with her for a long while, as if I were alone. Should one ask for more?

149. I shall gladly restrict myself on food, on living quarters; I renounce a large family even more easily than good wine. But it is hard to give up one's urge to wander. And hardest of all, a life without love and the female body. This condition is rather far off. Existence here and now is most inadequate. If it were to remain so, life would be a failure and unworthy of me. A certain sense of responsibility would perhaps keep me from renunciation, after all. Easter 1901.

150. The uncertainty with Lily tormented me more and more. I tortuously reasoned myself free of woman, but could not free myself from the dreamy look of young girls. During the second act of *Tristan* my nerves were really on edge. I looked fixedly at a creature who sat near me and later described her appearance in my diary to the smallest detail.

A few days later I encountered this pretty creature near the Propylæa; I followed her, and with my whole soul, lost myself again in her being.

In the evening I met Lily at a performance of *Fidelio*. She was dressed in

black, which is very becoming to her. I had not replied to a few lines of hers, and as a result, had not heard from her for eight days. Apologized calmly and thanked her for a ticket to *The Seasons*. I felt confident and believed I talked interestingly about people and things we both knew. Some time, when we are surrounded by nature, or on the water, I shall take her in my arms and tell her openly how I feel about her.

151. The plain truth is probably that from pride and from fear of spoiling things by a final approach undesired by her, I thought renunciation preferable.
 Lily on several occasions described her relationship to me as pure friendship. Once she did so even after we had kissed passionately. That was really something.

152. (Continuation of 63.) At times I fancied I knew how to draw, at times I saw that I knew nothing. During the third winter I even realized that I probably never would learn to paint. I thought of sculpture and started engraving. I have always been on good terms only with music.

153. Fräulein N., from Halle, wrote after a long silence, saying that she planned to come to Munich for a brief stay and wished to see me again. I wrote her that this long period had made me another person. Probably she would experience more maternal joys with me now. I now took art very seriously, I wrote, and was more worthy of her friendship than in former days.

154. (5.3.1901). In the rosy hue of dawn, I am all expectancy. Shall I be able to endure the sun, when it rises over the crest of the mountains? O apprehension of morning, as then in my life.
As then? Do I stand in the bright daylight?
Up from the couch! There is much work to be done!

155. I am God. So much of the divine is heaped in me that I cannot die. My head burns to the point of bursting. One of the worlds hidden in it wants to be born. But now I must suffer to bring it forth.

156. After the night of May 14th-15th I was more excited and divided than ever. We had embraced and kissed passionately, to my intoxicating delight.

But the recoil followed at once. Immediately after, she confessed that she loved someone else.

Now, the problem was to find out how much truth there was to it. This stirred up conflicting emotions in me. During this whole pro and con, her eyes continued shining and promising.

Then I became convinced that I would be victorious after all in an undecided affair. It was a matter of fighting, as never before, for a woman. There were many clues here. Doubt had only one leg to stand on.

I wanted to put love into everything. I could, it was given to me.

The crisis was at hand: the beginning or the end of my love.

What if it came to a parting? Sail out again, alone, sail far out on the lake. Bad times. To have to throttle one of life's demands.

157. A last time, I achieved tranquillity. Before the last decision. Eight days after that night (May 14th-15th) I once again felt capable of renunciation. I clung wholly to the task of art, a future that seemed a bit more attainable, now that I had restricted myself to a somewhat narrower field.

158. In that period fell some motifs related to sculpture—fettered female nudes. "Morning Draws Near" (after a night of love the young man dozes, the woman hides). "Leave-taking from the Woman." "Maiden Defending Herself" (the representation was somewhat in the spirit of Rodin).

159. I spent the Pentecost holidays with my future parents-in-law at the country house by the Tegernsee. Here I triumphed over Lily, after she already had promised me a few days earlier to give her Doctor So-and-So the gate.

160. 6.1.1901. Little rascal on my lips. Your time is up. We were companions, our friendship now has turned to ashes. I have won a piece of heaven, I have no use there for anyone from this world. The railers (they say I am in love) remain below and grow old. We up here draw the first circles of immortality.

161. June 1901. Misgivings arise. What had I to offer to Lily? Art did not even feed one man. And so the turn came again to think of parting.

On the ideal plane a great feeling of strength filled me, because of the victory or because of love.

But of what use was it in life?

162. Brangäne pricks up her ears, we said in the larch grove by the Tegernsee, as Puck watched us on a bench.

Why should friends not be allowed to kiss, we asked ourselves?

We do not even think.

In the end Lily remarked it would be wise to go home soon.

163. On June 8th we discussed what was to be done to provide our love with a serious conclusion. That day may be regarded as the most important of the entire period of our betrothal. Lily wanted to leave me time to develop, professionally as well as in general. She spoke of eight years. She too wanted to make progress during that time.

164. What perfection we reach through love! What an intensification of all things. What a touchstone it is! What a key!

Each of these days is a lifetime. If I had to end now, no better end might be imagined.

165. Lean on me and follow me; when the abysses gape below, close your eyes. Trust my step and the high, icy spirit. Then we two shall be like God.

166. Now the leave-taking sounds altogether different:

I grew up alone on the moor. Who ever helped me? Storms came and went, swept away what was weak. I remained on the moor.

Then you came and sought shelter near me. But fate bade us stop. You must grow strong through solitude, spoke fate. For the time being let thought alone be my shelter.

167.

Go your way, you grand desires,
Fare thee well, immortality.
Crumble, you mountains of the mind,
If the peak be solitude.

168. June 13, 1901, a hard day. Somber premonition of parting on the Königsplatz.

Departure from Munich on June 30th. Should this love not become my life and merely have been my most beautiful dream, then I shall find upon awakening that strength has turned to bitterness. And woe to that which deceives, no matter how beautiful it is. The powerful, the frightful truth shall win.

169. Do not ask what I am. I am nothing, I only know about my happiness. Do not ask whether I deserve it. Know that it is rich and deep.

I wanted to reach the goal before sunset. Near her. I had walked briskly. But I had reckoned badly. The unspeakable longing for the goal made the many hours heavy. Over a wild pass, I want to reach the gentle valley.

BERN, 8.5.1901.

170. Retrospect on the artistic beginnings of the past three years. Whatever in these diaries is unclear, confused, and undeveloped seems hardly as repellent, or as ridiculous even, as the first attempts to translate these circumstances into art. A diary is simply not art, but a temporal accomplishment.

One thing, however, I must grant myself: the will to attain the authentic was there. Else I might have been content, as a tolerable sketcher of nudes, to turn out compositions depicting Cain and Abel. But for this I was too skeptical.

I wanted to render things that could be controlled, and clung only to what I carried within me. The more complicated it seemed to me, as time passed, the madder the compositions. Sexual helplessness bears monsters of perversion. Symposia of Amazons, and other horrible themes. A threefold cycle: Carmen–Gretchen–Isolde. A Nana cycle. *Théâtre des femmes*. Disgust: a lady, the upper part of her body lying on a table, spills a vessel filled with disgusting things.

The very fact that the whole man at times fell very low in the course of these three years made him eager for and capable of purification. Many

projects are witnesses to this. In the end, the need for absolute form is not lacking either. Herewith equilibrium begins to establish itself. That my betrothal should coincide in time with this state is perfectly logical.

Before Italy (Summer of 1901);
Bern and Surroundings

171. The consciousness of strength endured. At first the separation was not overwhelmingly hard to bear. I derived a certain tranquillity from the fact that I had now become a moral person, even on the sexual level. As such, this problem could no longer disturb me. I did not concern myself directly with the fact that there would be no practical solution soon. The spirit was free of such turmoil. I could now devote myself with full concentration to some course of study. The three years in Munich had been necessary to bring me to this point. I now staked everything on Italy. I envisaged the possibility of realizing the humanist ideal only outside the field of special study.

172. I should have written many poems to give form to my newly gained creative strength. Of course, this intention was not realized. For to be a poet and to write poetry are two different things. However, that strength and tranquillity has remained dear to me even in my later life, and I don't intend to mock at it.

173. Oberhofen. July 1901. I gave you my all and still I gave you nothing, considering that I first received life from your hand—that you bore me anew in beauty (the beloved as mother of the reborn, moral man).

174. The storm sinks powerful legs into the hollow of the wave and into the neck of the oak. It looks like a fight between branch and foam, and yet it is a game. The divinity surveys it and preserves the limits.

 Similarly, I contemplated a thunderstorm combined with a hailstorm. July 27, 1901.

175. Philosophic strivings. Optimistic way. The only misgiving was to neglect the real task by delving too deeply in philosophy and poetry.

57

[Handwritten German text]

Diesseitig bin ich gar nicht fassbar. Denn ich
wohne grade so gut bei den Toten, wie bei den
Ungeborenen. Etwas näher dem Herzen der
Schöpfung als üblich. Und noch lange nicht
nahe genug.

Geht Wärme von mir aus? Kühle?? Da ist jen-
seits aller Glut gar nicht zu erörtern. Am Fernsten
bin ich am frömmsten. Diesseits manchmal etwas
schadenfroh. Das sind Nüancen für die eine
Sache. Die Pfaffen sind nur nicht fromm genug
um es zu sein. Und sie nehmen ein klein wenig
Ärgernis, die Schriftgelehrten.

176. I shall look for my God beyond the stars. While I struggled for earthly love, I sought no God. Now that I have it, I must find Him who wrought good upon me while I had turned away from Him. How can I recognize Him? He must be smiling over the fool, hence the cooling of gentle winds in the summer night. Mute bliss in thankfulness to her and a glance toward these mountain tops!

177. Cry toward the righteous God. Through good deeds on earth the hero reaches the road to the righteous God. 1. Parting from the beloved; 2. On the way; 3. Meeting with Prometheus; 4. Dream of a conversation with Ganymede; 5. Fata morgana.

178. Arise early to sow. Thy wife sleeps soundly, let her sleep. Thou shalt turn to thy wife only with the fruits of thy field.

179. Those were tempting waters that drew my mind into their wrinkly whirl. But how irresistible now is the power of the stream. As I passed, the old, sweet-dark homes called, where at night I had listened to the song of the crickets, lonely and secret under the scented elder-tree. Many a sad person I see standing on the shore. But I am on the waves, strong and fresh in body and soul. I want to flow together with the great stream. I want to flow with it.

180. A kind of Prometheus. I come before Thee, Zeus, because I have the strength for it. Thou hast favored me, this drives me toward Thee. Wise enough to divine Thee behind all and everything, I do not seek the mighty but the kindly God. Now I hear Thy voice out of the cloud: thou tormentest thyself, Prometheus. Torments have always been my lot, for I was born to love. Often I raised my eyes questioningly toward Thee: in vain!

So let the greatness of my derision knock at Thy door. If I do not suffice, I shall leave Thee this satisfaction: Thou art great, great is Thy work. But great in the beginning only, not in the accomplished. A fragment.

Accomplish! Then I shall cry hail! Hail to space, to the law that measures it. But I do not cry hail. Only the man who struggles has my approbation. And the greatest among them am I, who struggle with the Godhead.

In the name of my sufferings and those of many other men, I judge Thee for having accomplished nothing. Thy best child judges Thee, Thy bravest spirit, at once related to Thee and turned away.

181. I must be pale. My thoughts become muddled again. I don't sleep the whole night through. Is the soul yearning for the south? Is something missing in the north, or where? I have air and nourishment. And I have obtained the fullest love. Still, I cannot remain as I am.

Or else it shall be as in the past. Sorrow forcedly shut up in the breast. Hoarse laughter on a narrow path of escape. Till bursting. And I say again: this laughter is all that lifts us above the beast.

182. Brack tells about something observed on the Stockhorn: how a sheep in the act of giving birth had been attacked by jackdaws and similar riff-raff that tried to steal the lamb out of its womb.

183. Senseless talk (sense drifted away on the stream of wine).
 1. A good cast of the net is a great consolation. 2. This year, too, villainy tries to steal upon me. 3. I must be saved. By success? 4. Does inspiration have eyes, or does it sleepwalk? 5. My hands are folded at times. But right below them the belly digests, the kidney filters clear urine. 6. To love music above everything means to be unhappy. 7. Twelve fishes, twelve murders.

184. A poem with the following line-endings:
Eyes / breast / desire / night / laughed / sleep /met /
companions / order / trees / dream / night of the heart.

185. The departure was not so easy. I had myself vaccinated against small-pox and became very ill, a 104° fever. Haller felt only a slight itching. In Oberhofen I had to ask for money, I obtained a little. This caused a slight delay. Haller was impatient, but nonetheless consented to wait. He has to get to Rome quickly to paint his Solar Cycle.
 A terrible storm rages on the country. As always, whenever I am to experience something. Our black tomcat returned after six months, grown quite wild again. Lived by hunting, certainly.

Diary II

Italian Diary
(October 1901 to May 1902)

277. Milan, 10.22.1901. Arrival. Brera: Mantegna (Luini?); Raphael not particularly well represented. Surprise: Tintoretto.

Molto vino. Pimples from the vaccination. Tricky use of the Italian language. Hotel Cervo. Good food: risotto. Departure: 24th, at 3:40 p.m., to Genoa.

278–279. Genoa, arrival by night. The sea under the moon. Wonderful breeze from the sea. Serious mood.

Exhausted like a beast of burden by a thousand impressions. Saw the sea by night from a hill, for the first time. The great harbor, the gigantic ships, the emigrants and the longshoremen. The large Southern city.

I had had a rough idea of the sea, but not of the harbor life. Railway cars, threatening cranes, warehouses, and people; walking along reinforced piers, stepping over ropes. Fleeing from people who try to rent us boats: "The city, the harbor," "The American warships," "The lighthouses!" "The sea!" The iron bollards as seats. The unfamiliar climate. Steamers from Liverpool, Marseilles, Bremen, Spain, Greece, America. Respect for the wide globe. Certainly several hundred steamers, not to speak of countless sailboats, small steamers, tugboats. And then the people. Over there, the most outlandish figures with fezzes. Here on the dam, a crowd of emigrants from the South of Italy, piled up (like snails) in the sun, gestures as supple as an ape's, mothers giving the breast. The bigger children playing and quarreling. A purveyor opens a path for himself through the mob with a fuming plate (*frutti di mare*) brought from floating kitchens. Where does the striking smell of oil come from? Then the coal-bearers, well-built figures, lightfooted and swift, coming down from the coal ship half naked with loads on their backs (hair protected by a rag), climbing up to the pier along a long plank, over to the warehouse to have their load weighed. Then, unburdened, along a second plank into the ship, where a freshly-filled basket is waiting for them. Thus people in an unbroken circle, tanned by the sun, blackened by the coal, wild, contemptuous. Over

63

there, a fisherman. The disgusting water can't contain anything good. As everywhere else, nothing is ever caught. Fishing gear: a thick string, a stone tied to it, a chicken foot, a shellfish.

On the piers stand houses and warehouses. A world in itself. This time we are the loafers in its midst. And still we are working, at least with our legs.

280. High houses (up to thirteen floors), extremely narrow alleys in the old town. Cool and smelly. In the evening, thickly filled with people. In daytime, more with youngsters. Their swaddling clothes wave in the air like flags over a celebrating town. Strings hang from window to window across the street. By day, stinging sun in these alleys, the sparkling, metallic reflections of the sea; below, a flood of light from all sides: dazzling brilliance. Add to all this the sound of a hurdy-gurdy, a picturesque trade. Children dancing all around. Theater turned real. I have taken a certain amount of melancholy along with me over the Gotthard Pass. Dionysos doesn't have a simple effect on me.

281. We nearly decided to go to Naples (by one of the many other ways that also lead to Rome). But we are too inexperienced. Haller has psychopathic attacks, stutters, is afraid of being robbed. And Naples is an ill-famed place.

 And so we leave by ship for Livorno, and from Pisa, take the direct train to Rome. I would not have been in such a hurry to reach Rome, but Haller is eager to, because he proceeds pragmatically. A week in Genoa would have tempted me as a beginning. So now the study of the Renaissance starts on Monday, for there must be orderliness.

282. The sea voyage was an experience. Big, nocturnal Genoa with its lights numerous as stars gradually vanished, absorbed by the light of the open sea, as one dream flows into another. We sailed at ten o'clock on the *Gottardo*, stayed on deck until midnight. Then into our second-class cabin.

1 Klee	2 A man who was going to Alexandria	
3 empty	4 Haller (with a bracelet).	

At six in the morning I got up, having spent a very quiet night, and found the sea completely transformed, the island of Gorgona, tilted sailboats, fresh colors. At seven we landed in Livorno.

283. Like a dream, Genoa sinks into the sea; passed away from this world, did I dissolve like the last light? Oh, if only it were so! Could I?

284. Livorno dull. We fled as quickly as possible in a little horse carriage. The horse guessed our thoughts. The landing had been an amusing business. The boatmen, who fought each other with their oars: *Una lira*, of course. The staircase from the water, the customs office.

Much crowding at the railway station. Haller didn't have the courage to ask for tickets. He put his lips close to my ear and instructed me stutteringly: "1. *P-P-Pisa*; 2. *q-quando p-parte il t-treno?*"

The words lay, in fact, quite clumsily on the tongue. I push boldly on. Regarding point 1, I was asked, "*andate o ritorno?*" which I did not understand; regarding point 2, the gruff reply was "*alle mezz,*" which was not so simple either. This was my first lesson in practical Italian. And the train, which runs every half hour, was ready and took us to Pisa through rather unattractive country.

PISA

We stayed in Pisa from nine in the morning till five in the afternoon. Besides the Duomo, there is little to see; at a pinch the Piazza dei Cavalieri might be added. The Duomo is marvelous. How did the giant get into this burg? This spectacular display takes place quite a distance from the center of town, like a circus putting on its show at the entrance of a village.

We had to climb to the top of the leaning tower, listen to the echo in the Baptistery, etc. Afterward our energy was exhausted. Instead of looking for a restaurant we bought some chestnuts and sat down on a bench. Haller looked sad, leaned his head on his hands, and still managed to say before falling asleep: "Be careful they don't rob me."

The train speeding toward Rome, what a sensation that was.

ROME

285. Arrival on October 27, 1901, about midnight. We celebrated the event in a hotel near the railway station by a drunken bout on three bottles of Barbera. On the second day I had already rented a room in the heart of town, Via del Archetto, 20, IV, for 30 lire per month.

Rome captivates the spirit rather than the senses. Genoa is a modern city, Rome a historic one; Rome is epic, Genoa dramatic. That is why it cannot be taken by storm.

Impatience drove me at once to the famous sights, first to Michelangelo's Sistine Chapel and to Raphael's "Stanze." Michelangelo had the effect of a good beating on the student of Knirr and Stuck. He accepted it and discovered that Perugino and Botticelli fared no better. Raphael's frescoes stood up under the test, but not without my intending them to do so.

Less violent was the impression made by the equestrian statue of Marcus Aurelius and the statue of Saint Peter in Saint Peter's. His toes, worn away by kisses, add to the effect. Marcus Aurelius is concentrated art; with Peter faith also has a share. Not that I understand the believers who busy themselves about his foot. But they are there anyway. Who cares about Marcus Aurelius? The primitive stiffness of the bronze of Peter, like a piece of eternity in the whirl of the accidental (October 31st).

286. Epigrams with these line-endings:

Thence / for painting no sense
bartered away the loved music my son / scorn.

"Love as sun, I as swamp":
The sun infected as thanks
because in me it stank of swamps.

Beware! / in years / understood / available.

World / then others cost me my money
which I myself had cost my father.
Raised / pushed / herd / earth.

Fear of woman / wounds and boils / give birth on the mountain /
liberator from shame / jackdaws and vultures
would I be rid of the excrescence of my body.

Freer / bodies / grinding tune / women.

290. 11.2.1901. Went out to Via Appia to become acquainted with the
"environs of Rome." As we came to the city limits the Lateran palace diverted
us from our project. Also, the mother of all churches next to it. The Byzantine
mosaics in the choir, two delicious deer. After this *hors d'oeuvre*, over to the
Christian museum in the Lateran. Sculptures in a naïve style whose great
beauty stems from the forcefulness of the expression. The effect of these
works, which are after all imperfect, cannot be justified on intellectual
grounds, and yet I am more receptive to them than to the most highly praised
masterpieces. In music too I had already had a few similar experiences.
Naturally I am not behaving like a snob. But the Pietà in Saint Peter's left
no trace on me, while I can stand spellbound before some old, expressive
Christ.

In Michelangelo's frescoes, too, something spiritual exceeds the artistic
value. The movement and the hill-like musculature are not pure art, but are
also more than pure art. The ability to contemplate pure form I owe to my
impressions of architecture: Genoa—San Lorenzo; Pisa—the Duomo. Rome
—Saint Peter's. My feeling is often in sharp opposition to Burckhardt's
Cicerone.

My hatred for the Baroque after Michelangelo might be explained by the
fact that I noticed how much I myself had been caught up in the Baroque
until now. Despite my recognition that the noble style disappears with the
perfection of the means (one sole point of overlapping: Leonardo), I feel
drawn back to the noble style, without being convinced that I shall ever get
along with it. Boldness and fancy are not called for, now that I should be and
want to be an apprentice.

Later we came upon the Via Latina instead of the Via Appia, where a good
lunch was waiting for us in an inn (75 centimes, including a pint of wine). It
was plentiful enough for me to feed two cats and for Haller to feed a dog; I
suspect that some opposition to me was mixed up with his motives. The rustic

idylls in the inns here are charming. If I am to work as I already can, then I must come out here sometime with an etching plate.

Traffic of donkeys on these classic roads. Character of the suburb. Wine-shops and kitchens. My horror of seeing animals tortured.

To go back to town, we then followed the Via Appia that we had missed earlier. As we looked for it, we came upon a half-ruined villa in which a shepherd had settled. There was a good deal of bleating around the walls and skinned *agnelli* hung all about.

The finest wind whistled in the masonry. I drew the building, Haller painted with watercolor nearby; having no water, he used his urine.

How people can adapt themselves, how they nest in the ruins! The crosses on the old temples.

Once more we stopped in a tavern, had some goodish wine, a half a quart for 30 centimes, and sheep cheese, and, thus restored but very tired, strolled back home.

Nothing is overlooked, but the climate is not always easy to bear. The sun can sting, the wind is furious! Rainy days are very oppressive. When the weather is nice (*tramontana*) it gets quite cold, especially at night. I am afraid of what it will be like in January when I'll be trying to find the stove in my big room.

291. Haller perches in a somber studio. What dust and fleas! Once I came in while he was developing photographs of his Russian girl-friend Sch. in the chamber pot. He wants to push his Cycle to the Sun to completion. His energy can't be doubted.

He was fooled by a ravishing little model. She said she was not a professional model; she claimed she had overcome her scruples only to save her mother and four brothers and sisters from starvation (a letter to the Pope had brought no results). In the evening the little ones cry: *Mamma, fame!* The mother has almost lost her mind as a result. Too proud to beg.

One day Haller wanted to pay her and sent her out to change 50 lire; she brought back only 45, which he nobly didn't count till later. We now saw through the whole scheme. And yet she was such a splendid model. Stood undaunted on a platform of tables and chairs and ecstatically spread her arms to the sun.

292. A satire on the swaggering type:
It was one of those giants / who found all mountains too low /
dangers / blew / passion / thoughts / ran away / from some time /
limits / small / mine.

293. This week, again conquered a piece of Rome. The Pinacotheca in the
Vatican and the Galleria Borghese. In the Vatican, the utmost solidity, only
few pictures. An unfinished Leonardo ("St. Jerome"), a couple of Peruginos,
a priest in solemn dress by Titian.
 Raphael is more difficult to do justice to. Snatched away right in the middle
of an overwhelming effort. The possibilities indisputable, the actual produc-
tion too much that of a disciple.
 Burckhardt is less just toward Botticelli (one page in the *Cicerone*).

294. I have now reached the point where I can look over the great art of
antiquity and its Renaissance. But, for myself, I cannot find any artistic con-
nection with our own times. And to want to create something outside of one's
own age strikes me as suspect.
 Great perplexity.
 This is why I am again all on the side of satire. Am I to be completely ab-
sorbed by it once more? For the time being it is my only creed. Perhaps I shall
never become positive? In any case, I will defend myself like a wild beast.

295. In such circumstances there exist
 fair means.
 Prayers for faith
 and strength.

 Goethe's *Italian Journey*
 Also belongs here.

 But above all a lucky
 star. I saw it often.
 I shall discover it again.

One may well draw strength from the pantheistic piety of Goethe. Draw
strength to enjoy things, that much is sure.

296. Fasted / stomach weighs / endure / rested / carriages / forbid / buy / rent.

DANGEROUS ROME

299. More and more Renaissance, more and more Burckhardt. I already speak his language, for example.

One doesn't like to think, in this connection, of the Gothic garments of the Germans.

This doesn't apply to the Italian Dürer, the Munich Apostles are clothed in exemplary fashion.

Similar unfairness toward Baroque. That Greece existed is no longer believed. Bernini a raven foreboding misfortune.

November 15th. Important concert at the Teatro Costanzi. Conductor Gulli, Brahms' Serenade, Op. 11; Wagner's Siegfried Idyll; Mendelssohn's Italian Symphony.

300. Collection of ancient art in the Palazzo degli Conservatori. "The She-Wolf." "The Remover of the Thorn." Of particular interest to the connoisseur of nudes, "The Statues of the Muses." A rotating female figure, perfect as nature. The German turns it. His bride sits on a bench and admires him. The Italian makes silly jokes. The Englishman reads his guide, emitting noble sounds. You are never alone in museums.

301. Galleria Barberini. I have never liked Guido Reni, still his deeply felt "Cenci" is moving. One is involved as a human being by this portrait, it becomes a little dramatic scene. This unhappy love is felt precisely because it is a picture. The shape of the eyelids might move us to soft lamentation. The small mouth is at once the pole of suffering and the pole of bliss.

302. I am working on a composition. At an earlier stage there were many figures. I called it "Moralizing on Stray Paths." (Stuck calls a picture: "Sin.") Now the approach is satirical. The figures have been concentrated into three. The way of love. Now I have left out the woman. The problem is simpler and yet no less demanding. The woman is to be expressed triply in the attitude of

werde ich nie positiv? Jedenfalls werde ich mich
wehren wie eine Bestie.

*

295 In solchem Zustand gibt
es schöne Mittel
gebete um Glauben
und Kraft.
auch gottlos italienische
Reise gehört hierher.

Aber vor allem ein glücklicher
Stern. Ich sah ihn oft.
ich werd ihn wieder entdecken.

An der pantheistischen Ehrfurcht Goethes kann
man sich wohl stärken. Zur Genussfähigkeit
stärken einmal ganz sicher.

296 gelastet / magen / plastet // vertragen / gerüstet /
wagen / verbieten / kaufen / mieten.

Das gefährliche Rom.

297 Immer mehr Renaissance, immer mehr
Burckhardt. ich spreche schon seine Sprache.
eine Stelle z.B.

Sehr ungern denkt man in diesem Zusammen-
hang an die gotischen Gewänder der Deutschen.

Den Italiener Dürer ist damit nicht gemeint,
die Münchner Apostel seien musterhaft
gekleidet.
Ähnliche Ungerechtigkeit gegen den Barock. Man

the three. I must concentrate on working more intimately, there is not much ammunition at hand. Then why the big gun?

306. Epigrams:

In God's place / shrill / own beauty / tones.
Palette / save / never suited me / old man's poesy / departs / disgusts /
bloom / green.
Taken / come / paid / too thinly painted.
Creates / strength / chose / souls / to be modest / small /
trace / nature.
 11.25./26.

 The lines to fit these endings were too contrived, too well rhymed and too little dreamed, and yet they were conceived during a clear nocturnal hour. It is raining, not to say pouring.

307. The latest concert was not very good; it was the fault of the conductor, Vesella. Deeply affected during the last movement of Beethoven's Seventh, but the musicians were left the initiative. Many important voices were drowned, but on the whole there was both energy and exaltation. Orgies of symphonic sound were celebrated. Short measures were taken more earnestly than I am used to. Organlike swellings of the horn section. (The bassoons sound rough and strange.) Moreover, I have only recently become capable of understanding this work. Nostalgia for Mozart.

308. Yesterday after the theater, in the sharp cold of night, I saw an old woman and a not quite grown girl lie weeping in the street, before the gate of a house. Professional beggars? Anyway, it made an impression.
 Recently two men followed a coffin, dragging and helping each other along, arm in arm. How naturally these people pose!
 I gave a child some bread from the lunch table, but the hunger was real; pale face, lean, intense hands.
 Sickening habit of using the street as a toilet. The disgusting thing is the traces left; when compelled to catch someone in the act, as happens not infre-

quently, it is good to note that the thing is done with a natural decency.

What is this street-life when compared to Genoa? I often long to be there. There is enough art here. But more life there. If only spring were here, I would go to the sea nearby!

309. Today it was sunny (11.22.1901). We wandered far out, over the Aventine (Basilica Santa Sabina, splendidly primitive, with open wooden roof supports, mosaic pavement) and down to Porta San Paolo. At some distance from it stands another mighty basilica, unfortunately renovated after several fires, cold.

1 campanile
2 central nave
3 side aisles
4 *parvis*
5-5 façade

On the way back we followed the course of the Tiber, or more exactly, went upstream. Just before the last bridge were anchored steamers and sailboats that had been dragged this far. The nearness of the sea.

Near the appealing temple of Vesta an old man fell down with a large basket of oranges and lay there, looking at the rolling fruits. But already a number of children had come running to the rescue and filled up the basket again with great speed. First I had let myself be contaminated by Haller's unquenchable laughter, but later we thought about the nice traits of these people.

My Opus has become so simple that it no longer makes any progress.

310. 11.30.1901. For lack of a stove I bought three quarts of vermouth di Torino. By day a good deal of blue sky and pleasant October warmth, but the nights cold indeed. And after sunset I stole over to the cupboard to get the fat

bottle. Haller keeps on praising its effectiveness against fever. For my heart, too, vermouth is better than wine. Last summer I had drunk milk every evening except three. But here I am too lonely to manage without alcohol. A soft glow often settles over my mind then, I am full of hope and in good humor.

The Muses preferable to the feminine Apollo leading them. Observation of the Greek foot. The work of art as a posing model. Division of the toes into three groups: $1 + 3 + 1$.

311. *Triglie* are quite delicious fish (reddish). Eating and drinking. Thinking as little as possible while doing so, as if one were somewhere in Corsica or in Sardinia. And when, besides, a green salad, unimaginably delicate, happens to be served! O this South!

December 2d. Today they took my cat away from me and I had to look on while it disappeared in a sack. I understood at last what words had not succeeded in making clear to me. It was a cat that had been borrowed to catch mice for a period of time. And I had already given away my heart.

So now I shall purchase a *civetta*. I saw some sitting on a *bastone* in a store. They are good hunting companions *per la caccia*.

The padrona advices me against guinea-pigs, *sporchi, sempre urinare*. I must have something living, and the tortoise doesn't count: *dorme sei mesi*. Once the cat had a *mezzo pollo rubato*. The excitement. "*Ah, e un gran signore! Niente patate, ma un mezzo pollo, ah!!*"

Haller often played with it, until it jumped at his face; then he let fly with a couple of slaps on its hide, and his hand wasn't weak.

The weather is overcast, the temperature at night has gone up. I feel particularly well in consequence. The Teatro Costanzi announces a lyrical season. *Maestri cantori. Iris. Tosca. Boheme. Favorita* and many others. I would have liked to hear *Pagliacci* in Italian some time. The Duse, too, will perform, I feel enterprising. A money order from Menton did its part.

312. 12.3.1901. The first screech owl mocked me and died during the second hour of my ownership. Perfidiously he chose my absence to do it. Just before, he had still simulated hunger and devoured a goldfinch. Tomorrow I'll go with the *padrona* to *comprar una altra*.

Friendship with Haller not always untroubled. Incentive to rivalry in art. Recognition that he is more advanced in the domain of color. Realization that a long struggle lies in store for me in this field. "But in drawing, I correct him."

313. Small act of vengeance in the shape of an elegant satirical letter to Schiwago, after our friendship had not concluded satisfactorily.

314. 12.7.1901. Two letters and two postcards travel northward, they entail no answer. I want to know that most of the threads that bind me to the past are severed. Perhaps these are the symptoms of incipient mastery. I take leave from those who taught me. Ungratefulness to school!

What is left for me now? Only the future. I violently prepare myself for it. I did not have many friends; when I ask for spiritual friendship, I am almost forsaken. I still have confidence in Bloesch. Lotmar has great possibilities, my relationship with Haller is strange. We don't sort together. We'll probably always trust each other to display a certain honorable tactfulness of behavior. But we have no closer ties, and perhaps never had. He's a rather primitive fellow, is able to concentrate easily and be all of a piece. Can be measured. Not I. With such great differences we would never have joined had it not been for our common course of study. I've known him since he was six, and yet we made use of each other only when, two or three years before his graduation, he decided to become a painter. At that time he approached me and joined me in hunting for landscape motifs.

Brack is valuable, and yet there are barriers between us. Unfortunately one always has to take into account the moods and manias of this eccentric.

I'll willingly renounce many perfectly good friends.

My teacher Jahn is of a more paternal character.

I want to have nothing more to do with feminine friendships.

315. Haller unexpectedly receives a letter of Schiwago's from Russia, where she suddenly had to go because her mother fell ill. This must make his future relationship with her a rather problematical one.

How will my little letter reach her now? Perhaps her studio companion K. will send it on.

How indifferent it all seems to me. I recall an adventure in the Luitpold on

one of my last nights at a public ball, or rather toward morning. Was it my last adventure? Wassiliew had joined us, and Castella came with her as re-inforcement, with *monsieur le bois* (so we called his artificial hand). The ladies were strikingly and incompletely dressed. This led to awkward misun-derstandings as we were caught up in the drunken crowd. Wassiliew was close to tears. Schiwago, brave as always, flailed about with her hair flying when the threat in her gray eyes didn't suffice, and hit many a young buck in the face. It must have been bearable. Moral effects under such circumstances?

Returned to the Palazzo degli Conservatori and to the Capitoline Museum. In the former I met the flower of all Muses (description follows at the end). Such a neck I have never seen in nature. (Love for a Muse as an artistic atti-tude!)

316. Epigram with the line-endings:
Curse / search / fetch / stolen / gained / jumped / one / appear / a bit of joy / burning eyes for the most / through envy / my son, you are insolent.

Until now the *padrona* had fed the new wild screech owl by force, as one stuffs a goose. For the last three days, he has been feeding alone. He does not like it on the *bastone*. The floor looks like that of a stable. Fortunately it isn't made of wood but of stone.

Satirical opus:

The Happy One, he is a half idiot who succeeds in everything and bears fruit. Stands on his little property, one of his hands holds the sprinkler, the other points to himself, as to the navel of the world. The garden is greening and blooming. Branches heavy with fruits bend toward him. The medium is cardboard with a gray chalk background, tempera and watercolor.

I wrote to Lotmar, Bloesch, Brack, with the hope of receiving an answer in return.

319. Such phrases and melodic lines (later, Oriental music again reminded me of these quaint things) could be heard every hour; what is feminine is carried in the mouth. Two boys made use of a similar melodic pattern to sing a long, mournful ballad as they walked. Along the Tiber:

Solche Phrasen u. Melismen hört man stündlich, was
weiblich ist führt sie im Munde. mit ähnl. Melos
hörte ich v. 2 Knaben eine lange düstere Ballade
'm gehen, singen. Dem Tiber entlang.

drauf fusst lola lied, in d. Cavalleria.

Ist es nicht zum Erstaunen wenn ich nun von einem

Lola's song in *Cavalleria Rusticana* is based on this.

323. Is it not amazing that I should now begin to speak of a little girl about eleven years old? We were sitting in our delightful little eating place near Sorgin when as usual musicians entered and began playing their mandolin and guitar. The first piece sounded, as was to be expected, a bit out of tune, but full of feeling. Toward the end, the little girl, who had come in unobtrusively with the others, drew attention to herself through certain gestures, and as the final chords sounded, she came forward without a trace of timidity. We knew what was in store: a performance (and what a performance!). I have seen many artistic achievements, but never one so primeval. The little thing has a certain elegance of build; otherwise she is not exactly beautiful, nor is her voice a good one. We were taught to find beauty only in truthfulness of expression. We discovered that talent anticipates things through intuition which it could experience only later, having the advantage that primitive feelings are the strongest. The future slumbers in human beings and needs only to be awakened. It cannot be created. That is why even a child knows about the erotic. In fact, we heard its whole range, from the little couplet to the passionate scene and the tragic scene. The Southerner plays comedy more easily because his everyday behavior reaches such a pitch that he doesn't need to intensify it as much as we do. So the child was able to pretend to be more than she was. In the last analysis, it was a kind of natural enjoyment.

325. Poems of an epigrammatic sort with these line-endings:
Rhymed / glued / great pain / to be superfluous.

I believed I should at least succeed in making myself ridiculous.

Further:
Such a suffering head / yellower / believes / itself / ready to act /
ridiculousness / cured / born / hairy / paired / deceived / lying.

327. 12.15.1901. Rome's youngest museum, the National Museum in Diocle-
tian's Thermae. Part of it is housed in Michelangelo's great cloister. Simply
to walk here is beautiful enough. An orange grove with hundreds of fruits.
The arrangement of the works of art is nowhere so carefully planned as here;
they are enjoyed *andante*. The statues are not treated like propped-up bowl-
ing pins. Each piece occupies its proper place. My feeling for bronzes is
growing.

For the last few days the weather has been rainy and warm. Yesterday
rainstorms with thunderclaps. Today unfortunately somewhat colder and yet
not clear. I work every day with my window open. Too little happens at night
during the season of short days. Carnival time is going to bring some life into
the place, so they say.

La Duse plays the title role of D'Annunzio's *Francesca de Rimini* and her
performance never flags. Only her *ingresso* has become a bit weaker.

The night before my birthday was stormy, filled with lightning and heavy
showers. And extraordinarily warm. Storms often accompanied important
events of my past life. The last year not without its mad complications. Such
a one shall not come again. For not all that has been attained shall fall to
pieces. I believe in the possibility of carrying things through. Let those who
love me rejoice.

D'Annunzio's *Francesca da Rimini*. Two good acts (III and IV). The crip-
pled husband was excellent (Rosaspina). Paolo was really handsome. La Duse
has spirit, but she is shot through and through with hysteria and morphine.
Her way of speaking chromatically from the top to the bottom of the scale
ends by provoking stinging headaches. The high notes are thin, nasal. The
middle range is more lively, the low one thoroughly soulful. She speaks well in
hoarse tones, but carries this trick to the point of obtrusiveness. Her appear-
ance is very beautiful. The author was called, but did not appear. Angry, the

audience shouted all sorts of nasty remarks. The boldest of them was: "Has your little Gabriel taken off again?".

330. Short life / sour striving / much discontent / must paint / shameful / saddened / a real giant / super-score / huddled on the piano stool / shake one's curls.

Rain at night. Something tells me the lie that I have lost you. I could almost believe it. I feel glum and humble. The heart rebels, the eye burns. Without tears. Only the night outside weeps. Loneliness. The *sirocco* was the culprit. Altherr corrected me: "Better say: the wine!"

335. Ancient sculpture at the Vatican. I found myself more mature in my growing admiration for the Apollo Belvedere. I already loved the Muses dearly. No feeling for the Laokoön group (the thorax of one of the boys is said to be uniquely beautiful). New understanding for the Cnidian Venus. Here, in agreement with Burckhardt. Tomorrow I shall go to Spitthöfer's and wander through his store. German is spoken there.

338. From Saturday to Sunday I went on my second Roman binge. On the first we had celebrated the first day on Gymnasium-hallowed ground. Yesterday's brought a severe hangover. This time I had no vaccination pimples to get rid of.

339. The day in the bookshop will be recalled as one of the finest. A few purchases. Back home I find a yellow slip informing me that something is waiting for me *ferma in posta*. The expectation of a letter from my fiancée gave me courage and I tried to reach the goal by myself. In vain, because I started off with the notion "customs office." The second try, with Haller, worked. A cure for stammering now gives him the courage to use his good knowledge of spoken Italian. Two heavy parcels soon rested in my arms. On them it said: "Beethoven Quartets."

340. I own a series of the most beautiful photos of ancient statuary. . . . I never tire of spreading them out before me. It purifies me of certain desires. I

flirt (with Muses) and I am the better for it. I no longer believe in the banishment from paradise.

341. In January I'll join the Association of German Artists in order to get back to drawing from nature. When I am back in Bern next winter I'll have time and opportunity to learn anatomy very thoroughly, like a medical student. Once I know that, I'll know everything. To be independent of these horrible models! For satirists too like to be free and independent. Now, thunder is rumbling again, most strangely, as if below the ground, faintly and intensely, making everything tremble. And this at Christmas! Earthquake mood.

342. A cry of longing for Paris. At the theater (Dramatico Nazionale) I saw Réjane in a Parisian farce. It was certainly better than La Duse, with more style than D'Annunzio. For me it was a walk through an almost forgotten world into a slice of actual present-day life. It gave me food for thought. The world of the play is immoral. But the actress is decent, and the play is there for her. It was followed by a small dialogue in which Réjane plays the part of a *soubrette* (Lolotte), comical, daring, and beautiful throughout. The main play is called *La Parisienne* (by Henri Becque).

As a man who is not one-sided but who is yet concentrating on one aim, I've fought my way through many different things. As a maturing boy I experienced my most burning dreams. My first attempts to make them real brought very middling results, and sometimes shameful ones. However, I shunned ridicule; it is particularly difficult to be personally present on such occasions. So, shameful experiences raised me higher and higher, up to the asceticism of this Roman period.

As I entered the theater, I was surrounded in the loges by fairy-tale female apparitions like those in my early daydreams. A kind of melancholy came over me, as when listening to Schubert.

On the Beatenberg there is a little wood. There as a boy I played games that were both upsetting and enjoyable with a delightful girl from Neuchâtel. When years later I returned to those old haunts, feelings similar to today's stole upon me. Réjane's fascinating diction was partly responsible for my

state. One forgets oneself, one's daily work; the whole beauty of unworldly seriousness is blown away. The little girl, too, spoke French.

343. . . . rest / do / sigh no / . . . secretly, swiftly / one would have to be made of stone / to blame the child for it.

Read early comic playwrights, like Aristophanes and Plautus. *The Birds* is quite delightful!

Continual downpours with thunder and lightning. The windows tremble. The absence of passion in Pellico's *Francesca da Rimini* is amazing. Is it still alive? Long live old Aristophanes.

Song in praise of *vino* vermouth, the drink, three quarts, the large flask, but it is so dangerous that sometimes I am forced to use *granatina di spagna* instead, a little wine that stimulates the wit more, but incredibly sweet.

I tear up my fiancée's letters dating from before our engagement. Certain turns of phrase irritate me. I wouldn't mind if my part of this correspondence were to suffer the same fate.

347. Schiwago is a serious person, I don't know why a certain tension existed between us. Wassiliew had more talent. She also made good drawings and expressive caricatures. An extremely attractive personality. Unfortunately, as poor as a church mouse. It puts a certain pressure on her.

Last winter, I am told, she suffered from her breakup with Haller. She couldn't be to him what he, as an uncomplicated person, demanded of the woman he loved. For this she still lacked the courage, which only a certain maturity provides. She had tried to be friends. But of course that never works once Eros has made his appearance, even though it is unconsummated. He wants to grow to the point where he will have his way once and for all. And so they parted (as Haller tells it).

Can one not tell by looking at Demosthenes that he still finds speaking difficult? The forehead indicates the greatest strain. The photograph is good. Reality hardly makes a greater impression.

Sapellnikoff (later I once played music with him and Barjansky: Schubert's Trio in B. 1914) I heard as a boy, while vibrating to Chopin. Sapellnikoff was great at this music. I recall him as a broad figure, but not tall; as a musician in the orchestra, I sat very near him.

12.19.1901. Today I informed Haller that I had dreamed about Fräulein Wassiliew, whereupon he claimed that he had dreamed about "You." A funny moment, provided he was not just parrying. After that, he remained silent for some time; evidently he was still preoccupied, not by this incident, but by the affair it alluded to. In the Palazzo degli Conservatori he noted that he was not sufficiently receptive. While we ate he spoke again of Wassiliew and confided in me in a way he never had before. He too had already known her in Bern (I, since childhood); they painted landscapes together in the neighboring countryside. In Munich he brought her to Knirr's and followed her everywhere. For a time they both lived in the same boardinghouse, until it went broke; that is probably where they saw most of each other. Occasionally, they also came to my studio on Amalienstrasse; I was the right person to play the third man because I was having an affair, and indeed it was always very cozy and pleasant. Later Schiwago joined us and the four of us were often together, and a fine clearness and candor reigned among us. But only temporarily. Haller became secretive and sullen. The cause of it, I suppose, is to be found in the confession he made to me today. During the summer of 1900 he wrote passionate letters to Wassiliew, then in Basel. One of them went: "If you wish to remain a virgin, you must not see me any more." She was such a good daughter that she asked Father Wassiliew for advice! Naturally he didn't want to send her back to Munich. But then she promised not to see Haller anymore and was allowed to return to Munich. An attempt in Munich to be "friends" failed of course, and now Wassiliew herself asked that they separate, because of her promise. Haller now moved closer to Schiwago. Probably Wassiliew had told her about their anguish, and Schiwago felt called upon to act the motherly adviser; such a role surely appealed to her great goodness. This got her quite intimately acquainted with Haller. Perhaps he hoped to find a substitute in her. At any rate, he withdrew from us in the process and also drew Schiwago away from me. Without causing me harm, for I myself was going my own separate way. Only Brack was terribly furious about the stealthy ways of his friend Mändu.

Today Haller claims that he had no love relationship with Schiwago but only friendship, or at most a love relationship without any sensuality. Because Schiwago, he says, has no sensual leanings whatsoever. Can such a thing be?

Now his hopes are fixed on Wassiliew again, because Schiwago has returned to Russia. I believe he would be capable of marrying Wassiliew if he could afford to. In short, the prospect for him is not really very splendid.

Haller drew closer to me in the last year of high school and I responded. At that time I was richer and more mature. In Munich I still was, at first. That kept him in check and made him respect me. But suddenly he became a man; he managed it abruptly and joltingly, because he had to conquer his difficult nature. A sharp mind helped him in the process. I remained copious and confused, which created disharmony. He became impossible in a hundred little ways and upset many good elements in our friendship. I still want to do my best for him, as long as it is within my own interests. However, the sharp eye that watches over the limits of these interests sours friendship disturbingly.

350. That Aristophanes! I wish I too might write a good comedy (attempts in that genre followed).

1902

355. On January 1st, for the first time I again drew from nature: a foot. The Association of German Artists has a comfortable place, only somewhat narrow. A handsome and well-knit male model was posing. I have progressed after all while not working from nature. Life-drawing is almost a pleasant distraction. It became my best foot, not life-size, far from it. Haller worked on a large scale; his attention was drawn to the fact that his way of shaping forms was Baroque, and he was urged to overcome this tendency by observing the good and bad examples of it in Rome.

357. Sunday, January 5th, we went up for the first time to the Palatine, the crown of the seven hills. A brilliant day. Vegetation grows and blooms there the year round, as if this hill had a privileged climate. Pines with thick crowns grow there, and fairylike palm trees, and groteque cactuses looking like strange immigrants. I understand the emperors who swaggered up here. The view of the Forum must be one of the most splendid in the world. Nowadays

this ruinous mass could have a shattering effect on us, if fabulous light didn't atone for it, as happened yesterday. Domus Livia has beautiful murals, a foretaste of Pompeii. The vessels for oil and wine are still in the kitchen. The wine-jugs are pointed at the bottom, so they can be buried in the earth easily. The expanse of the palace of Augustus! Or just the race track!

Around this gigantic ruin the laughing splendor of modern Rome lies like a huge wreath. St. Peter's, in the distance, whose dome would be a triumph over decay, if the eternal sky didn't spread its vault above it. All things have their time, this marvel will suffer a catastrophe too. And it's useless that the individual's fame survives.

Caught up in these thoughts, I begin to feel downcast. Wouldn't it be wise to enjoy your little bit of life naïvely, somewhat as the seemingly impervious modern Roman does who strolls this ground with a tune on his lips. I don't hate him from envy, but today there is some envy in my feelings. (Better to sleep, best not to have been born.)

These are not my best, but among my most lucid moments. And now I ought to have "You," to forget it all.

358. One of the most beautiful aspects of antiquity appears in Xenophon's *Banquet*. The presentation fascinates by its grace, by the refinement of its jesting. The subject matter is serious enough, Socrates is the main theme. There is talk of love, of that flawed manifestation of the time. Socrates is well acquainted with it, but doesn't approve of carnal intercourse. I would like to see your face if you were to enter, led by the writer's hand, into the house of Callias, where a phenomenon is being unambiguously discussed whose existence "You" were only half willing to believe when I told you about it.

Thus I penetrate more and more deeply into the ancient world.

359. 1.8.1902. In the Teatro Costanzi: *Favorita* by Donizetti. Perhaps this wasn't the right opera of that master to hear first. It is a reminder of Halévy and Meyerbeer rather than the delightful Rossini. The singers' cadenzas are enough to destroy you. One of them sang as if from another world, magnificently, like an archangel or like God himself. The tenor Bonci. His sparrowlike figure is rather disturbing. The others didn't sing extraordinarily well at all. The ensembles were well conducted (conductor, Vitale); good, very

large choir, superb orchestra. The acting is deplorable; they all ride every spark of dramatic life to death.

360. The Tolstoy and Murger books arrived. *Bohème.* A sun that warms only superficially. No ray of sunlight reaches down to the depths of the human condition, where I am fond of sojourning. A kind of reading indulged in on the side, like a cigarette, like a daydream at sunset. But then, I *do* have time for leisurely reading.

Aristophanes' *Acharneans,* a most enjoyable play. Plautus' *Bramarbas* doesn't stand up next to it, a much poorer sort. I would also like to read Zola's *Rome* here.

A third person joined us: Schmoll von Eisenwert. Haller already knows him, I had only heard about him from Trappt. I am pleased that he also is an engraver. I hope to benefit from his technical experience. He draws on aluminum plates with pen or with lithographic pencil.

362. 1.14.1902. Yesterday I saw *la belle Otéro* in the Variété Salone Marguerita. First, a half-dozen singers, five of whom were not at all unpleasant. Then Otéro; at first she sang in a rather poor voice, posing in exquisite attitudes. When she started playing the castanets she seemed unsurpassable. A short, breathless pause, and a Spanish dance began. Now at last the real Otéro! She stands there, her eyes searching and challenging, every inch a woman, frightening as in the enjoyment of tragedy. After the first part of the dance she rests. And then mysteriously, as it were autonomously, a leg appears clothed in a whole new world of colors. An unsurpassably perfect leg. It has not yet abandoned its relaxed pose, when, alas, the dance begins again, even more intensely. The pleasure becomes so strange that one is no longer conscious of it as such.

Apart from what is after all of an orgiastic character, the artist can learn much here. Of course there would need to be still another dancer if one is not only to feel the law of movement, but also to understand it. The point at issue is perhaps only the complication of linear relations that subsist between bodies at rest. This topic for the time being constitutes my real field of research.

363. Sentences caught in a dialogue:
Watch, now I'll show you something; namely, the best way to hang myself. I have reflected that life in this or that manner would still be possible. But neither manner suits me. Therefore, I want relief, quick relief. / What are you doing there? / Go, you disturb me. / What if I were your friend? / Friends I had. / What if I brought salvation? / Salvation as a super-rope, as a super-poison-bottle? None other! / Look into the eye of the old friend of men, look into my eye gray with age. / Strange! What is your intention? / Want to see, we want to see Rome. / Rome as salvation?

364. January 16, 1902. Because of Lismann, I must go and see Nöther. Nöther thereupon spoke to me during the evening life-drawing session. Finally I went to his home, but he wasn't there and his wife was ill, which puts the matter off. Still, I'm caught! Isn't Lismann rather officious? At any rate, he's so insignificant that he had better be kept at a distance.

"You" must go to the peasant dance with a good conscience. Be merry, but don't get tipsy, for then "you" become amorous.

Sensuality is the malleability of the flesh when it is submitted to higher pressure. Eyes dazzled by colors. Ears drenched in sound. Noses in odors. The same is true for the organs of love.

365. Puccini's *La Bohème*. Excellent performance. A work in which all components, given equal importance, interact. How all the details, which have such an amusing effect in Murger, have been sacrificed to the main elements of the plot. The cast of characters is a fact in itself, indivisible amidst the mad change of misery and lust for life. As a drama this primitive, unmotivated business would make only a poor impression. Through the music, however, everything is humanized with such penetrating emphasis that the keenest pity extends to these people and their destinies as ennobled. The fateful language of music accomplishes this.

In the death scene, particularly, it attains a beauty such as doesn't often occur.

The main instrument seems to be the violin, which can't revel enough in

pathos and dithyramb, while at the same time powerful bass tones introduce a note of somber destiny.

Victorious little Bonci sang the Poeta, Pasini-Vitale gave a superb interpretation of Mimi. The staging and acting were good this time (*realismo!*), the death-scene was played masterfully indeed.

366. Excursion into the Campagna. . . . At the evening life-drawing session a ravishing little model poses, the plump Maria. I'm no longer at ease, perhaps because I don't have practice any more (?). Passion can also be transferred to other domains. Small agitations in friendship. Haller is beginning to hate Schmoll. Schmoll irritates him. Haller's electric spine. He takes lessons from a clergyman to cure his stuttering. The main result is to give a little polish to his Italian. Another symptom of agitation is Haller's urge to juggle about in certain criminal activities. We express doubts about his daring, which leads him to do some catastrophic things. At bottom, we mean no harm; still, the damage he suffers satisfied us!

Schmoll is a fine comrade. His drawings of landscapes are undertaken with the greatest love and executed with the utmost delicacy. He is a landscape painter through and through, even in character. A poet who stands in an intimate relation with nature. . . . Haller can't understand him. I try to feel my way into this sensibility of his, since something can be picked up from him here and there, in regard to the expressiveness of materials, for example.

Nöther I only visit out of politeness, at first without my violin. First, take the time to give the place a sniffing-over.

But why did God put this sweet, stupid Maria in front of us? Girls, so goes the talk, are hard to come by here. And yet they are more appetizing than those in Munich. If only for their clean underwear!

Thursday, January 23d. I drew a few queerly shaped tree trunks in the park of the Villa Borghese. The linear principles here are similar to those of the human body, only more tightly related. What I have thus learned I at once put to use in my compositions.

On January 24th I had a serious talk with Haller.

367. Four epigrams on a given rhyme-scheme.

368. 1.27.1902. Performance of the *Meistersinger* (*maestricantori*). Everything went off very smoothly, almost militarily. Impeccable voices, pure; gorgeous sound of the orchestra. Still, everything was distorted and weakened. Even in the Prelude the Beckmesser theme was completely misunderstood; the pointed fugue-tone turned into mild, harmonious figures, that is, into something meaningless. There were also plenty of mistakes in the tempo. Later Beckmesser also had a melodious, finely tuned lute and a wonderful voice. Sachs was German enough, but also crude. David made big sounds. The women better, Pasini-Vitale was excellent as Eva, quite unrecognizable after her Mimi, which is as it should be. The public called for encores of the beating scene and the quintet. And so there were two beatings. The quintet did not sound quite authentic here. The celebration on the meadow was a complete failure. The work was cut noticeably. Still, everyone stood when the garlands were distributed in order to slip away by-and-by.

369. Tuesday, January 28th. Today in Munich the peasant ball takes place in which "You" participate. I grant You Your naturally happy disposition that enjoys the moment. I am made differently. At the market on the Campo dei Fiori I made a few modest purchases, a couple of old frames and an imitation Tanagra. My compositions look good in a frame.

I go to bed thinking of "You" and filled with deepest longing.

Often in the afternoon I lie down on my bed because I'm cold. Mostly, I sleep for an hour or two in this way. At dusk I set out on my way to the evening life-class, which takes me across the Corso. The whirl of activity here, as in a salon, appears to me like something in a dream. The beauty of the women, too, is sometimes quite incredible. The fairy-tale eyes. And I sigh softly, as I just now sighed in a dream. I am like a young monk.

We now eat *al vero frascati*, Piazza Colonna, after Sorgin had taken to thinning our wine with water.

Schmoll gave me *Niels Lyhne*, a novel by the soulful Jacobsen. I am stimulated by Schmoll, but I can't confide in him. He is too one-sidedly German.

Outwardly, I am in good shape, despite a few inescapable fleas. I am on good terms with Civetta. I am allowed to caress her. My heart is calmer than

in Munich. Once a week it pumps hard. The warm winter also has its good features.

Since I parted from "You," I have spoken to no woman, and also find this right. I want no part of it.

371. Currently I am painting with venomous pleasure on themes from a German sentimental poet. A result of reactions against Schmoll, or in reaction against antiquity (Attica) . . . Niels Lyhne.

On February 4th there was a thunderstorm such as occurs only in the middle of summer north of the Alps; then followed a golden day, then an April-like confusion.

Every evening, regular life-drawing course from six to eight at the artists' association. My earlier studies of the nude are more effective, my current ones are unattractive analyses of forms.

Ancient Italy remains the chief thing for me even now, the main basis. There is a certain melancholy in the fact that no present lives up to this past. It is probably ironical that ruins should be admired more than what has been well preserved.

372. Yesterday we went out to the Ponte molle, half an hour away from the Porta del Popolo. The Tiber has risen considerably, is even much dirtier than usual, and in places has completely inundated the street leading to St. Peter's. It sweeps along a great deal of wood, for which people are literally fishing at the Ponte molle. A fine spectacle: people cast wooden hooks—made from twigs tied to string—toward the booty, and almost always haul in a good catch. Must hark back to the time of Romulus.

We couldn't easily follow the return route we had chosen, because of the flood, and became lost in side streets. Two riders, a gentleman and a lady, galloped unconcernedly through the flooded area and we realized how menial two human feet were. As compensation, we were treated to the sight of two toads locked in embrace in the bushes. The male small and agile, the female unnaturally swollen, almost to the point of bursting. Misinterpreting the act at first, we tried (Schmoll and I) to separate them. Schmoll was quite wild. "Phew, this is really disgusting!" he kept saying, and resorted

to his cane. When he had succeeded in separating them, the male sneaked away in a huff, but his fat mate remained helplessly prostrate on her back, expressing her great misery by agitating her limbs heavenward. Sumptuous orange spots on her belly lent the business a contradictory splendor. A horrible thought—to take it home for my bird—fortunately entered my mind too late. From this, one can see how nastiness comes into being; from the example of the two toads it can be seen how difficult is it, after all, to separate lovers. Let us remember this, even though we are human beings.

My plan to go to Naples. There is a German boardinghouse there, where one can live for two lire a day. A hint from above.

373. 2.6.1902. We now regularly drink a heavy red wine from Frascati. Yesterday it was so sweet that I immediately lay down at home and at eleven o'clock disappeared from the face of the earth. Now I'm awake before the break of dawn. Considered objectively it might be that my state is not a pretty one, least of all my gigantic thirst for the bottle. For me alone there is something strangely stimulating about these moments. The mind is lucid, an end in itself; thinking processes are broadened. Early days, things fallen asleep, hidden things, possibilities, melodies of the past and the future, timeless plans, float by, one after the other, and I feel rich under a hoard of gifts and must have hope. Then the day wakes, the nearness, the sharpness, and I am disturbed. I close my eyes in order not to see it, fall asleep again, heavily, am assailed by dreams, and frequently awaken only in the course of the afternoon without feeling restored.

374. I work with tempera, using pure water, to avoid all technical difficulties. In this way everything goes slowly and well, one thing after the other. Two or three days for a head, a day for each arm and each leg, a day for the feet, the same for the waist, and every appendage a day each.

Haller proceeds quite differently, because he is striving for a kind of organic color effect. In my case the color only decorates the plastic impression. Soon I shall make the attempt to transpose nature directly into my present creative means. Work goes more freely on an empty belly, but it easily leads to forsaking the sterner kind of morality. To put it bluntly, exactness suffers

from it. In particular, I never want to reproach myself with drawing incorrectly because of ignorance.

"Your" sweet note brought me joy and soothed me with the expectation of detailed news. The news I have from Bern is not very good. My mother has to stay in bed from time to time, and I know when this happens from the depressed mood of her letters. How I have had to defend myself against this pessimism! And there is the prospect of having to live there for some time in order (without worries) to go on working.

I'm often irritable; "Your" letters then have the effect of a soothing medicine. I read Tolstoy's *Power of Darkness*; it makes a strong impression, but is not without brutality. He could be an artist; here he is first of all a fanatic. The confession falls under this heading. The man had to hang himself to preserve his ethical equilibrium.

375. 2.12.1902. "Your" adventures at the ball, with Karpeles there, are really delightful; for him too, and he probably convinced himself for a moment that he was getting his *revanche*, since I once snatched a woman away from him. It wasn't to my credit, most likely.

About Schmoll—is he consumptive or a woman in disguise? I can add that he is really only a female painter. His intellectual and emotional world is completely feminine (Haller openly questions his virility). During his ecstasies in the Park Borghese he becomes furious when Haller from time to time gives off a contented belch. He is a pietist, a canting beauty-worshipper, has no appreciation for the salt of truth, can't transgress anywhere with a sense of humor. He believes himself a German. Whether in the good sense, is questionable. Perhaps one shouldn't be German, for there have been Greeks, Romans, and Popes. There are higher values even now than the Germans'. Alertness of the spirit, not dreaminess, is such a value. As a matter of fact, Goethe is the only bearable German (I myself would like perhaps to be German in his way).

To begin with, *Niels Lyhne* is well written; it is felt from the bottom of the heart to the ends of the fingers. And still I find in it too many blossoms and too little of the plant's total organism: a mollusk poesy without spine. But I haven't yet progressed far enough to pass a definite judgment.

Now my screech owl flies up to its *bastone* on its own. Last night I un-expectedly encountered him up there.

I want to play the Beethoven Quartets that "You" sent me. Today the books arrived with Jacobsen's short stories. I'll never have the talent to equal these little presents.

Those apes in the park of the Villa Borghese! Adorable. Except for the one baboon, which is morally below zero. The most lugubrious existence I ever saw. And withal, terribly human. Uglier than the devil, but otherwise closely related to him, begotten by him on a shriveled witch. O northern jungle. O Blocksberg. He doesn't fit in Rome.

376. 2.25/26 (Monday and Tuesday). Excursion to Porto d'Anzio by the sea (Altherr, Haller, Schmoll, and I). At six in the morning we began to carry out the program we had planned the previous evening over the fourth quart of wine. With a radiant sun and a fresh breeze, we decided to take a sailing trip. Altherr was the only one whose nerve failed, and said, "Damned boat." In a way, I had to admit he was right. For two hours everything went well; after the third hour we got seasick, since we made little headway and ran into nasty, choppy waves; the last two hours, I felt chipper again, and completely all right toward the end. We were far out (but my catastrophe occurred within sight of sailors' boats and laughing witnesses). The life of the tiny harbor at Porto d'Anzio is delightful. Out on the sea, many boats, dolphins, and lastly, the phosporescence; something quite wonderful. Dinner afterward was a feast; unfortunately my chair went on swaying for hours. We slept marvelously, in spite of a big bedbug. Altherr is rather eccentric. How he washed! He sprayed water on himself from the wash basin, but kept jumping back a step each time. In the morning his snores awakened me. As he was about to choke from snoring, he started and said in his sleep: "Silly thing, eats flies."

The weather changed completely that night, and a powerful storm whipped the sea and scoured the land. There were a good many spectacular scenes. Boat after boat with their sails torn to shreds took refuge in the little harbor: we were watching from the mole, almost swept away by the wind and cov-ered with brine from the breaking waves. Altherr wearing his frock-coat. The surf was particularly impressive in Nero's Grotto (once a posh bathing place),

near which is the scenery pictured in Feuerbach's "Medea." I now understood at once the peculiar waves in this painting. Haller went swimming; it was beautiful to watch him hurling himself across the surf. The rest of us were content with foot baths. Until noon the storm brought us rain and drenched us in spite of our raincoats. Altherr's frock-coat! He realized how comical he was and adapted himself to it; he suddenly pretended to be chasing a butterfly and put on a mad act, after which he was more dressed in sand than in the coat. The return trip in wet clothes, a glimpse of the Alban Lake. At home, put on fresh things from head to foot.

The shore near Porto d'Anzio is glorious. You imagine that you are no longer in this world. Everything is unfamiliar, from the smallest anemone to the aloes and the cactuses. The trees often dwarflike. The coast frequently changes in shape, what lines this produces! Anzio itself lies a little behind neighboring Nettuno, which resembles a fortress. In the west, small islands are visible (Brigands' Islands), in the south, mountains down to the region of Naples. Close by, the very characteristic Circe's Cape.

My relationship with Haller has become clear: neither rancor, nor hatred, nor love, nor friendship, but habit and nothing but habit.

378. 3.1. Excursion into the Campagna, in a fair-sized group; from St. Agnese out into the magnificent Campagna. New elements gradually enlarge the company. The only danger is too much fun. Herr Sohn-Rethel, from the Rhineland, chases every butterfly (Haller stutters and acts proud), Altherr of Basel is completely out of his mind. Caspar acts German and is a Jew. Schmoll is impotent and acts ecstatic. We can all agree only if we have wine. Often the waves here rise almost as high as they did on the sea the other day.

We tried to get a dish of risotto from some peasants, but it was hardly edible. The first bad meal in Italy.

With the same crowd we went once to a wine cellar. Enormous cats with scratched-out eyes. Heavy Syracusans, harmless, but terrible nuisances.

One day Sohn circulated a 1,000-lire bill among us. I tore it in two, half on purpose, half by mistake. Sohn turned pale, but we pacified him. The following day the bank replaced the bill. His fright, fitting punishment.

379. New compositions. The satire is dissolved in a slightly mournful mood. An aristocratic boy, weak and sensitive, strides over the ruins of a golden age, an epigone.

Then, treated the theme of "The Three Boys" anew and with more refinement. Besides, I begin to hope in a vague way of creating with new intensity not only intellectual works but beautiful ones. The road will be long, the task subtle and intricate.

I am sending "You" a little photograph: Haller and I on a bridge of the Tiber. Here Schmoll's taste—he snapped the picture—was just right. The light was exquisite.

Before this month is over I want to go to Naples, but I have no definite plans as of now, because the necessary money hasn't arrived yet. At the Teatro Albano (Popular Opera) I heard a piece of trash, an opera called *Francesca da Rimini*. The admission price was low and the atmosphere gay. Enthusiastic audience. A good prima donna had landed here by mistake. The calves of a pageboy remain in my memory, otherwise nothing, the music least of all. (Matches lighting up in the house.)

In the same theater I had heard Mascagni's *Rantzau* under the composer's own direction. Pretty awful.

380. We spent the 6th of March with Cléo de Mérode, probably the most beautiful woman alive. Her head, everyone knows. But her neck must actually be seen. Thin, rather long, smooth as bronze, not too mobile, but with delicate tendons, the two tendons close to the breastbone. This breastbone and the clavicles (inferences about the bare thorax). Her body is tightly covered, so that it harmonizes well with the bare parts. The fact that the hips are hidden is more deplorable in that her virtuoso's art of movement must reveal the effects of a peculiar logic, for instance when she shifts her weight from one leg to the other. In compensation, her leg is almost bare, as is the foot, which is very shrewdly draped. The arm is classic, only more refined, more variously alive; and then there is the play of the articulations. The proportions and mechanism of the hand reflect, in small, the beauty and wisdom of the organism as a whole.

This has to be looked at with precision: here the main lines are not enough, and no substitute of a pathetic sort is available (she seems asexual). The

substance of the dance is in the soft-lined evolutions of the body. No soul, no temperament, only absolute beauty. She is the same in the Spanish dance as in the gavotte of Louis XVI. Next to the gavotte, the Greek dance (Tanagra) suited her best. An Asiatic dance was not convincing. After every dance she completely changed costume. The consequence of all this is that she is more difficult to do justice to than Otéro; she presupposes an understanding such as the Parisians seem to have. Here it is certainly lacking. The reception was friendly, but a little pig who followed her act was a more spectacular success.

381. 3.10. *Tosca* by Puccini. Such atrocious things seldom occur, even on the stage. In contrast to *La Bohème*, the action here is extremely taut, which naturally produces rougher impulses in the music. The performance was very good, Emma Carelli was wonderful, the orchestra incredibly rhythmic and pathologically sensuous. The staging was lavish.

382. Reading: the first volume of Zola's *Rome*, Tacitus' *History of the Caesars*, Tiberius and Nero; the terrible and grandiose picture of the last of antiquity. Today more than ever, I believe in succession through the Germans. Especially since it was impossible to permeate Germany with Latin culture. And should we not be able to germanize Russia, some last future will be hers.

384. "Three Boys."
 I. I can hit birds in their flight. I myself made my bow. This art makes me proud.
 II. Last spring I felt my arms twitch, I believed I should embrace something. A quiet yearning made me wander off with the clouds. Why did I shed tears then?
 III. She was not one of the lovely girls, she was a woman, almost as strong as I. As I seized her, I felt the pulse of her hot blood, her breath seared my face. At the same time my whole being glowed for the liberation that comes from woman.

385. *The Epigone.* In me runs the blood of a better time. Sleepwalking through the present, I cling to the ancient homeland, to the grave of my

homeland. For the soil devoured everything. The southern sun does not help my sufferings.

The Spanish dancer Guerrero is well built and delightfully cheerful. All in all, her act is too light to be more than entertaining. Technically speaking, the upper part of the body lacks mobility, it remains too stiff amidst the otherwise free flow of lines; the dance, as a result, sometimes gives the impression of skipping. The rhythm of the feet is particularly good.

Jacobsen's "Mogens" is a wonderful short story. *Niels Lyhne* is a short story too so far as content is concerned, unfortunately treated too much in the epic vein. After the book had been given to me by Schmoll I used to get very angry about the marking of various passages with a pencil. Shows how biased we are, for when I discovered that the marks stemmed from "You," my feelings turned completely around, and I kissed one of these passages.

387. Now I am going to write to the boardinghouse in Naples. There is another good model at the life-class, so I'll be glad to draw till the end of this week. Next Saturday then! Herr Caspar wanted to travel with me, but now he has decided to come a few days later. Haller and Schmoll are staying longer in Rome and therefore don't have to be in a hurry about Naples. Before I go to Florence I shall do Rome again, as if I had to cover it in a week or two. When shall I see it again? At any rate, never again "for the purpose of studying." For now I'll first have the damnable duty of exploiting what I've gained. Perhaps I can still push through my claim to spend a short time in Paris. Then I'll be "through" with my studies. In a way, this critical state of affairs pleases me. He who must, will. And a trip to Paris from Bern, after I have spared the family funds for a while, might no longer be such a great strain. (Spring of 1903, maybe?)

388. *Iris* by Mascagni. Strong impression owing to sometimes stirring music and an ideal performance. Two important artists, Emma Carelli and the demonic tenor Borgatti. One phrase entrances me altogether:

NAPLES (EASTER, 1902)

389. Arrival, Sunday, March 23d, in the morning. That evening, San Carlo: *Mefistofele*. Monday, the harbor; in the afternoon, Posilipo.

Tuesday, San Martino-Corso Vittorio Emmanuele. German Consulate, Aquarium.

In those three days I saw so much that my account cannot even remotely keep up with it. Next to Genoa, Naples is indolent, dirty, and sick. Next to Naples, Genoa is onesided. Naples displays the greatest pomp beside the greatest misery—harbor life, rides along the Corso, sophisticated opera, even a touch of Rome: the Museo Nazionale. In addition, the matchless, paradisaical scenery. The sea is more powerful in Genoa, but also more monotonous. Here, a real bay surrounded by singular coastal mountains and locked in by colorful islands. And I can see all this from the balcony of my room. It lies at my feet, a giant hemisphere, the magnificent city with its roaring voice. On the left, the old town with the harbors and old Vesuvius; on the right, the modern Villa Nazionale and the Posilipo. Around the house and behind it, gardens with fresh greenery, fantastic shapes and a thousand blossoms. This splendid lookout is called Salita del Petrajo, Villa de Rosa 48, Pensione Haase, Napoli. The sea is gorgeously blue and quiet. The city, an animated mixture of patches, blocks of houses in sunlight and shadow, white streets, dark green parks. The prospect is a reminder of Christ's temptation. Sheer joy gives me wings, suspends me at the center of spheric splendor, at the world's navel.

But there is work too, it is not always like this hour of rest. Below at the harbor, you try to make your way through an incredible world that sounds quite different from what it is in the song of "Santa Lucia." What people they are down there! Ugly and poor, they lie about in the sun, sick, lousy, tattered, half naked. I am neutral—attracted to them without pity, with a kind of knowledge-hungry aversion. One delight of the artist is to let himself be thoroughly infected like this. I smile as I rebel against it, I know my art needs this as a basis. Its blossoms will wilt easily until the great strengthen-

ing. May the day of proof come. To be able to reconcile the opposites! To express the great manifold in a single word!

Teatro San Carlo: Boito's *Mefistofele*, a kind of Faust. The performance was somewhat uneven. The basso who sang the title role was superb. Gretchen sang in a curiously refined way, quite simply and intimately, but she looked so plain, almost Saxon. The tenor had some nobility but no grasp of the music. The orchestra doesn't match the one in Rome. Conductor Mascheroni insipid.

Splendid theater, heavy and dark, gilded from top to bottom, somber, gigantic.

For two lire I sat in the orchestra, in madly perfumed air, among the common folk. I even conversed a bit with them and flattered their neapolitanism. Part of it I believed myself.

A *ballo* followed, almost too much of a good thing, with a lavishness of display that was new to me. The prima ballerina, a really very young girl, rather small and dark, struck me as being on the crude side according to any standards of virtuosity.

390. The aquarium is extremely stimulating. Especially expressive are such native creatures as octopi, starfish, and mussels. And snakelike monstrosities with poisonous eyes, huge mouths, and pocketlike gullets. Others sit in sand over their ears, like humanity sunk in its prejudice. The vulgar octopi stare out like art-dealers; one in particular eyed me with compromising familiarity, as if I were a new Böcklin and he a second Gurlitt. *Niente affari!* A gelatinous, angelic little creature (transparent and spiritual) swam on its back with incessant movement, swirling a delicate pennon. The ghost of a sunken steamship. Upstairs in the library the frescoes of Marées. A half-year before, the subject matter would have been quite strange to me, but now I can feel my way into it. The presentation deeply and sincerely appealed to me. Certain works of Marées at Schleissheim misled me in regard to him (a judgment that was later completely reversed).

391. In the Museo Nazionale I was fascinated most of all by the collection of paintings from Pompeii. When I entered I was profoundly moved. The

ancient paintings, in part wonderfully well preserved. And this art is very close to me at present. I had anticipated the treatment of silhouette. The decorative colors. I take all this personally. It was painted for me and dug up for me. I feel invigorated.

392. Maundy Thursday (3.27) morning again at the Pompeian wall paintings. In the afternoon busy with entries in my journal, then at the German Consulate around four o'clock to ask whether I could get aboard a warship. But there's none in the harbor.

Afterward I walked along the Corso Vittorio Emmanuele to the Posilipo without any special plan. On reaching the tunnel, I suddenly felt enterprising and went through to the other side, looked at the village called Fuorigrotta, whose entire population was in the street and stared back at me. Then I followed the perfectly straight road for three quarters of an hour, to Bagnoli. From there (pestered by a cabman who kept trailing me) along the superbly foaming sea, back toward the Posilipo (twenty minutes), and then home in two and a half hours by way of the long ridge of the Posilipo, while a wondrously clear night was falling. The perspectives of the nocturnal sea are a tonic for sense and soul. No other coast is so interesting. Bold islands (Nisida) and the large and lofty island of Ischia, the dangerously steep, mountainous Capo Miseno, Capo Coroglio, and Capo di Posilipo; in the distance, the picturesque town of Pozzuoli, the Phlegraean fields. Finally Naples again, now like a quiet harvest of lights at my feet. Oh, the overflowing jumble, the displacements, the bloody sun, the deep sea filled with tilted sailboats. Theme upon theme, till you could lose yourself in it. To be human, to be ancient, naïve and nothing, and yet happy. It is good to be so for once, as an exception, a holiday.

393. Easter, 3.30. Since Good Friday the weather has been unsettled; today there is an alternation of sunshine and showers, the two sometimes together. As a result, I have stayed home a bit more and sketched a few impressions, bizarre sights. How quickly you feel at home here. I believe I would thrive better here than in Rome. Life is more stimulating, stranger. I must come back later, be a Neapolitan for a while. Enticing!

394. Yesterday, to the museum for the third time, with my Burckhardt. The walk there along the broadly curving Corso, which gradually slopes downward, is very attractive. The ancient statuary, particularly the bronzes. The disclosures made to us by statuettes with their coloring partly preserved. The eyes, which one must imagine painted.

On April 1st Caspar arrived and at once felt happy and communicative. He told about an unhappy love affair in his youth, speaking of himself in the third person. He had a smart travelling outfit with knickers and ribbons (a great deal of green), but only wore it the first time he went out. It attracted attention and even aroused protests from some fresh youngsters. Criticized Schmoll. We readily agreed on this.

395. On April 2d the two of us undertook a major excursion: Pompeii, Sorrento, Amalfi, Gragnano.

April 2d: Pompeii, Castellamare, Sorrento.

April 3d: Sorrento, Positano, Amalfi.

April 4th: Amalfi, over the pass to Gragnano, Naples.

The undertaking met with complete success. It had development, variety, and suspense. The weather was radiant. On the first day we spared our feet like true gentlemen.

At eight in the morning we took the train to Pompeii, visited the museum and the ruins. Plaster casts of the bodies of people and dogs are very impressive. Lovely buildings, a few temples and a wonderful house. When you have seen the best works that were found here, which have been removed to Naples, the place takes on life. After a morning spent this way we had a late lunch in a garden restaurant in the new Pompeii. At the station where the horse carriages stopped things were brisk and animated; we were offered a cab back to Sorrento for three lire—what a find that was! We didn't have to be asked twice, climbed into the prim little buggy, feeling like two young lords, and trotted merrily off to Sorrento by way of Castellamare. The rascally coachman was amusing. He was retroactively furious about the cheap price; on the way he met a pal of his, who was allowed to hop aboard (*fratello*, of course). We good-naturedly let him in. Then came a "nephew," ten years old, who had to have a rear seat in the carriage, for he was a poor boy and dead tired. He looked more like a prowler to us. Caspar thought he would

be an annoyance to us on account of his strong odor, and we declined. A sigh and a curse rose from the coachman's seat, and on we trotted, from one heavenly prospect to another. Before we reached our destination our driver tried to raise the price a little. When he saw that we would not give in he stopped just before reaching the first houses of Sorrento, claiming that he lived there, and we alighted quite content to walk the short distance. Now, since he had received no tip, he proposed to drive us to the hotel for a dish of macaroni. We absolutely refused, and he followed us for a while in his cab, proclaiming to one and all that we had been driven here from Pompeii for three lire without buying him a dish of macaroni. We enjoyed this as an adventure you don't experience every day. In town, a young agent took us under his wing and led us to a dingy looking but good Albergo e Ristorante della Scala, Ferdinando d'Esporito, Piazza Tasso, on the main square, one franc for the bed, the food good and cheap. One idyllic thing about it was that to enter our room we first had to go through another bedroom, which was occupied. That night we necessarily went to watch the tarantella, in a cabaret where beer was served and people were speaking German. The air smelled heavily of the cheap, cloying perfume of a famous region. Chillon-like atmosphere. The financial value we set on the dance brought another fruitless protest.

POSITANO-AMALFI

On April 3d we left Sorrento early in the morning and walked for seven hours along the road to Amalfi. I don't want to describe the countryside. We paused in Positano; the owner of the Hotel de Roma wouldn't let us keep going and offered us a *collazione* for two lire, including wine. It was a real bargain. The dining room was flooded by light from all sides. Through a gauze curtain stirred by a soft breeze the midday sea was visible. A majestic sight. Later some Germans joined us at our table, but they were refined people who didn't force their conversation on us. After a thorough rest we left this radiantly cool refuge and hit the road again. Before reaching Amalfi we drank our afternoon coffee on a picturesque terrace. Actually Amalfi was closer than we thought. We soon realized it when we saw the riff-raff gradually fill up the road, with

the aim of cheating tourists. Escorted by a mob of urchins, we walked through the tunnel into the old sea town, the fallen rival of Genoa, whose decline we documented at every step (among other things, a large bone came flying at us from some hidden corner). All the hotels seemed full, the man in the Hôtel d'Italie showed us a room at three lire per bed. His face had a touch of shrewdness about it as he insisted that no other room was available in all of Amalfi. We promised to come back if this were true. And we really did come back after a half hour. The look of triumph on the shrewd features of the innkeeper! After that, however, the man became quite friendly. We sat down on a terrace with a fine view, directly facing the Duomo. The sight of the activity below convinced me for the first time that I was in the far South. A natural dramatic performance of an incredible sort was visible from the balcony of the hotel. The food was very plentiful, but the Germans who sat at the table next to us were not exactly of the best. Disgusting attempts to be friendly by German painters from Capri, who are so despised. They were scandalized that we had neither been over there, nor showed any eagerness to go. As we paid the bill we thanked the innkeeper; there was much good nature in his face after all. We hired a little guide because we had special plans for April 4th.

Caspar is somewhat more gifted at languages than I am; he even manages to make himself understood in this country of thieves. As I said, we hired a little guide to lead us to Gragnano, at least to the top of the pass; one of those bedraggled urchins with Moorish eyes. The ascent through a valley with mills went off smoothly. When the condition of the paths began to be a problem the little fellow grew scared and only went on with us against his will. About a hundred yards higher up he vehemently refused to guide us any farther, and when we tried to persuade him to continue, he went off into a little fit of rage and tears. We paid him—*soldi* trickled *andante* into his hand; when a *ritenuto* made its appearance he burst out in tears again, and so the money went on trickling *adagio* until he was wholly comforted. He hadn't really exploited us, yet we were just beginning to need his help from this point on.

It had become high and lonely. A mountain top is much more lonely when a vast sea is below. Soon no path at all could be seen, but the rumble of a waterfall invited us in one direction. Feeling very hot, we rested at its foot. As

I saw Caspar relaxing, as fresh and youthful as a young girl, some sort of feeling of responsibility came over me. "Stay here, I'll look for the path and signal to you when you are to follow." I climbed up the rock above his head to the top of the waterfall. Once there, the other bank seemed to me a wiser choice, and I crossed the water by hopping from stone to stone. When I realized how slippery and muddy these stones were, I became unsure of myself and of course immediately slipped away with all my might in the natural direction, to wit, down. In my fright I closed my eyes, but everything went well and painlessly. After two or three momentary landings, I wound up right on top of the slab of rock where our camp lay. "Where in the world did you come from?" asked the astonished Caspar. "Out of the waterfall, as you can see," was the most accurate logical answer I could make. But now we had to push on, so I could climb myself dry again. This adventure made us feel bold, and we were guided by the feeling, climbing in the most splendid sunshine, letting our route be dictated entirely by the formation of the rocky mountainside. Soon we struck a path on which we met marvelous individuals and groups of people; once a group of women carrying pitchers on their heads came toward us. We had already spied them at the summit, and enjoyed the spectacle of their descent while we were resting. Caspar took pictures with his Kodak. We soon reached the sublime solitude of the heights; the panorama unfolded to the north, so that the Bay of Salerno and the Bay of Naples could be seen at the same time, an eternally unforgettable impression. We now followed a dale that sloped down toward the north, and leaving behind the bare solitude of the high pass, we reached a sparsely wooded region where the loveliest anemones grew. Right after, a painless descent began into a sunny valley full of spring flowers. We avoided the road to Pimonte, and without paying much attention to paths, we climbed directly down to the railroad station of Gragnano, where we caught the train back to Naples.

396. The weather is less clear. Caspar complains about it in Santa Lucia. Just like Hamburg, he says. I sense the moment when enthusiasm wanes, the moment when a certain fatigue sets in. At such times you must either think of leaving or remain quiet, ready for a stay of another, more permanent sort. Caspar's presence was profitable in every way—an intelligent, aristocratic-Jewish mind, reliable judgment, insight into people (Schmoll). I cannot recall

a single difficulty. Final visit to the museum. Departure at eleven at night on April 6th, arrival in Rome at seven in the morning. In 1914 I covered the same distance in four hours without my heavy felt hat (thank God).

397. Rome (4.7.) at first struck me as waste and desolate. The air was full of dust and the sky heavily overcast. I drove home, washed, and changed my clothes after the night trip. Then I went to Haller's; I believe the separation dusted a good many trifling differences from our friendship, and we were delighted to see each other, like old comrades; we know each other so well and both speak the same Bernese German.

On the following day the weather was wonderful, and I liked Rome again. A letter from my fiancée did the rest.

The Italian spring is more opulent, but the German spring seems more powerful because it follows a real winter. More contrast.

People often ask about the beautiful Roman girls, but no question could be idler. After all, I don't want to marry one. And it is probably more difficult here than anywhere else to start something frivolous with a woman. In the last five months I have literally not touched a woman. This was not purely deliberate, and it would not have been easy anyway. I am not speaking about prostitution, I never did have anything to do with that and never will. I probably wouldn't have fought off successfully a little affair that involved no great excitement and danger: I am only human, I also eat and drink.

I saw *Iris* again, the second act and the prelude are still excellent. This time Borgatti didn't sing. As a result, La Carelli made an even greater impression. An Italian Ternina.

Concert by the Kaim Orchestra at the Costanzi. Weingartner conducting. Mozart's Jupiter, Schubert's Intermezzo from *Rosamunde,* Liszt's *Tasso lamento e trionfo,* Beethoven's Seventh Symphony in A.

4.10. Three of us (Haller and Schmoll) made an excursion to Tivoli. The waterfalls have been reproduced in pictures and described often enough. In the afternoon we visited the Villa d'Este and toward evening the Villa Hadriana, an absolutely heavenly corner of the earth. In the evening there were subdued and serious color effects of a somberness and subtlety that one would never believe possible in Italy, which is unjustly regarded as a garish

land. There is a moral strength in such color. I see it just as much as others do, I too shall be able to create it some day. When?

Leaving Rome like this is not without its emotion.

On the way to the Villa Hadriana we had an amusing experience. A hackney caught up with us as we were walking along. The occupant, a lean, professorial German with a gray goatee, was so enamored of his honeymoon partner next to him, that he must have imagined himself alone in the world with her and the horse and the driver's back. Right behind us he launched a barrage of faun-like kisses at the thin, rather faded lady. We made a stand, yelled like a bunch of Hurons, lined up on both sides of the road and had the frightened pair run the gauntlet. The incident kept us amused for quite some time, until the carriage was nearly out of sight. We rehashed, analyzed, mimicked. "Oh, he was pleased with his morsel of flesh."—Haller couldn't get over it . . . I would hate to be caught this way between fifty and sixty.

4.13. Rome is as melancholy as I am; it shrouds itself in dark veils and weeps with me. Anyway, I have a great deal to do and to think about, especially how I am going to pack all my things. But I shall be able to leave only when I have the money. And when the money arrives I must be ready to leave. Old Rome, with its eyes full of rain.

I have already rented a room in Florence and know where to eat. I expect to meet Jean de Castella there; for some weeks he has been visiting Florentine pawnshops. A great rascal and a big child. How he mimicked the frightful ape and mauled his pretty sister!

How overfed I am and insatiable, and how hungry for the novelties of Florence. The after-dinner nap in Bern. Then perhaps the dreadful awakening, the reversal of direction: instead of penetrating into myself, a going out of myself! I have already dreamed about it, and clearly.

Yesterday (4.12.) I saw the Roman Salon, the annual exhibition in the Galleria d'Arte Moderna. The only good displays are the drawings, etchings, and lithographs by the French. Above all, Rodin's caricatures of nudes!— caricatures!—a genre unknown before him. The greatest I have seen were among them, a stupendously gifted man. Contours are drawn with a few lines of the pencil, a brush filled with watercolor contributes the flesh tone, and another dipped in a greenish color, say, may indicate clothing. That is all, and

its effect is simply monumental. Someone else exhibits caricatures of the theater and the music hall, among them Sarah Bernhardt as Hamlet, and a stiffly motionless *chanteuse*. There is also Forain, who with a few hard lines characterizes his subject to the last detail. The others differ from this little band by trying to outdo themselves. These people struggle, the Germans especially, and nobody can make any sense of them. By contrast, how honest the charming Parisians are, with their borrowed Latin inspiration, who keep their temper and their whores and their wit! Who could be repelled by this, it is so seductive! The lag-end of ancient culture. Paris, the image of imperial Rome and no less in decline. What is it that Zola wants, the Republican! France is clever, but no longer on the rise.

400. 4.15. Everything is packed. After I had seen the works of the ancients time and again, I devoted my last hours to viewing the Borgia apartments in the Vatican. As I am inclined to count Michelangelo among the moderns, I may legitimately claim that these *appartementi* are the most beautiful thing produced by the Renaissance in Rome. The Villa Farnesina, which I had seen earlier, comes far behind them; a certain emptiness, as in a fortress, prevails there. But here everything to the smallest detail shows lively elaboration, wholly infused with the same masculine energy. Not just a place for an occasional visit, but to spend a lifetime. Pinturicchio, a great artist.

After imbuing myself completely with this world, I visited the Egyptian Museum (to be thorough). It was a mistake. The works remained grotesque stage props.

Then I paid a farewell visit to my friends among the ancient works of sculpture and now believe I can leave Rome with a clear conscience. My train leaves for Florence at 11:10 p.m.

Short get-together with my friends. It is true, people are always especially nice at leave-taking. Schmoll has a wonderful way of wishing you luck. Since our walking trip near Naples Caspar had won me over completely. Haller accompanied me to the railroad station; at home he witnessed my farewell to the *padrona*, who was deeply moved and spoke profoundly beautiful words. Then we took a cab to the station.

When dawn came I was already in Tuscany. Waters gushed and flowed. The land was bright with blossoms, a joyful garden of fruitfulness. . . .

An elegant carriage pulled by a great, fat horse drove me through the fabulous theater of the lovely new town. In the Via dei Benci 14/2, the *vetturino* obligingly rang the doorbell for me, breaking the morning slumber of Frau Haag, a more-than-lifesize Florentine from Aargau; she was the precise opposite of that tiny lady from Berlin in Naples. Soon a bowl of coffee was steaming in the best room, and I felt at home.

FLORENCE (APRIL 1902)

401. Address: Via dei Benci 14/2, care of Frau Haag. After weathering the night journey without any difficulties, I arrived at my new quarters in a fine carriage at 6:15 in the morning. I spent the day getting my bearings; I'm amazed by the presence of so much architectural beauty. At noon hunger drove me to look for a restaurant, and I found a pleasant place near the Duomo, very clean and not at all expensive. The heavy traffic at the Napoleone had frightened me a little, the entrance is by way of the kitchen, where a gray-haired cook in fantastic slippers officiates. And the Chianti in the little restaurant is just the way I prefer it: slightly dry and tangy. I drank another like it only years later, in Tunis. After lunch I caught up on the sleep I had missed on the previous night and slept incomparably deeply and soundly. Reborn, I made a second tour, along the Arno. After dinner the cheap entrance fees lured me into the Teatro Verdi (previously Pagliano), where *La Traviata* was being produced, unfortunately on a rather modest scale. The theater is shaped like a long box, as big as it is dirty (more like a *Volksoper*). I admire the work, a wealth of ravishing inventions, stirring melodies. The atmosphere of the last act. The woman who sang Violetta, someone named Milanesi, wasn't bad. A good baritone served as protection against some fatuous oaf of a tenor. The ensembles and the staging pitifully poor. The orchestra large but bad. The musicians were not even dressed in black. This fitted their proletarian talents.

Coming up from the South, one does not get the impression of a truly Italian city. It is rather an international place, small but delightful. That the people are international is more noticeable than elsewhere, and likewise the prostitution. On to enjoy my last Italian meals!

402. Thursday, 4.17. I bought my pass and spent most of my time visiting the Uffizi, a museum you can get lost in. The quality is really unique. The *tribuna* with all its masterpieces is the finest spiritual treasure imaginable. After two and a half hours I left, deeply moved, feeling very small and shaking my head.

But I was not to savor these mixed emotions to the end, for who should appear at the gallery's exit? Our delightful Bohemian Jean de Castella. He was like a wedge from my Munich period driven into what Italy had made of me. He had remained faithful to himself, I had grown a beard and had changed in various other ways. He looked even more unkempt, the same peculiar pointed hat, the same overcoat and jacket. New English pants (knickers, of course), new yellow shoes, remarkable for their solidity and clumsiness. The big, weighty gold ring still at the pawnshop in Munich. "But I have the chain!" Another innovation came to light later: a rash, which tormented him horribly at times.

"Where are you going to eat?" "Oh, in a hole, it's vulgar but interesting! There are only Socialists at the table, but they love me." I could picture the *milieu*, including Jean, but personally I did not much feel attracted by it. Besides, he warned me: "If you come with your beard, they will say you are a gentleman and won't have you. But with me, it's fine. Do you know, they sing songs, beautiful but loud, everyone as loud as he can." By chance we passed by some such dive. "Is it like this one?" "Oh no! What do you mean? This one isn't nearly crude enough. Mine is much worse."

After some resistance I persuaded him to eat with me in my establishment, and he ended by feeling very comfortable there and visibly enjoyed the smell of clean tablecloths. But about the wine he said, "It's just as good there."

And so I now had a companion. In the afternoon we visited a few churches; unfortunately the light was poor. After dinner we strolled through the streets and past the cafés surrounded by wonderful bustling activity. Enchanting Florence!

403. 4.18. In the Galleria Antica e Moderna, to see Botticelli's "Primavera." Of course it surprised me at first, because I had imagined it wrongly, from the point of view of quality as well. Colorlessness partly due to wear. This is what contributes the historic element to a picture and becomes part of it. It is quite

a different matter to try to produce new pictures with worn-out colors, like Lenbach. If one loves the patina brought by the centuries, who knows whether one wouldn't reject the pictures in their original state. I once saw the "Birth of Venus" suddenly appear in the distance like a fata morgana. I then tried to see it as it was in actuality, but without the slightest success. Her colors are rarely spiritual.

Then I wandered over to the Pitti Palace, a very large gallery. From its riches I first singled out Titian's famous portrait of "La Bella" and a small portrait of a woman by Botticelli (the simplest and most consummate bit of painting). On the whole, I didn't feel drawn to Titian's color; it is more sensual than spiritual. Botticelli is a better colorist, better also than Mantegna. Paolo Veronese is also very much superior to Titian in this respect, even though he isn't a very appealing master otherwise. But to represent a beautiful Venetian woman, a spirituality obtained by the play of colors is less necessary than a voluptuous tonal twilight. And that Titian possesses as almost no one else does; he is the golden twilight of a southern evening. But this man knows how to lose and control himself at the same time. Some lines around the chest and shoulders have the fire that comes from this kind of strength.

In his small work Botticelli has known how to reduce his color pattern to such a limited set of contrasts that a kind of colorlessness ensues, which is not offset by a sensual tonality, but which itself functions as an expression of chaste love. This type of feminine beauty, moreover, really has no aggressiveness. The pose in profile harmonizes with it remarkably well.

After I had looked through it, I followed the connecting gallery to the Uffizi. In about ten minutes it leads you over houses, roofs, across the Arno (Ponte Vecchio), sometimes affording a view. Having reached the end, I sat down in front of the *tribuna*, and looking at a surprising portrait of a woman by Raphael, I meditated intensely on the personality of this Proteus of paint-ing. I also considerably improved my opinion of Lucas Cranach by looking at his "Eve," particularly by observing the creative treatment of the legs.

Jean accompanies me without a jarring note, in harmony. He doesn't think much and yet is always in the right place. It was good to have found him.

In the evening we went to the small, noble "Teatro Pergola" where the Japanese actress Sada Yaco and her company were putting on a guest-per-formance, together with Loie Fuller.

Sada Yaco doesn't stand out from her troupe like a diva; instead, it is the style of the company as a whole that makes a phenomenal impression. A kind of primitive consciousness pervades the whole thing, both the plays and the art of performing them. The poses develop in abrupt movements and remain fixed for long moments. Dancing and fighting are the essential features. The dancing is accompanied by barbaric music. During the fighting heaving chests emit "kh!kh!" and "th!th!"—sounds that lend rhythm and plasticity to the performance. The grotesque humor! And the acrobatic skill! Sada Yaco herself has the dimensions of a Tanagra figurine. Everything about her is as lovely as the way she chatters. Nothing is left to chance! Not the least little fold in her dress. The way she weeps indicates the high quality of her taste (what unappetizing tears I've seen on our stages!). The way she goes to bed, sheer enchantment. A sprite or a woman? In any case, a *real* sprite. For all style here is based directly on reality. For instance, the death of one of the characters from a dagger-blow, and how, at the very end, he shakes his legs in a final spasm!

La Fuller, purely technical, purely decorative.

404. 4.21. Meanwhile I met two young ladies from Bern at the Ponte Vecchio; they are named Brüstlein, Gilonne and Eliane, my neighbors on Obstbergweg. Intelligent and congenial girls. They invited me for tea.

I went, ate many cakes and drank tea by the quarts. Toward evening we visited the city park (Cascine) where there is a lot of promenading back and forth.

The first feminine society after a long period of social life exclusively male naturally had a pleasantly stimulating effect on me and I became a bit unfaithful to my friend Jean. To describe my relationship with the girls accurately, I must say that I found both equally sympathetic.

Tuesday, 4.22. With the young ladies in Fiesole. We had a light meal up there and watched an impressive funeral procession of a priest or monk. On our way back the moon was shining. Heavy scent of wistaria and lilac, which hung here in the thickest profusion. And the song of my first nightingales. Only an envious dog was still down to earth.

4.23. At the archaeological collection. Marvelous Egyptian, Etruscan, and tapestry sections. Every day Jean paints a picture of the Ponte Vecchio. He has a boatman deposit him on a small grassy island on the Arno and sits there

captive, with his pointed hat, until his pilot picks him up again a few hours later. How did he manage it with his Italian? The street urchins have discovered him and bombard the helpless *pittore* with *merde*. Jean consoles himself by thinking about the money he hopes to make.

405. 4.23. In spite of poor performances, I returned to the Teatro Verdi to get acquainted with Donizetti's *Lucia*. Whenever the music is in the popular style, it manages to be moving. But sometimes it gets into a middle ground between the operatic and the instrumental style, when it has a challenging, ungrateful effect. But in such an old work, wherever something inexplicable still appears, it must have been undertaken arbitrarily, without justification.

A young fellow from Aarau who goes by the beautiful name of Hühnerwadel ("chicken leg") sculpts and amuses himself around here. He isn't stupid at all, took a look at my little jocular drawings, in which I let myself go completely. He emphasized the fact that they were all three-dimensional. He knows Paris and lives here in Montmartre style. He lures me into it a little, and lures poor Jean in over his head. Once when leaving our eating place, we were surprised by a sudden April shower and fled across a wide square. Hühnerwadel ran with great expressiveness. There was something impetuous and buck-like in his last turn which unexpectedly brought him and us after him into an odd little place, a *café chantant*, where a piano rehearsal was just going on. This rehearsal, which we could take in for the price of a bad cup of coffee, was distinguished by a hypnotic monotony. Only a chanteuse changed the pace and danced a cancan for us, though she wasn't dressed for the part.

406. 4.24. Associating with my young ladies gave me a certain rounding off, after I had dealt solely with young men all during the winter. As a result, my exterior life acquired a certain polish which is not to be confused with perfection of the inner man. Only my feeling for my fiancée (I didn't use the term myself, for it was all still a secret) raised me to a certain pitch of feeling for life. A milieu like Florence could easily nourish pleasant illusions.

I devoted the morning of the 24th to the church of Santa Croce. From four in the afternoon to eleven at night, I was with the two girls.

The morning of the 25th at the Museo Nazionale (Bargello), after I had already taken a hasty walk through its chambers with Jean; this time, alone

and more seriously. Donatello was the main point of attraction. The stylistic perfection of his Saint John the Baptist. I did not yet realize very clearly that it was the Gothic that stirred me so much more intensely than the Ancient and the Baroque. A personality like Michelangelo should have baroquized the Gothic—that was what underlay my yes-and-no attitude toward Michelangelo. His importance as a transformer of styles was completely clear to me. Actually such a transformer of the Gothic is lacking. Otherwise Rodin would not be driven in that direction (Klee 1915).

The ravishing Carrand collection; I was particularly fascinated by the cupboard with the ivory carvings. The incredible amount of art lavished on a comb! The spaciousness of the building! The courtyard! The women who sit around, painting. In the afternoon, made an excursion with the young ladies from the Porta Romana to the Certosa. This area is a part of paradise. Why did the priest with the noble white beard shake his fist against that hill? "*Aquei socialisti!*" Socialists here, in this spring season? Dinner in the neighboring village. At night, wandered in high spirits back home.

4.26. Spent the morning in the Cappella Medici; but here too I didn't manage to get into any warmer contact with Michelangelo. Respect, highest respect! Yet there is nothing colder than this princely crypt. Intentionally? Hardly.

The afternoon in the medieval Museo S. Marco.

407. The fresco by Perugino on Via Colonna, beautiful, harmonious impression. Natural, uncontrived monumentality.

Then the Convent dello Scaleo. Andrea del Sarto's "Baptism" is more in the manner of the old masters than his murals. The execution in yellow is very instructive.

Sunday, 4.27., it rained hard. In the morning, went to the wonderful Cathedral-Museum S. Maria del Fiore. Organ railings, Donatello after a Della Robbia. A "Magdalen" by Giovanni della Robbia is still more magnificent (also more Gothic). But I simply don't like the technique used by these worthies. Photographs ennoble their works. How the figure and the rocky landscape blend, a masterpiece.

On the 28th, tea with the young ladies, drank it by the quart. Afterward, the usual walk back to the Cascine, all the way to the end, where two rivers

cleverly meet. Landscape very peculiar (somber mood). On the way back at night there were glow-worms in the air; on the 29th, the three of us again, along the opposite bank.

We went home before evening, because I had made an appointment with Jean and Wadel.

We loafed through town; I completely yielded to the leadership of the two Bohemians and entered a real bordello for the first time. Bold curiosity drove us up the stairway, past a couple of polyglot streetwalkers to the open door of the salon. A perplexing solemnity prevailed here. There was little conversation. The *padrona* was knitting. The damsels, perfectly decent, standing along the wall. Only their dress revealed that we hadn't entered the wrong house. After our eyes had quickly taken in these impressions, we turned around. Now the streetwalkers came to life, the German-speaking one said to us: "What's the matter with you? Ashamed? Why are you leaving?" These words put me to flight and the others followed. Outside we laughed heartily. It really had been comical. All three of us had had some experience with girls, and now, up there, they had taken us for greenhorns. For a moment it seemed to us that there also was muted laughter upstairs (the tip to the cabman who had guided us went for nothing, a dead loss.)

We consoled ourselves with wine, too much wine, and ended up in the demimondain café on the Piazza Signoria. Soon the company we had been wishing for was sitting at our table. A pleasant, dark creature and a real whore, painted and prettied up and yet unattractive. When we left, we were two couples plus a single, and the single was myself. I understood Wadel, I wouldn't have been completely incapable of acting the same way. But that good soul Jean, how could he! His face, as we left, clearly showed that he was very much aware of the questionable side of his project, in spite of the wine. But one had gotten into this debauch and the joke was so good that it had to be carried through. And after all, who knows which of the two had more pleasures to offer, the young wanton or the old sow? Deep in thought, I walked slowly home. The following day proved me right. I felt well. The sky was brilliant, as it has to be in Florence.

4.30. In the morning, returned once again to the Uffizi. This time looked at the Germans. Dürer well represented; Holbein, less well. But Lucas Cranach shows so much the better for it: besides "Adam and Eve," I particularly

noted a miniature diptych portraying Luther and Melanchthon, particularly Melanchthon.

409. Since I've been seeing Jean, I have again been thinking a good deal about Munich. He dotes on Toni Reitmayer. "Oh, I'll never again have anyone like Toni." And yet she stole the money he had sent her to redeem the heavy gold ring.

I remember Moreau from Lausanne, who was like a rooster, and always cheerful in spite of the perpetual fog, until one day he suddenly lost his spirits. "I want to stay at home now. I have closed the windows and the curtains, I have lit the lamp, and I have said: This is the sun."

I remember dirty little Karfunkle from New York: "Ya know, I vant to hev a villa, and it should be fixed up swell, ya know, with lotsa food and wine on the table. And after eatin', ya know, I'd go in the kitchen and then I'd take the maid and ya know!"

In connection with these recollections, I met Max Schmidt, from Lörrach near Basel, today. His collar couldn't be any higher. His monkey face has become even more melancholy. The gay South makes a stronger contrast than the moors around Munich. He said in tired tones: "Do you know the Egyptian museum?" I find it very beautiful. I went then to see the fresco by Perugino. How different it is in contrast! Only the customary two tears were missing. What will such a milk-belly do in this wine-country.

Disgustingly sour breath of this tearful *super-suckling!* In the Via dei Servi, to boot. And all that money!

On May 1st the money for the trip arrived. I still visited the Boboli Gardens and the Uffizi's graphic collection: Mantegna, Dürer, Rembrandt, and others —superb! The stained glass windows in Sta. Maria Novella were the last thing to delight me in Florence.

On May 2d, at 9:10 p.m., I took the train to Bern, via Milan and Lucerne. Jean de Castella and Hühnerwadel from Lenzburg brought me to the station. I slept very soundly until Milan. Here I met the waiter Lips, who had left the Grand Hotel in Rome with a few pullets. Thus I also got to have a slight taste of that establishment's cuisine. And their Marsala wine is thoroughly palatable. From Flüelen to Lucerne by steamer. The tender green of the beeches

produces a new world. O chaste, German spring, so utterly devoid of perfume, only the pure, strong scent of life! The only real and true spring!

At home I found everything in order, a good bed, meals without tips, two ravishing cats, Miezchen and Nuggi, gray on gray.

Diary III

411/412. 6.3.1902. My Italian trip now lies a month behind me. A strict review of my situation as a creative artist doesn't yield very encouraging results; I don't know why, but I continue nonetheless to be hopeful.

Perhaps from the realization that at the root of my devastating self-criticism there is, after all, some spiritual development.

Actually, the main thing now is not to paint precociously but to be or, at least, to become an individual. The art of mastering life is the prerequisite for all further forms of expression, whether they are paintings, sculptures, tragedies, or musical compositions. Not only to master life in practice, but to shape it meaningfully within me and to achieve as mature an attitude before it as possible. Obviously this isn't accomplished with a few general precepts but grows like Nature. Besides, I wouldn't know how to find any such precepts. A *Weltanschauung* will come of itself; the will alone doesn't determine which direction will yield the clearest path: this is partly settled in the maternal womb and is ordained by fate.

As a beginner in this profession I shall not be able to please people; they will ask things of me that any clever young person with talent might easily come up with. My consolation is that the sincerity of my intention will always be more of a check to me than my lack of skill. Starting from an awareness of the prevalence of law, to broaden out until the horizon of thought once again becomes organized, and complexities, automatically falling into order, become simple again.

Two letters to Lily, one partly written in Florence and one written offhandedly during the first days in Bern (chiefly devoted to answering her).

An attempted portrait of Bloesch: For God's sake! Heine: "The Florentine Nights," "The Elemental Spirits," "The Rabbi of Bacharach." Maupassant: "Fille de ferme," "Le Vieux," "La Dott." Plato: "The Apology of Socrates."

Maternal love, a bit too close to instinct. Mere drive. You have to work at the other love, which is more ethical, more social.

The "Bloesch portrait"!! Tempera (al fresco) with blue cravat, away with it before it's completely born!

Advancing along a spiritual path: with every step, more solitary. Divergence

from my father. The latter "younger" than I. Fantastically talented but irritable. Without measure, in spite of his intellect.

Fearfully sober things, these: the canvas, the painting surface, the base. Not much more exciting: the tracing of lines, the treatment of forms. Over it all, light, the creation of space through light. Any content is prohibited for the time being. The purely pictorial style. How far away the true experience of these things still is!

For the time being, the notion of the art of living is more fascinating. No convention such as "the profession." Thoughts about broadening the horizon: that, by all means!

413. Hilterfingen am Thunersee. 6.4.1902. I sit on the same spot I did a year and two years ago. Some sixty feet above the sea, between the church and a young grove. An idyl! Everything that once seemed distant to me, intimately closer. "Ulysse a vu la mer," it said in our primer. That large body of water . . . but it's small; you can hear the river Kander rushing into it on the other side. The Stockhorn over yonder is no trifle, of course, but there are lords of more consequence who covered themselves up in order not to disturb us. This is the essential thing about these mountains.

What a change within me. I have seen a piece of living history. The Forum and the Vatican spoke to me. Humanism jumps at my throat; it is more than an invention of high-school teachers to torture their students. I must go along with it, if only for a little way. Farewell, elves, moon fairy, star dust.

My lucky star is not rising, not for a long time yet. Rejoice, barbarian! if you can think clearly. "Ulysse a vu la mer" and I, Rome. Enough of magic! Here is neo-classical Europe!

414. Haller says in reference to his Mama: I've got cyanide, after all. . . . 2. What energy she has! If only I had it! 3. She gets on my nerves! 4. Acts frantic in the house.

About his Papa: 1. He'd be all right, but he just got to be that way. 2. When I think of the energy he must have had once! 3. You know, he thinks she's ill. 4. And he doesn't want to count anymore; you know, he's looking for some kind of a rule.

About girls: 1. I don't want to see her. 2. Don't need to carry anybody on

my back! (To me:) You don't harm me! 3. I've got a mushroom on my chest.

About his painting: 1. You know, something on a small surface, I can't bring it off. 2. I thought, what things would come to be on this canvas! But it was not to be! 3. Mimu will never do it. He'll remain silent. He'll keep it to himself.

About the dust on his hat: Let it stay there!

About God: He means well with me, he doesn't hurt me! Not everything about me is good.

To the beggars in Rome: I'm a beggar myself.

415. My future father-in-law wants to know the truth. I can give it to him, provided Lily agrees. No mean day, the seventh of June. Brack would ignore such a letter, Haller would be unable to produce an intelligent answer ("Writing, I can't bring it off.").

Gorki: Literature. Art. I needed different fare. Perhaps in the manner of the Nietzsche quotations in the *feuilleton* of the *Berner Bund*.

416. 6.8.1902. To train my thought, I wrote down a few didactic remarks about art. Dry theoretical compromise between strict and impressionistic painting. The countryside provides moderate bases for it.

Still waiting for Lily's answer. What will she have to go through? Things are less moderate there in Munich. Meddlesome fathers hardly belong among the pleasant things of life.

417. "Herr Medizinalrat, Your letter at first surprised me, but basically it was not unexpected. Your simple and straightforward manner deserves a reply in the same spirit. I would have told you the truth even if you had asked me for it less loudly.

My relations with your daughter, Fräulein Lily, which were very close from the beginning, have now grown into what could be predicted, and far be it from me, since the occasion has arisen, to wish to hide the facts from you, for our relationship could only stand to gain, in my eyes, from telling you.

That it did not happen sooner (for lack of an appropriate occasion) did not strike me as improper, in view of our youth, which could benefit from using the time thus gained as a trial period; my parents too know nothing about it

yet. This is why they have not invited your daughter, as their son's fiancée, to visit them.

But knowing my parents' way, I am convinced that your daughter will also be welcome as my fiancée.

Above all, I am convinced of the impossibility of any human hand being raised successfully against us.

With renewed insistence on my gratefulness for the fact that you addressed yourself so frankly to me, I remain your devoted Paul Klee."

418. Lily approves the above letter, the first draft of which I submitted to her, so that the situation is already settled in my mind. I am happy about her firmness as well as about our being in accord, which is not to neglect the seriousness of the situation externally. I did well by being cautious. (6.10.1902.)

419. Aunt Luise: "They've got a lot of cupolas like that in Italy. They think highly of them. They're starting with that in Switzerland too (in every other respect, my aunt is sane)."

Someday the historical savings bank will have to fail. Then, perhaps, I shall be able to step upon the stage anew and say: Now I stand here on my own two feet.

420. Satire must not be a kind of superfluous ill will, but ill will from a higher point of view. Ridiculous man, divine God. Or else, hatred against the bogged-down vileness of average men as against the possible heights that humanity might attain.

421. In earlier days (even as a child), the beauty of landscapes was quite clear to me. A background for the soul's moods. Now dangerous moments occur when Nature tries to devour me; at such times I am annihilated, but at peace. This would be fine for old people, but I . . . , I am my life's debtor, for I have given promises. To whom? To me, to her (loudly and firmly), to my friends (silently, but no less firmly). Frightened, I jump up from the bank, the struggle begins anew. Bitterness has returned. I am not Pan in the reeds, I am merely a human being and want to climb a few steps, but really climb them.

Affect the world, but not as part of a multiplicity like bacteria, but as an entity, down here, with connections to what is up there. To be anchored in the cosmos, a stranger here, but strong—this, I suppose, will probably be the final goal. But how to reach it?? To grow, for the time being simply to grow.

As exercise: To set up goals that do not hold for the multitude—a kind of playing of études. Higher things will then follow more smoothly, more easily.

Peace doesn't exist, the peaceful man devoured himself (one evening, in the Bächimatt, near Thun).

422. O individual, you who serve no one, you useless one! Create aims for yourself: Play, delude yourself and others, be an artist.

Now, so many substitute aims lie about that the choice is painful. The wanderers on the path of art damnedly resemble the vagabonds on the road. Schiller's *Fiesco*, good subject, and *Poems*. Gorki, *The Vagabond*.

423. 6.18.1902. Back to Bern. I talked with my mother about Lily and about the invitation. At home, you are not up against anything that you don't know. And just for that reason Lily will be invited. I didn't speak directly with my father, most likely he is already informed.

424. Fairies are always elderly and rather strict. Otherwise it would necessarily have happened in some fairy tale or other that the boy, upon being granted the usual three wishes, would have asked for the fairy.

Hanslick, *Of Beauty in Music*, very intelligent and purely theoretical. Feuerbach, *A Testament*.

425. 6.22.1902. Everything that used to be foreign to me, all the rational procedures in my profession, I now begin to resort to after all, from necessity, at least as a matter of experiment. Apparently I am becoming perfectly sober and small, perfectly unpoetic and unenthusiastic. I imagine a very small formal motif and try to execute it economically, not in several stages, of course, but in a single act, armed with a pencil. At least it is genuine activity, and repeated small acts will yield more in the end than poetic enthusiasm without form or arrangement. I am continually occupied with the nude body, which is well adapted to this kind of work. I project on the surface; that is, the

essence of the subject must always become visible, even if this is impossible in nature, which is not adapted to this relief style. The absence of foreshortening also plays a crucial part in the process. It is small and tight work, but at least it has become a real activity. I am starting to learn all over again: I begin to execute forms as if I knew nothing about painting. For I have discovered a very small, undisputed, personal possession: a particular sort of three-dimensional representation on the flat surface.

And when night comes I can lie down with the consciousness that work has been accomplished. And that also means something.

A flying man! I force the third dimension into the flat plane. Disposition of the arms, paired legs, absence of foreshortening.

I even dream about it. I dream of myself. I dream that I become my model. Projected self. Upon awakening, I realize the truth of it. I lie in a complicated position, but flat, attached to the linen surface. I am my style.

426. 6.30.1902. Decided to adopt Lily's plan that we meet again secretly in Pöcking, not to be confused with Peking, on the Starnbergersee. I feel free, especially in view of my future father-in-law's negative attitude, to undertake anything for which I can assume responsibility myself. It will be more important for Lily than for me to make sure of not being discovered.

427. Haller back from Italy. He sees that I have made progress, but he only sees or wants to see what lies closest. He assures me emphatically that I'll certainly attain outstanding mastery in nude-drawing.

To be sure, I still want to learn anatomy. But that is more a means than an end. His knowledge is only partial, just as his recognition (of my merit) will never be complete. If only he doesn't remain stuck with nude-drawing.

428. July 1902. My Papa and I.
I: "You've read the letter from Doctor Stumpf, haven't you?"
He: "Yes, I've read it."
I: "We ought to answer soon, you or mother."
He: "Yes, I intend to."
I: "But I would like to know what you'll say, if it's all right with you?"
He: "You may read it." (end).

RECAPITULATION

429. After the productive years of academic study, my first attempts were not pictorial, perhaps rather poetic. I knew no pictorial themes. Why go to the academy then? So you can answer the questions put by your uncles and aunts: yes, I went there.

When I sensed my academic-artistic fiasco, I flirted with sculpture. A brief conversation with Rümann convinced me of the impossibility of learning more with that man than in any other art school. The concern with form in itself (without technique), and how it brings with it modeling through tones, did no harm. And served as good preparation for the Italian trip.

In Italy I understood the architectonic element in the plastic arts—at which point I was groping toward abstract art—today, I would say the constructivist element.

Now, my immediate and at the same time highest goal will be to bring architectonic and poetic painting into a fusion, or at least to establish a harmony between them.

Unfortunately the poetic suffered a great change in me. Tender lyricism turned into bitter satire. I protest.

If only I survive, a saucy voice cries in me. For the more I am built up, it's the truth, the more things seem to be crumbling around me, in the big, broad, bourgeois world.

Or am I mistaken? Then I ought never to have been born. And neither can I die now!

Music often consoled me and often will console me, when the need arises.

430. The thought of having to live in an epigonic age is almost unbearable. In Italy I was almost helplessly under the sway of this thought. Now I try to ignore all this in practice and to build modestly, like a self-taught man, without looking left or right.

As of now, there are three things: a Greco-Roman antiquity (*physis*), with an objective attitude, worldly orientation, and architectonic center of gravity; and a Christianity (*psyche*) with a subjective attitude, other-worldly orienta-

tion, and musical center of gravity. The third is the state of the modest, ignorant, self-taught man, a tiny ego.

431. I, a childish man, want to crown thee with flowers, thou pallid face. One can read on the white walls that somewhere close there are chrysanthemums.

Thy cool lips need a slight fever, perhaps a kiss will protect them from dryness.

How beautiful thou art in colors which are only a semblance of colors. My satiate yet hungry eyes wanted newly assembled figures.

And should I die, two flowers of evening shall shine softly in the twilight. I shall say "credo" to thine eyes with the delicate, deep rings and believe what shall be in them at the hour of our parting.

433. The Oberpöcking Plan became a reality. Then two days in Munich. Hotel Central, owner Georg Stecher, July 27th, 5 marks for a suite, July 28th, two breakfasts served in the room, 2.40 marks/7.40 marks (instead of words).

The trip lasted from July 19th to 28th, 1902. In Munich we visited the Sezession exhibition, ate great menus at the Luitpold. At night we went to see the Geisha operetta at the Gärtner Theater.

Next morning, painful parting. I at 12:40 p.m. to Lindau, Lily 12:55 p.m. in the direction of Chiemsee (instead of words).

For there are no words.

435. My mood brought the Swiss much rain on their national holiday. But my mood was not uniform; in me, there was also a great, great deal of sun. Around me only darkness. Among other things, Fränkel, whom Bloesch took me to see. The night after he received his doctorate, he coughed blood. Beautiful eyes. Trouble with his hearing.

Later Yvette Guilbert at the Apollo Theater, in Bern. There, all was well again, on July 29th.

436. Silly ways of speaking: Having the will but not the power,
To say the Gods begrudge it to one.
To deny lady Venus honestly and sensibly.

To believe that Christ is still alive.
Silly ways of speaking.
 Zola, *Abbé Mouret*. Gorki, *Friends of Youth*.

439. Studies of nature with the Kodak are the latest thing. Sometimes, I now paint tentatively in oil. But I do not get beyond technical experiments. Certainly I'm very much at the beginning or before the beginning! No silly way of speaking. One of the lessons learned from these technical experiences in painting is: Spread no new chalk base over oil paint.

441. Haller on wine: Now let's go fetch him! Ah, how I like him! Come, my friend, come to me! Ah, if I didn't have you!
 On swearing: I now swear by the one below. His ear is more open than that of the other. The other's too high up. But he sees us, he sees everything, the dog!
 Haller went a-hikin' (up the Stockhorn).

442. *La Bourgeoise:* "I must please. To be sure, my feet are small enough, but they could be still smaller, like W.'s. Shoes shouldn't be too narrow. My toes have long been pressed upon one another, but in my shoes, no one sees it.
 Men sometimes fall in love. One must take advantage of it. I, for instance, did not pay attention. And yet one marries only once. The best is a man with money and a future, with both.
 With time, unfortunately, one grows older. Perhaps there are remedies for wrinkles after all? But a young-looking hat sets many things straight. Even today, men sometimes follow me in the street.
 The worst is the neck, that's where it starts. The arms have suffered least. I wear half-way sleeves, and when there are visitors, I move my arms. My beautiful, youthful elbow then becomes visible.
 I often have my picture taken. What do I care about the resemblance, provided the picture looks young? To look young is to be young. Actually, I no longer am young.
 My husband gave me a child, that is, it came by itself, as children will. It takes after me and is quite gifted. It is good in geography and has many

other talents. It will certainly become a great artist. I hate all people who say something that sounds critical about my child. I take it personally. I only want to hear flattering things. My child is a lucky child. What failed in my life will succeed in its life. All it does, suits it. I find it beautiful. That is maternal love, and there is nothing higher than maternal love."

443. Gertrude is not beautiful, she looks angular and brown, and she has a broad nose. Her belly is very big, I think this is due to her eating too many potatoes. But Betty has a ravishing figure, her skin is white as snow, and her little face is positively beyond description. The two of them have been dancing together merrily for a while, and I observe them from the window, that is, I observe Betty. Later, I have to go out and shake hands with Betty as I pass by. Gertrude stands aside.

God is just. He trains Gertrude early to stand aside; later on, then, she will suffer less from not getting a man. And if one really thinks about it, Betty might some day have too many and run the danger of becoming involved with the wrong one. Gertrude, on the other hand, remains a pure virgin, and the Savior loves her.

But in heaven it might well be that the two exchange their roles.

There is understanding, up there, for broad noses and fat bellies.

Remember that, dear children.

444. a) Know you my laughter about you?
 Be glad you do not know;
 For it would burn you terribly.
 And now it burns only me.
 b) And it is all right with me
 Should you spawn a flat generation.
 My kind must die.

445. 9.1.1902. Today I made a nice experiment. I covered a glass plate with a layer of asphalt; with a needle, I drew a few lines into it, which I was then able to copy photographically. The result resembles an engraving.

447. I spent ten days in Munich, from the 20th to the 30th of September. I left on the 20th (with Bloesch), saw Lily again, had dinner with her. On

the 21st, we went to the Isartal: Baierbrunn and Konradshöhe; then to the rose garden and finally to *The Marriage of Figaro*. Facing us, sat Menzel; made a good impression in the Residenztheater. On the 22d we visited the Glaspalast. In the afternoon, a visit to the police bureau. At night, alone. On the 23d, the Pinakothek, then to my place in the Catholic Casino, then the incognito was dropped and I paid calls on Arcostrasse. On the 24th, back to the police and to the Pinakothek. At night, alone. On the 25th, a Thursday, I registered at the 1st Regiment (infantry) on the Marsfeld. A very beautiful spot; too bad, I was not allowed to stay on right then. In the evening, at the doctor's. On the 26th, music at Lily's. Sezession gallery. Theater (Rose Monday). Afterward, with Bloesch. On the 27th, in the Nymphenburger Park, where I took a picture of Lily. Then a visit to the local draft board and an excursion to the Isartal (Pullach). On the 28th, Bloesch left. Again, a visit to the draft board, accompanied by Lily. Teatime and walk in the Hofgarten. In the evening, in Arcostrasse. On the 29th, bought material for painting, lunch in the Luitpold. Then, departure.

448. In October I spent some time in Oberhofen on the Thunersee: I myself didn't know why. Then at last I settled down to the work that was sternly reproaching me. I am now to play first fiddle in the orchestra. Herr Intzi brought me the score of Liszt's Faust Symphony and of an overture by Grieg. The Mephisto theme is full of pitfalls. Neither the orchestra nor the conductor will master it. Thanks to Weingartner, I know how it should go.
 Otherwise, in good health. Duty calls to work. In many ways, my thoughts are still in Munich.

449. On October 16, 1902, I heard Eduard Risler play Johann Sebastian's "Chromatic Fantasy and Fugue," small pieces by Couperin, Mozart's A minor Sonata, Sonatas in E, op. 109, and in C minor, op. 111 by Beethoven, and, in conclusion, "Abends," "In der Nacht," "Fabel," and "Traumeswirren" by Schumann.

451. At the first subscription concert we played Mendelssohn's Italian Symphony, excerpts from Beethoven's ballet music for *Prometheus* and the

overture "In Autumn" by Grieg. Violinist Geloso, from Spain, played Saint-Saëns' Concerto No. 3 in solo works.

453. I'm going to do everything that I still haven't done. I'm going to study anatomy with the medical students. I'm going to draw nudes, along with the provincial painters, from a horrible model dragged in from the hills. I know that they aren't examples to follow, and will never be. But I want to behave as if I were still much less. In this case, less has more possibilities, too. I don't want to have been a "student of Stuck," for that would be enough to impress most people; I want to let sound in my ears the criticism of a certain gentleman with martial beard, that decorative painter gone wild.

On November 2, 1902, a piano recital by local artist, all sorts of respect for him, but too soon after Risler.

On November 1st started the course in anatomy. A peculiar festival for the dead. On November 6th a concert by a Swiss trio, interspersed with singing by Philippi, an alto. This lady from Basel sings with inner conviction, but also rather monotonously. From November 7th to 9th, I took part in a trip made by the orchestra to Neuchâtel and earned some pocket money. An excursion to Valangin brought rest and recreation, abundant food at the Hôtel du Soleil gave strength, good wine provided consolation. The mountain panorama is described in Baedeker.

L'oeuvre by Zola.

455. Second subscription concert. We played Brahms' Third Symphony and an overture by Rheinberger. On Siamese-twin grand pianos a Mozart concerto for two pianos was performed, and other pieces.

456. Every morning, I work from half past eight till eleven o'clock in the anatomy room. On Saturday at eleven, Professor Strasser lectures for artists (what artists!). And on Wednesday, Thursday, Friday, at an evening course at the Kornhaus, models pose in the nude. Here, Messrs. Born, Boss, Colombi, Link, and others excel. All "Hodlerize" more or less. The models are strictly *à la* hills.

Bloesch wants to go to Paris, the dog.

457. Camilla Landi, a great artist, sang on September 24th. Pedro Sechi: "Lungi dal corro ben"; Scarlatti: "Se florindo è fedale"; Benedetto Marcello: "Il mio bel fuoco"; Brahms: "The Lark's Song," "In The Solitude of the Forest," "In the Churchyard"; Schubert. "The Gravedigger's Homesickness." Then Strausses and Frenchmen for the colony.

Boccaccio: *Decamerone* (in German); Schnitzler: *The Veil of Beatrice.*

"I feel as if I had merely rested in my parents' house, as one does on journeys, and came from somewhere else and had to go somewhere else, and when I awakened in the morning and looked around me, I often felt . . . as if I were not at home," she says, the little one.

459. Now I even traveled with the orchestra to Burgdorf to play the Pastoral Symphony and various trifles. I earned twenty francs. From time to time I return to the small picture on a plate, technical attractions to tempt and delude me. With watercolors as long as possible, then fix them and use oils on top. This operation invariably comes to a rapid and dismal end. "Resigned Man in Spring," that is probably what I shall soon be myself. Now it is still December and still 1902.

460. Ah, what things sensibility can do, and most of all German sensibility.

461. Technical experiments in painting. The themes are not the main concern, nonetheless:
"A Father With His Son" ⎫
"Madonna" ⎬ Ironical point of view.
"Poet with Blooming Branch" ⎭

462.
 Across dry fingers stretched a cloth.
 A resounding salvo suddenly goes off.
 The used-up missile, fallen dead,
 Right out beneath the eye is spread.
 And then—whereat the fingers crack—
 It's wrapped up quickly in the rag.
 To name this pastime, we now chose
 The legend: Old Woman Blowing Her Nose.

463. There are still degrees. We were in Olten to provide violin accompaniment for the concert given by the choral society. There too the conductor is called Munzinger, which is ominous. His work is fittingly called "Autumn Melancholy."

464. Jean de Castella suddenly writes from Paris: "Dear Klee, I have been meaning to write you every day, but that's how it goes here: from morning till night, one must run around, and still one doesn't get what one wants. It's too big. Otherwise, pleasant little women, etc. My address is 9 rue Campagne première, Atelier 31 bis." And then again: "This postcard was written fourteen days ago. I wish we could correspond in some other way than writing. Here, one has experienced so much through the day that one can never do half of what one wants. Now one will have to wait until next summer. Do you still draw compositions, besides doing anatomy? I go to the Julian School in the afternoon only. I find it perhaps more serious than Munich, for the studies there follow nature more closely, that is, no style and completely as on photographs. But the boys are assholes, there isn't a single artist in the whole school. Paris is wonderful only one has no time. Yours, J. de C."

465. Two cold days in Oberhofen. F. Th. Fischer, *Auch Einer*. Performance of *The Messiah*. Fräulein Sommerhalder from Basel, the alto, narrated Christ's sorrows with pious commiseration, and so much for her own private benefit that the thread snapped and she was suddenly lost. Sistermanns is a virtuoso, and a drunk! The rest is silence.

466. Upon seeing a tree:
 the little birds excite envy,
 they shun
 thinking about trunk and roots
 and have self-satisfied fun all day
 with their swinging
 nimbly on the newest-sprouted twigs, and
 singing. (12.24.1902)

A *un homme triste*, in his family album: this man has carefully refrained from feeding on the fleshy flesh. He has only smelled it, meanwhile he remains pure and much too cowardly to act. (12.28.1902).

Vignette: "The rock of Sisyphus rolling toward the number 1903."

1 9 0 3

469. The feeling of responsibility toward my fiancée and parents and unsuccessful attempts to paint often brew a kind of suicidal mood.

470. I only have you! Father cannot find his bearings in my "fantasy." In her way, mother probably has faith in me. Friends, some of them, are in part objectively despairing, some of them are not. And no doubt I'd give people much trouble as a friend. Love must never cease.

471. Chrütli is the name of an old Swiss devil, the patron devil of abortion. In exercising his profession he justifies himself by saying that God let his natural son be slaughtered too, and that the latter was already a grown man.

474. Many variants on the theme Father and Son. "A father with his son. A father through his son. A father in the presence of his son. A father proud of his son. A father blesses his son." All this represented clearly; unfortunately, I afterward destroyed it. Only the titles survived.

475. On January 14th and 15th I was in Basel to hear a concert by the Meiningen Hofkapelle, led by Steinbach. The following works were played most magnificently:

1. *Variations on a Haydn theme*, by Brahms. 2. Brahms: Fourth Symphony. 3. Third Brandenburg Concerto by Bach. 4. Mozart: Variations and Rondo from the *Tenth Serenade for Wind Instruments*. 5. Mozart: Gavotte from *Idomeneo*; Schubert: ballet music from *Rosamunde*; Mendelssohn: Scherzo from *Midsummer Night's Dream*. 6. Richard Wagner: Prelude to *The Meistersinger*.

Then, on the following day, I was dragged to the opera, where a very

mediocre performance of a not very pleasing opera by Goldmark, *The Queen of Sheba*, was being given.

476. On January 16th, as a special concert, we played a symphony by Philipp Emanuel Bach, Dvořák's *Die Waldtaube*, a symphonic poem, the Funeral March from the *Götterdämmerung*; and Berlioz' *Le Corsaire* overture. In between, Gandolfi, a bass with a superb voice and the skill of a virtuoso, sang a concert aria by Mozart: "Ach wie bald muss ich verlassen," an aria from Spohr's *Faust*, two old Italian songs: "Begl. occhi" and "Vittoria mio cuore," and a scene from Boito's *Mefistofele*.

477. From January 23d to 26th, journey to Neuchâtel with the Bern Orchestra to perform Verdi's *Requiem*. The soloists were Frau Dalcroze-Faliero, Camilla Landi, a tenor from Paris, and a bass who came from Harlem.

478. I have read a work by the poet of our city, a drama: *Aretino's Muse*. Here too, it is the friend of Italy and the wanderer through Italy who speaks; the only difference is that this is a bit painful in a drama. Such writing, the fruit of travel, is more appropriate as a *feuilleton* in the *Berner Bund*. Sometimes the old editor slips into lasciviousness; which is supposed to mark the exuberant Venice of Titian. But here too the creation doesn't completely come off. What takes place is merely an approximation; he probably thought, the journalist, that the material was tailor-made for him. He may have wished or wanted. But that in itself doesn't make the thing Aretinian. Besides, it's obvious that such a post-offspring of a post-Renaissance could only have thin blood.

479. The third subscription concert stood pretty much under the sign of d'Albert. First we dragged in a large Symphony in C minor by Glazounov, then came Beethoven's Piano Concerto in G, then the pianist grabbed the baton and conducted a minuet and a gavotte from the opera *The Improviser*, then he played Chopin and ended by directing the overture to the same opera. Now, this music is certainly not without wit; it's quite entertaining to listen to and also, once you know it, to play. At the rehearsal, not even the harp had been prepared. The conductor of our society brought out the following

remark: "You composers always believe the harp is the main thing." But Eugen was not even irritated by this piece of insolence. His small eyes just blazed up slightly.

There is no need to waste many words on a concert given by the high bourgeois choral society, with a very mixed program.

480. When I was still a loose rascal, I knew lewd songs. I still remember one line: "He came down and she was knocked up." The rest have gone with the wind. Now I am painstaking and virtuous.

I can also vaguely remember several projected pictures. One was called "Disgust"; it represented a woman who spilled a liquid from a pitcher. Another picture was called "Shame." In the graying dawn one saw a pair of lovers—he was still asleep, she was making an apprehensive gesture toward the window where the new day was appearing. Then there was a drawing where dice were being cast for a woman. One could dare to represent such banalities if one found the unique form for them.

484. In the fourth subscription concert, my good old teacher played Brahms' Violin Concerto with very commendable success. In addition, a singer from the Opéra comique, a woman named Garnier, sang two arias by Mozart (one from *The Magic Flute*). We played the overture to *The Magic Flute* and the magnificent E-flat major symphony by Mozart. The program was exemplary. Our conductor copies Arthur Nikisch and puts down the baton from time to time. Naturally, the machine keeps on running, and the nasty motto of the musicians is carried out literally: "Just don't look at him!" After my teacher had been much applauded by the people of Bern, a certain Herr Cousin, who also plays in the first violin section (almost inaudibly) and who has dubbed himself Professor, patronizingly shook his hand—not wishing to remain in the background—and said: "I cannot understand how, with all the lessons you give, you still find the time to practice!"

485. Serious color studies of nudes and heads. Only as practice and first training. Very strict determination of color values through water color. On top of it, some oils, simply for blending. The results are quite unattractive, little of importance to be hoped for here. This month of February is devoted

to color. I painted many nudes from nature and even the portrait of a head, my sister's! Lotmar came and said spicily: "He's forced to!" when he saw me paint. Then, when he reached for the mat to take a closer look, punishment overtook him with a great promptitude and amidst cries of "ouch!" A thumb tack had penetrated his finger! From Stuttgart he brought greetings from Haller. The latter has secretly become a student of composition under Count Kalkreuth there. I must now create alone; from the social point of view, my studies are finished.

486. The subject of my pictures seems to become simpler. I sketched a "Meeting." Two men have just walked by each other. The one, his hands in his pockets, turns his torso back toward the other while striding on. That is all.

487. Adele (actually, she has a different name) uttered a loud laugh when she heard a hen cackle in a most amusing way. She then tried to imitate it with her beautiful voice. But her deliberate effort was much inferior to the unintentional imitation of the animal's voice produced by her laughter.

In general, Adele is a very peculiar female. She has, when she is not imitating temperamental animals, a phlegmatic disposition which one might take for the exhaustion that follows outbursts of passion. But Adele knows no outbursts of passion.

O Adele, your name says everything, even though your real one is different. Should Adele marry—and why shouldn't there be some one whose taste she pleases?—then the law will sanction, one might say, her descendency. Then no objection could be made to it.

Which is better, Adele as maiden or Adele as mother? But easy; until now she has stayed away from the business of reproduction. There are no secrets here.

Adele is averse to all bungled work.

488. Hebbel, *Maria Magdalena*. While reading it, I remembered vividly the impressive performance in Munich with Triesch as Klara, Possart as Leonhard, Lützenkirchen as Wolfram, Schneider as Master Anton, and Conrad-Ramlo as the Mother.

In addition: *Gyges' Ring* and Kleist's *Prince of Homburg*; and short stories by Riehl: "Comedians' Child," "Quartet," etc.

At the fifth subscription concert we played Liszt's Faust Symphony, an intermezzo from the ballet music for *Prometheus*, by Beethoven, and a "Simplicius" overture by a Swiss composer, Huber. Busoni played C. M. von Weber's *Konzertstück*, Liszt's *Harmonies d'un soir*, two choral preludes by Bach, the great Polonaise by Chopin and, as an encore, a Paganini-Liszt piece. A subjective but very great artist! Recently, we had heard the same Polonaise performed by D'Albert, whose rendition, compared to this, seemed utterly pale in retrospect. Busoni's phrasing is a chapter in itself. We are a full orchestra of more than sixty musicians and aren't equal to these ten fingers. . . .

489. One of Bloesch's inspirations—he dragged me to a lecture on physiognomy in the Palmarium. I had never heard one of these lectures, but Bloesch ought to have known that this would be no good. The speaker was an ignoramus, protected for some reason by the religious folk in town, and had been well recommended to the daily paper. The paper commissioned Bloesch, that bottomless pit of learning, to write the report. I, of all people, had to take the second seat reserved for the press, because Bloesch doesn't like to be alone. The lecturer began by remarking that a great deal of fraud was common in this field, but that he preserved himself through study and virtue(!). Later on he ventured to contend that black hair was a sign of melancholy. He claimed that, thanks to his marvelous methods, he had thrice saved a boy from throwing himself on the railroad tracks. At this point only politeness and the prevailing piety kept us from taking abrupt leave. The account in the daily was not so favorable as the gentlemen must have desired. And yet the treatment was very mild.

491. Another big disappointment, but at least a paid one. Concert by the Bern Men's Choir! The director an ass with a lion's mane.

A few days later Professor Thürlings dragged me to the Museum Society, a men's club reserved for members of the highest bourgeoisie. I had to play several trios with him and the Romance languages scholar Gauchat. Food and wine were magnificent (at Pfister's).

493. Sunday afternoons in Bern are so depressing. One would like to rejoice, as in *Faust,* when everybody is out walking after a week's work. But these poor people are so ugly for the most part that they are hateful rather than pitiable. And it is no simple, healthy ugliness.

You can detect the marks of original sin even in the tender features of children. And this half-peasant, half-smalltown lack of taste. Wherever a bit of bodily grace remains, it's mercilessly rooted out by their way of dressing.

The shoes—God knows, children's feet grow quickly—but their new shoes, the Sunday shoes especially, are designed strictly for growth. The stockings are a testimony against any color sense. The boys' pants are designed to bulge over the knee. All this speaks an ugly, crabbed jargon. Only the colors don't speak, they shriek to the heavens.

And the overloaded baby carriage, what a pitiful sight! The pregnant mother, pale, nasty, and tough!

Toward evening the effects of alcohol begin to show up. Cretinism is growing in importance; the effects of the two converge. Élan missing in everything, all motion damped. The people are ashamed because at heart they are not so bad as they look. Somehow the whole Sunday smiles with embarrassment.

How difficult has any social feeling been made for us!

494. On March 19th and 20th, I again went to Neuchâtel with the orchestra. We played the Faust Symphony under a somewhat better conductor and the Faust overture by Richard Wagner. A tenor named Pinks sang something from the *Meistersinger* and songs by Löwe and Strauss.

Afterward I and a few others joined the Italian oboe player Palmia, who took us to the Circolo Italiano, an establishment with a pronounced comedy atmosphere, with Chianti, Asti, and Stracchino (like the tulip among flowers). Delightful atmosphere.

495. On the following day I went to Zürich to hear a concert given by some orchestra from Berlin under the direction of Richard Strauss. The program was composed of Bruckner's D-minor Symphony, Beethoven's *Egmont Overture,* and *Don Juan,* and *Death and Transfiguration* by Strauss.

In the afternoon I went to the State Museum, mainly in order to see the original mural *The Battle of Marignano* by Hodler.

The Tonhalle is lavishly decorated. The concert ended at a quarter past ten; at a quarter to eleven I was at the station and at two o'clock I arrived in Bern. On the following day Bloesch had to sit for his portrait (head) as punishment for various misdeeds. But he promptly created more mischief by refusing to sit still.

496. From the *Hefte für schweizerische Volkskunde* ("Journal of Swiss Folklore"). Tramps' signs (authentic):

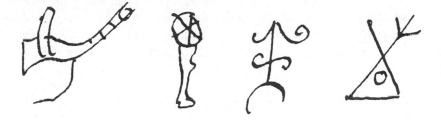

Names of devils: *Chrütli, Federwisch, Schuw, Tüntzhart*. Rogues' jargon of 1735. Butter = *Muni* or *Bock*. To signal = *pfeifen*. Peasant = *Ruch*. Farmhouse = *Kitt*. Bed = *Metti*. Beggar = *schnury*. To beg = *jalchen, schnuren, halunken*. To confess = *brillen*. Bread = *Rippel, Lehm*. Doctor (learned person) = *Grillenhaus*. To eat = *achlen, buttlen*. To examine = *verlinsen*. Fish = *flössling, flossen*. Meat = *carne, busem*. Gallows = *dolmer*. Priest = *galach*. God = *Doff-caffer* (the good man). Gold = *Fuchs, blatis*. Shirt = *gembsli*. Chicken = *steutzel*. Dog = *kohluff*. Cat = *ginggis*. Child = *gampis*. Mary, the Mother of God = *mämmi*. Paternoster = *stiger*. Tailor = *Stupfer*. Rope = *längling*. Bull = *böhm*. Tobacco = *Nebel*. Woman = *Eschi*. Tavern-keeper = *Spitzi*.

497. At the sixth subscription concert, we played Beethoven's Pastoral Symphony, an orchestral excerpt from *Prometheus*, and overture to *Coriolanus*.

499. I participated in the choral concert given by the Cecilia Society (4.5.1903) and in this way got to know Brahms' *Requiem* quite well. Still,

I can't share the predilection of so many musical amateurs for this work. A particularly good and inspired rendition might make it more palatable. As it was, it proved downright boring from time to time, even most of the time. And this one work wasn't enough for the conductor of our Society. We had to play first a sluggish composition by Carl Reineke (introduction, fugue, and chorale): *Pro Memoriam*. And he squeezed himself, semi-incognito, in between with the performance of a serious song, orchestrated by himself, which he had sung by an overripe soprano from Geneva. This closes the current musical season in Bern.

502. I spent four days resting in Oberhofen on the Thunersee (until Good Friday). Twice the weather was good, and it snowed twice. As a result I devoted myself to reading Gorky's "My Traveling Companion," "The Vagabond," "The Steppe." The last was especially good.

503. And now I was recruited by the Société chorale de Neuchâtel for its fifty-second concert, but it was really worth it, for the main work to be performed was César Franck's *Redemption*, and it was done beautifully. The soloists, from Paris and Geneva, blended into a good quartet. Individually they were somewhat uneven. "La lyre et la harpe," a much weaker composition by Saint-Saëns, came first. The entire performance had a certain fire.

A choral performance in Thun compared very unfavorably with these concerts (May 2d). The conductor of the local society almost transcends the comic. He gives the downbeat to the right, to the left, sometimes up, but seldom down. At the beginning of a composition, he acts as if he wants to get a truck moving, and in the process lets out a peculiar strangled sound.

From Thun I went back to Oberhofen for a few days, caught six fishes, and took walks through blooming orchards.

505. The art idiot, as a rule, is a very respectable, hard-working person. All week long he sweats around the navel and under the armpits. Can he be blamed if he wants to indulge his own preference of art on Sundays? Must his brain, searching for relaxation, strain on the seventh day as well? Now, too, there are works that are absolutely disquieting, or that go so far as to breed discord. The Russians, for instance, who are being read so much nowa-

days. Ibsen, too, was certainly an evil man. Böcklin is bearable, although his fantasy roams too far. But everything was much better in the old days! Art then was much more accommodating. Today, everybody wants to be a unique phenomenon.

And what about us art idiots? Are we complete nonentities? Artists live off of us, who buy their books and paintings. And besides, don't they enjoy our democracy? Therefore, honorable citizens of Switzerland, forward!

Zola's *L'oeuvre*—what an uncanny book! It has a bearing on ourselves! How horrible to experience this book while oneself is at the verge of ghastly possibilities. It also becomes clear to me that I still need Paris. I realize it. I must go there.

As if I were pregnant with things needing form, and dead sure of a miscarriage!

506. 5.21.1903. With Bloesch, I made a fine walking tour to Schwarzenburg (five and a half hours, till nine o'clock) and Guggisberg (eleven thirty), Guggershörnli (twelve o'clock). Lunch and a rest in Guggisberg. At three o'clock, on by way of Rechthalten to Fribourg, the uncanny town with the high suspension bridges (half-past six p.m.). At night, back to Bern by train.

I had been in Fribourg several times as a small child. We then lived in Marly le grand at times. Those were my first impressions of traveling. The enchanted location of the city, the Catholicism, travelers' rests, vermin. Strange children from strange lands. A Catholic priest in a long robe and always cheerful. *Tables d'hôtes* in the open. Trout. Bathing in brooks. Reeds with brown, cylindrical heads.

507. Gradually compositions again make an appearance, poetic (satirical) conceits expressed in one figure or in a few. I still come closest to success with drawing. When I use color the results are more dubious, for these painfully gained experiences bear less fruit.

"The Dead Genius," "Mama and Papa Lament over the Green Cadaverous Child," and so on.

508. Toward the end of May and the beginning of June, I spent two and a half weeks in Munich, eight days on official business. The pretext of this trip was my draft board examination. In March I had written about this

matter to the civilian head of the recruiting commission, Munich A, and now it was to be decided.

5.28: arrival at 5:18. Lily came to pick me up and we drove through the English Garden. I again took lodging in the Catholic Casino.

5.29: To the draft board on Kohleninsel, to be informed about my examination. Then to the Pinakothek.

5.30: a Saturday. Extremely painful examination with a mild result: auxiliary service. At night, *The Meistersingers of Nürnberg*, with Knote, Bender, Feinhals, Fräulein Tordeck. Conductor, Zumpe.

5.31: In the morning, went to the Sezession exhibition. Then drove to Possenhofen with Lily. We strolled to Feldafing and back again, by way of Oberpöcking, to Starnberg, where we spent the night at Pellet-Meyer's.

6.1. (Pentecost) back to Munich. In the evening, *Tannhäuser* with Morena, Senger-Bettaque, under Zumpe's direction.

On 6.2., a day of rest.

6.3.: Back to the Sezession and to the Glyptothek. In the evening, *Fidelio* (Morena); at the end, the great overture was masterfully conducted by Zumpe.

6.4. At night, *Lobetanz*, a kitsch opera, with R. Walter, Fräulein Tordeck, and Bender.

6.5. In the morning, in the English Garden. Evening, Italian performance of *La Traviata* in the Gärtner Theater.

6.6.: Here begins the official part of my trip with an introductory visit to the doctor [Lily's father]. Afternoon, Schack Gallery; evening, *Manfred* with Possart.

6.7.: In the Biedersteiner Park in the morning. Afternoon in the Nymphenburger Park, chased off by rain. Evening, played duos at the doctor's.

6.8.: Evening, in Pullach at the Raven Inn.

6.9.: Evening, *Faust and Marguerite* by Gounod.

6.10.: In the evening, went to the Old Pinakothek. In the afternoon, went to Höllriegelskreuth-Konradshöhe-Grosshesselohe with Frau Stumpf and Lily. At night, played duos at the doctor's.

6.11.: In the morning, had an early glass of beer on Cathedral Square. Then to lunch at the doctor's, with spring roses for his wife. In the afternoon,

a visit to my former teacher Knirr. At night, *Katharina Cornaro*, an opera by Lachner, with Morena, Raoul Walter, Feinhals. Beautiful Renaissance-style staging.

6.12.: Quiet day; on quiet days more inner activity.

6.13. and 6.14.: Tapering off; on the fourteenth, departure at 12.35 p.m.

From the Sezession exhibition, a few pictures left a lasting impression: Zuloago [sic], *The Bullfighter's Family*, Hodler: *Tell, Impressions of Four Ladies*. The Glaspalast had nothing to offer.

512. June 1903. Back in Bern I find my sole consolation in a light opera company from Vienna. "Vienna Blood," "The Maiden of Belville," "The Miner," and "The Sweet Lass" saved me from total loneliness. Toward the end of the month I prepared engravings; first, invented appropriate drawings. Not that I want to become a specialist now. But painting with its failures cries out for the relief of minor successes. Nowadays I am a very tired painter, but my skill as a draftsman holds up.

513. July 1903. Studies from nature, with Louis Moilliet, after a drawing of a nude boy, are to protect me from getting off the track, graphically. On the other hand, I must avoid the danger of missing graphic possibilities because of a fear of natural perspective.

The first attempt is at least technically successful. "Woman and Beast." A first version of this theme, none of whose prints survive except perhaps in some provincial drawer. The second version still exists.

The beast in man pursues the woman, who is not entirely insensible to it. Affinities of the lady with the bestial. Unveiling a bit the feminine psyche. Recognition of a truth one likes to mask.

Hebbel, *Epigrams, Genoveva*. The epigrams are good.

514. "Virgin in a Tree." Technically more mature, thanks to the use of lines of varying heaviness. First I etched and engraved the contours of the tree. Then, the modeling of the tree and the contours of the bodies, then the modeling of the bodies and of the pair of birds.

The poetic content resembles, at bottom, that of "Woman and Beast."

The beasts (the birds) are natural and paired. The lady wants to be something special through virginity, but doesn't cut an attractive figure. Critique of bourgeois society.

515. Hebbel: I prefer *Judith* to *Genoveva*, the untruths are strong and creative, as in *The Robbers*.

Dostoiewski, *Clear Nights*. More like a short story. Very pure. Attractively small lives. Certain connections with *The Sorrows of Werther*.

Louis Moilliet is beginning to understand me. But then we have worked together. He saw how I blocked out the nude and how much I made use of it in my drawing. He has seen my few engravings and knows in what an unusual way they are connected with the life studies. He is not precociously mature; when we were going in for frivolities, he was still childlike.

517. New engraving: "The Comedian," first version. Grotesque mask on a grave, moral head. Accompanying the reading of Aristophanes' comedies. Unfortunately I could not resist the temptation to use the scenery of this grandiose theater in an engraving. The transfer of the contents of a church to a nearby museum, a festive procession done in Mantegna's style, failed completely, even as a drawing, in spite of successful details. The mask as work of art; behind it, the man.

On the 14th, Lily is expected for a longer visit.

519. September 1903. On September 14th, all is empty around me, cold and waste, nasty and cursed. Then I worked furiously, much more than the lone result—the engraving "Two Men, Presuming Each Other of Higher Rank"—might indicate. I looked for consolation in it for my social position. The first time, impatience made me etch the preliminary sketch too soon; then I went at the composition again and improved it considerably. With the etching, too, I had better luck than the first time.

Some drawings followed, more in the manner of the old woodcut; for example, a female figure seen from the front, the upper part of the body turned away toward the left, across the leg on which she rests, both arms on the left side. She almost looks like an architectural sculpture. What will come of this kind of thing?

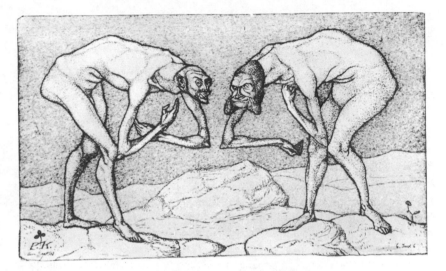

TWO MEN MEET, EACH PRESUMING THE OTHER TO BE OF HIGHER RANK, 1903, 5

520. The new Stadttheater will be inaugurated with a performance of *Tannhäuser* and *Il Trovatore*. There is only one very good singer, Frau Guscalewicz, but she is really very good. Her acting too has a certain grandeur.

Hebbel, *My Opinion About Drama* and other theoretical writings.

Since the Musical Society has refused me the free tickets I asked for, it will have to do without my participation in the orchestra this season. Instead I will write criticism for Bloesch's newspaper. This way I'll go to the theater and to concerts even more often than I want to.

At the first symphonic concert the violinist Capet, from Paris, played wonderfully.

521. October 1903. Multatuli: Max Havelaar. Attack of tonsilitis, heavy case, four days of high fever. Lotmar acted as physician.

As soon as I felt better we organized exhausting string quartet orgies. I played first violin; Moilliet, second; Lotmar, viola; Lewandowsky, a dermatologist, cello.

Tolstoy, *Anna Karenina.*
Second symphonic concert, an all-Schumann program.

522. November 9th to 11th I spent in the mountains; on the 9th I was even up on the Beatenberg.

The next orgy of quartets gained special significance because our violin professor played the viola. Lotmar and I alternated at first and second fiddle. I led an opus 18 and the opus 95 in F minor. He, an opus 18, opus 59 in F-sharp, and again an opus 18. A real Beethoven festival. But the hardest job was old Professor Lotmar's who had to listen to all this.

Then professors Reichel and Gauchat also had their pains (trio hunger). So we organized a Hummel–Mozart–Beethoven festival. Reichel is a legal expert, the son of the former state musical director in Bern. Primitive musicians (their music center is in the bowels).

La Otéro in Bern!

523. November 1903. Reworked "Woman and Beast," this time with some satisfaction.

527. Collector Reinhardt in Winterthur asks to be sent some etchings; his wife sends them back with the comment that they did not please. My first success in my own eyes gives me the strength to produce an ethical manifesto: "To die honorably."

536. December 1903. When I learned to understand the monuments of architecture in Italy, I won an immediate illumination. Although these are utilitarian structures, the art of building has remained more consistently pure than other arts. Its spatial organism has been the most salutary school for me; I mean this in a purely formal sense, for I am speaking in strictly professional terms. But to be a professional is an indispensable preparation for higher achievements. Because all the interrelations between their individual design elements are obviously calculable, works of architecture provide faster training for the stupid novice than pictures or "nature." And once one has grasped the idea of measurability in connection with design, the study of nature will progress with greater ease and accuracy. The rich-

ness of nature, of course, is so much the greater and more rewarding by reason of its infinite complexity.

Our initial perplexity before nature is explained by our seeing at first the small outer branches and not penetrating to the main branches or the trunk. But once this is realized, one will perceive a repetition of the whole law even in the outermost leaf and turn it to good use.

The first fruitful period is interrupted. The danger mentioned in 513 became apparent. Nature lured me onto paths which did not agree with the simple abstraction of the first successful works. These contained the germ of further works, which, for the time being, were not yet within the realm of the creatively possible. Nature had already become a useful crutch which I was then forced to use too long, I would say until the year 1911, inclusively. The engravings that followed were executed from an accumulation of knowledge that no longer fitted the latest experiments, and therefore already contained the germ of death. After them came the loosening and the contact with the impressionistic world (1908 to 1910).

538. Striving toward the purification and the isolation of the masculine type in me. In spite of a readiness for marriage, to reduce oneself completely to oneself, to prepare oneself for the greatest solitude. Distaste for procreation (ethical supersensitivity).

539. There are two mountains on which the weather is bright and clear, the mountain of the beasts and the mountain of the gods. But between them lies the crepuscular valley of men. If perchance one of them gazes upward, he is seized by a premonitory, unquenchable yearning, he who knows that he does not know, for those that do not know that they do not know and those who know that they know.

540. At the third symphonic concert Schnabel played very beautifully Beethoven's Piano Concerto in C minor and Schumann's delightful and profound *Carnival*. The orchestra played Haydn, Mozart, and Mehul.

At the choir's Christmas concert Bach's cantata No. 61, *Nun komm, der Heiden Heiland,* was performed first, a composition on a curious text: "Come Jesus, come to your church and give a happy new year . . . sound teach-

ing . . . pulpit and altar." To compose this required truly great musical sovereignty. All the more marvelous is the poem from the twelfth-century Christmas carol by Spervogel the Elder. Robert Volkmann adapted it superbly for *a cappella* choir. At the end, Anton Bruckner's *Te Deum* was performed.

1 9 0 4

546. Lenau, *Don Juan*, on the occasion of the performance of Richard Strauss' symphonic poem. At the theater: *The River* by Max Halbe, *Hand and Heart*, a Swiss play by Anzengruber. Humperdinck: *Hänsel and Gretel*. We heard this opera as boys at the old Stadttheater, when Georg Richard Kruse was the director. The ravishing Gretel caused a great deal of excitement at the time. The entire *Bärengraben* was in love with her. A native yelled: "Dasch es Chrötli!" ["There is Gretel!"] This time Gretel was no ravishing Polish singer, but a realistic figure in poor clothes, with a sagging stocking; not a theatrical darling, but a real little beggar.

At the fourth symphonic concert the following works were performed: *Romeo and Juliet*, a fantasy by Tschaikowsky; the prelude to the third act of *Gwendoline* by Chabrier; and *Don Juan* by Richard Strauss. In between, cellist Gérardy played with the sweetest tone a concerto by Saint-Saëns and various solo pieces.

548. I have now done three versions of "The Comedian," the last is etched on copper. But I always found that zinc gave more beautiful lines. Is this problem solved now? Perhaps for the time being.

A quintet orgy at Professor Reichel's. The professor has composed one himself. Not at all bad, for a legal expert. I played first fiddle, had rehearsed carefully to please him.

For a change of pace I had to sweat out another bout of tonsilitis, it lasted a full week. This time Michaud was the doctor; he prescribed hot cloths around the throat, but I refused them.

550. At the theater, I then saw *La dame blanche, The Tales of Hoffmann*, and Ibsen's *Hedda Gabler*.

Read: Goethe, *Conversations with Eckermann*, who is now dead too, in spite of Heine. Beaumarchais' *Barber* and *Marriage of Figaro*. Byron's *Childe Harold's Pilgrimage*. How little this poem appeals to me! It is said that sometimes a tear bedewed his eye, but that pride turned it to ice: that, to be sure, is beautiful. ". . . the oft-told flames, / Which, though sometimes they frown, yet rarely anger dames." Not bad either:

> The old man from the Berner Bund mounted the Bernese stage
> (Father-in-law to the respected cousin).
> A faun formed a pair of nymphs (teen age);
> Otherwise things were of pretty fusty vintage.

551. At the Opera: *The Merry Wives of Windsor* with Frau Herzog. *Don Juan* with Frau Herzog. *Rose Bernd* by Gerhart Hauptmann. Read: "Michael Kohlhaas" and the other short stories. Also, a biography of Kleist and *The Broken Jug.*

Symphonic concert: Brahms' Fourth. Mendelssohn's Hebrides overture. An operatic tenor by the name of Giessen sang an aria from *Cosi Fan Tutte* and a few trifles. The Bohemian String Quartet played a Haydn quartet, Beethoven's opus 131 in C-Sharp minor and Smetana's quartet *From My Life.* The latter was interpreted most admirably.

Two new engravings don't satisfy me. One is called: "The Woman Who Learned the Truth about Herself." The title would be all right.

553. At the end of March, Lotmar came to Bern for a short while. So we immediately got up a string quartet. I played first violin; Fräulein V., the niece of the *Berner Bund* columnist, second; Lotmar, the viola; and Professor Gauchat, the cello. We gave a smooth performance of three Mozart quartets.

The following day I was at the house on Feldeggweg again, and since the beautiful viola was still there, we played the most intimate music, the two of us making an excellent audience: duos for violin and viola by Mozart, two extraordinary little works.

Grillparzer, *Journal.* An autobiographer could use this kind of self-analysis as a model.

555. Progress? Probably. But for the time being the perspective ahead is blocked. This is perhaps the proper time for a review, and perhaps it will even give me courage.

Serious purpose dates from my third year of study in Munich. Then the great humiliation of the apprenticeship in Rome. Toward the end of that period I began to react against it by means of "caricatures." Hühnerwadel said in Florence: Projection of the third dimension. In Bern, I tried to achieve closer and closer contact with my own natural bent. But Italy still stuck in my digestive tract and for a long time I was somewhat constipated. What especially hindered my emancipation was my copying from nature, which I did sometimes consciously and sometimes involuntarily. When I saw this duality, I was at least able to produce a few legitimate works without direct study of nature. Every attempt to connect the two immediately produced things that were stylistically weaker. I wanted to take the bull by the horns and studied nature all the more, even anatomy. When shall I be able to bridge the gap?

557. In April the Choral Society put on a very respectable performance of Schumann's Scenes from *Faust*. At the Opera you could hear the "Hojotoho." We had a second string-quartet session at Lotmar's: two by Mozart and two opus 18 by Beethoven, C minor and B major.

Read: Eleven one-act plays by Strindberg, and *Swedish Experiences*. In the plays the characters are not so much real individuals as symbols for the self or the various selves of the author. A style completely new to me. After that, I turned again to more familiar things, like *The Sunken Bell*, which, I must confess, struck me as a little tawdry in places. Mérimée's Carmen story seems to me of the highest quality.

I even read Schiller's poems, because I just received the first volume of the Jubilee Edition.

558. Toward the end of April I spent three days in Oberhofen on the Thunersee and had an excellent rest away from my drawing table!

An excursion made toward the middle of the month with Bloesch and Lotmar had been a bit too exhausting. We walked through the forest to Laupen and then to the handsome town of Murten (with its circumvallation).

Lily surprised me with presents, among them a very interesting Rodin album. Particularly "The Burghers of Calais"! But not everything is good.

Worked stalled for a time. What I did do (a bit of painting) would have

to be considered a kind of recreation in work. Also, I began to sort out the material of my diaries a bit. A number of entries might safely be omitted; suffice it to note that I used to come back now and then with my head heavy from wine, and that on those occasions I always felt I was a poet. And yet that I wasn't drunk enough for that after all. And that the Neuenburg wines served in the restaurant at the railroad station really tasted wonderful. (The snails too, but that's another story.)

559. In May 1904 read: Gogol, *The Revisor*. Schiller, *Enemy of Mankind* and *Don Carlos*. Hebbel, *The Tragedy of the Nibelungen*.

Monotonous, radiantly beautiful days hurt my work. Sometimes I do a few nervous lines which are very expressive. But at the same time a slight fear seizes me. Is a further broadening of my realm to come?

560. With Bloesch I once again went out into our beautiful country. We took the Gürbethal railroad to Thurnen and climbed up the Riggisberg. As we had arranged, we met Brack, who has set himself up here as a landscapist. In the afternoon we took the gorgeous path to Bütschelegg and spent a magnificent evening there. Down below, our ways parted, Brack returned to the landscapes on which he is working, and we walked back to Bern in four hours. Bloesch is turning into a complete freethinker and often expresses very anti-religious views. It is good that his father, the little theologian, no longer has to experience all this. But an alert dog heard a particularly nasty remark and bit him on the leg for it. When he wanted to cut off a branch to protect himself from another attack, the knife cut his finger. I interpreted this as a punishment from heaven.

561. Read: Calderon, *The Marvelous Magician* and *The Alcalde of Zalamea*. Lotmar urged me to read the letters on painting by Wilhelm Ostwald, but they didn't appeal to me very much.

My work doesn't progress too well, as if the study of nature had poisoned it somehow. The work called "The Lady" had something attractive as a silhouette, but the modeling, because of its compromise with realism, has destroyed the whole charm of it. In fact, I ought to think about a procedure for carrying through my linear inventions without losing their original quality. Dry

point, if the mechanical resistance of the metal did not hinder me. Rodin's sketches of nudes are a good example of this. I see it clearly, but cannot abandon the formal vision of the first engravings so quickly, as long as it still means and promises something to me.

562. "Prophet," a zinc plate worked on (etched) under heavy pressure. It is an example of the style of the old woodcuts. I was able to make a few prints of it by hand. It is not etched deeply enough for the press. I was able to make the prints still more appealing by coloring them. On the whole, a rather weird production, more for the curiosity seeker.

563. June 1904. We frequently hold rehearsals for the Swiss Musical Festival which is to take place here at the end of the month. They did call me back, after all. For the time being we are busy with a symphony by Herr Huber, from Basel. It is a very difficult piece. At the same time the Lausanne Symphony Orchestra is holding its own rehearsals, separately for the moment; later they will join us.

564. I was so much in need of keeping my head perfectly cool, and now a downright tropical intermezzo fell from heaven. I wandered about restlessly. Once I stood all of a sudden by the Aare. I had wandered there so completely engrossed in myself, it was as if my brain had been burned out. What a sight —suddenly the emerald, racing waters and the sunny, golden bank! I felt as if I had awakened from a wild dream. For a long time I had not bothered to look at the landscape. Now it lay there in all its splendor, deeply moving! How I had missed it, had had to miss it, because I wanted to miss it! Until today I had led a life of thought, stern and void of the hot blood, and I shall go on leading it, because I wish to do so. O sun, Thou my lord!

The time has not yet come, the tangle of struggle and defeat has not yet been unraveled. There are still swamps, warm vapors rise and collect between me and the firmament, a host of arrows are turned against me.

565. The yield of this harvest of "Swiss" music is very, very meager. The Symphony (No. 31, the "Heroic" in C, by Hans Huber) might be counted if one wished among the more serious new compositions. A *Bizarrie* for piano

and orchestra by a Herr von Glenk holds its own as a truly humorous crea-
tion; a pianist named Richard showed what it was really like; before this ex-
cellent interpretation we had been somewhat perplexed by it. Herr von
Glenk didn't conduct his music any too skillfully. In contrast with it, there
was the somewhat conventional modernity of the *Symphonic Fantasy* by
Volkmar Andreae. The second evening (chamber music) brought nothing at
all, absolutely nothing. The third, a choral concert, gave us the only significant
work, the D-minor Mass by Friedrich Klose. That's all! Vain were the labors of
Swiss citizens Lauber, Courvoisier, Reymond, Meyer, Isler, Pahnke, Charey,
Fassbänder, Gustav Weber, Niggli, Haeser, Staub, Joss, Ehrhard, Karmin, the
brothers Munzinger, Kradolfer, Meister, Hess and also Hegar (in spite of the
effect produced by the latter's *Ahasuerus,* especially when conducted as ad-
mirably as he did). A quartet by Henri Marteau also belongs among the wash-
outs.

And we proletarians had to play it all in one of the hottest summers that
ever came along.

566/67. June/July. End of June, beginning of July, I spent a few days im-
mediately beneath the summit of the Stockhorn. I went to Thun with Brack,
then by mail carriage to Amsoldingen-Stocken. Here we started the ascent
along the northern slope, zigzagging through pine forests. During a first pause
near the timber line a giant bird beside us flew away. It was a rock eagle. Then
on, by way of Alpigtal, to the Bachmatt, where we had a thorough rest. After
this point there is a steep area until the place is reached where one turns
toward the southern side of the mountain. Brack was loaded with painting
gear and was remarkably cautious in walking. From the turn, the Stockhorn
inn is no longer very far away. We were given "the room with two beds"; who-
ever came later had to sleep on the floor. In ten minutes you reach the top,
practically on all fours.

The crest is bewitching. The sound of bells and cowbells of the high
Bachalp carry up from the depths. Once there was a thunderstorm on Thun,
and I saw lightning bolts at my feet. For a few moments, half-hours at the
most, a dream of being free from the labors of the past years. But then a voice
seemed to call: "Come back, you are not yet entitled to flee."

Dear, distant towns, grant me a brief respite; then, yes! I will return. I want

to finish it, I don't want to flee. I want to take the culture route, I want to keep my hand on the drill.

I decided on the southern path down, by the two lakes, around the Mieschfluh, down by the rather ugly Chrinde into the Simmental. In Erlenbach I asked for good ham and good Vaudois wine; I missed something in being reduced to milk, bread, and cheese.

I again spent a few summer days vacationing in Oberhofen. The place was still filled with happy memories of Lily. But I shut my eyes whenever I walked by them, from delicacy toward the sensitive soul.

568. Haller visited me. He praised the engravings; no objection can be made to that, after boring away, completely by oneself, at the hard stone.

As if the unction of his praise had had a prompt effect, I etched "Feminine Charm" and "The Allegory of the Mountains."

In "Feminine Charm," a refined version of the *unveiling of the lady*, everything takes place in the facial features.

The fourth canto of Byron's *Childe Harold* pleased me more than the preceding ones (twenty to twenty-four!). But Heine is more enjoyable. *Occasional Poems, Winter Tales*, for the second time. Xenophon, Plato's *Symposium* very beautiful.

570/72. Through the indiscretion of Fräulein Pacewitsch, I came into possession of letters and poems by a Japanese gentleman.

I. 4.18.1904. "My dear Fräulein, Lily of the valley, lily of the valley!
My dear lily of the valley! / Thou art pretty and pure like innocent maiden / The rain, the wind, the hands of men / Threaten to tear Thee from soft bosom of her mother. / Nonetheless you look so happy / Thy whole fate thrown in the hands of nature. /

Lily of the valley, lily of the valley! / My dearest friend thee has stuck in the button hole of my coat. / Thy perfume me refreshes out of the tiredness. / Thy spirit as little angel into my dream comes.

O dear lily of the valley, be thou for ever in bloom! / Respectfully Dr. Sch."

II. June 25th. "My dear Fräulein, Herewith I take the liberty to express great gratitude for your very friendly invitation. So far I had never lived as

agreeably and natively in Bern as today at your home. I have drunk brotherhood with you and hope it will begin a new life for us. I love you, if I might dare so to name, so too much, and the flood of feverish love swallows me more and more deeply with gruesome swiftness.

But I am always afraid whether you really can love me and rightly so. I am a gentleman from Far East, that is, of completely different race than in Europe. I do not know the local customs exactly; I do not master the language. Moreover, I have a heavy weight on my boulders, that is, to accomplish a splendid work here, so that I might be able to demonstrate the capacity of the people of the Rising Sun and at the same time obtain a good chair at Tokyo University.

But my dear Fräulein! Your look my blood makes bleat! O dear my Helen! In my soul lives your image, and Your Kiss makes me happy (albeit I have enjoyed no kiss from you). I have no doubt that tonight you will come to me in dream.

At last I dare to express my burning wish, namely, should tomorrow Sunday the weather be beautiful, after dinner to come with me to the Gurten and up there to wander with me in the marvelous green wood.

Your loving friend Dr. Sch."

III. June 27th. "Very honored Fräulein P.: I promised you on Saturday that I wood visit you this evening. But quite unexpectedly you went to the Polish Students' Society, in spite of our appointment. It is clear to explain who is wrong.

I believe you have until now come so much toward me that one hardly think about it as a simple friendliness.

I love the truth, my heart is too noble; too pious, to be deluded by you in vain.

You are a noble Fräulein, I am also a gentleman; I believe it brings us not good reputation, we both unmarried living persons, to be in intimate intercourse, and therefore I wish herewith to take leave of you.

Farewell, my respected Fräulein Dr. Sch."

573. The rule of our lord the sun is hard, because of a lack of adjustment to it. Adaptation has turned us into Northerners after all. The way of life, the ideas about work, and as a matter of fact the whole ethical scheme, can't

stand too much sun. I saved myself by a kind of resignation and watchful waiting. I intermitted.

My vital functions were locked up somewhere or other in a strongbox, well preserved. An ear applied to it could hear the pulse ticking softly.

574. There were a few cases of typhoid fever in Bern. They came in very handy for my future father-in-law, and he was able to put a resounding veto on Lily's projected visit. This led to a little intrigue between Bern, Munich, and Braunschweig, where Lily was staying with her grandmother. Two solutions appealed to us: either I would go to Braunschweig, or Lily and I would meet in Oberhofen on the Thunersee. We outwitted the old gentleman in this way, and he had to be satisfied with the latter solution.

575. Lotmar showed up. He is leaving Strassburg. After the holidays he will start as Sahli's assistant. Of course, a musical set-to was organized at once, in spite of the sultry summer weather. Mozart's *Divertimento*, one of his most beautiful works, and Beethoven's *Serenade*, both for string trio, were taken by storm. We had a public of experts, Frau Hermann-Rabausch with two perfectly delightful Brussels griffons. These prizewinning dwarf dogs spend the day at the dog show. At night the mama dog takes them in. But during the day, too, she doesn't leave them alone for a moment; she alternates with a Bavarian boob of a nephew in sitting in front of the cage.

Gorki's *Night Asylum* given a mediocre performance at the summer theater. I particularly liked the "Why? No Idea."

576. Lily's visit was set for mid-August, and she told me to be in Basel on a Wednesday, where we met happily. From Bern, "more specifically" Oberhofen, we took beautiful tours, among others a beautiful ride to Interlaken, Lauterbrunnen, Wengen, Wengernalp. Here we had lunch within view of the towering mountain, on which we gazed to our heart's content and then walked up to the Kleine Scheidegg and down to Grindelwald, where we caught the last train.

Another time we took the train to Beatenberg where we visited—O love—my Helen, who had expressed the wish to become acquainted with my "bride." Then the two of us took the direct way down to the Beatus cave, the "Lad-

der." We looked at the inside with its new furnishings and then, passing up the steamer, walked straight back to Oberhofen. At that time there were no landings yet near the caves. You had to walk to the inlet.

On a third occasion we took a trip to Geneva, from Bern, that is, and were overcome by that beautiful city with the glittering tourist traffic and the merry street music. I saw coffee-shop violinists who played their instrument in the manner of cellists and pressed their right-hand thumb between the finger board and their hair. Still, their sound was exceptionally strong. I heard again, after a long time, my beloved "vieni o notte dolce" sung by an Italian street singer.

After this bewitching place, this charming piece of France, Lausanne didn't seem very attractive to us, like a bastard child of Bern, very much *patois*. In Montreux, the scenery at least is enchantingly beautiful.

In the way of art, too, there was much to see. In Geneva, the Rath Museum, with a group of the finest Corots. Among them a kind of nude figure, the best thing in the newer painting. In Lausanne we visited the Swiss Salon. "A Woman" by Amiet was hung there, covered with great pasty-looking sun spots. She looked blotched all over. And yet is was a relatively outstanding picture! (In Basel we had seen the best Swiss gallery.)

In Bern we had all sorts of visitors whom I was able to welcome with good music. I must note an extremely fine afternoon: Haller brought to my house Karl Hofer, Brühlmann, Cardinaux, and Brack, as well as Hans Reinhard, the rather strange son of his and Hofer's patron. There we had listeners such as can only be found among painters who are equally fervent. A contrast to all the painted idols in Lotmar's house.

As a matter of fact we had an exciting session there too, for once, because the professor had bought a beautiful Bechstein at an auction. Piano sonatas, trios, quartets (Mozart), and quintets (Schubert's Trout Quintet) were played with enthusiasm.

577. Read: Ibsen, *John Gabriel Borkmann, Little Eyolf*. Lily had read *When We Dead Awake* aloud to me.

The Opera reopened with a performance of *Aïda*, but this opera is too difficult for local resources. The *Postillon de Lonjumeau*, on the other hand, came off very nicely.

We were tickled with Max Brack in Munich. He does have a certain luck with women. It seemed to us that something was going on between him and a *filia hospitalis* in Barerstrasse, and we asked him how things stood with her? "Well!" he replied drily; "we just cough together!" By this he meant very preliminary relations through the wall, from one room to the next. After a concert at the Kaim he arrived with his coat, after the usual run on the cloak-room, all excited: "Oh, how they smelled today!" (sounding exasperated) "Especially one old woman!"

His relations with Haller were very informal, as between schoolboys. From time to time they fought, half seriously; but once, when I was present, it got to be very much in earnest. Brack was stronger and finally pinned him on his back. Then he began to play all kinds of unmentionable jokes on his defeated adversary. The scene lasted quite a while and ended with a sharp slap on Mimu's (Haller's) ears. Mimu is a man who hides what he is doing, Brack is a man who secretly builds up spite. This is the basic reason for such scenes.

They are supposed to have been at each other once at the top of the Stock-horn.

578. In September I escorted Lily on her trip home, as far as Zurich. Expecting to see each other soon in Munich, we found leave-taking not so painful as usual. In Zurich we saw the Künstlergüetli; it had a few beautiful pictures.

In the meantime I read Shakespeare, *Romeo and Juliet*, Molière, *Tartuffe*, and Gottfried Keller, *The People of Seldwyla*.

Then I was in Munich from the 15th to the 25th of October. I visited the museum print room several times. During her brief stay in Bern this summer Wassiliew had got me excited about Beardsley. I asked for his earlier and later work. His style is influenced by the Japanese and is thought-provoking. There is something seducing about it, and one follows with some hesitation. I was handed an English book about Blake. Karl Hofer had raved about it. It was closer to my current point of view. I found Goya's "Proverbios," "Caprichios," and especially the "Desastros de la guerra" thoroughly captivating. Lily gave me many photographs of paintings by Goya. These were the things I laid to good account professionally at the time. It was more necessity than impulse, more a willingness to lay myself open to these things that were signs of the new times. For I may have been too much out of touch, after all!

I was able to hear some wonderful performances at the Hofoper. Hans Heiling conducted by Felix Mottl, with Feinhals. *Tristan and Isolde* (Mottl) with Knote and Senger-Bettaque. *The Devil's Part* (Mottl) with Raoul Walter and Bosetti. Then too a rather weak new item: *The Curious Women* by Wolff-Ferrari, splendidly performed under Reichenberger's direction by Charlotte Huhn, Breuer, Tordek, and Bosetti.

At the Schauspielhaus, *Der Kammersänger* and *Salome* (Wilde). (I had seen a more moving performance of *Salome* in Bern with Fumagalli and Swoboda.)

At the Gärtner Theater: *The Grand Duchess of Gerolstein* (Offenbach).

Particularly marvelous were the Chinese acrobats at the Deutsches Theater. Real Asians are better than English aesthetes tired of Europe. Saharet came and went like a light wind, leaving behind as the last, if not the single, impression of her, her leg poised between the closed curtains.

Fully laden back to my bachelor's den.

579. In Bern a performance of *The Flying Dutchman* which, as the critic for Bloesch's newspaper, I had to listen to at least in part, was very painful. The little orchestra was unbearably harsh, as if it were trying to smash tin ears to pieces.

And I was plagued by a little violin pupil named Roby. A girl painting student worked very hard and with less noise. I earned pocket money and now only had to take room and board from father. On Saturday afternoons I kept up the custom of meeting with Jahn in the coffeehouse on the Amthausgasse. On Tuesday and Wednesday nights the orchestra rehearsed; I was now indentured for a fixed fee to play at the symphony concerts. The only days I still had all to myself were Sunday, Monday, Thursday, and Friday.

580. The longish interruption did no harm to my work. At times I still thought a little about Blake. But then, in God's name, I was completely myself again! I engraved the final version of "Woman and Beast," "The Monarchist," and the new "Perseus."

I had to have a great deal of patience with the printing, because Max Girardet was away, but the feeling that these were relatively crucial works was not, I hope, a deceptive one! When I worked on the little etching "Feminine

Charm," I was forced to think of the Polish woman. *A look that did not deceive* might be the legend. She is living and studying in Toulouse now; she is said to suffer from tuberculosis. Lily of the valley, lily of the valley!

In my mind I arrange an exhibition of the engravings and already think about the order in which they are to be hung.

581. I am learning to decipher viola keys, so as to have greater variety in the string quartet.

At the second symphony concert we played Händel's Concerto Grosso in F major, Rameau's suite from *Castor and Pollux*, and the Third Brandenburg Concerto in G major by Johann Sebastian. The Quatuor Vocal Bruxellois sang wonderful old music. *Chanson de table* by D. Friederici (1624–?), Madrigal by Waelrant (died 1595), *Les Tribulations Conjugales* by Orl. de Lassus (died 1594), Madrigal by Mathieu le Maistre (died 1577), Madrigal by Ph. di Monte (died 1594), *Le Moys de May* by Jannequin (1528–?), *Chanson de May* (sixteenth century), *Gagliarda* by Hasler (died 1612), *Deux chansons soldatesques du temps de Charles* VIII (anonymous), Chanson by J. Mareduit (died 1627), *Chanson Napolitaine* (1520–1580) by A. Scandello.

At the third symphony concert only Beethoven was played. 1. The Second Symphony, 2. Overture to *Egmont*, 3. Overture to *King Stephan*. Pianist De Gréf played the Concerto E-flat major on a superb Pleyel.

After that we went to Neuchâtel again. Beethoven's Second, a symphonic poem by Liszt, Mozart's Violin Concerto in E minor, wonderfully played by Thibeaud.

Read: Ibsen, *Ghosts, The Pillars of Society, The Wild Duck, An Enemy of the People*; Molière, *Don Juan*, with foreword by Voltaire; Raimund, *Spendthrift*.

582. December 1904. Printed at last, and I am satisfied. This new Perseus has dealt the sad dull monster Misfortune the death blow by cutting off its head. This action is reflected by the physiognomy of the man whose face functions as a mirror of the scene. The underlying marks of pain become mixed with laughter, which finally retains the upper hand. Viewed from one angle, unmixed suffering is carried *ad absurdum* in the Gorgon's head added

on the side. The expression is stupid, rather, the head robbed of its nobility and of its crown of snakes except for some ridiculous vestiges. Wit has triumphed over Misfortune (a more refined sequel to the "Comedian").

583. When looking at any significant work of art, remember that a more significant one probably has had to be sacrificed.

583a. At the end of December, Jean de Castella turned up once again. Every time he has moved a step closer to total self-neglect. At the railroad station, he paid for caviar, Pommard, and Asti. Quite drunk, he boarded his train as usual. He no longer tells me about his new religion, "otherwise, you will again take from me!" He still has not forgotten his Toni in Munich. "Oh, I would give ten years of my life to start there again because such a beautiful life will never come back."

I read Oscar Wilde's *Socialism* and *Man's Soul* on the advice of Professor Lotmar.

1 9 0 5 B E R N

584. At Lotmar's, with Jahn on the viola, we played Beethoven's Harp Quartet and Opus 18 in D major, and also the Viola Quartet by Haydn. A string-section rehearsal for *Death and Transfiguration* was scheduled on January 7th. On the 8th I took a beautiful walk with Lotmar through the Gurtental by way of Köniz. We discussed the incredible proposition of my future papa-in-law that his daughter pay for her room and board. But what can you say about something like this? We stopped at Kehrsatz and ran into Brack.

At the fourth symphony concert, on January 24, we played Brahms' Second and his Academic Overture. Halir played Beethoven's Concerto. When the orchestra lagged behind, he took sly little breathers. Better than rehearsing for a long time, he thought, as he faked the tempo. He also performed the Adagio from Spohr's Ninth Concerto and two Hungarian Dances by Brahms-Joachim. The latter spirited. In a booming voice, this giant asked whether there was an inn that served Pilsner beer.

585. January 1905. "The Hero With the Wing," a tragicomic hero, perhaps a Don Quixote of ancient times. This formula and poetic idea, which murkily made its appearance in November, 1904, has now finally been clarified and developed. The man, born with only one wing, in contrast with divine creatures, makes incessant efforts to fly. In doing so, he breaks his arms and legs, but persists under the banner of his idea. The contrast between his statue-like, solemn attitude and his already ruined state needed especially to be captured, as an emblem of the tragicomic.

Read Heinse, *Ardinghello*, Hebbel, *Diaries*, Oscar Wilde, *The Ballad of Reading Gaol, Aesthetic Manifesto*.

586. *A scene.* THE PLACE: *the square before the railroad station in Bern; in the background, the station with its triple portal; on the left, the well-known open corner.*

The protagonists: Brack (drunk) with two friends; Dellacasa, with a drunkard.

BRACK (*coming out through the central door with his friends, steps forward; shouts to friend A*): You're horrible! (*To friend B*): You too. You're both horrible! (*Pause.*) Nasty fellows!

(*Dellacasa enters with his drunken companion from the right*).

BRACK (*not recognizing him*): Who are they? . . . do I like them? No! I don't like them! (*comes nearer, somewhat more softly*): But I won't harm them! Whom *do* I harm? Nobody! Who are you? (*Very close.*)

DELLACASA: Us? Who are *you?*

BRACK (*recognizes him*): Ah, it's Dell! Hi Dell!

DELLACASA (*holds out his hand to him*): Mighty fine, Bracky-boy, at this late hour!

BRACK (*sniffs at him*): Say, you!

DELLACASA (*while Brack continues to act around him like a dog, with comfortable slowness*): It seems you're still the same!

(*The friends and the drunkard laugh.*)

BRACK (*has caught fire, points in the direction of the red-light district*): I don't wanna go home yet!

DELLACASA (*who just came from there*): You're too late! They just closed!

BRACK (*tottering*): Then I'll stay here! (*Proves this statement true by collapsing on his back.*) (*To Dellacasa*) Help me on my feet!

DELLACASA: Can't you do it yourself?

BRACK (*irritated*): You're a scoundrel, a nasty churl! (*Furious.*) A low-down scoundrel!

DELLACASA (*good-humoredly extends his hand*): I won't take such talk from you! (*Pulling.*) Come, I'm gonna help you!

BRACK (*back on his legs, calmed down*): That's the way!

DELLACASA: And now good-bye! I've got to go home! (*Exit.*)

BRACK (*calling after him*): Hey you, can't you stay a bit longer?

DELLACASA (*in the open corner*): Here's to us!

(*The drunkard suddenly realizes that he has lost his guide, runs after him as best he can.*)

DELLACASA (*calling from a distance*): For a while! (*A word that is being slipped in meaninglessly everywhere. Twenty years later, I ran into another such expression: "all in all."*)

BRACK (*leaving, to his friends*): You're horrible, the bunch of you!

(*Exit one and all.*)

587. I give up as too anecdotal the subject of a rubberlike creature striving upward, which thereby becomes so thin that the arrows aimed at him cannot hit him, but at most graze him.

588. At the Opera I heard tolerable performances of *The Abduction* and *Carmen*. On the other hand, the performance of *The Magic Flute* was very bad. I remember how as high-school students we were enchanted, in our spoiled innocence, by the figures of Papagena and Micaëla! Of Carmen we were afraid; then too, she struck us as too worn out for youngsters. The page boy in *The Huguenots* with his delicate woman's legs was just our type. We actually always had in mind the woman playing the rôle.

589. My chief instruments, the sharp pencils and engraving needles, have been given these beautiful names: Lupus, Füntzhart, Chrüttli, Nero, Judas, Rigoletto, and Robert the Devil.

590. As I scratch away in the living room, sharpening one of these pencils, an ill-humored, wilting lady is indulging in inflammatory speeches. It is not meant for me, but it hits me anyway. My little strokes run over from the drawing pad onto the newspaper I've placed underneath. This diverts my anger and gives me time to consider exactly which three words would be the proper retort. In the process my body trembles very softly.

591. Last Sunday two Russian greyhounds violently attacked a local dog pulling a cart. The people at once sided with the one that was working for the dairy business. Now, were they taking sides against the foreigners (strange riff-raff), I asked myself, or with the proletarian? This problem constantly preoccupies me. Moilliet is no real ally, for he said: "Let them bite each other's asses!" Moilliet is a man of the world, and becoming more so every day.

592. Our Quartet is to perform semi-publicly, at a charity event organized by the Russian Students' Association for those who fell in the St. Petersburg street fights. We rehearse Beethoven's Opus 18 in C minor, Schubert's variations *Death and the Maiden*, and, as an encore, the little Serenade by Haydn. Since I am not ambitious, I let Fritz play first fiddle and leave him the work of having to learn it all. Our teacher Jahn plays the viola. Lotmar is all fire, all eagerness. This fellow will burn himself out prematurely, if he undertakes everything with the same unrestrained energy. The fire that burns in him also burns with thought about the purpose of the project. I was more for a joyous work, but this he didn't understand at all.

A peculiar person, with imposing gifts. But without grace. And all intellect. I am beginning to realize that this is onesidedness. For me, as a creative artist, it would even be a hindrance. I have just enough of it.

Yes, the fellow who plays the second fiddle understands many things quite well.

592a. Before "taking the stage," Fritz was in a state of latent excitement. While we were tuning up backstage, he knocked the bridge down. Jahn made a very nervous, very high leap into the air. Luckily the tuning fork held steady. But now the intonation was in danger. Upstairs they all quieted down, and

Fritz played with great energy. It was a real triumph. On the following day he brought the instrument, a Guarneri del Gesù lent by Frau von Sinner, to the violin maker, to be sure that nothing had happened to it.

During the party the news spread that Plehne had been the victim of a criminal attack, which threw a pall over things.

592b. We quartet players now mustered new courage and tried out new partners: a Fräulein Mauerhofer, a pupil of Berber, and a Reverend Lauterburg from Schlosswyl. I played my first viola part (Dvořák).

593. Read: Gottfried Keller, *Dietegen, The Lost Laughter*; Hebbel, *Diaries* (continuation). Then a nonfiction book by somebody called Deutsch: *Sixteen Years in Siberia.*

Work of an essentially preparatory kind. A "Phoenix Bird." A man with clenched fists as antlers. And one who, caught up in emotion, grows the fangs of a wild beast.

At a concert by the Choral Society, Brahms' Rhapsody for male choir and alto was the only work of importance. *The Sea* by Nicodé is shabby.

Haller wrote twice. First, he needed his Kangaroo for the contest exhibition for Swiss Scholarship holders. And then, on an open post card, came this request:

"Rome, via Flaminia 110. Dear Friend, I come to you with a peculiar request. Please send me at once, by registered mail, a few twigs of Thuja (about 300 grams), for making tea. You can get information about the tea from Brack. Best regards to you and to the others from yours, Hermann Haller. Greetings also from Hofer." On the address side of the card the following riddling, anonymous words were written in pencil: *"fortuna, che ve l'ho rimandato io, e ricevete un grosso bono N.S."*

597. At the fifth symphony concert, Casals played, one of the most marvelous musicians who ever lived! The sound of his cello is of heart-rending melancholy. His execution unfathomable. At times going outward from the depths, at times going inward, into the depths. He closes his eyes when he plays, but his mouth growls softly in the midst of this peace.

At the rehearsal he browbeat our Association's conductor heavily. Casals

YOUNG MAN LEANING ON
LYRE, 1905, 33

arrived about half an hour late. The conductor greeted him watch in hand. The Spaniard, who doesn't understand Swiss humor, was peeved by this gesture. Obviously thought to himself: we shall see how good you are. The tutti of Haydn's Concerto began. (N.B.: main rehearsal before an audience of paying customers.) Our conductor has never been good at selecting tempi, and he naturally picked a completely wrong one. Casals tried to set him right. In vain, of course! Now he started his solo and it sounded as if the gates of heaven had been thrown open. However, since he was not Halir with his breathing spells, he demanded that everyone keep measure. Now the conductor got scared and couldn't make the orchestra come in correctly in spite of repeated attempts. The Spaniard had long since realized that the conductor didn't feel the music, but now he began to suspect that his knowledge of the score might be faulty, besides. He called aloud every note of the tutti entrance to him. It rang out as sharp as could be, just like a solfeggio class.

The audience was eager to discover how pianist Brun would fare in the Boccherini sonata. But the Spaniard had left with the words "*Ah, c'est terrible de jouer avec cet orchestre!*" refusing to play another note. Fritz Brun was very glad and rehearsed with him later at home where Casals said he was satisfied.

At the concert Casals sat growling in front of the orchestra as it was playing the introductory bars. The conductor turned around dumbly beseeching his opinion of the tempo. The Spaniard endured it for just one beat, and then he joined in with the basses, and with a few taps of his bow on the back of his instrument, brought order to the proceedings.

We had to play Mozart's Symphony in G minor, an overture (*La Vestale*) by Spontini, and the little *Cosi Fan Tutte* overture, that most wonderful of wonderful works.

Besides Boccherini, Casals, as a solo, played a saraband by Bach.

599. What does the artist create? Forms and spaces! How does he create them? In certain chosen proportions . . . o satire, you plague of intellectuals.

600. Concerts in March. Bohemian String Quartet: Mozart's D minor, Dvořák F major, Beethoven's E minor op. 59. In Neuchâtel I participated in

the Saint Matthew Passion and even recruited Lotmar for it. Kaufmann sang the tenor part very well; the Christus as sung by Oort, from Utrecht, also had dignity. The choir obviously had worked hard. It lacked only that supreme power.

In Bern we played the year's last symphony concert. Liszt: *Preludes*, César Franck: *Les Djinns* for piano and orchestra, Richard Strauss: *Death and Transfiguration*, Berlioz: Roman Carnival overture.

601. At a quartet session, Lotmar and Lewandowsky blew up in succession. Lotmar, in his excessive enthusiasm, had laid it on thick; Lewandowsky compared his performance with the violin-playing of a Strassburg concert master. I played the viola and wasn't responsible (Beethoven's op. 18 in G, Mozart C).

Read: Heinse, *Ardinghello*. Ibsen, *The Master Builder* (it has remained too much an idea, but very captivating); Ovid, *Metamorphoses*, in an old bilingual edition from the German Artists' Library in Rome.

Many things have gone topsy-turvy with me: I heard *Pagliacci* and *Hänsel and Gretel* without knowing the Ring. I saw plays by Sudermann before Ibsen, and Ibsen before Hebbel.

Amiet before Van Gogh (later notation).

I was bedridden from March 11th to 13th (fever, hoarseness, cough, and cold).

602. 3.20. "The Aged Phoenix" does not represent an ideal figure; he is really 500 years old, and as can be seen, all sorts of things happened to him during that time. This cross between realism and fable is what produces the comic effect. Its expression is not without a tragic side, and the thought that this creature will soon be reduced to parthenogenesis doesn't open any cheering perspectives. The rhythm of failure, with a 500-year periodicity, is a sublimely comical notion.

Although Ovid is not the right author for it, a number of nice things are to be read there about this bird (*Metamorphoses* XV, 393 f.). I prefer him not to be brutally burned, in this I agree with Ovid. Printed for the first time on Monday, March 20th.

Now comes "The Threatening Head"; I am almost inclined to believe that

this will be the last print in the strict style and that something entirely new will follow. I turn my eyes toward Spain where Goyas grow.

603. We have just printed "The Threatening Head." The end is gloomy enough. Some destructive thought or other, a sharply negative little demon above a hopelessly resigned face.

March/April 1905. The printing of a second version had to wait for some time because Max Girardet was stuck in the army jail.

604. D. is in love, of course only half happily; that is, he still doesn't know where he stands. And now he consults me. What could I tell him? She is a professional violinist and is quite talented. But everything about her is a bit too blond-on-blond, a bit lean, no longer in her first bloom, which rather contradicts the childlike features. From Cologne.

Eyes the color of forget-me-nots were once again responsible for poor D.'s losing his peace. No doubt, devouring love is something beautiful and strong, but then she ought to be of the right mettle. D. probably feels pretty inadequate and flees from really fiery women. Or he doesn't imagine himself worthy of their interest. Rightly, perhaps.

Everybody has to thresh these things out for himself and not look for sound advice from others. But I gave him courage: first she ought to be really his, and only then would he see whether in the long run she would be the right one for him.

605. I wouldn't be suited to play a part like D.'s. But I do not mean this at all contemptuously. I have already seen Haller experience such great passions. In contrast to these people, I have developed a cunning, practical strategy. I know exactly how to recognize all the dangers; during the years when I was still halfway childish, some few moments gave me fleeting glimpses of these hells, and that was enough.

Since then, what is most intimate for me remains most sacredly locked up. By this, I mean not only love—for it is easy for me to talk about this—but all the exposed positions around it, upon which the assaults of fate in one form or other have some prospect of success.

Whether this strategy may not lead to a certain impoverishment will appear in time. I did not choose it freely, it developed early in me.

Perhaps it is because my instincts as a creative artist are the most important for me. Or perhaps the whole matter should not be interpreted so rationally: perhaps an ageless philosophic spirit holds sway, who overcomes this world, even if it means leading us into the wilderness.

One thing is quite certain: in creative moments I have the great privilege of feeling thoroughly calm, completely naked before myself, not the self of a day but the whole sum of self, totally a working instrument. A self that is subject to quiverings and convulsions cheapens its style and steps out of the frame wearing a top hat.

One sometimes feels like saying to a "work of art": "Good day, Herr Self, what kind of a necktie did you put on today?"

Thus stand I armed, should an Opus 2 come upon me.

Should nothing new come, I shall have nothing to say any more. As an omen, I break off relations with everything that lies behind me.

606. Read: Tirso de Molina, *Don Juan* (a few remarkable scenes), Gogol, *Dead Souls*, a very important work, performance of *The Revisor* at the theater, not played Russian enough. Wedekind, *Hidallah*. Opera: *Tales of Hoffmann*, Guscalewicz showed really great art in her impersonation of Antonia in the last act. For a few minutes one forgot the provincial stage, the stage in general, the thing began to breathe.

The choir sang Mozart's Requiem, it was a very beautiful performance. The four soloists, too, sounded fine. Before that, came a cantata by Johann Sebastian, *Herr, bleibe bei uns, denn es will Abend werden*. What masterpieces!

607. Others have interpreted the "Comedian" long before me. Gogol, *Dead Souls*, I, Chapter 7. ". . . that there exists a kind of laughter which is worthy to be ranked with the higher lyric emotions and is infinitely different from the twitchings of a mean merrymaker."

He calls his novel "a world of visible laughter and invisible tears. . . ."

Further on, the Russian saying: "To carry the laughing tear emblazoned on one's scutcheon."

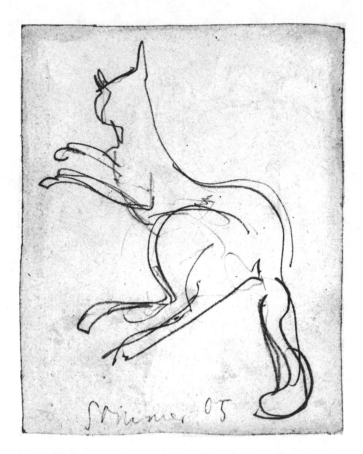

CAT, 1905

Somewhat more banally, Heine says: "To laugh, as if death were tickling us with his scythe."

608. I once heard a pretty Swiss song:

> Why fret myself about me?
> I've never been so great.
> It'll take a while yet to be
> The lad I be at this date.

610. April 1905. "The Threatening Head" is a gloomy conclusion to this set of engravings. A thought more destructive than action. Pure negation as demon. The physiognomy for the most part resigned.

611. War on intellect! I may well say this, having gone through it. My friend Lotmar, you served me well, I shall forever thank you for it, but now our ways part once again. I can still see you quite clearly with the naked eye, over there.

I must strive farther, or else I shall grow poor in this clean orderliness. Or else it will turn into an idyl.

And what is recorded is no longer alive. Amidst such surroundings I must not settle in the long run. Or else I shall lose myself.

Sometime, I must sink on my knees, in a place where there is nothing, and be deeply moved by the act.

Enough of this bitter laughter about what is and is not as it should be.

615. The fragmentariness which is typical of so many Impressionist works is a consequence of their fidelity to inspiration. Where it ends, the work must stop too. And so the Impressionist actually has become more human than the sheer materialist. The notion of sober, practical craft ceases to be valid at any cost.

616. A and B have long disputed over the wine bottle and hold contradictory views. In their state of drunken sentimentality, they move conciliatingly toward each other. Each delivers his speech with such eloquence that B lands in A's position, and A in B's. With a surprised look, they shake hands.

618. "The Aged Phoenix," as a simile, has something Homeric; there is a resemblance in one respect, but otherwise its form is autonomous.

One more thing may be said about "The Comedian": the mask represents art, and behind it hides man. The lines of the mask are roads to the analysis of the work of art. The duality of the world of art and that of man is organic, as in one of Johann Sebastian's compositions.

It is quite delightful to elaborate such considerations in retrospect.

In earlier versions of "Woman and Beast" the woman suffered too much. Later I gave her that not altogether disgusted expression.

Dissertations could be written about the significance of the "ugliness" of my figures.

621. I spent eight beautiful days in Oberhofen on the Thunersee with my father, almost all of Holy Week [*Karwoche*].

Kar comes from *chären*, "to lament." When our Myz, the noble gray little sprite of a cat, has one of its talkative days, we say: "You're a *chäri!*"

We did a great deal of wandering about. Once, to Gunten and Merligen, then along the path to Siegriswil, then the road to Aeschlen and back to Oberhofen by way of Schönörtli. Another time, by boat to Thun, across the forest to the Heiligschwendi rest home and back along the trail to Oberhofen. A third time, we walked to Scherzligen (crossing the Aare by boat), along the road to Gwatt, Einigen, Spiez, and back to Oberhofen by steamer. At Eastertime this lake is particularly attractive.

623. X's mother is a creature not yet dead but nonetheless already extinguished. Her body lives, her spirit is no longer present. A living corpse. She is mentioned suddenly, after I had not heard of her for years. "My mother is . . . ," and one is literally startled at hearing the word *is*. "My mother is not feeling well enough, I won't go to Munich. My mother doesn't feel well enough to be visited."

624. X. has become engaged to Y.Z. In Neuchâtel I noticed how much Y. felt drawn to him. But we all judged him wrongly, and didn't think him capable of this step. I said to myself, W. admires beauty so much, in art, for instance, that something might perhaps be done for him along this line, some

day. Now Z. had a beautiful head, full of character, but she was in no way a beautiful woman.

W.X., a person difficult to approach, even for his friends, a fortress of the first order, has been taken by a simple Russian student.

To my question about what he had meant when speaking of the inner obstacles that stood in the way of his engagement, he replied: "During the entire past, I have never spoken a word about what my mother's sickness means to me, and to my father, and what this, in turn, means to me; and now I for once had to come completely out of myself . . . It shook me to the depths."

After a pause he obviously tried to say more, but couldn't get it out. "No, I can't start all over again!" he exclaimed and, jumping up from his chair, ran to the door.

A strange person, who flees his friends when they show sympathy. I felt apprehensive about him in the event this melancholia should grow worse sometime.

From April 24th to 28th, I was once again laid up. Always the same throat trouble.

626. It is quite an amusing experiment to look at a picture with only one eye and to discover how the objects in the picture acquire relief. Why is this the case? Actually one-eyed vision doesn't throw things into relief; in spite of the compensation provided by experience, which the brain brings to such imperfect perception, we still completely misjudge spatial things when we look at them with one eye. Accordingly we cannot apprehend with certainty the surface, as such, of the picture; and this fact favors a delusion produced by the forms that are represented. They acquire relief more easily.

627. Basically my father has the finest qualities, but his parting remarks are not always easy to swallow. He seemed quite nasty to me one time: I was lying in bed with a 104° fever from my smallpox vaccination before my trip to Italy. "Well, now, isn't this pleasant?" he said ironically. As if I hadn't known myself that it would be anything but pleasant. I also knew that he did not approve of my vaccination. Hadn't he always until then used every means to keep his children from being vaccinated? If only he had said to me beforehand: I will resent it, if you have yourself vaccinated! That at least wouldn't

have been illogical. And he would really have had the right to triumph only if I with my vaccination had caught smallpox, while he without vaccination had sat at my bedside in good health. Also, I was of age now and my engagement prevented me from taking any personal risks I pleased.

But otherwise my father is quite all right.

628. While we were sitting at the inn the other day drinking Pilsner, a man came in, coughing heavily. In a choking voice he said: "The good fellow has a bad cough!" Another day I heard loud yelling in the neighborhood: "What's the matter with that dog? Look at him barking at my missus. Say, you dog, get hold of yourself."

632. June 1905. Granted: I am relatively satisfied with my etchings, but I cannot go on in this way, for I am not a specialist. Nevertheless, for the time being, I won't drop it all, but rather find the logical way out. A hope tempted me the other day as I drew with the needle on a blackened pane of glass. A playful experiment on porcelain had given me the idea. Thus: the instrument is no longer the black line, but the white one. The background is not light, but night. Energy illuminates: just as it does in nature. This is probably a transition from the graphic to the pictorial stage. But I won't paint, out of modesty and cautiousness!

So now the motto is, "Let there be light." Thus I glide slowly over into the new world of tonalities.

633. Working with white corresponds to painting in nature. As I now leave the very specific and strictly graphic realm of black energy, I am quite aware that I am entering a vast region where no proper orientation is at first possible. This terra incognita is mysterious indeed.

But the step forward must be taken. Perhaps the hand of mother nature, now come much closer, will help me over many a rough spot.

The step forward must be taken, because it has long been preparing itself in many aspects of my work. For these few etchings are far from representing the entire production of the past two years. A great number of sketches did not lend themselves to being fitted into that strict, abstractionist affirmation of form. They lie in wait.

I am ripe for the step forward.

I begin logically with chaos, it is the most natural start. In so doing, I feel at rest because I may, at first, be chaos myself. This is the maternal hand. Before the white surface, on the contrary, I would often stand trembling and hesitant. But then I gave myself a conscious jolt and squeezed my way into the narrow confines of linear representation. Then everything went quite well, for I had trained hard and thoroughly in that field.

It's convenient to have the right to be chaos to start with.

Nor are the first signs of light on this black ground as vehemently compelling as black energies on a white ground. One is thus able to proceed in a much more leisurely way. The original blackness works as an opposing force and begins where nature leaves off. The effect is that of rays of the rising sun streaking the sides of a valley, with the rays gradually penetrating deeper as the sun ascends. The last dark corners are merely a residue.

All this stimulates certain ideas about technique: woodcut and lithography. Perhaps the compensation for many bitter hours is approaching.

635. In Beethoven's music, especially the late works, there are themes which do not allow the inner life to pour itself out freely, but shape it into a self-contained song. In performing it, we must take great care to determine whether the psychic content expressed concerns others or is only there for its own sake. I personally find the monologue form more and more attractive.

For, in the end, we *are* alone on this earth, even in our love.

636. O keep the infinite spark from being stifled by the measure of law. Beware! But do not quite leave this world behind, either. Imagine you are dead: after many years of exile you are permitted to cast a single glance earthward. You see a lamppost and an old dog lifting his leg against it. You are so moved that you cannot help sobbing.

637. In ancient Rome, emetics were set on the table. Now, clothed in tails and white tie, set on chairs, they are neatly distributed among the guests. I have seen it in artistic society.

638. Individuality is not an elementary sort of thing, but an organism. Ele-

mentary things of different sorts coexist in it, inseparably. If one tried to separate them, the components would die. My self, for instance, is a dramatic ensemble. Here a prophetic ancestor makes his appearance. Here a brutal hero shouts. Here an alcoholic *bon vivant* argues with a learned professor. Here a lyric muse, chronically love-struck, raises her eyes to heaven. Here papa steps forward, uttering pedantic protests. Here the indulgent uncle intercedes. Here the aunt babbles gossip. Here the maid giggles lasciviously. And I look upon it all with amazement, the sharpened pen in my left hand. A pregnant mother wants to join the fun. "Pshtt!" I cry, "You don't belong here. You are divisible." And she fades out.

639. I cut into a black background with a needle, on a 13 × 18 cm. glass plate. Then I pressed an unexposed photographic plate against it in the dark. Then I exposed it briefly and was able to develop a photographic negative. The prints made from it provide strikingly close equivalents of the original.

640. More and more parallels between music and graphic art force themselves upon my consciousness. Yet no analysis is successful. Certainly both arts are temporal; this could be proved easily. At Knirr's they rightly spoke about the presentation of a picture, by which they meant something thoroughly temporal: the expressive motions of the brush, the genesis of the effect.

Knirr . . . What a refreshing atmosphere of good fellowship there. High-spirited Morerot from Vaud; how, during one of those long, foggy stretches in November he got depressed. "Already three weeks it is cold. No sun. I go to room and light lamp, so I believe the sun shines!"

641. An oppressed, poor schoolboy's heart confessed it to me. It drove him to the window away from his copy books, away from the pen dipped in the inkwell. His eyes wanted to stray in the open air and strained against the window glass and he knocked his forehead against it. Happy the children who were playing down there, happy the smile of Irene, the lovely girl. Happy his eyes that followed her. Happy his oppressed, poor schoolboy's heart.

But the trees were jealous, and hid his eyes' sole earthly joy. How much longer would they hold Irene captive. Time ticks and ticks, and the pen has already been dipped.

PORTRAIT OF MY FATHER, 1906, 23

And he confessed to me that he had seen his face in the mirror: it was filled with love and free of the ugly pimples. He knows that a better lot awaits him than today's. He knows it is out there in the distance. And the locomotive whistles.

There is bliss, not only above the stars, but also here on earth. There will be women later, somewhere, in some country.

To these women he prays. Temples stand there, raised in honor of their sex. And one shall come, who will not be just one, but the whole sex. "I bring greetings from Irene," she will say. And her voice is music.

643. Artist-martyrs of antiquity. (Laökoon, chapter 2, paragraph 3) . . . as if the Greeks had not had their Pauson, their Pyricus. They did have them, but treated them with stern justice . . . Pauson . . . , whose low taste delighted in expressing what was most faulty and ugly in man's appearance, lived in abject misery. And Pyricus, who painted barber shops, dirty workrooms, jackasses . . . with the zeal of a Dutch artist, as if such things in nature had indeed great charm and were seldom seen, received the nickname "Rhyparographer" (painter of dirt), although the luxury-loving rich paid for his works their weight in gold. . . . The authorities themselves thought it not unworthy of their attention to restrain the artist forcibly within his true sphere. The Theban law is well known which ordered him to make his models more beautiful than they were and prescribed punishment for portraits that made them uglier. It was not a law aimed at ignorant daubers, as is usually thought by commentators, even by Junius ("de pictura . . ."). It condemned the Greek ghezzi, the clever trick of getting a resemblance by emphasizing the ugly features of a model, in a word: caricature.

644. The night before Wednesday, May 31st, I took the train to Paris with Moilliet and Bloesch. We arrived at half past ten in the morning, drove to our hotel on the rue de l'ecole de Médecine in a cab. After that, we took a first walk to orientate ourselves. In the afternoon, to the Louvre. At night, *bal de nuit* at Les Halles.

6.1. Ascension Day. Whistler retrospective. Panthéon (Puvis de Chavannes), walked across the Bois de Boulogne to Saint-Cloud. Back on the Seine. At night, to the Théâtre Sarah Bernhardt: *Il Barbiere di Seviglia* in Italian.

6.2. Luxembourg: Rodin, Puvis, Manet, Monet, Renoir. Louvre: Velasquez, Goya, Watteau, Fragonard, Millet. At night: the outer Boulevards, back by way of Les Halles (toward morning).

6.3. The Morgue. At the Hôtel de Ville, bad frescoes by Puvis de Chavannes. Afternoon, the Louvre: Millet, Corot. At night, in the Opéra Comique, an opera called *Chérubin*, by Massenet.

6.4. (Sunday). Luxembourg. The Salon. At night: Comédie Française: *Tartuffe*, and *Il ne faut jurer de rien* by A. de Musset.

6.5. Interrupted journey to Versailles (on account of the rain). In the afternoon, slept. At night, Folies Bergères and the Boulevards. Quieter day.

6.6. Louvre: the collection of ancient sculpture. Salon National (better). At night, the outer boulevards, cabaret.

6.7. Louvre, the old French painters. In the afternoon, back to the better Salon. At night, at the Grand Opera: *Armide*, by Gluck.

6.8. Jardin des Plantes. At night, ball at Bullier's.

6.9. Started the day at half past twelve by having lunch. Then, to the Louvre: Rembrandt and Frans Hals. Five o'clock tea. At half past six, the two others abandoned me for the first time, because they were going to see *Tristan*.

6.10. Luxembourg, back to Manet, etc. Sorbonne (Puvis de Chavannes). Trolley to Montmartre, Sacré Coeur, panorama of the city. Trolley in the direction of the Eiffel Tower. A sudden shower prevented the ascension. Cab to the Opéra. *Armide* for the second time.

6.11. (Pentecost). Panthéon, monumental fountain by Carpeaux. Lion de Belfort. Gare Montparnasse. Omnibus along Boulevard St. Michel; at night, Opéra Comique: *Louise* by Charpentier.

6.12. Morning in Versailles. In the evening, back in Paris, Taverne d'Olympia, disgusting night club.

6.13. A farewell visit to the Louvre. Tea at five o'clock. At 7:40 p.m., departure for Bern.

645/49. Main impressions of the Luxembourg. The earlier Hodler stems from the "Poor Fisherman" by Puvis de Chavannes. The color gray with a mild color scheme. Manet, starting with Velasquez and Goya, gradually coming over into the present. Monet uneven because he constantly pushes ahead, but many-sided in compensation; Sisley refined! Renoir, the facile,

so close to trash and yet so significant! Pissaro more tart. Carrière, pictorial mannerism, enticing and instructive example for mastering tonalities.

Société Nationale des Beaux-Arts; Zuloaga, "Mes trois cousines." Deep-toned painting, hence the great effect achieved by jewelry, teeth, etc. Figures and landscapes are well related.

Louvre: Poussin, Claude Lorrain, particularly Watteau, a great painter. Fragonard uneven. Chardin monumental in small paintings.

Millet, "Spring," superb landscape; important paintings, besides, on the upper floor: 2892, 2895, 2993, 2890 (the calmest).

Ingres. Corot, Courbet. I do not quite understand Delacroix.

Frans Hals. These pictures are in excellent condition (compared to Rubens, almost no dimming). Only the portrait of Descartes is very yellow. Rembrandt, especially in his later years!

Raphael leaves me very cool. Titian has decayed, for the most part, into uniform yellowness. Tintoretto a great painter. Veronese; Leonardo, some magnificent works of his here. His pictures, too, have only been preserved imperfectly, but since he does not have the same tendency to cultivate warm tones as Raphael or Titian, cool tones remain effective under the yellow sheen. Of course everything is much too dark. A pioneer in the handling of tonalities.

In this illustrious company Dürer best holds his own when his work is calligraphic. Velasquez, figures blocked out with pride and considerable *élan*. I far prefer Goya. Ravishing sonorities from gray to black; among them, flesh tones like delicate roses. More intimate formats.

Coming away from Leonardo, you don't ask for much of a career anymore.

650. The newspaper boys on the run: "Enfin! La Paix! tout de même!" (Fingers raised:) *ho-ho!* A refrain from the cabaret

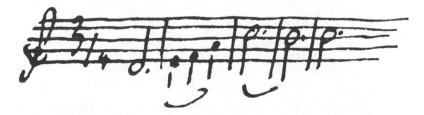

Moilliet was the darling of the cocottes, his nice face and childlike expression lured any number of them. He was quite calm, let them talk with him and left them just as easily. Along the way he mumbled a lot of nice things: "I've got no more illusions about where we belong . . . ," and again: "at home it's like this: only our Fido thinks, but he doesn't talk."

Waltz heard at the *Bal de Nuit*:

Added to this, the atmosphere of rotting fish, dust, tears, work, a horse lying in the street, cocottes skipping rope, the incoming train with provisions for one day. The sleeping people along the wall.

Bloesch attracted little attention from the cocottes. They warned each other: "C'est un savant!" All I got was a few faces made at me.

651. The performance of the *Barber* was excellent. At last an Almaviva, his voice was like a violin. The little Bonci would have sung the part much the same! Rosina (Pacini) ravishing, not at all insipid, youthful verve throughout. Great vocal technique, The orchestra did not sound delicate enough. Massenet: *Chérubin*, well manufactured music, but manufactured. *Louise*, a contrived work of the purest sort. Both performances at the Opéra Comique very accomplished, distinguished more for the skillful ensembles than for outstanding soloists. *Armide*, which we heard twice, was a great event. First,

this man Gluck. Then, the way it was done, each part of the opera went effortlessly. A sense of style without any fumbling experimentation. Not the individual will of a conductor. Total achievement. Fine ballets. Splendid orchestra. As soloists, Affre (tenor), Fräulein Bréval (Armide), Delmas (baritone), etc., etc.

A similarly impressive event was the performance of *Tartuffe* at the Comédie.

Final impression. Sunny afternoon on the Boulevard, with us riding in a carriage to the railroad station, beneath chestnut trees covered with red blossoms.

652. Read: Andreiev, *The Red Laughter*. Lynkeus, *Fantasies of a Realist*. Not books to my liking. Bought a Lucian in a French edition, much better! Keller and Reiner in Berlin do not want to exhibit my engravings.

660. July. Things are not quite so simple with "pure" art as is dogmatically claimed. In the final analysis, a drawing simply is no longer a drawing, no matter how self-sufficient its execution may be. It is a symbol, and the more profoundly the imaginary lines of projection meet higher dimensions, the better. In this sense I shall never be a pure artist as the dogma defines him. We higher creatures are also mechanically produced children of God, and yet intellect and soul operate within us in completely different dimensions.

Oscar Wilde: "All art is at once surface and symbol."

661. July. Position of the engravings in their frames. 1. 32 × 43: 7.5 cm. from the top./ 2. 32 × 43: ditto./ 3. 43 × 43: 5.8 cm. from the top./ 4a. 32 × 43: 5.8 cm./ 4b. 32 × 43: 6.9 cm./ 5. 10.4 from the top./ 6. 8.5/ 7. 7.5/ 8. 8.2/ 9. 6.00/ 11. 8.2/ Sequence for hanging: 1, 2, 8, 5, 11, 10, 6, 3, 4b, 7, 4a, 9.

I wonder whether I am now capable of expressing motion in engravings? The fear of making two lines run into each other in the process of etching is painful. Aquatint?

662. A few days in Oberhofen, among them a peaceful evening, a real evening (see No. 714).

Read: Balzac, *La Femme de Trente Ans.* Lermontov, *A Hero of Our Time* (the "Princess" in it!).

Max Reichel, the violinist from America, was there. This drove us to play quintets; I played second violin, since he is a professional. He poked a little fun at the composition by our brother the jurist. I admit that Mozart's C major Quintet is better. What an andante, the model of andantes!

Another quartet session with a first-rate professional, concert master Pescy, a very temperamental solo violinist (a gentleman from Szegedin). I alternated with Lotmar on the second violin and the viola. Lewandowsky made a show of fake elegance on the cello. If he acted this way on the horizontal bar, he would have broken his neck long ago.

664. With his calligraphic line, Dürer circumscribes the whole realistic aspect of the ear. Manet elegantly brings out with the brush the pictorial values corresponding to the play of light.

An exercise as a joke: Represent yourself without mirrors and without the kind of *a posteriori* conclusions that you get from mirrors. Exactly as you see yourself, therefore without a head, which you do not see.

670. The subject in itself is certainly dead. What counts are the impressions before the subject. The growing vogue of erotic subjects is not exclusively French, but rather a preference for subjects which are especially likely to provoke impressions.

As a result, the outer form becomes extremely variable and moves along the entire scale of temperaments. According to the mobility of the index finger, one might say in this case.

The technical means of representation vary accordingly.

The school of the old masters has certainly seen its day.

673. The good Lewandowsky has sent me my first customer, his colleague Dr. Frank Schulz, who lives in Berlin W., Motzstrasse 54, ground floor.

675. Haller as landscapist in the Elfenau. Boy swimmers come crawling to make fun of him. When he tries to catch them they hop into the water. Haller soon accepts the situation and goes on mixing his pigments ardently

and pasty. The boys begin heckling again. Haller darts a furtive glance at the closest one, turns around lightning fast and daubs him *à la prima* with a full *coup de pinceau*.

If I had to paint a perfectly truthful self-portrait, I would show a peculiar shell. And inside—it would have to be made clear to everyone—I sit like a kernel in a nut. This work might also be named: allegory of incrustation.

677. Photography was invented at the right moment as a warning against materialistic vision. Yes, my dear Alexander Reichel, what a funny kind of learning you're parading. What does "nature" count for here? The real point is the law according to which "nature" functions and how it is revealed to the artist.

This you don't grasp, you imbecile; and yet this is far from the whole story. One tells you as much as this only because one doesn't dare to tell you all, and still one overestimates you enormously in doing so. (Otherwise, you are quite all right.)

680. I laid a perfectly normal asphalt base for etching on a zinc plate. Then I drew as I pleased with the needle, without exercising any caution, and indeed even on blank surfaces with the knife. I now spread over this technical crime, as if in atonement, a veil of aquatint (to be laid or sprayed on, as one prefers). This is to prevent blurring and to lend the blank surfaces depth.

681. "The law that supports space"—this should be the title appropriate to one of my future pictures!

Today I have still not reached that point; meanwhile, to the question: "Do you like nature?" I answer: "Yes, my own!"

One does not lash what lies at a distance. The foibles that we ridicule must at least be a little bit our own. Only then will the work be a part of our own flesh. The garden must be weeded.

685. July. Lermontov: Rousseau's *Confessions* are vitiated from the outset by the fact that he read them to his friends. What autobiographer can feel

that this reproach doesn't touch him?! To think of it as often as possible might perhaps tone down the untruths a little.

686. I got drunk, for the first time in ages I was really drunk again. But very properly drunk this time. Only champagne, labeled Heidsieck. *Mais ce n'est pas moi qui a payé!* In bright daylight, a smile on my lips, I wandered home in a tuxedo and Bloesch's top hat. In bed I again felt very, very good. No trace of worries, everything in order. You may roll over without fears and fall asleep! I only made one little mistake when, out of old habit, I tried to turn off the lamp. It is day, I do not have to put out any light, I said in muted, solemn tones.

I needed a few days more to get rid of my smile, which seemed stereotyped like a ballerina's.

689. August. "I'll get rid of it!!" says my dear, gentle father, the idealist and singing teacher. What will he get rid of? A certain something in the timbre of the voice of a certain lady, who actually is not a lady.

690. Am I God? I have accumulated so many great things in me! My head aches to the point of bursting. It has to hold an overflow of power. May you want (are you worthy of it?) that it be born to you. (Aside:) They also were not worthy of Him they crucified.

More realistically: Genius sits in a glass house—but in an unbreakable one—conceiving ideas. After giving birth, it falls into madness. Stretches out its hand through the window toward the first person happening by. The demon's claw rips, the iron first grips. Before, you were a model, mocks the ironic voice between serrated teeth, for me, you are raw material to work on. I throw you against the glass wall, so that you remain stuck there, projected and stuck. . . . (Then come the lovers of art and contemplate the bleeding work from outside. Then come the photographers. "New art," it says in the newspaper the following day. The learned journals give it a name that ends in "ism.")

692. Cigarettes can be lighted at Pecy's style of playing.
A demon of the lowest sort disturbs me and wants to torment me. Stand-

ing behind me, he whispers to me in a persuasive tone about Gretchen's evil
spirit. "Do you remember. . . ."

Your Opus One is something done long since? Justify this, but not with
words.

"I am an old man, if my deed is not successful." (Prose): You broke the
bridges? Where to, now? You break bridges, but not the limits that are pre-
scribed for you and for your talent. (I reach for the sword.)

The demon: Defensive struggle, like that of cats . . . (after a pause:)
What keeps you going is the curiosity to find out how far you will get and
how, O autobiographer, the relationship between man and artist will shape
itself in time? (after a long pause:) The autobiography your masterpiece????

(I turn around to face him, but the apparition has vanished.)

693. In my eyes, the engravings lie before me as a completed Opus One,
or more exactly behind me. For they already seem curious to me like some
chronicle taken from my life. I now ought to prove this to others, not to
myself, by doing something. I have very definite feelings, but have not yet
transformed them into art. For the others, therefore, I am the old man who
is sinking fast and about to jump off.

So now I have to struggle again, and chiefly against the inhibitions that
prevent me from exploiting my original talent. It is certainly not free, but
this does not entitle me to yield to the inclination to underestimate it. More-
over, I still struggle much too impetuously; if I were to pursue this matter
rationally, I should not even think of the word "struggle." Thus furious
surges and fits of depression alternate in a frightful way.

For the time being, a spectator's interest in this process keeps me alive
and awake. An autobiographical interest. Dreadful, if this were to become
an end in itself.

697. Vague irony is rather widespread. Life not serious, art not gay. A
certain hovering suspension of expression.

Perhaps I am making things too hard for myself? Yesterday I would still
have rejected *The Portrait of Dorian Gray;* today I enjoy it. The day before
yesterday it probably would have intoxicated me.

698. Lily . . . Trip to

1 Spiez, Montreux, Villeneuve, St. Maurice.
2 Leuk, Leukerbad, Gemmi, Schwarenbach (Lily rides up).
3 Gemmi, Schwarenbach, Kandersteg.
4 Öschinensee, Öschinenalp, Kandersteg.
5 Gasterental, Kandersteg (Blausee), Frutigen, Interlaken.
6 Brienz-Rothorn-Interlaken, Bern.

699. September. "Dear Herr Klee, the art critic is named E. Heilbut, Berlin W., Kurfürstendamm 128; the lady whom you wish to apply to, *Frau Direktor* Stern (Berlin). With best regards, your devoted Felix Lewandowsky."

700. Demon 692 is stirring again. You must pray: let my soul forget that it errs (Neuchâtel).

If only pain were to turn you—red laughter—into a beast that jumps at one's throat, you stupid smiler—pink smiling—(Lindau).

702. I copied the foreword to *Dorian Gray*. Did the same for other thoughts of Oscar Wilde. In a way because it was foreign to me, but perhaps true after all. Terrible, this: all art is useless.

Further readings: Turgeniev, *Waves of Spring*; Mérimée, *Colomba*. Lynkeus, *Fantasies of a Realist*, rejected them. Hebbel, *Herod and Mariamne, Michelangelo.* Rufin, *Julia.* Hauptmann, *Elga.* Wilde, *De Profundis.* Out of the last, I copied the passage about Hamlet. The finale too insistent.

707. October. From October 21st to 30th, I was in Munich unofficially, to kiss youth on the mouth ere the hour dies. But also for other reasons. Saw *The Devil's Part, The Barber of Bagdad* (Mottl), *The Tales of Hoffmann* and Klose's *Ilsebill* (Mottl), Adam's *Doll, Die Fledermaus.* Klose calls his work a dramatic symphony that tells all. The orchestra's performance was superb; not much could be heard from the figures on the stage.

At a Kaim concert Schneevogt conducted with a certain elegant vigor Liszt's Faust Symphony, Wagner and Berlioz. Ludwig Hess, the tenor, sang

solos. I heard in a main rehearsal parts of Mass in A minor by Johann Sebastian (Mottl).

Rops (*Les Diaboliques*), *le sphinx, le bonheur dans le crime, le dessous des cartes d'une partie de whist, le plus bel amour de Don Juan*, and many other things!

709. (Abridged:) "Dear Professor Heilbut, Berlin. I thank you for the friendly way in which you wrote me. Perhaps these indications will suffice for the time being. I am twenty-five years old, was born near Bern, raised in Bern (graduated from high school, in the humanities). Three years in Munich, with Knirr and Stuck. A winter in Rome. Then worked for two years without anything to show for it. In the summer of 1903, the first worthwhile work (engraving). Since my trip to Paris this summer a new period. Your proposal to publish one of the engravings in Cassirer's periodical naturally most welcome. Two works would be better. In any case, please do 'The Virgin in the Tree.' With respectful regards, Paul Klee."

710. Maybe I am inclined to perdition, but I am also inclined always to save myself quickly. I don't want anything to grow too big for me, even though I may want to experience it. I simply don't want it. I must be saved.

711. Musical events: an organ concert of particular importance was given by the Parisian Mahaut. The program was exclusively devoted to César Franck. 1. *Fantaisie la majeur*, 2. Cantabile in E, 3. *Pièce héroïque* (!), 4. *Panis angelicus* (song), 5., 6., 7., chorale in C, in G minor, in F minor. 8. *Air de l'archange* (*de Rédemption*).

At the second symphony concert, we more or less played our way through Schubert's Great C major Symphony and a romantic overture by Thuille. Rehberg, a pianist from Geneva, played the Piano Concerto by Hermann Götz.

At an organ recital by the good Herr Pfyffer in St. Imier, I appeared as soloist (to please him) and played the G minor Sonata by Tartini and the Adagio from Mozart's Violin Concerto in A; also, violin obligatos to a composition for voice.

We played quartets with Jahn; Schubert's G major and Beethoven's F minor; another time, clarinet quintets with first clarinetist Jähnisch.

712. November. I dreamed I had to give the funeral oration of a mediocre burgher. I reconstruct approximately what I said there (measured words, humble tone):

The excess of hope, later the lack of despair which this man, now dead, indulged in, can no longer be altered now. He clung to life anyway, but rather out of habit, and an indolent fellow like him never finds an end by himself. An ear, an all-too-human ear, gladly conveys to the heart the flattering talk uttered by kindred spirits. Yes, especially by women! He listened and forgot the motto he had learned in the eleventh grade: either persevere or quit. But he did his duty as a citizen, which is enough of an example for you mourners. R. I. P. (Muted thunder above.)

713/14. Really to love animals, that is: to raise them to the same level in relation to what is above.

A good moment in Oberhofen. No intellect, no ethics. An observer above the world or a child in the world's totality. The first unsplit instant in my life.

718. Our city's orchestra has improved a bit with the years. A good conductor might shape it into a really usable instrument. In the symphony orchestra we are twelve first violins, twelve second violins, six violas, six cellos, five basses; two flutes, two oboes, two clarinets, two bassoons; two trumpets, four horns, four trombones, two drummers, one harp—in all, sixty-two musicians. For compositions requiring a large orchestra, we call in reinforcements from Basel or Zurich.

721. The little bourgeois who lives on the floor below, across the hall: "I've hung the bird in the back of the room. Up there it was too warm for him. That's why he doesn't whistle. He is too close to the sunshine. He feels well there, and he just looks out without thinking. In the back, he will certainly start whistling. I'm going to whistle for him tomorrow."

722. A witty worker to a woman gathering bits of wood on the building-

site: "Pick up the stones too, they also burn!" She: "Not really?" He: "Sure! You simply have to let them dry!" She: "Not really?" He: "I found that out up on the Sangwäg" (Both strictly accurate [transcriptions in Swiss dialect].)

724. In Munich, last time, a very nice interlude took place. I sat in a restaurant having dinner and waiting for Lily with greater longing than usual. Just then a man came to my table and tried to bum the fare to Bamberg from me. I told him: my ready cash right now amounts to fifteen pfennig, and I am just wondering who to sponge from, if necessary, to pay for my dinner. He thereupon left, rather skeptical, and yet it was true.

725. Farewell, this present life that I am leading. You can't remain so. You were distinguished. Pure spirit. Quiet and solitary. Farewell, my honor, as soon as I take my first step in public.

726. December. True anecdotes. Dr. Schultz and Lewandowsky, having drunk a lot, were walking home. The (recent) earthquake sent both of them sprawling. They apologized politely to each other.

At the Meitschimärit (Maidens' Market), I saw four men leave a brothel and, to express their appreciation, strike up a touching vocal quartet.

Lily had to help a young lady, a cook, who was ashamed of her poor handwriting, by carrying on her love correspondence for her.

One who, in the midst of the sharpest pain, grows a wild beast's jaws.

It must be a kind of shipwreck when someone is old and still grows excited about something.

730. At Christmas, I visited Lily for two weeks. I had picked her up in Zurich. We spent a day in Oberhofen. While I was fishing there, some urchins called to me: "Mister Silly! The fishes are down at the bottom!"

We played music as if we were starved for it. Time and again too at Professor Lotmar's. There we played the A major Trio by Brahms and Beethoven's Trio op. 70, No. 2. Once as I was playing, among other works, Mozart's Concerto in A major, painters Brack and Cardinaux and zoölogist Dr. Voltz listened. I had a sudden insight into the meaning of Beethoven's Violin and Piano Sonata in C minor.

729 [*sic*]. At the third symphony concert we played Beethoven's Eighth and the Leonore Overture No. 1. Kreisler, a most wonderful violinist, played Beethoven's Violin Concerto and the Devil's Sonata by Tartini.

733. Read: Meier-Graefe, *The Böcklin Case, Manet and his Circle,* Baudelaire, *Fleurs du Mal* (!). At the theater we saw a comedy by Shaw: *Heroes,* which was very entertaining. Klinger, *Painting and Drawing,* of very doubtful value. As if only the beautiful subject were acceptable in art! The beautiful, which is perhaps inseparable from art, is not after all tied to the subject, but to the pictorial representation. In this way and in no other does art overcome the ugly without avoiding it.

735. Professor Heilbut writes from Berlin: "Dear Herr Klee, I am extremely sorry to have to tell you that my publisher, Cassirer, for reasons of expediency, on account of the subjects, cannot bring himself to publish one of the engravings in the magazine.

I now intend to write something about you in a highly esteemed Berlin newspaper (*did not happen*). I hope that this will focus some attention on you and induce some art gallery owner to ask you to let him exhibit your collection of engravings. In this hope I propose that you leave the engravings with me for the time being, in order to avoid the transportation back and forth that would become necessary otherwise. Respectfully yours, E. Heilbut." 12.20.1905.

736. I wrote my future father-in-law, against his will, a mollifying letter:
"My dear Herr Medizinalrat: I hear from Lily that you are annoyed because we revealed our engagement to our friends. I know that you were against it in the past, but I don't understand how you can still think it possible to keep it a secret now. And so it was best after all for us to reveal the irrevocable fact. We only regret that in doing so we did not inform you about it beforehand, etc., etc. With best regards, yours truly, Paul Klee."

If I had not written mildly like this, the blame would have fallen on Lily's head when she returned to Munich. When we are married next summer he

will have to swallow a much more bitter pill. This time he answered quite politely, asked sarcastically about the new household's means of subsistence.

737. Tonight the moon was a pearl that actually portended tears. No wonder, with this raging windy weather. At one point it was as if the heart stood still. The brain has evaporated. No thought, except for the heart that stood still. Don't yield, self! With you, the world would crumble, and Beethoven lives through you!

1 9 0 6

743. January. Lily celebrated Christmas and the New Year with us and stayed on till January 7th. No doubt our celebration was more modest than an all-out bourgeois German Christmas, with specified gifts "to the value of . . . ," but it was cordial and peaceful instead.

Drawing and painting on glass gives me all sorts of little pleasures. A sentimental lady, with hypertrophied bosom, accompanied by a tiny dog, is completed.

At the theater there was a really outstanding *Carmen* (with Frau Gay as guest artist) to be admired. I had never seen the primitively instinctive nature of this unique character so charmingly embodied. The little local people, in contrast, were like well-behaved dolls; only Don José was a little bit carried away at the end by this beautiful beast of a woman. In *The Marriage of Figaro* the provincial actors and musical dilettantes were on their own again; still they couldn't completely mangle this incredible work. Even Thürlings liked it, only the overture was still too fast for him. Considering the rather sloppy execution, I concede his point, but then you would no longer feel the tone of light comedy. I would like to hear it played with greater precision and a whole shade faster still, so that the laughter of the wind instruments at the end might sound like laughter . . . Munich!!

When it comes to Mozart, there is no substitute for Munich. By this, I don't just mean Herr Geheimrath von Possart. This man, after all, can travel even to Bern, where he started his career. And he did come to Bern.

But the entire symphony concert took its cue from Munich. Overture to *Faust,* Venusberg Music. Love scene from *Feuersnot* and Don Juan by Richard Strauss. The Witches' Song with the music by Schillings. The old man was bewitchingly amiable at rehearsal; everybody was swept off his feet by him. "Brother Medardus became old and weak." In what truly Possartian fashion he said it!

I read a unique book: *Candide* by Voltaire. Three exclamation points. Then again Strindberg's eleven one-act plays and his writings about *Miss Julie* and the modern drama. Then Taine, *La philosophie de l'art.*

744/45. No one has to get ironical about me, I see to that myself.

I dreamed that I beat a young man to death and called the dying one an ape. The man was furious about it: wasn't he breathing his last breath? All the worse for him, I answered; then his evolution cannot continue!

Oh, the overfed bourgeoisie!

747. Democracy with its semi-civilization sincerely cherishes junk. The artist's power should be spiritual. But the power of the majority is material. When these worlds meet occasionally, it is pure coincidence.

In Switzerland the people ought to be honest and prohibit art by law. After all, the most honored citizens never moved on this level. Here are the real semi-barbarians. And the masses believe the country fathers because no real society of artists exists of a sort that might attract public attention. The 999 creators of trash still love to eat their patrons' bread.

Science is better off. But the worst state of affairs is when science begins to concern itself with art. Soon the time will come to leave Switzerland forever.

748. Dream. I flew home, where the beginning lies. It started with brooding and chewing of fingers. Then I smelled or tasted something. The scent freed me. I was completely freed at once and melted away like a piece of sugar in water.

My heart too was involved; it had been far too large for a long time, now it was blown up to inordinate size. But not a trace of oppression. It was borne to places where one no longer seeks voluptuousness.

MASCULINE HEAD, GYPSY TYPE, 1906, 4

If a delegation were to come to me now and bow solemnly before the artist gratefully pointing to his works, I would not be surprised much. For I was there where the beginning lies. I was with my adored Madame Monad, which means, so to speak, being fruitful.

749. Doctors are witty people. Why, they ask, must Professor Sahli have his anus operated on? Doctor Tapeworm had to be pulled out, they answered.

750. February. New works on glass: "A Girl Writing," after a pencil-drawing from nature, stepping, all white, out of a fish, etc.

Played music at the Zionist Student Association: Schubert's String Quartet in A minor, with the good Jahn as violinist.

Acquired a Testore violin of the year 1712, got rid of the old, charmingly revarnished Mittenwalder. One falls in love with violins. But when they are jilted, they don't commit suicide. That's convenient.

At the symphony concert we played the excellent symphony by César Franck, Berlioz' Cellini Overture, and Liszt's Mephisto Waltz. Baritone Louis Fröhlich from Paris sang splendidly, especially the Mephisto Serenade from *The Damnation of Faust*.

This time I just read world literature. Rabelais, *Gargantua and Pantagruel*. Molière, *Les Fourberies de Scapin* and *Le malade imaginaire* and, by Hoffmann, *Zinnober* and *Phantasiestücke*.

753. February. The hybrid blossom is an appropriate symbol for a good marriage.

A *bon mot* overheard in the arcades of Bern: "He must be wearing a pair of new shoes in his head; that's why he's carrying it so stiff." The Allemannic bear doesn't want to lag behind the other animals on the Allemannic scutcheon. By no means!

756. February 1906. Since my last works, I have gone much further in practice, because I have succeeded in maintaining my style in the immediate presence of nature. Now my struggling is over. I may enter life now. I am speaking of things like the "Little Garden Picture," on glass.

Your head is a tower with lenses where light rays dance.

757. My work in the studio will grow considerably more lively. I have succeeded in directly transposing "nature" into my style. The notion of "study" is a thing of the past. Everything shall be Klee, regardless of whether impression and representation are separated by days or moments.

If sometime I should again be unable to express myself on an empty stomach, I'll just have to go hunting, lie in wait, and strike the best way I know how. Production will not have to be interrupted then, never again. Naturally a certain dualism will be unavoidable at first.

I wonder whether I shall ever get as far in the realm of color? At any rate, still another limitation has been broken, and, at that, the heaviest, hardest limitation there is for an artist. This improvement jibes wonderfully well with my plans for marriage. It will be good to live in a large city, and for Lily it will be good to leave her parents' house. Both of us will simply work. For how long I don't know; I am just not to be evaluated by bourgeois standards.

It would be shortsighted to set a time limit, so as to explain the shipwreck eventually. As long as I work, there certainly will be a right to hope. And I will work!

758. March. For my kind of composition, it is essential that the disharmonies (profane imponderables, defects or roughnesses) in the values be brought back into equilibrium by counterweights, and that the harmony regained in this way not be wanly beautiful but strong.

In category A (without nature) a good work on glass, "Marionettes." The puppet drawn in black, the strings in purple.

At the fifth symphony concert we played Borodin's Second Symphony as the main work. The blind pianist Fabozzi played Chopin's Concerto and various solo works.

Shortly after, we played the same symphony in Neuchâtel, and besides, Berlioz' Cellini Overture. The wonderful violinist Capet, from Paris, was guest soloist. (Violin Concerto by Brahms, *Album Page* by Richard Wagner, and solo pieces by Bach, *Sarabande et double, Bourrée et double*.)

From Neuchâtel I traveled across the Jura to Basel to hear the Joachim

Quartet. Mozart's E-flat major, Beethoven's C minor op. 18 and B major op. 130. A lucky coincidence enabled me to become acquainted with good French Impressionist paintings. Simon, Carrière, five Renoirs, four Monets, a Degas, etc., and a room devoted to Rodin.

In Bern, Verdi's *Othello* (love purified of jealousy by death—how beautifully the music expresses this at the end!) was performed; it impressed me, because I hadn't known the work before. The coloratura Wedekind was guest artist in the *Barber*. She is unattractive as an actress, something inferior emanates from her. The Berner Bund put on *Oenone*, a drama by Grillparzer. One celebrates one's native writer, and no one can object to it. It is so very natural. To be sure, if he were a prophet, the local temples would close before him.

759. March. A nice anecdote still survives about the days when Haller was a high-school student. To punish a teacher, it was decided that somebody had to shit on the handle of his door "before sunrise." Two strong twelfth-graders raised Mimu to the proper height. But then Thiessing suggested that it would be more practical to produce the coating in a more comfortable position and then somehow to transplant it to the ordained place. But Haller rejected this procedure as too commonplace. He had no pity for the twelfth-graders: the sacredness of the act was to inspire them with the necessary strength.

To emphasize only the beautiful seems to me to be like a mathematical system that only concerns itself with positive numbers.

760. Ingenious glass-pane technique: 1. cover the plate evenly with white tempera, if need be by spraying on a diluted mixture; 2. after it has dried, scratch the drawing into it with the needle; 3. fix it; 4. cover the back with black or colored areas.

The trained hand often knows far more than the head.

The compositional harmony gains character by dissonant values (roughnesses, imperfections), which are brought back into equilibrium by means of counterweights.

761. O poet! Wishest thou to describe the rotten air of a grave, and art

thou without the inspiration that is so needful for it? Then buy a *camembert*: by sniffing it from time to time, thou wilt succeed.

762. Dream: I am visiting a magician in his garden. A bench, all made of crimson roses, stands there. Please! He urges me to sit down. I pretend to. He sits down without batting an eye. My sitting attitude gradually becomes painful. Facing me, the magician's daughter stands at the window; I smile at her in embarrassment. Irritated, she closes the window, but observes me all the more unabashedly from behind the curtains.

In our dreams moments of our life often recur which have surprised us and made us momentarily helpless. They are mostly trifling occurrences. The great impressions of times when one has exercised self-control remain at a distance.

763. With Bloesch, I took the Neuenburg train as far as Ins, and the electrified, secondary line to Sugiez. From there we went to see the Wistenlacherberg (Mont Vuilly); from its top, the lakes of Murten and Neuenburg can be seen, as well as a part of the Bielersee. Fine walk through vineyards, under warlike cannonades of hail. It was a somber day, swept by a north wind. Rhythmically, snow clouds sailed through the blue sky. We had a lunch in Môtier. Then we wandered through the most beautiful, flower-strewn spring landscape over to the sedate village of Gümmenen, then took the "Direct" train home. I feel closer to the lake country than to the Alpine regions.

764. The etchings now are to be assembled in a single, large frame for the Sezession in Munich. Otherwise the jurors might pick the collection apart. Lily ordered the frame in Munich; this way we shall save the cost of transportation. 1. "Woman and Beast"; 2. "Hero with a Wing"; 3. "Virgin in a Tree"; 4. "Comedian" (copper); 5. "Feminine Charm"; 6. "The Two Men"; 7. "The Monarchist"; 8. "The New Perseus"; 9. "The Aged Phoenix"; 10. "Threatening Head."

For Professor Stuck, I am assembling a portfolio of separate printings of the same plates, so he will be prepared and perhaps will put in a good word for me. If not Berlin, then at least Munich! I believe it will work out.

765. April. Trip to Berlin and back by way of Kassel, Frankfurt-am-Main, and Karlsruhe.

Sunday, 4.8. Bloesch and I went to Basel, where we had dinner at the home of Louis Moilliet's brother-in-law. That same night we traveled on by way of Frankfurt, Fulda, Erfurt, Weimar, Halle. Monday, 4.9. Arrival in Berlin at 2.40 p.m. Jonas Fränkel, Bloesch's friend in his student days, picked us up at Anhalter Station. Soon we found a private room in the vicinity (Köthener Strasse) and were able to take our first exploratory walk. Potsdamer Platz, Leipziger Strasse, Friedrichstrasse, Linden, the Palace of His Majesty, museums, the Brandenburg Gate, Wertheim.

Tuesday, 4.10. At the Kaiser-Friedrich Museum until three o'clock. Had a meal somewhere or other, mediocre. Linden, Reichstag Building, Bismarck monument (!), Siegesallee (!!). In the Tiergarten, the Kaiser rode by theatrically. Took the underground from the Tiergarten to Potsdam Station. Sudden decision to go to the Comic Opera. Asked a coachman for directions, jumped on a bus. *Marriage of Figaro*. Later, dinner and then to a café. Back home at two in the morning. Figaro had been staged very cleverly by Gregor. Costumes in the style of the Revolution by Walser. The musical part was not as good as in Munich. The director caused a disturbing interruption in the last act when, for the sake of atmosphere, he had nightingales twitter. I was particularly receptive this time hearing the magnificent things that follow "Engel verzeih mir." This is the very highest level of ethos, only expressed so much more economically than in *Fidelio*.

Wednesday, 4.11. To the Centennial Exhibition (National Gallery). Paid particular attention to Feuerbach, Marées, Leibl, Trübner, Menzel, and Liebermann. Empire and Biedermeier did not exactly appeal to me. Lunch at one o'clock. Then to the Pergamum Museum, where we suffered a great deal from the sultry weather. Thirst drove us into a tea shop (Aschinger). Then the year's first storm burst. On the Potsdam Station a blackbird sang with touching idealism. We had enjoyed the Comic Opera so much that we went to see Donizetti's *Don Pasquale*. The performance was even better than yesterday's. Fräulein Francillo-Kaufmann we recognized as an old acquaintance from the Hoftheater in Munich. She looked most lovely, and the director had taught her how to act.

NUDE STUDY IN THE ART SCHOOL, 1906, 30

Thursday, 4.12. Went to the Kaiser-Friedrich Museum for the second time. At night, to the New Theater, where the *Midsummer Night's Dream,* staged by Reinhardt, was playing. Afterward a friend of Louis Moilliet who studies music with Humperdinck invited us to an excellent meal and to a nocturnal automobile drive through the Tiergarten. It lasted until four in the morning.

Friday, 4.13. (Good Friday). A quiet day, with a long siesta. At five o'clock I paid a visit to my Professor Heilbut in hopes of inciting him to keep his promise. A pleasant man with a slight nose defect. He was very sympathetic and agreed that I was right to move to a large city. Gave me a handsome biography of Goya with many illustrations (by Loga), a kind of collateral. If he doesn't keep his word—and he will be able to send me back the engravings only when he has some good news to tell me—I shall have the handsome biography of Goya instead. At seven o'clock I went to have dinner at the home of my first buyer, Schultz. He has a comfortable place. His wife is expecting, and so is he—namely, patients.

Saturday, 4.14. Morning at the Zoo. In the afternoon, at the Ethnic Museum. At night, went to the Lessing Theater, where *Rosmersholm* was being given, with Triesch, Reicher, and Bassermann.

Sunday, 4.15. In the morning, went to see the parade. At night, to the German Theater, where Reinhardt has staged *The Merchant of Venice.* Portia: Sorma. Shylock: Schildkraut. The sets by Corinth. It was one of the best theater performances I have ever seen in Germany. Oddly enough, the Berliners don't applaud much.

Monday, 4.16. I took leave of the country's capital, its theaters, its one-mark meals (bread and mustard free), its bedbugs, and its nice people with their little amusements. Why does one never hear anything but insults about Berlin? After all, it is really a very pleasant city!

The train left at 8:35 and went through Potsdam, Brandenburg (on a lake), Magdeburg, etc. At 1:46 Lily and I met happily in Kreiensen. At four o'clock we reached Kassel.

Bloesch had wanted to stay on for a little while in Berlin and to join us later.

766. Kassel. Tuesday, 4.17. During the morning, at the extraordinary museum. After lunch, we rested until five o'clock. In the evening, we visited Wilhelmshöhe.

Wednesday, 4.18. Early in the morning Bloesch turned up while we were having coffee. He had traveled all night, "a soldier pressed against my breast," and looked it. We visited the Museum again, with its outstanding collection of Rembrandts. After lunch we strolled through the well-scrubbed city.

Thursday, 4.19. We left (Lily and I) at 9:40 a.m. for Marburg, where Lily paid a call at the Schwanallee. Meanwhile, I felt somewhat ill-humored at this fraternity students' hangout. Besides, the weather gradually became quite rainy.

At five o'clock in the afternoon we arrived in Frankfurt-am-Main.

Friday, 4.20. Spent the morning at the Städel Gallery. Bloesch joined us again to visit the Meunier retrospective. Afterward we went to the palm garden as usual.

Saturday, 4.21. Again to the Städel Gallery, then to the Zoo and at night to the Opera, where *Titus* was given a distinctly mediocre performance.

Sunday, 4.22. We made an excursion to Wiesbaden and took the beautiful walk to the Neroberg, with its fine view.

Monday, 4.23. We visited the Goethe House and began to think with melancholy about having to take leave of each other.

Tuesday, 4.24. We parted at 6:20 a.m. Lily's train to Munich left at 6:30.

At nine o'clock in the morning I arrived in Karlsruhe. Had breakfast in some insipid establishment or other and set out for the Kunsthalle. Here I saw the celebrated Grünewald, which frightened me, and Feuerbach's "Last Supper," which again left me a little cold. The train for Basel left at noon. I arrived there at four o'clock and devoured a good Swiss meal, I don't remember where. At 6:22 I was already back on the train, and I reached Bern at nine o'clock in the evening.

767. Concerts in Bern. 6th Symphony concert: Haydn's C major Symphony and the Overture to *Alceste* by Gluck. Ludwig Hess sang a tenor aria from *Don Giovanni* and many songs, among them Schubert's "Sei mir gegrüsst," which he interpreted charmingly.

The choral societies performed *Il Paradiso Perduto* by Enrico Bossi, a fairly operatic oratorio. An alto, Frau Kraus-Osborne, sang quite beautifully. There were about eighty of us musicians. At the Theater a tenor appeared as guest artist and had the misfortune to become completely hoarse. Two philistines commented:

1: "What that fellow needs is bear's dung." 2: "Why, then he's come to the right place!"

My best reading was of course Loga's biography of Goya, which Professor Heilbut had so innocently given me.

768. May. I work feverishly from nature, partly in the garden, as if I were bent on showing that the trip I had taken was profitable. Of course, as luck would have it, a great many difficulties crop up. In this way the month is spent before one realizes it. Goya hovers around me; that probably is the main trouble: but it must be overcome. I once again read in my favorite book, *Don Quijote de la mancia.* Also, a bit of Ibsen, letters, and Chekov, whose somewhat brutal wit does not appeal to me particularly.

770. In our garden I lavish pious attention on the bergamots that I brought back from Rome and replant them by making a strong branch grow independently. This procedure also provides a neat experiment in the field of capillary action.

A Plant with two branches *a* and *b*;

B Branch *b* is bent down and fastened to the ground by its middle.

C After it has struck roots at this point, it is severed from branch *a*.

D The new plant *b*I/*b*II grows independently; from now on, the circulation of the sap in branch *b*I is reversed.

772. The people of Bern are a bit slow; they probably think more than they say, or else they certainly would have shouted something up to "Knie" on his high rope, as he was making the following home-spun speech up there: "The performance will last an hour and a half. For this hard period of work we are forced to demand a fee of at least twenty to thirty centimes. Every sort of work must be paid, and I know that none of you would work an hour and a half for thirty centimes."

"Now up on the highest rope! For this, we must ask for an additional sum of ten to twenty centimes! I am sure that none of you would do such risky work!"

(German clowns are far from being this witty.)

773. June. Am working almost feverishly in spite of great heat and very sultry weather. Hesitation between the, so to speak, classical style of the engravings exhibited in Munich and a certain loosened style such as the Impressionists display.

At the beginning of the month, a few days in Thun. Once Heinz Lotmar came; we took the walk from Spicz to Leissigen. In Bern I visited the Schänzli with Olga Selig. Naturally on a Saturday, my only social day, or more precisely, afternoon. He starts at the Café "Jahn"; once he ended in the Engried at Frau von Sinner's.

I became acquainted with Ernst Sonderegger, a fine man; Haller had sent him to me. A fine, inward-turned smile.

Here and there, an intense, discreet side glance, which one hardly sees but which one feels like an ultrared [*sic*] ray. He comes from Davos, feels a kindship with the satirist in me. He explains his bent toward it autobiographically, in part by the bad treatment he endured in early youth. My satirical glass pictures evoke for him the name of Pascin, but he finds greater concentration in me. Seems to understand me well, up to a point. It's possible to converse profitably with him about people.

775. When I wanted to render an asphalt base—which had become too rich and was already warmed—somewhat more fluid by sprinkling it with turpentine, it marbleized in a most attractive way into a new kind of aquatint base. This is how one makes discoveries in one's stupidity.

776. Water, upon which waves, upon which a boat, upon which a woman, upon whom a man. Already thought out in the summer of 1904. Rocking construction.

777. Romantic fits? Play of fancy? Reverie? Vaporous masses heaped toweringly? Darting lightning? (Dramatically:) Out of joint goes the law! Oh!

SEPTEMBER

Personal news. Engaged: Dr. Ferdinand Knoblauch, secretary of the Chamber of Commerce, Fräulein Josepha Mayer, daughter of the Court stirrup master; artist Ernst Paul Klee, in Bern, to Fräulein Karoline Stumpf, daughter of *Medizinalrat* Dr. Ludwig Stumpf. — Married: Lieutenant Ludwig von Hacke, of the 2d Light-Horse Regiment, at present serving at the riding school, and Fräulein Emma Meyn, daughter of landowner Charles Meyn, of Cuxhaven; District Judge Dr. Michael Maduschka and Fräulein Hildegard Roth, daughter of the *rentier* Anton Roth.

** Famili .nachrichten.* Als Verlobie sind vom Standesamte aufgeboten: der Handelskammersekretär Dr. Ferdinand Knoblauch hier mit der Hofsporermeisterstochter Fräulein Josepha Mayer hier; der Kunstmaler Ernst Paul Klee in Bern mit Fräulein Karoline Stumpf, Tochter des Medizinalrates Dr. Ludwig Stumpf hier. — Vermählt haben sich: der Leutnant im 2. Chevauleger-Regiment Ludwig Freiherr v. Hacke, zur Zeit kommandiert zur Equitationsanstalt, mit Fräulein Emma Meyn, Tochter des Gutsbesitzers Charles Meyn in Cuxhaven; der Amtsrichter Dr. Michael Maduschka hier mit Fräulein Hildegard Roth, Tochter des Rentiers Anton Roth hier.

Munich

778. October. I am legally a spouse, for at the mayor's office I walked through the door labeled "Married." Herr Henzi dispensed noble exhortations to us from behind a large bouquet of flowers, which his words skirted, sometimes to the left, sometimes to the right, and which he addressed sometimes to me, other times to my bride. On the Münsterplatz the market was open, and the butchers had a laugh as we walked by their stands. Such were their simple souls.

In Munich that soul is of a different nature. The city is less friendly, especially when you live in a small boardinghouse on the Fürstenstrasse. The people, on the other hand, are quite cheerful. I looked with amazement at the monotonous, smoke-begrimed façades of the houses in which I was now to be a good burgher.

But there are also temptations. Music, opera, cheap picture frames. Even in the long run, it is certainly livable.

Work still not as it should be, but work nonetheless. Nice little apartment at 32 Ainmillerstrasse, in the building overlooking the garden, second floor on the right.

A modeling table, plaster. Why that? Just bought it!!

Freischütz led by Mottl. Flute solo by D'Albert and the unpalatable *Feuersnot* by Strauss, Richard. *Samson and Delilah* with the pasty Preuse-Matzenauer. At the Gärtner Theater, Offenbach's witty *Orpheus*. A piano recital by Max Pauer: Couperin-Rameau: Eroica Variations, Brahms' F-flat minor Sonata, wonderfully played pieces by Liszt . . . Schneevoigt, conductor at the Kaim, acts the virtuoso, but has nothing in him. The old Lily Lehmann sang, remarkably well, "Ich grausam" from *Don Giovanni*, five songs by Richard Wagner, and many songs by Robert Franz. Amusing reading: *Anatol* by Dr. Schnitzler. Hebel's *Treasure Box* is better. Hard as I try, I make absolutely no contact with Byron (*Don Juan*).

779. November. A certain comfort, though perhaps a bit insidious, cannot be denied. A nice, warm room for working. Lily's grandmother gave us a big,

shining *chiffonnière* in *bourgeois* Empire style; the many drawers bring order into my work things.

In Bern I had been commissioned to do "Portrait of a Child," a colored drawing on glass, for druggist Albrecht-Moilliet in Basel, and executed it right away. The fee was two hundred francs. A price for friends.

Immediately, Frau von Sinner also wanted to have a portrait made, and I am now dutifully working at it, not to stretch her impatience too far.

Besides, I moved with the utmost zeal on the smoothest surface, on glass, simplified, threw off ballast, until little or none remained.

With a friendly introduction, a portfolio under my arm, I went to see Dr. Geheep at the *Simplicissimus* offices at a very dirty spot along Kaulbach-strasse. I thought, since Pascin was held in esteem there, that I might be acceptable too. But Geheep, after conferring with his colleagues, asked—with all due respect—for things that might fit *Simplicissimus* better. Since I am in no way a virtuoso, and don't wish to become one, I unfortunately was forced to drop the idea altogether—so pleasing from the economic point of view—of becoming a cartoonist for *Simplicissimus*. Even Pascin's art seemed to make the gentlemen sigh softly.

November/December. There were plenty of concerts, and I heard enough of them. Busoni played, among other works, the Opus 25 Études by Chopin superbly. Then Max Pauer again; this time he showed us what a man Mendelssohn was. The great Meschaërt sang songs and ballads with deep musicality and perfect declamatory restraint; Marteau played the Brahms Violin Concerto.

At the theater, Berlioz' *Destruction of Troy* led by Mottl, which is enough said. But, on the other hand, a horribly styleless performance of *Tartuffe* on 12.18.

780. December. In this city of five thousand painters, I now live entirely alone and for myself. I remembered Lichtenberger, a student of Knirr's, but found him tired and disillusioned. This is of no use to me.

Speaking as one human being among others, life was quite monotonous. In Solln my acquaintance from the good old days with Frau Frida Fischer was renewed. Then Frau Hofman-Menscher, Lily's former teacher, invited me to Brahms' Sonato op. 100. And once Lily's little pupils came to our house for their audition, which made a pleasant change.

SOOTHSAYERS CONVERSING, 1906, 33

The work consisted mostly in transposing older motifs into the new, loosened style. The cool casualness with which this was done sometimes almost deluded me into thinking I had attained a certain mastery.

781/782. As I look back on those days, I rate first in importance the display of the engravings at the Sezession show; less important was a show at Wachendörfer's in Frankfurt-am-Main, which aroused no interest whatsoever. The "Portrait of a Child" for Basel brought me two hundred francs, and the "Portrait of Frau von Sinner" in Bern, six hundred marks.

At the end of the year I heard Richard Strauss' *Salome* conducted by Mottl, with Knote, Preuse-Matzenauer, Larsen, Feinhals, etc., and *The Magic Flute* conducted by Mottl, with Bender, Bosetti, Knote, Zimmermann, Brodersen. The direction of Mottl was unique! Such restraint in spite of all that vigorous tension, and when once in a while he emphasized a passage, like "die Wahrheit, die Wahrheit," what an effect he got! Finally, Stradella with Knote, chiefly in order to be able to hear his beautiful voice to my heart's content, for once.

Fritz Kocher's essays are of considerable interest from the psychological point of view. But Byron! Byron! I shall never quite come to an understanding with you, no matter what.

1 9 0 7

783. January. Lily's friends invite us to see them; I couldn't claim that this is any advantage to us exactly! But I don't at all wish to underestimate people with a really friendly interest and who don't sound my gravely injured father-in-law's horn of lamentation.

Coming from bourgeois, after all, this gesture implies a certain generosity.

Among the people from earlier days who have turned up again—besides Lichtenberger, whose creative drive is exhausted—is Wassiliew. One change in her consists in her obvious pregnancy (if only Haller could see it!), and this I suppose will quite disappear again. She is now called Eliasberg, *it being the case that* she has married a German-Russian-Jewish literary gentleman of that name. All in all, it was a pleasant and entertaining evening, and there

were all sorts of things to listen to, look at (among others, Beardsley's Salome illustrations), and "learn," since this gentleman is informed, if only superficially.

784. I again turned to paper; with India ink, applied partly by spraying, I made some tonal drawings, using older drawings in the process. Tonality is beginning to mean something to me, in contrast to the past, when I seemed to have almost no use for it.

Eliasberg wants to try his luck again with *Kunst und Künstler* ("Art and Artists") now that Heilbut has been fired as editor. The new man is named Karl Scheffler. I sent engravings and pictures done on glass, among them "Father," "Couple in Brown," "Past Grandeur," "Drawing, Portrait of My Father." This last-named work he called "The Prophet Elias."

To the jury of the spring Sezession show I submitted these pictures on glass: "Comedy," "Lyrical Submersion," "Woman and Beast" (green-red).

785. Heinemann, the conservative gallery, soared upward to show the French Impressionists. Above all else there was the magnificent "Absinthe Drinker," by Manet, which helped me greatly in my efforts with tonality. Then a large array of works which gradually move toward colorism, from "Bon Boc" to "Lady with Parasol." Either the "Absinthe Drinker" is really the strongest work of the lot, or I am particularly attuned to it at this time. By Monet, there were landscapes of Paris (Boulevard scene!) and surroundings. Courbet was represented by the great picture "The Wrestlers."

At the Sezession there was an ensemble of works by Uhde, very respectable, but somewhat pale next to the French, and only in some details genuinely Impressionist. Hölzl has made amazing progress, but the fact that there has been progress is in itself even more interesting. Herr Schramm is a ghastly painter.

785a. Mottl conducted a charming opera by Berlioz: *Benedict and Beatrice*, following "Tant de bruit pour une omelette." Fräulein Fassbender really is a great artist.

Humperdinck's *Forced Marriage*, on the other hand, oh my!

Reisenauer, a superb pianist, played—one can't say that he played the

piano, because it sounded completely de-pianotized. Opus 110 in A-flat major by Beethoven, Schubert's *Moments Musicaux* (there was one!!!) and *Impromptus*. Then many pieces by Chopin, one by Field, and a few by Liszt! An experience.

D'Albert had a hard time, I remained quite cool, and the piano rattled. The angry face with the little piggish eyes didn't succeed in wrenching the stuff out, either. I remained cool down to the very heart.

Stavenhagen-Berber-Kiefer played together, and that was that. The Bohemian String Quartet is still good, in spite of the change of violist.

Mottl returned to provide some new experiences. This time it was the Eroica!!! Hebrides Overture and "Bohemia's Groves and Meadows" preceded it.

786. February/March. The good will of the brand-new head of the family and father-to-be moves me to undertake a really absurd project: "A Portrait without Commission for the Summer Show of the Sezession!"

If the real production had not just fallen off sharply I could have allowed myself even less to do such a thing.

Moreover, Scheffler refuses me, and likewise for the spring Sezession exhibition. He wrote two or three pages to Eliasberg; he grants that I have talent, but detects too many mistakes. Kubin too is bad, he says, but at least imaginative. Now I look like an ass, as people say in Munich.

Apropos *papa*—that's just the way it goes. I can't call it a joy, but it certainly is better now than later, since Lily is thirty years old.

787. April. The portrait that I have undertaken for the exhibition excites me. The glass plate is so beautiful and pure. Why all the dabbing with a brush and pricking with a needle? And the damned deadline.

The people of Bern want a humor magazine, a degenerate cross between *Simpel* and *Jugend*. Certainly fated to be stillborn. But the artists hurry, while there is still time to get something out of it. Significantly, I am the last one to be approached. But Aemilius Cardinaux did remember me, let's give him credit for that. After all, he might have forgotten about me until the day of the bankruptcy.

Other worried voices are heard from old Switzerland. My "Portrait of Frau

von Sinner" arouses a good deal of excitement. Fritz Lotmar has to defend me!! . . .

Nice of him.

788. Mottl's preference for comic opera is very pleasing. It enabled us to hear Donizetti's *L'Elisir d'amore*, with Bossetti. Herr Geiss was lively, though not fiery, and rather dry and comical. This was played recently.

Then I saw some Shakespeare again. *Richard III* played by Herr Lützen-kirchen. It wasn't too bad. A still better performance was put on by a woman of the people beside us (*sotto voce*, in the balcony). She hated Richard violently. "There he is again, the scoundrel," she hissed when Mathieu made his entrance. It was unbelievably funny.

Händel oratorio *Saul*. It is very good. Felix von Kraus gave a beautiful display of interpretive power and sang the dialogue with Samuel all by himself. Ludwig Hess, the tenor, conducted without any technique; his conception of the work was a little affected.

A large collection of works by Toulouse-Lautrec. The graphic pieces are particularly good! But Trübner's skill is so cold that it gives me a cough.

Michelangelo's letters. Wedekind, *The Waking of Spring*, good.

790. My successes to date. I sent the engravings to Keller and Rainer in Berlin. No. Then to Heilbut, likewise in Berlin. He asked Cassirer, who said: No! As a "student of Stuck," I was able to exhibit them at the Sezession show of 1906, in Munich. The critics remained silent about an event which, to me, had a certain importance after all, except for a small paper in one of the Forest cantons, which shook its head mightily, a gesture signifying in our climes: "No."

I went on developing cautiously and, after Heilbut's fall, turned confidently to Karl Scheffler. The latter shouted "No!" several times. And from the rooms of the Sezession on the Königsplatz, above which the spring sun shone, an echo resounded: No! *Simplicissimus* had also whispered No, which found its complementary echo at the Debschitz School on Hohenzollern-strasse. "No—in green." Herr Schmoll had thought of handing me over the position which he had given up, but he had not reckoned with the landlord, the good friend von Eisenwert. True, my Swiss patrons, who had commis-

sioned me to do their portraits, paid me as agreed, but that money was eaten up more quickly than can be imagined. To make up, I now received a visit from Green Heinrich, looking prematurely wilted, who invited me to the handsome leftovers of a banquet served to the voracious artists of Zürich-Bern-Basel. "Yes?"

791. May. Ibsen: *When We Dead Awaken???* *Don Giovanni* conducted by Mottl at the Hoftheater. Joachim Quartet, May 11th.
 Haydn is performed extremely subjectively these days.

Beethoven: Opus 127 E-flat. Schumann: A minor. May 13th: Mozart's D

Brahms: B major, the least of all. Beethoven: Opus 59 in C.
May 17th. Yes? Yes! Sent several drawings to Green Heinrich.

792. We were invited by a patroness, with a touch of affectation, and her retired husband, a pig-headed Hessian. Name is B., the place: Prien am Chiemsee. Broad and humid countryside. The whole party was later invited over by someone named Zimmermann, a kitsch painter. Good cigars. Carriage ride. Wine.
 At B.'s, the food was heavy. Nicest thing about it were the boat rides and the walks which we took by ourselves.

Dr. Voltz met his death on an African journey. A kindly, brave man. He stepped into some fighting by Frenchmen in Liberia. Just before, he had told me: "Maybe it will kill me, and if it doesn't, I'd like to get married." I can still see him before me, in the Nydeck arcade. Fritz always dragged him to hear music. "Toward the end, he started to like it."

793. June. I am obsessed with tonality. I squint convulsively (if only some teacher had advised me to do this!). Now I also know why one draws with charcoal. Now a picture like Corinth's "Portrait of Ansorge" also means a little something to me.

July. *Götterdämmerung, Fidelio,* and *Così fan tutte,* all conducted by Mottl. At the end of June I made the acquaintance of Albert Welti.

In July my father came from Bern for a visit. We showed him Munich. He was probably supposed to take us back with him, but he made off early on the grounds that he was needed at home. Or maybe our vegetarian diet didn't suit him? *Did carrots and peas make him cease? As you please.* We followed him at the end of July.

794. August and September. Bern. We spent two months there. Bloesch came from Rome, Fritz and Olga Lotmar from Berlin. Hallermändu from Finland. A great deal of music. Lewandowsky, the capering cellist. Dvořák's Dumky Trio suited him, it was not so austere. But I bungled a great deal in this gypsy stuff.

A preacher joined us to play quartets. Music reconciles! I played the viola in Opus 59 in C major. A couple of times, I made noticeable mistakes, in the little minor passage, on the low string. In other respects my Bergonzi was exquisite.

We are testing. We are testing names. A: Julian, Felix, Alexander, Joachim, Franz; B: Susanne, Helene, Henriette, Franziska, Charlotte, Eva.

795. Work was also accomplished in Bern. Outdoors. Charcoal, sometimes touched up with color. On a misty autumn morning I spread the large, humid sheets of Ingres paper out on the gravel in the garden and inspected the van of my army with Hallermändu. The General gave praise. Afterward he praised himself in affable tones: "I've always wanted to do hard things, until I could

do them. I puttered around, you understand! Afterward, I always dropped it. But in art things don't go so fast; you've got to stick with it, probably forever."

A light-hearted way to justify his relation to art. Done unsentimentally. I rediscovered the beautiful quarry in Ostermundig. Or acquaintances had to sit for me in the garden.

796. Leissigen. In September we spent some time in Leissigen, in a small furnished apartment, rented at off-season rates. We didn't catch much fish. The *bourgeoisie* from Basel was rather disturbing. My wife very fat. Food in Bernese peasant style. Beans with bacon at the Steinbock, not bad at all. At night we prepared our own food.

There were plenty of flies for casting near the woodpiles. But there were considerably fewer fish. Here and there a steamboat. Walnut trees, beautiful, aromatic walnut trees. Vis-à-vis Beatenberg. Yes, yes.

News came of Joachim's death. I sensed something like this during the Fugue in C major.

798. Munich. The section marked "Being a Father" gradually begins. Once again reached my destination, thinking of what is to come: all sorts of forebodings. Errands at the Military and the Tax Bureau add a sort of acrid spice to the atmosphere of expectancy.

Pleasant news that Ernst Sonderegger is settling in Munich. His wife sings; she was well disposed toward us right from the start. He is a good, kind man.

I swing like a pendulum between the sobriety of my recent tonal studies from nature, which I continue here by chasing through the suburbs with portfolio and easel, and the fantasticality of Ensor. The fantastic is not always cheap, not always literary. Sonderegger introduced me to this Ensor. Something of that sort had to exist. Then Daumier!! To a lesser extent, De Groux and Gavarni. A complete Parisian, this Sonderegger. Would certainly prefer to be there, if his wife were not intent on making a career in music.

Berlioz' *Trojans at Carthage*, with Fassbender as Dido, conducted by Mottl, a splendid performance from the musical point of view.

Lamond, a warm person, not a pianist like Reisenauer: he just plays the piano; the human quality comes out of the total performance; the indi-

vidual sounds come from the piano. When Reisenauer played, it wasn't a piano, it was magic.

In general, we listen to music like hungry wolves, but don't always hear the best.

800. November. Out of necessity, I wrote my father-in-law Stumpf a long letter, straight from the heart. I told him that I alone had read his letter because, even though I understood nothing about medicine, I thought it proper to spare my pregnant wife. But that same wife of mine knew I was answering and what I was answering, and that she approved.

Regarding the deadly insulting letter from Uncle Hansen or Professor Schlie in Holzminden on the Weser, I wrote that this was to be said: Lily, even without the letter, would have found out sooner or later anyway, from the letter to Horns, the opinion entertained about the Uncle by father Stumpf, to the effect that Professor Schlie was trying to swindle an inheritance.

Also, father Stumpf had told us in a letter at the end of September that in view of the situation he did consider an inheritance swindle to be possible.

I should like to ask: Would the Herr Medizinalrat ever have taken a reproach like this in a friendly spirit?

To speak of the child's way to his heart was, I ventured to say, a manner of speaking.

I naturally did not tell father Stumpf even in this letter that I had often been in Munich, of course secretly, since I was not welcome as a prospective husband; but I did mention ironically that, on one occasion when he thought he had caught me, I had an excellent alibi: just then I was walking the Boulevards of the French capital.

Then I became more serious and went on to say that these days morality is no longer always self-evident. "Order means life" was a fine phrase; there was only one other spot in the letter that I almost preferred, the one where Herr Medizinalrat had deigned to say of me, "I have always been a good example." And yet I said I could not remember, from the day when Herr Papa-in-Law had bid me look more deeply into the chaos of his soul, having seen anything but hostility, insult to others, praise of himself, and the like.

The future had now arrived, I said in conclusion; these old squabbles no longer concern us; the best we can do, is to draw from them the lesson that we must provide a better home some day for a child, I said, and that I felt justified in casting to the winds the pious wishes of such an inept person.

That is about how I wrote, since the past had now become so very unimportant and since we would soon be educated by our child, and no longer by Papa and Mama. "Preferring not to have contact in the future" I added at the end, and signed my first and last name beneath. Yes, indeed! On November 1, 1907.

801. Heard nothing until 11.14. Now the stepmother wrote as best she could in her not too happy situation. The matter will remain hopeless until the older of us two mellows, grows senile, as it were. . . . Until one of us becomes imbecilic. Until that day we shall simply have to work, play music, and drink tea.

Anna Sonderegger certainly has sensibility and also a certain interpretive gift. But the voice has something wrong with it, it seems to me.

At Zimmermann's, an art gallery on Maximilian Street, one can gather an impression from time to time. Pascin is currently showing a number of works there. The strongest thing about them is their depravity and a certain French aesthetic culture. The mixture of Paris and the Balkans. In the final analysis, inconsistent and effete.

I try to carry over what I learned from my charcoal drawings from nature into free composition. In addition, I etch, using the *reservage* process.

Lily too craves for music, or perhaps she intends to give birth to a musician? At any rate, we consume enormous quantities of it:

1. A Jubilee concert by the wind section of the Hof Orchestra. 2. Tschaikowsky's Trio *Vie d'un Artiste*, played exemplarily by the Press Maurina trio. 3. The Christmas Oratorio (the first three cantatas). 4. César Franck's D minor Symphony and Richard Strauss's *Don Quijote*, conducted by Pfitzner. 5. A charming concert by the *Société des instruments anciens* from Paris. Shortly after that concert, the childbirth pains began.

802. Felix Klee, born on November 30, 1907.

A Fräulein Singer, a Professor Saudner, and a Dr. Ashton were in charge.

The business took thirty hours. I kept house, the charwoman Theresa Schatzl helped as best she could in her confused state of mind.

Saudner and Fräulein Singer were mostly in disagreement. About the position, about everything. She finally turned out to be right.

Forceps were not used for a long time. My wife was supposed to labor, but she became more and more languid. A bath was given to stimulate her. No effect.

Dr. Ashton's arrival gave an impetus to things. The funny part was that I no longer thought of the child, only of my wife who had to undergo this pain.

The operation and being sick; I wasn't conscious of anything else. I helped and sprinkled the mask, for the narcosis was not deep, and all three people, the two doctors and the midwife, had their hands full.

When the child arrived, "a boy," I was astonished again that everybody didn't disband quietly, but that instead a new center of attention was formed.

And what a center, as I was to learn hourly and thoroughly from then on. The first to leave were the doctors; we sat, Fräulein Singer and I, by the bed, quite pleased about the end of the ordeal. The child was safely bundled up and sleeping. Then the midwife—a young lady, incidentally, not at all the traditional type—left too, and now we were alone, a real little family.

Perhaps this reads like a bucolic novel, and yet it was a stirring moment; indeed, one hovered close to emotion, but then back again to the grossly practical, for instance, when a "rabäh, rabäh" penetrated my sleep and I had to resurrect from a deathlike state, heat some water, add some milk, press the bottle against my eye, and then shove it into the open gateway! How the fellow guzzled! But then he left us in peace again.

803. On the following days there were visitors—they were turned away, but the chickens they brought were let in. If all of them had lived, we would have been the possessors of a magnificent poultry farm and had eggs for the rest of our lives.

Exceptionally, I let in three parties, the Eliasbergs and the Sondereggers and Fritz Lotmar, who came from Berlin to sell himself to Kräppelin.

804. Sonderegger feeds me his favorite fare: Daumier and Ensor, Van Gogh's letters, Baudelaire's writings, Edgar Poe.

Concert at the Academy, not included in the subscription series. Mottl conducted the Ninth, preceded by Gluck's overture to *Alceste*. The instrumentation had probably been overdone. For Gluck sounded different from the way he did in Paris, altogether different, strongly psychological, the wind instruments dominating the strings.

In the Ninth, the first movement was particularly stirring, and perhaps also the scherzo, which should not be played too heavily. The adagio, Mottl took so slowly that the musicians could barely blow their instruments. I don't like to hear the last movement, I prefer to imagine it. Really, something always goes wrong with the intonation.

1908

Looking back at the end of the year created a little more serious mood than before. To bring children into the world is no trifling matter! Over the entire horizon, bluish, phosphorescent flashes of sheet lightning.

I as actor in the middle of the circle: "Never mind the lightning!" Yet the pose didn't last long; a single day is enough to make us a little larger or, another time, a little smaller.

Something of the spirit of Joseph the carpenter belongs to any humble head of a family. A good deal of nobility, of adventurousness, of bizarreness, of spirituality is hidden behind the locked door.

Van Gogh is congenial to me, "Vincent" in his letters. Perhaps nature does have something. There is no need, after all, to speak of the smell of earth; it has too peculiar a savor. The words we use to speak about it, I mean, have too peculiar a savor.

Too bad that the early Van Gogh was so fine a human being, but not so good as a painter, and that the later, wonderful artist is such a marked man. A mean should be found between these four points of comparison: then, yes! Then one would want to be like that oneself.

In fact, I really do go out into the snow in all seriousness, station myself there, freeze, freeze stiff, but work. I accomplish little in comparison with the abundance around me; but I accomplish a great deal in comparison with the poverty and simplicity of a small bourgeois homestead.

Sometimes color harmonies take hold of me, but then I am not ready to hold them fast, I am not equipped.

807. February. The lady, the one from, the lady from K., from Königs, from Königstal can, can go, can go to, can go to blazes. The little family agrees, agrees on this point! On February first, 1908. Besides, I don't know this lady, nor do I have any need, any need for commerce with relatives and am therefore, therefore quite free, free of doubts.

809. I am going to try it without speculation now, without any spiritual life of my own. I am going to try it on a small scale, in toned-down, slightly bourgeois fashion. The fourth part of me that's Swiss is going to try it.

Go to school like a good boy to find out from teacher Meier-Gräfe or teacher Karl Scheffler what I have to do to become a good artist.

Even in high school I was devoted to drawing from nature.

There is no need any more to do completely without personality, but to be free from excessive concern with personality (the teacher raises his forefinger), that's what counts, that's what we must wrinkle our brow over! At my age one has personality; and, anyhow, am I not one of the finer young men now, *in arte?*

If nature herself doesn't obey any personality, any central will, if everything about her is a matter of habit, occasion, and adjustment, then all the better.

But what if a God exists? (Pshtt!!)

The teacher declares: "Why should you concern yourself with the being of God: look at one of his flower beds, that is sufficient."

"Oh, teacher, I want to be good!"

"Besides, it is good for you to live and work outdoors; no intellectual pallor to be found there! You shall be a little, busy ant amidst bees and butterflies."

"Teacher, may I play a little mu-mu-music besides??"

"Versatility in the arts? By all means, you must, you may! Versatility in the arts is good, provided it does not lead to works of integrated art."

811. Learned how to differentiate tonality (with or without colors) from the coloristic. Got it!

812. Exchange of letters with Albert Welti and Kreidolf concerning my admission into the Society of Graphic Artists (Glaspalast). Welti had unexpectedly proposed it to me.

I thanked Welti for the good thought and his friendship. I said too that the place where he exhibited could not be bad for me either. And that I thought very highly of Herr Kreidewolf. Still, I probably belonged more with the Impressionists, at least judging from my current work (the teacher's words were beginning to bear fruit).

I valued Max Liebermann and Uhde, I said, but the French still more.

And so, if there were still no objections, I would let my name be voted on next Friday.

I wrote my congratulations on the commission from the Swiss Government. I was sorry to see him move to Bern but hoped, together with my wife, to play violin and piano music for him at Melchenbühlweg during the summer vacation.

Kreidolf answered informing me that I had failed. That was terri-bull. At the end of the letter it said: Claude Lorrain Strasse, 17.

813. Due to a personal meeting with the kindly but very drunk "Prszebyszewsky," I read his book, *On the Ways of the Soul, or Gustav Vigeland.* That is, I tried to read it, but soon found myself as delirious as the author and now can't remember a thing.

Wedekind's *Music* I was at least able to understand. In addition, I busied myself with Boccaccio's *Decameron* and Balzac's *Contes Drôlatiques.* Now the question occurred to me whether I too might not illustrate a beautiful book some day?? Finally, *Little Eyolf.*

Music: Aca-Academy: a small, innocent Symphony in C, No. 6, by Schubert, Ritter's "Ride to the Grave of Good Music," *Don Juan* by Richard the Last. A new Munich string quartet (Kilian, ouch! Industrious mediocrity).

And then the virtuoso conductor Ganzner, with pop favorites. Cellini Overture, Prelude and Love Death, and the inevitable Pathetique by Tschaikowsky (with the Kaim Orchestra).

The best was the eighth concert at the Aca-Acad, with a splendid rendition of the Pastoral, the first movement broad, strong and countryboyish, the

scherzo rather fast, the Thunderstorm incredibly dramatic, the final allegretto very fast! A very spiritless violinist, odd Ahner, played a newly discovered so-called Mozart Violin Concerto No. 7 with too large an orchestra. A doubtful pleasure, to be truthful about it.

813a. March. The glass picture 1908/56, "The Balcony." In March I once again played nurse for a while; a serving wench left us in the lurch. As a result, I was forced to go back a little on my program of *nulla dies sine linea*. This led to a successful work, which shows a particular freshness of form. I had already seen the picture a couple of days earlier, from my kitchen balcony, naturally, which was my only way of getting out. I was able to free myself from all that was accidental in this slice of "nature," both in the drawing and in the tonality, and rendered only the "typical" through carefully planned, formal genesis. Have I really come out of the jungle now?? This kitchen balcony, the empty lot, the Hohenzollernstrasse. A prisoner's view in several directions.

814. Welti and Kreidolf came to look at my works. I showed my all, so to speak. With true instinct Kreidolf immediately made for the "Balcony." Welti, with a childlike smile, remained open to everything (or, more exactly, *closed* to everything new). About "Pregnancy" he said, "By and large, one sees some fat women like that." He had already liked my engravings in the past when he saw them being printed at Girardet's.

3.15. Soon after, we paid him a visit in Solln. But there were so many people in the little room, the entire Frau-Frieda-Fischer-Salon and the rest of Solln into the bargain, that it made a cheesy mass. Cordiality is responsible for such uncongeniality. The boys were there too, especially the inimitable five-year old Ruedi. A wild little beast, awe-inspiring. The older one is going through puberty, gets a well-intentioned box on the ear from his father from time to time.

Kreidolf a bachelor, a bit *triste*, quiet, not unmanly. In the middle of it all, a gigantic jug of milk and a few large, round cakes.

816. The spring Sezession exhibition is making a real effort. One can now see the latest art from Paris, which jibes with Herr Meier-Gräfe's views.

Bonnard, no doubt cultivated, but very small and tight, very narrow. There is something to be learned from his economical way of selecting his values. He is so restrained that the bright accents, for all their quietness, can give a triumphant effect. Vuillard is weaker still, even though he strives to achieve a style that transcends the European. By Roussel, a beautiful still life with flowers.

The strongest is Vallotton, but a very unpleasant manner of painting. Not painting, and yet appetite for painting. But somehow he is quite a man.

Also, a large collection of drawings by Liebermann—"which Liebermann?" they asked in Solln. For people out there, there are two Liebermanns. Also etchings by the same artist. Long-familiar, well-assimilated things!

I stand on the kitchen balcony myself and hunt with some luck for children playing.

Two more exhibitions, quite important ones! Van Gogh at Brakl's and Van Gogh again at Zimmermann's on Maximilianstrasse. At Brakl's, a great deal; at Zimmermann's, the very famous pieces, like "L'Arlésienne," and many others. His pathos is alien to me, especially in my current phase, but he is certainly a genius. Pathetic to the point of being pathological, this endangered man can endanger one who does not see through him. Here a brain is consumed by the fire of a star. It frees itself in its work just before the catastrophe. Deepest tragedy takes place here, real tragedy, natural tragedy, exemplary tragedy.

Permit me to be terrified!

817. On April 1st, Liszt's *Holy Elizabeth* at the Hofoper. On the 2d, the delightful mustering assembly; it smelled of people and barracks. A nauseating combination. On the 3d, Fritz and Olga arrived. That night we went to Piper's. Piper, quite a personality, has musical passions—Mahler and Bruckner—which I don't share. Music mustn't go that way, in any case only for a moment! A plebeian called Esswein plays a certain role there, reads aloud when we don't disturb him. Lily had to join in some banging *quatre mains*. Ear-splitting. The landlord threatens and curses downstairs. On leaving the "salon," the guests are insulted on the staircase. A thoroughly refined atmosphere about the whole thing. Through the intercession of

Eliasberg, who takes an interest in the publishing house. Fruitless for me, because of outspoken opposition. I openly showed my boredom.

On April 6th, *Tiefland*, a contrived work by d'Albert. The cheap pieces have success. Brodersen's acting was extremely stupid (*verismo*); Fassbender did well.

On the 9th, I put in my first stint of correcting at Debschitz's (nude). On the 11th, Saint Matthew Passion (Mottl), uncut performance with a one-hour intermission.

818. Schmoll's recommendation to Eisenwerth had its effect, and Debschitz entrusted me for one month with the correction of his evening class in drawing from the nude. I went at it of course with frantic zeal.

Then Hallermändu came and had even more praise than last time. He wanted, almost, to buy the "Balcony." He also liked the "Children in the Construction Yard."

In the third place, I again sent works to the Sezession. "Balcony," "Children in the Construction Yard," and "Pregnancy" were refused. I had priced them at two hundred marks and one hundred and fifty. "Street with Carriage," "Suburb with Courtyard," and "Street beneath Trees" were accepted. One hundred marks each. A comparison of the figures tells the story. The confraternity of kitsch is out there on the Königsplatz!

During this period, an excursion to Kochel, Kesselberg, and Walchensee was put off again. The two of us on Good Friday.

819. May. My job as corrector at the Debschitz school was extended through May and June. The people there draw industriously, but are also quite mediocre. It's questionable whether I am achieving very much there. But it is not without interest. An exhibition of works left behind by Busch shows that this artist was not merely a specialist, but also a thriving painter; naturally he's somewhat limited in this respect. Thinned-out and trimmed-out Hals, but something of Hals does remain. Not a cheap dauber, but a well-oriented European. A few of his lads with red jackets belong in a picture gallery, they are really good.

820. 5.14. *Barber of Seville* led by Mottl; Rosine: Bosetti; Basilio: Bender; Bartolo: Geiss. 5.15. *Marriage of Figaro* at the Residenztheater, conducted by Mottl; Count: Feinhals, Suzanne: Bosetti, Bartolo: Sieglitz, Basilio: Walter, Antonio: Geiss. 5.16. Opening of the Sezession. 5.24. The painter Thomann from Zürich visits me. Invitation to join the "Walze." Gave Thomann my acceptance.

821. 6.16. At Frau Fischer's in Solln with the Sondereggers and Kreidolf. 6.23. *Faust* at the Artists' Theater, a Court performance. Staged by Fritz Erler. A good Gretchen: Lossen.

822. Genesis of a work:
1. Draw strictly from nature, possibly using a telescope.
2. Turn No. 1 upside down and emphasize the main lines according to your feeling.
3. Return the drawing paper to its initial position and bring 1 = nature and 2 = picture into harmony.

823. Said Herr Waldemar when the carrion fly lit on his hand: "May I ask twice for a little patience!"

824. Oil painting I.
I shall paint human figures from nature in a deeper sense, dividing them into two time periods and treating each separately.
1st state (imperfect): the space, the environment; this stage must be allowed to dry too.
2. Action begins (perfect, passé défini, aorist): the figure itself. For: in nature too the environment was already complete when motion joined in, occurred. From the outset, economy is required in 1, so that 2 may be effective without forcing. Furthermore, there remains:
3. To test the mutual effect of 1 and 2. The picture is finished (Color applied with a palette knife, because brushes always smudge right away.)
 Oil painting II.
1. Laying down the local colors, in broad strokes, by areas.
2. Modeling by means of darkening and lightening. Again, the picture is finished.

227 / Munich 1908

825. He has found his style, when he cannot do otherwise, i.e., cannot do something else. The way to style: *gnothi seautón* (know thyself).

826. All sorts of books read and performances attended in June and July. *Homo Sapiens* by Prszybscewsky, Parts I and II, banal, delirious monster; don't like it.

Wedekind, *Gnome* and *Pandora's Box*. Schick, Böcklin's "Eckermann."

Guest performances by the Berlin Chamber Players (Reinhardt). *Gnome*: Schön played by Steinrück. Lulu: Eysoldt; Schigolch: Schildkraut. The best theatrical performance imaginable in this style. Shaw's *Mrs. Warren's Profession*; an entertaining play. Mrs. W.: Fräulein Wangel; her companion: Steinrück; Pastor: Schildkraut!! (how he took his curtain call!) etc. *Angele* by Hartleben, and so on, less impressive.

827. Another oil painting.

1. Laying down complexes of color patches, freely produced from my feelings, as the ineradicable, essential core of the work.

2. See in this "nothing" an object (the marble tabletops in my uncle's restaurant), make it figurative and clarify it by means of lights and shadows. A given ground tone was laid down first, which now shows through here and there over the entire surface. The picture is finished.

828. Armed with binoculars, went hunting in the fields outside town. This is the best way to outwit one's models. They suspect nothing, and their poses and faces are natural.

829. Thomann writes that an article is to appear about "Die Walze" in the review *Die Schweiz'g*, and that my etching "The Comedian" is to be reproduced.

Then a Swiss fellow called Willy Lang, the author of the article for *Die Schweiz'g*, writes me that having had the occasion to become acquainted with my engraving, he would like to arrange for the publication of one or more prints in the review *Hyperion*, and begs me to think about his proposal.

Then the said Willy Lang writes again telling me that he had spoken with Blei, that Blei wanted a plate, that I ought to visit Blei at his home at

Hubertusstrasse 13, that I should bring along as many works as possible, so that Blei could make a selection. He urged me confidentially not to ask for too little (the gentlemen are able to pay), say, two to three hundred marks, and my becoming as well known as possible through these things would be an even greater gain. Very sincerely, Willy Lang.

And so I travel to Nymphenburg, ring at No. 13, am let in and escorted inside. Blei is sitting at his desk, showing me his back. He is lost in thought. I stand still and wait a few moments. Then a lean face with gigantic horn-rimmed spectacles turns around toward me, in a carefully calculated way. So this was the discoverer of the latest Munich "genius," Mayershofer. He talked to me with the most synthetic naturalness. He has known the engravings since the time of the Sezession show (1906), but had been unable to secure my address at the time.

He picks the "Hero with the Wing," because of the size, since he wants to print the exact original. But he has co-editors. Three hundred marks. Fine.

Has co-editors.

830. 7.2. Performance of *The Gnome*. 7.5. Photograph of Lily and Felix on the balcony. 7.7. Performance of *Mrs. Warren*. 7.12. Went with Lotmar to Frau Fischer's. 7.19. Birth of Walter Lotmar.

831. The line! My lines of 1906/07 were my most personal possession. And yet I had to interrupt them, they are threatened by some kind of cramp, perhaps even by finally becoming ornamental. In short, I was frightened and stopped, although they were deeply embedded in my emotions. The trouble was that I just couldn't make them come out. And I could not see them around me, the accord between inside and outside was so hard to achieve.

The changeover was complete; in the summer of 1907 I devoted myself entirely to the appearance of nature and upon these studies built my black-and-white landscapes on glass, 1907/08.

No sooner have I mastered that stage than nature again bores me. Perspective makes me yawn. Should I now distort it (I have already tried distortions in a mechanical way)? How shall I most freely cast a bridge between inside and outside??

Oh, the enchanting line of the sweep of this bridge—some day!
In Bern, the uniquely beautiful angora cats Nugg and Myz died.

832. Let action be the exception, not the rule. Action is in the aorist tense;
it must be contrasted with a static situation. If I want to act light, the static
situation must be laid on a dark base. If I want to act dark, we need a light
base for our static situation. The effectiveness of the action is greater when
its intensity is strong and the quantity of space occupied by it is small, but
with slight situational intensity and great situational extension. Never give
up the all-important extension of the static element! On a medium-toned
static ground, however, a double action is possible, depending on whether
one considers it from the point of view of lightness or that of darkness.

833. There are days that resemble a battle that reeks of blood. Now it is the
depth of night, but not for me, for the others, for the dullards who do not
sense the battle. They make music, easy, coarse songs. Then they lie down.
 I cannot find sleep. In me the fire still glows, in me it still burns here
and there. Seeking a breath of fresh air, I go to the window and see all the
lights darkened outside. Only very far away a small window is still lit. Is
not another like me sitting there? There must be some place where I am not
completely alone! And now the strains of an old piano reach me, the moans
of the other wounded person.

834. Reduction! One wants to say more than nature and one makes the
impossible mistake of wanting to say it with more means than she, instead
of fewer. Light and the rational forms are locked in combat; light sets them
into motion, bends what is straight, makes parallels oval, inscribes circles in
the intervals, makes the intervals active. Hence the inexhaustible variety.

835. At 11:15, departure for Bern with Felix and Theresa. 8.6. Arrival in
Bern. 8.11. Photo of the entire family. 8:12. *The New Amadis* by Wieland.
8.21. Lily and I leave for Beatenberg. 8.23. Waldbrand, Amnisbühl. 8.24.
Lower Burgfeldalp, Habernlegi. 8.25. Gemmenalphorn, Niederhorn 8.26.
Waldbrand. 8.27. Brienzerrothorn by cogwheel train. At night, on foot from
Interlaken to Beatenberg. 8.29. Bad weather drives us to Bern.

836. Heighten the lighting process psychologically in places; heighten where the spirit needs it, not where nature sets up its highlights.

837. Magic. Far away from thee / immediately in front a path rises / branches out, / no path inclines, / a path inclines, suddenly vanished, / softly awake: / through night and sun.

O thou soulless bliss, / o thou quarrel of the crowd, / thou cacophony / caused by the crush of questions.

Already suspicious / who could squeeze his way through there? "who could pass through that Gate," / right in front, the Gate: / in front of it, straight ahead.

And no path at the left / and on the right an enclosure: of delicate flowers.

What is to be done? / There no one can come, / the fat God, / the good gardener / demands that there: No one can come through.

And yet such a one comes, / yet such a one!

Laughter can be heard: listen to advice, / man of action, / man of heaven knows what business!

He guesses nothing, / he goes through, / treads upon three violets / and, in no time is comfortably on the other side.

The imbeciles gape, / gape after him: after him: the wight.

What light, among us, / what wonders! / What feasts, / what nudities, / friends with cups, / ladies with fans, and this fop acts so familiar.

The imbeciles are dazzled, / at once / they too want to leave: for the promised land.

A thousand thunders / through sleight of hand: now the gate has a wall, / separating shimmer from shudder. / Covered with hair of fire / beard against beard, / a row of tigers stands there.

Dusk lies in wait. / The sounds dissipate, only the beasts / are heard / growling softly / through the night.

Until the obscure ones / without grumbling, / steal away.

838. September. 8. Excursion with Lily from Lanzenhäusern to the Grasburg, then to Schwarzenburg, Guggisberg, back to Schwarzenburg. 9. At Louis Moilliet's. 13. Sketched in the garden. 15. Walk to Reichenbach with Lily,

Bloesch, and Lotmar. 27. Lily went back to Munich. 29. Painted on white oil paint, wet on wet.

839. October. 1. With my father to Biel, on foot to Neuenstadt, here an hour in delightful spots on the lake, on the little steamer to Erlach; loafed and fished there. 2. Papa went to Munich. 17. Lily came back to pick us up. 18. Took leave from the Weltis, received three engravings as a gift. 19. Arrival in Munich. 31. Our new cellist: Dr. Fritz Strich.

840. Pictures have their skeleton, muscles, and skin like human beings. One may speak of the specific anatomy of the picture. A picture representing "a naked person" must not be created by the laws of human anatomy, but only by those of compositional anatomy. First one builds an armature on which the picture is to be constructed. How far one goes beyond this armature is a matter of choice; an artistic effect can proceed from the armature, a deeper one than from the surface alone.

And instead of books or hollow oaths, that is, instead of official lies, I cherish a wakening, living word. Naturally people who can hear it are needed. The many intervals must be present in it, at least latently. Books are made of split words and letters, split until they are sufficient in number. Only the professional journalist has time for this. A noble writer works to make his words concise, not to multiply them.

Beyond the constructive elements of the picture, I studied the tonalities of nature by adding layer upon layer of diluted black watercolor paint. Each layer must dry well. In this way a mathematically correct scale of light and dark values is the result. Squinting facilitates our perception of this phenomenon in nature.

841. November. 10. Steinbach conducts Brahms: Serenade, First Symphony, and Academic Overture. 11. Sent six drawings to the Sezession in Berlin. 13. Beethoven's Fifth Symphony conducted by Mottl. 25. Wedekind reads an act of *Censure, Dance of Death,* and poems.

842. The chief drawback of the naturalistic kind of painting—to which I continually return for thorough orientation and training—is that it leaves

no room for my capacity for linear treatment. Actually no lines as such exist in it; lines are merely generated as frontiers between areas of different tonalities or colors. By using patches of color and tone it is possible to capture every natural impression in the simplest way, freshly and immediately.

Line as such could appear in the severely scientific-naturalist type of painting only when color is left aside: in other words, in tonal painting; to be precise, as a substitute for the color limit between two areas of identical tonal value and different color value in nature.

A work of art goes beyond naturalism the instant the line enters in as an independent pictorial element, as in Van Gogh's drawings and paintings and in Ensor's graphics. In Ensor's graphic compositions the juxtaposition of the lines is noteworthy.

In fact I am beginning to see a way to provide a place for my line. I am at last finding my way out of the dead-end of ornamentation where I found myself one day in 1907!

With new strength from my naturalistic *études*, I may dare to enter my prime realm of psychic improvisation again. Bound only very indirectly to an impression of nature, I may again dare to give form to what burdens the soul. To note experiences that can turn themselves into linear compositions even in the blackest night. Here a new creative possibility has long since been awaiting me, which only my frustration resulting from isolation interfered with in the past. Working in this way, my real personality will express itself, will be able to emancipate itself into the greatest freedom.

843. December 8. Moved into a small studio: Feilitzschstrasse 3/4. 11. Harold Symphony under Mottl. From the 22d till the 27th. Had tonsilitis, fever up to 104 degrees. 29. Got up. 31. Two Eliasbergs, two Sondereggers, two Lotmars, and Professor Lotmar from Bern celebrated Christmas with us. Put an extension on the table, a feat of composition in this small room.

844. Well-composed pictures strike us as completely harmonic. But the layman draws a false conclusion when he believes that such a harmony of the whole is achieved by making each individual part harmonious. The effect of this can only be feeble, because once a first part has been brought into harmony with a second part, it no longer requires a third part. Only when one

TWO AUNTS, NUDES WITH CRESTS, 1908, 14

and two are set harshly against each other does three become necessary, in turn, to transform this harshness into harmony. This new three-part harmony then carries much stronger conviction.

845. The form occupies the foreground of our interest. It is the object of our efforts. It belongs in the first rank of our *metier*. But it would be wrong to conclude from this that the contents that it embraces are secondary.

P.S. I sent the following six pictures on glass—black watercolor—to the black-and-white section of the Berlin Sezession, and they were exhibited there: "Pregnancy," "Street with Courtyard," "The Balcony," "Street beneath Trees," "Children in the Construction Yard," "Musical Tea."

O horror / Until his ripe old age / he was a man who / no matter how tickled / never did sneeze. But at the end it came / with a cannon-like blow of his horn / and that was the end / of the administrator.

1909 MUNICH

847. January. 3. Marées' exhibition at the Sezession, an event. Piano recital by Max Pauer. 20. At Blei's with India ink drawings. 24. At Meier-Gräfe's with India ink drawings. Debussy's *Pelléas and Mélisande*, the most beautiful opera since Wagner's death. 31. *Siegfried* conducted by Mottl, with Knote, von Roy, Fassbender.

848. The deep pleasure that comes with artistic development may well be described some day as a manifestation of energy, but only because this liberation is at times crowned with thorns.

Rest and unrest as changing elements of the pictorial discourse.

849. Whenever a gallery-mad Munich artist or some dauber newly arrived in the city has his erotic crisis, he composes an "Adoration of Woman." You see a female nude, a waitress, salesgirl, or the like, and kneeling in front of her, Herr Painter, also naked. And yet the best erotic picture hangs in the Pinakothek, Rubens' "Bride," with a feathered, velvet cap on her head, gloves, and a pearl necklace—more beautiful than real pearls. A heightened portrait

GIRL AND LITTLE BOY ON THE FLOOR, SIMPLE CONTOURS, 1908, 31

of a woman. And, without actually mixing up with Sallies and Sues, one constantly has the opportunity to treat people to this kind of childish stuff!

850. A good picture seems incomplete until the last brush stroke.

851. In my new workroom I have the chance to do a considerable amount of oil painting. All sorts of experiments, always strongly inclining toward tonal values. Now and then a moment of liberty, like "Boy in Fur."

852. February. 9. Peasant dance. 11. Mottl conducts wonderfully a symphony in F major by Haydn, with the smaller Hoforchester: 1. Presto, 2. Adagio, 3. Minuetto, 4. Allegro molto with a slow, minuet-like movement in between. 17. Russian masked ball. 20. Ball at Zöller's.

853. At the end of January I went to see Meier-Gräfe, who was here for the Marées exhibition, with a portfolio full of India ink drawings. He wanted to see first how I would develop—would I please keep him in mind. "Maybe something will come of it!"

I had been recommended to him by Blei. Blei had been really delighted with the same drawings. He wants to use three of them in *Hyperion* instead of the etching. But only a little later, he says.

Whereupon the local spring Sezession turns down all five of my drawings.

854. (Here follows a daily and detailed fever chart kept by Paul Klee, of his son Felix between March 1st and May 8, 1909. [Editor's Note.]) [See the "Felix Calendar" at the end of the book.]

855. This illness interrupted everything as will appear from the preceding lines. I completely took charge of the child's care, only in the worst period did I have myself replaced by a nurse. Olga Lotmar also helped me often, of course expertly, being a doctor. The physician in charge, Dr. Trumpp, was quite excellent, especially in the first, nonsurgical phase. Once he called in the ear specialist von Nadoleczny and twice Professor Pfaundler. From the moment the throat swelling appeared at the end of March, Trumpp began to go wrong, declared it to be tubercular, although it was only present on one side. This error he stubbornly clung to until the operation took place.

The surgeon, Dr. Gilmer, proved to be right and saved the child's life.

The first exceedingly dangerous moments came in the period from March 12th to 14th.

856. (Case history with fever chart in the "Felix Calendar.")

857. Nature can afford to be prodigal in everything, the artist must be frugal down to the smallest detail.

Nature is garrulous to the point of confusion, let the artist be truly taciturn.

Moreover, in order to be successful, it is necessary never to work toward a conception of the picture completely thought out in advance. Instead, one must give oneself completely to the developing portion of the area to be

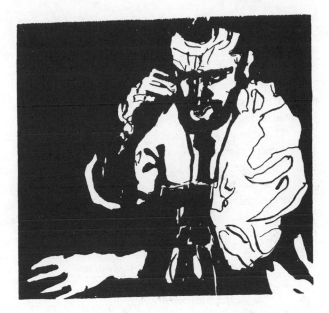

SELF-PORTRAIT—DRAWING FOR A WOODCUT, 1909, 39

painted. The total impression is then rooted in the principle of economy: to derive the effect of the whole from a few steps.

Will and discipline are everything. Discipline as regards the work as a whole, will as regards its parts. Will and craft are intimately joined here; here, the man who can't do, can't will. The work then accomplishes itself out of these parts thanks to discipline that is directed toward the whole.

If my works sometimes produce a primitive impression, this "primitiveness" is explained by my discipline, which consists in reducing everything to a few steps. It is no more than economy; that is, the ultimate professional awareness. Which is to say, the opposite of real primitiveness.

I also saw eight pictures by Cézanne at the Sezession. In my eyes he is the teacher *par excellence*, much more of a teacher than Van Gogh.

858. I spent the period between June and October in Bern, so that the child might recover more quickly. The incision still had to be treated and cauterized a bit. For this, I took the trolley with Felix to the Bärengraben, then to the Villette, and carried him on my shoulder to the Inselspital. Here Professor Stooss gave him post-operative treatment.

I did take notes on his linguistic development, but the main phenomena are over and done with. It begins to sound like German now. Cases like "bite bite" ("please please") are becoming more frequent, things learned and repeated occur more and more. The nice thing about it is the element of mishap in the child's verbal mimicry, for instance, instead of "Kuh" ("cow"): "Ko"; instead of "Gritli": "ti-ti" and "gaga," later "ge-ge." Interesting too were the inversions; instead of "Schuh": "usch."

Two sojourns in Beatenberg, one with the child; however, it only partially did him good. At any rate he slept very badly.

Beautiful excursions: Wohlen, Frieswielhubel, Aarberg or Gemmenalphorn or Gunten Sigriswil, Justistal, St. Beatenberg.

859. Work of the summer and autumn of 1909.
a) I scattered different spots as parts (tones) of the color harmony over the entire canvas, gathered them into figures, partly with the help of the contouring line;
b) Collecting forms and perspectives from nature with the ardor of a bee. Handled them in part in calligraphic-linear fashion,

 in part by rendering the lightest notes ![darkest notes symbol] and the darkest notes

The middle tones silently in between.

861. We are much too much concerned with biography in art, no matter how captivating it may be to investigate problems like Van Gogh and Ensor. We owe this to writers, who can't help being writers. I want to know, at least right now, as an experiment occasionally to be made, the tone of the particular work as such. I want to find out whether or not I'm looking at a good picture and just what is good about this particular work. I don't want to examine the common feature of a series of works or the differences between

two series of works—no such pursuit of history for me—but to consider the individual act in itself, and were it only a single work that accidentally had the luck to become good, as recently happened with two or three of my "paintings."

For the fact of my not painting good pictures with a certain measure of regularity results precisely from my imperfect knowledge of what makes a good individual work.

How well every tenth person knows the difference, in the biographical sense, between Rubens and Rembrandt. But no one knows how a particular picture by one of these masters is constructed as a matter of mundane fact.

862. I am well acquainted with the Aeolian-harp kind of melodies that resound within. I am well acquainted with the ethos that fits this sphere.

I am equally well acquainted with the pathetic region of music and easily conceive pictorial analogies for it.

But both are unnecessary to me at present. On the contrary, I ought to be as simple as a little folk tune. I ought to be candid and sensuous, an open eye. Let ethos wait in the distance. There is no hurry. Let pathos be overcome. Why try to tear oneself violently away from a joyful existence here and now??

The difficulty about it is just to catch up with developments that already lie behind, but "it must be done!"

863. Open thyself, thou gate in the depths,
 Cell underground, release me
 who senses light.
 And bright hands come and seize me,
 and friendly words are spoken joyously:
 Forth, you beautiful pictures, wild beasts,
 spring forth from thy cage
 that fingers may glide lovingly
 on flaming hide.
 And all is one as once in God's garden:
 day and night,
 and sun and splendor of stars.
 (In the paradise of those trembling with poetry.)

864. Hyperion Verlag acts bizarrely. At first, the to-do and the recommendation to Meier-Gräfe. Then in all likelihood they listened to his opinion behind the scene. And then Meier and Gräfe hadn't quite been able to work out a decision, and he probably uttered an oracle in the jargon of contempt: "Well, maybe it'll turn into something some day."

This I surmise, for when I went to take back from this publishing firm, this sleeping firm, something appropriate for Berlin they more than willingly gave me back everything.

Now what kind of a head is this Blei, this noble blockhead? Didn't he a short time ago discover the local genius Mayershöfer! The latest baboon from Giessen, the baker boy four stories tall! And surely completely without any Meiers and Gräfes. For the bearer of these two names has something after all, too much ever to be taken in so easily by Mayershöfer. Or had the bearer's opinion about my future actually been optimistic, and was it that the vain Bleis wanted to be the only ones to have flair, to be on the track of new talent? The problem will never be solved, so let's wipe a sponge over the tracks of the whole business.

865. Project for illustrations: Voltaire's *Candide* with its condensed riches provides innumerable stimuli for illustration. Sonderegger is more in favor of the *Sentimental Journey* which, as a result, I read, and certainly with great pleasure. The fewer temptations for illustrations don't compensate, however, for the inferiority—speaking as the illustrator I now want to become experimentally—which I recognize in this work. In *Candide* there is something higher that attracts me, the exquisitely spare and exact expression of the Frenchman's style.

866. December. I am almost thirty years old; this scares me a little. "You've had your time, your dreams, your fantasies. What really matters now is to be what you can. Realism now and no affected high-fantastics henceforth!"

But the vagabond will remain incurable, that's sure!

The Berlin Sezession didn't accept without a hitch this time, but at least it accepted the best, not the worst, as the jury on the Königsplatz here does. First, the "Sketch of a Portrait in Chiaroscuro" after Felix, and second, the "Caricature of a Woman in Négligée," charcoal and watercolor.

PORTRAIT OF MY SISTER IN PROFILE, 1909, 24

867. Horrible messy piece of writing with the purpose of patching up the tattered marriage of the E***s: "Z. has freely decided to come back to you, in the belief that a new life can be rebuilt. I hope you will strengthen Z. in this conviction and show her what a strong man you have now become. Even she considers it unjust to abandon you in such a moment of change. Not pity but decency brings her back to you. Win her again by giving her the necessary proof." (The things one writes out of the kindness of one's heart!)

868. Felix talks: "Nic," this means "kin(d)," that is, "child"; in short, he inverts the sounds. "Pipar" ("Papier"); previously, "usch" ("shoe").

First sentences: "dat si daddy" (that is daddy). The following month: "dat is daddy!" "Dat si foot," "dat si light"; "whereishe?" "there-si!" ("coocoo a dada"). When he hears children's voices, he rushes to the window and screams: "nic!"

Ended the year with Morgenstern's *Gallows Songs*.

1 9 1 0

869. January. The pantograph, system A

The function of this pantograph is to enlarge or to reduce the scale of drawings. To enlarge: plant the needle at No. 1, the guide point which passes over the drawing to be enlarged on No. 2, and the pencil which makes the desired enlargement on No. 3. (For reduction in scale: needle at No. 1, point for passing over at No. 3, pencil at No. 2.) The dimensions of the copies are determined by displacing evenly screws 5 and 6. (For unenlarged copies: needle at No. 2, point and pencil at No. 1 and 3 or No. 3 and 1.)

System B

Let ruler EF be parallel to CD and AB. At point of intersection O, where diagonal AC intersects EF, the needle is planted as unmovable axis. The point is attached to A and the pencil to C.

The proportion of size of the two figures *a* and *o* is the same.

AO to OC equals AE to ED and can be changed as desired by displacing the ruler EF.

871. Prepare a base for painting by mixing paint powder and water containing glue and apply it like a chalk base; this enables one to work on a base that will set off both light and dark tones from the outset. For instance, *caput mortuum*. Against white, any light element appears dark from the outset, and by the time one has managed to subdue the white, the whole thing has gone wrong. Relativity of all values!

This is why I was so pleased with the creation of my black watercolors. First, applying a layer, I left the main points of light blank. This extremely light gray layer gives at once a very tolerable effect, because it appears quite dark against the blanks. But when I leave out the points of light of secondary importance, and apply a second layer on the first dried layer, I enrich the picture greatly and produce a new stage of logical development. Naturally the parts left blank in the earlier phases remain blank in the ensuing process. In this way I advance step by step toward greatest depth, and consider this time-measuring technique fundamental as regards tonality.

Beauty is as relative as light and dark. Thus, there exists no beautiful woman, none at all, because you are never certain that a still far more beautiful woman will not appear and completely shame the supposed beauty of the first.

872. On Shrove Tuesday the greater part of the winter lies safely behind, and a quick retrospective glance is in order.

I cannot say that the survey is a cheering one this time. For I am still incapable of painting, in spite of my sharp observation of tonal values and in spite of my clever way of determining the proper gradations of light and dark.

The transfer of the time-measuring technique to oil paint cannot be carried through very successfully, in spite of gasoline! Now I attempt to stage simultaneously a light action and a dark one against a middle ground, and to bolster

these active elements by a softly murmuring modulation of the middle tones. Perhaps this will also lead to some goal.

873. March. And now an altogether revolutionary discovery: to adapt oneself to the contents of the paintbox is more important than nature and its study. I must some day be able to improvise freely on the chromatic keyboard of the rows of watercolor cups.

874. The light-form. By this I mean the conversion of the light-dark expanse according to the law by which lighted areas grow larger when opposed to dark areas of mathematically equal size. This was observed previously by focusing my eye unsharply (as distinguished from the squinting used for measuring chiaroscuro). Now carried through with greater thoroughness by means of a lens (glass eye).

This magnifying glass brings into view at the same time the color essence of the natural phenomenon. All detail is simply eliminated.

The attitude of the will during this process is the following: not to let the form be dissolved by the light expansions, but instead to end by recapturing these motions, contouring them and binding them firmly to each other. I can imagine this optical phenomenon in stone. Neo-plasticism, who knows!

875. April. Launched a new offensive against the fortress of painting. First, white thinned out in linseed oil as a general base. Second, color the entire surface lightly by applying very large areas of different colors that swim into one other and that must remain free of any effect of chiaroscuro. Third, a drawing, independent of and substituting for the unformulated tonal values. Then, at the end, some bass notes to ward off flabbiness, not too dark, but colored bass notes.

This is the style that connects drawing and the realm of color, a saving transfer of my fundamental graphic talent into the domain of painting.

876. Cultivation of the means in their pure state: either the proportion of tonal values in itself; or line, as a substitute for omitted tonal values (as a boundary between tonal values); or else contrasts of color values.

For, in art, everything is best said once and in the simplest way.

Puccini's *Madame Butterfly* with Bosetti. Moving affair. A few passages of good music, *La Bohème* better.

877. May. Now, before the types have been cultivated in their pure state, the devil of cross-breeding already shows up again. Must I break off the struggle and return to the first position: "the brushstroke in itself"? The brushstroke at most in a few situations, but in no case so as to give the impression of mass!

878. Limited palette: 1. white, 2. black, 3. Naples yellow, 4. caput mortuum, 5. and 6. Possibly also permanent green and ultramarine. And the grays need watching! A warm gray: Naples yellow-black. Cool gray: white-black.

879. June. Transfer of the shadow image, of the chiaroscuro time-measuring process into the realm of color, in such a way that each degree (the number of degrees is to be reduced to the strict minimum), each degree of tonal value, that is, corresponds to one color; in other words, one must not lighten a color by adding white to it or darken it by adding black, but there must always be one color to a degree. For the next degree, the next color. Ocher, English red, caput mortuum, dark madder, etc.

P.S. Rational: the shadow image; irrational: the color image. Perhaps the two cannot be melted into agreement, but it should at least be tried!

Gluck's *Iphigenia in Tauris*, Mottl; Iphigenia: Fassbender; Orestes: Feinhals; stirring performance.

Marquis von Keith with Wedekind in the main role; strange to see how he spends himself on his own work. Alien to me, but piquant!!!

880. July. I am holding my first one-man show in Switzerland, because I hope to sell more there and because "circumstances" already have made me known there to some extent. I start with the Kunstmuseum in Bern (August). Then follows the Zurich Kunsthaus in October, and finally perhaps an art gallery in Winterthur. Fifty-six items, all nicely framed. Finally, the Basel Kunsthalle will follow, on January 1, 1911.

1.	1909	Landscape with oak—Wittikofen	100.–
2.	1909	Five oaks	100.–
3.	1909	Belpberg	100.–

4.	1909	Belpmoos—Tree over shrubbery	100.–
5.	1910	Young woman—Light form	100.–
6.	1909	Beatenberg—Birenfluh	80.–
7.	1909	Beatenberg—Garden of the Hotel	100.–
8.	1909	Beatenberg—Hotel Seen from Below	80.–
9.	1910	The Isar after it Rose	100.–
10.	1910	New alley—Military Avenue	50.–
11.	1909	Quarry near Ostermundigen, Seen from Above	80.–
12.	1909	Children Playing—The Round	50.–
13.	1909	Quarry near Ostermundigen, Seen from Below	100.–
14.	1910	Orchard near Munich—small	50.–
15.	1910	Orchard—Peasant with Trees	100.–
16.	1909	Man Drinking	100.–
17.	1910	Girls Playing (scrawled)	50.–
18.	1909	Leafy wood—Eggholz	100.–
19.	1907	Path through Forest—Hirschau (charcoal)	100.–
20.	1909	Bird Cage (pencil)	50.–
21.	1909	Study of a Head—Lily (pencil)	100.–
22.	1910	Etching	50.–
23.	1908	Busy Square—Balcony	200.–
24.	1907	Quarry (charcoal and watercolor)	150.–
25.	1909	Asters (watercolor)	200.–
26.	1910	Garden (watercolor, wet on wet)	200.–
27.	1909	Near Munich (pen and dabs with brush)	120.–
28.	1909	Child on Collapsible Chair (black tones, large)	150.–
29.	1909	Child on Collapsible Chair (small)	100.–
30.	1909	After my Father (not for sale)	
31.	1910	Lilac	120.–
32.	1910	Set Table	100.–
33.	1909	Fruit bowl	100.–
34.	1909	Head of a Woman (glass)	100.–
35.	1909	Asters by the Window	120.–

36. 1907 Betty (colored chalks) 100.–
37. 1910 Footbridge in Rain (watercolor) 300.–
38. 1910 Garden near Munich (watercolor—banal) 150.–
39. 1910 Sugiez—Steamboat (watercolor) 150.–
40. 1910 Sugiez—Canal, Near Lake (more like a sketch) 150.–
41. 1910 Sugiez—Canal, toward North (sold) 200.–
42. Breaking Waves
43. 1909 Sketches of Children (six pen drawings) 50.–
44. 1910 Near Munich (reduced by means of pantograph) 100.–
45. 1910 Near Munich—Military Gravel Pit with Houses (playing) 100.–
46. 1909 Oberwiesenfeld; The Houses Near the Military Gravel Pit 100.–
47. 1909 Schleissheim—Façade of the Castle 100.–
48. 1909 Seamstress and Woman (pen drawing) 50.–
49. 1909 Justistal (pen drawing) 100.–
50. 1910 Bern I (drawing pen—disproportionate) 80.–
51. 1909 Bern with Cathedral (brush dabbings) 100.–
52. 1909 Bern—Meadow with School House (brush dabbings) 80.–
53. 1909 Drawing for Woodcut 100.–
54. 1909 Dancers 100.–
55. 1910 Road to Schwabing 50.–
56. 1910 View (pen) 100.–

881. Summer in Bern. August-September. Watercolor, wet on wet, on paper sprinkled with water. Swift, nervous work with a specific resonance, whose parts are scattered over the whole.

Similarly, pen drawings on paper sprinkled with water and covered with naïve contours, on which I applied tangent spots, from within and from without in turn, with the brush.

I twice visited the region of Murten for a day. In both cases a few works resulted at once. The first time was lovely summer weather, and I crossed the

great bog, leaving the road that connects Kerzers and Müntschemier, making for Sugiez. This wasn't such easy going, and I leaped nimbly through the air over many a water-filled ditch. At the largest one, I gave myself courage by throwing my painting gear across ahead of me; after that, the owner just had to follow. (A ten-yard run before jumping!) Such tours are nice when you're alone and arrange everything without having to consult anyone but yourself. The summer is sultry and this has a strong effect on the flora of the bog. At one point I met some foreign laborers who understood none of my languages, very strange in Switzerland. What country did they come from? Poland. Then a large stud farm appeared: "Belle Chasse." After two hours of strenuous hiking I paused and set up camp below the bridge on the Broye at Sugiez. From this point I wandered here and there, lay in wait for the little steamer, allowed myself to be mocked by automobilists from Neuchâtel. The main thing was that I did some shooting!

October. The second time—autumn had already come—I dragged the old man along and consequently took it a bit easier. In the forenoon we fished in the Broye, in the afternoon we climbed up on the marvelous Mont Vuilly, where the thrushes are at home. Here I quickly noted down a few views. In the evening a steamer took us to Murten, where we arrived in an enchanted mood by nightfall. The end is banal; we waited until the silly train at last arrived.

Other excursions brought me and Lily into the region of the Belpberg, the Längeberg (Bütschelegg). We spent a few days in St. Beatenberg, already very late, the weather not too good.

November. Finally, I went once on a hunting tour along the left bank of the Gürbe, through the much smaller Belpmoos. In this most lonely region, strange creatures scurried across the river bank. On reaching this spot I heard suppressed, suspicious laughter. As a result, my fright wasn't too great when a horde of Indians suddenly fell on me with war whoops. One had his face completely covered with a red handkerchief. Amid crackling gunfire, they danced around me, the victim. The gang soon calmed down, since they saw that I was proof even against the first shock of surprise.

At night they again sweetened the banality of my way home: the dusty road from Kehrsatz to Wabern. Tired and tame, they passed me, and whooped briefly and mechanically, all of them stretched out on a wagon on which the kindly peasant had let them ride.

READING ON THE BED, 1910, 13

It was a beautiful summer. Lily was even quite willing to remain in Switzerland.

But I "didn't make a move."

882. December. After getting back to Munich, I find a really delightful intrigue in Schwabing; I may also be involved obliquely since I happen to be living in Schwabing too.

Toward the beginning of the year it seems that Z., E.'s wife, saw some wax dolls at the home of Lotte Pritzel, who was the mistress of a good many men. These wax dolls moved her deeply.

(Aside: it's really amusing to see the community get excited over tidbits like these.)

Out of the depth of her emotion, she copied the dolls, the only difference being that by error her figures lacked a wire armature and had bodies molded all the way through, and thus stood fixed and immovable: wax statuettes.

Now E., the husband, had tried to cover up the story of their origin, a fact about which our cello-playing gentleman, the brother of one of Lotte's lovers, complained to me. The art critic Michel was said to have been wised up by Lotte only after exclaiming: "How strange, I saw such dolls just recently." But an art critic is a human being as well as a lover, and might have given Lotte the reputation of being dishonest.

Even my friend Earnest, it seems, belongs completely to the Schwabing set, for he deemed it important enough to whisper into Lotte's ear: "Your dolls are being copied!" Later he brought written proof of this allegation by exhibiting a copy of a letter by husband E., in which the latter gives vent to his joy at the thought of how furious those little Pritzels would be, if Z.'s dolls were to be shown in public first!

So Earnest had his joke—this was something about which he couldn't be completely earnest, since he still got along quite well with E., sketched him, and wrote him friendly dedications!

In the meantime Lotte got at E. and showed him the copy of the passage of his letter that Earnest had jokingly passed on. Whereupon E. took Earnest in bloody earnest and not only denied the said passage himself, but demanded that Earnest issue a written denial too.

Earnest, however, refused to admit that he had lied and merrily kept up the joke; he finally placed the original manuscript in which E. had set forth his request into Lotte's hands (Lotte's hands are said to be lovely).

Whereupon E. exclaimed, "Damn it, the game is up."

883. Kubin writes Z.: "Wernstein am Inn, Upper Austria, November 22d, 1910. Dear Madam. In recollection of my visit, I have a favor to ask of you which perhaps you can do me. I would like to acquire a small drawing by Klee and beg you to transmit this wish to him with my greetings. What I should like most would be for him to send me a few items for me to choose from— priced favorably, if possible, for a fellow artist. His marvelously logical recent development (an example of it hangs in your home, under the fake Ensor [this is by Ernst]) interests me especially, but let him enclose some older pieces of work too. The things will be sent back by return mail, registered, etc., Alfred Kubin."

In short, an act of recognition outside of Schwabing; I felt flattered by the

Klee 1910 15

Karikatur v. Möbel

CARICATURE OF A PIECE OF FURNITURE, 1910, 15

fact and sent the pieces. He chose "Canal Harbor," which is actually an ice factory near Munich, a drawing done in the late autumn of 1910, a light-form executed by imposing spots on lines, wet on wet, for forty marks, and wrote me: "Dear Herr Klee, Your beautiful consignment (I am keeping one piece) has given me wonderful pleasure. Of course what I would like best is to keep them all, but it's the same old story. I find your progress really admirable; I am always encouraged when I come upon good efforts neighboring my own. Didn't we both start out from abstractions, to find ourselves today with deeper empathy for the actual world? I shall come to Munich for a few days at the beginning of January and also pay you a visit. I hope you won't be away. I am sending back your things tomorrow. I've enclosed a small work by myself; please consider it a token of my gratitude for your kindness! With best regards, your devoted Alfred Kubin. December 16th, 1910."

884. Small satyr play. Winterthur, November 21, 1910, addressed to Herr Klee, painter in Bern:

"Your works have been on show at our gallery since November 15th. We are obliged to note, however, that the great majority of the visitors expressed very unfavorable opinions about your works, and several well known, respected personalities asked us to stop displaying them. As a result, we beg you to tell us right away what we should do; perhaps you might send us explanations about your work which we could hand out to the visitors of the exhibition. Hoping to hear from you, we remain respectfully yours, The Art Gallery at High House."

My reply: "Dear Sir, Your embarrassment is certainly regrettable. But as a connoisseur of art you have no doubt heard that, here and there, good artists have come into conflict with the public. Without trying to compare myself to anyone, I need only mention the familiar name of Hodler, whose bearer now does handsomely, in spite of earlier friction. An artist who, in addition to his works, provides explanations of them must have little confidence in his art. That is the critics' role, and I refer you to the review by Trog, *Neue Züri Zytig*, October 30, 1910. At the end of the time of exhibition agreed between us, be so kind as to send the works to the Kunsthalle in Basel. Respectfully, Klee."

885. Light considered from the draftsman's point of view.

To represent light by means of light elements is old stuff. Light as color movement is somewhat newer.

I am now trying to render light simply as unfolding energy. And when I handle energy in black on a white surface, I ought to hit the mark again.

I call to mind the entirely reasonable black made by light on photographic negatives.

Moreover, the lesser thing is always made special note of, so one imagines the situation of singling out a few highlights on a white surface by means of lines.

To heap up an untold quantity of energy lines, because of these few highlights! *That* would be the real negative!

ADDENDUM TO JULY 1910

886. "Dear Dr. Blei:

Since at one time you expressed such strong interest in my work, you might be interested in knowing how *Hyperion* acted toward it in due course: it remained silent, silent, silent. Moreover, I have a request to make: two years ago, I had sent you the zinc plate for "The Hero with the Wing," which was being considered. Since the publishing house also remains silent about this, I would be very grateful to you if you could inform me about it as soon as possible! Yours sincerely, Klee."

(P.S. He will have noticed how I dissociate him from the publishing house, in order to be able to tell the "publishing house" the truth.)

887. Another pleasant exchange with a publishing house. This one is called "Light and Shadow." At the request of someone or other, I sent in:

1. "Construction Yard," pen drawing, 1910,
2. "Hannah, Profile," pen and brush, 1910,
3. "Steamer on Canal," pen and brush,
4. "Gravel," pen and brush,
5. "On the Thunersee" (house and boats near the Hünegg), pen and brush,
6. "Cart on Way to Market," pen and brush,

7. "Bern," pen and brush,
8. "Hannah's Head, front view," pen and brush.
Addendum: after three quarters of a year, the decision was negative.

1 9 1 1

888. January. Kubin, my benefactor, has arrived. He acted so enthusiastic that he carried me away. We actually sat entranced in front of my drawings! Really quite entranced! Profoundly entranced!!

He returned that night for our music session, with Karl and Maria Caspar. In his enthusiasm, he didn't even fear such calm witnesses as these.

"As regards development, you are the first of them all! Is it not so. . . ." (Whereupon he slipped in:) "I trust you also have some hope for my development?" In saying this, his voice succeeded in sounding magnificently sincere. He is certainly a fascinating person, an incredible mimic!

Is he musical? His assertion that music excites him too much is suspicious.

The Swabian couple had their quiet fun about it all. She saw my drawings for the first time; one cannot tell how deep an impression they make on her. She's as happy as a lark about them. He is more precise, spoke of baroque Gothic, a catch-phrase that Kubin greeted with vigorous applause.

I don't want to know about it! I want to be stupid about these things. Intelligent in the professional part. The rest is in the hands of God!

889. Z. brought the art critic Wilhelm Michel. In the spring of 1910 certain works had somehow been shown to him, without success. Now a number of things, I suppose, have changed for him. After all, there was no Z. for him at the time.

O sweet Schwabing. He quickly suggested that we undertake to do something together and finally went off with a whole pile of drawings. The first attempt was supposedly made on Herr Koch, a former traveling salesman in wall paper, now Councillor Koch and Publisher of *Kunst und Dekoration* ("Art and Decoration"). He didn't like my work and for the days ahead predicted a new, loving manner of execution. Then an attack was launched against the former custom tailor Thannhauser who now owns the Modern Gallery in the Arco Palace. This worthy, who had returned my works to me

unopened when I dealt with him personally, now said yes, in principle, to "the influential gentleman of the press."

In half a year, the gentleman of the press was transformed by love, the gallery owner by fear.

The gentleman of the press is very pleasant, doesn't hold forth much, acts quite modest, and has begun to behave like an uncle toward Felix. But then we are all human beings! This holds true everywhere, and especially in Schwabing!

890. February. I am starting a precise catalogue of all the works that are still in my possession.

892. Am continuing to play with a dark notation for light-energy. My interpretation, in the sense of a photographic negative, can yield thoroughly positive pictorial results against the white background.

In addition, I am attempting to arrive at a rhythmically distorted composition while preserving order. In studying this problem I resort to a mechanical device. Theoretically, the pantograph might be set incorrectly, but the resulting distorted picture can't often be predicted.

To get around this flaw, I thought of the following: I drew an ordinary correct drawing on glass. Then I darkened the room and lit a candle, though a gasoline lamp is best, because the size of the flame can be easily regulated. I placed the glass pane at an angle between the source of light and the new sheet of paper, which lies horizontally on the table.

Result: In the "correct" image, we find AB, BC, CD, whereas the projected or distorted image shows the reverse, A_1B_1, B_1C_1, C_1D_1.

In each case I made the most varied experiments by altering the angle of inclination of the glass plate until I hit upon the conversion of the image most satisfactory to me. But each conversion was justified somehow by the fact that the disproportioning obeyed a rule.

In many cases, I finished off the composition by applying the basic pseudo-Impressionist principle: "What I don't like, I cut away with the scissors."

893. Two liberties of graphic simplification: the characteristic minority is noted down; for instance, in a snowy landscape with a great, great deal of snow, the few remaining parts without snow are indicated as black energy (black in nature and black in the rendition), or in a dark landscape with few lights, these few lights are also indicated as black energy (white in nature).

One may even imagine the two instances combined in one scene.

894. Now I again need the contour, that it gather and capture the impressionisms which are fluttering around. Let it be the spirit ruling over nature.

SPRING

895. All the things an artist must be: poet, explorer of nature, philosopher! And now I have become a bureaucrat as well by compiling a large, precise catalogue of all my artistic productions ever since my childhood. I have left out only the school drawings, studies of nudes, etc., because they lack creative self-sufficiency.

896. In spite of love and fear, my one-man show is not materializing so easily as was thought at first. The two Hebrews Brackl and Thannhauser find no commercial incentive in my one-man debut. If you are so brash as to stand out from the average, you must at least be famous. But how you are to become famous without exhibiting is a point on which the two gentlemen can give no advice. And the gentleman of the press is too befuddled by love to exert his influence adequately in the proper place. Anyone who has so many children rather tends in this day and age to be neurasthenic. In Bach's time things were different.

YOUNG MAN RESTING (SELF-PORTRAIT) 1911, 42

To put it briefly and bluntly: the hallway offered by Herr Thannhauser was a little offensive. In consequence, one first had a try at Herr Brackl. The latter wrote back very nicely:

"In these works, which . . . , there is something quite out of the ordinary here and it would be a shame, therefore, to exhibit these plates in my gallery, where people primarily look for paintings and specifically for the works of the honorable Artists' Association 'Scholle,' and where absolutely no interest is taken in graphic artists of extreme modern tendency (I am practically never able to sell creations of that sort—I can hear him saying this in his tenor voice).

In appreciation of your truly great talent and in my joyful willingness to serve Herr Wilhelm Michel, I would say yes, but in view of etc., etc., etc."

In conclusion, this laurel-wreathed ass sent me to Littauer, to Steinicke, to Bertsch, to Putze, etc.

"Do not take this refusal badly and do not hold it against your respectfully devoted Franz Josef Brakl."

Thereupon, we returned ruefully to Thannhauser and contented ourselves with the hallway and the limited number of thirty items. It will take place in the beginning of June. The gentleman of the press said consolingly: "You will have many more exhibits; let's not start out now with the most favorable conditions."

897. Came out of a certain depression that threatened to overcome me owing to external "success"; shook myself vigorously. I had to shake myself, for I lack the whining, purgative organ for a *De Profundis*.

Father Voltaire was pleased with this, for he never moaned either, and beckoned to me. I was there in a trice and started at once to illustrate *Candide*. Following his paths, I found many a weight was shifted, which previously had been in its proper place, as was indispensable to my equilibrium; perhaps I actually recovered my real self at this point, though my opinions in the matter are uncertain to this day.

Concurrently, attempts at mediation with the outer world were made, 1911/41, 1911/42, 43, etc., but then the sciences brought a diversion, while for the time being nothing happened with *Candide*, except struggling and more struggling. Finally in the beautiful MM [Month of May] a kind of spring began to awaken here too. With the desired equilibrium, the work began to move ahead.

I really wanted to say many more beautiful things, but I am and shall remain superstitiously opposed to fanfares.

898. Johannes Mescaert sang. The man is Vogl, Gura, Joachim, and Casals combined in a single person. From "The Miller's Songs" by Schubert. "The Poet's Love" by Schumann. As encores, Schumann's "Moonlit Night," "Ich hört ein Bächlein rauschen," and still another song by Schubert.

Caesar and Cleopatra, a witty play by Shaw. Very well played, Steinrück and Terwin, etc.

SCENE IN THE RESTAURANT, 1911, 89

899. The longer my production moves in a definite direction, the less gaily it progresses. But just now something new seems to be happening to the stream: it is broadening into a lake. I hope it will not lack a corresponding depth. I was the faithful image of a part of art history; I moved toward Impressionism and beyond it. I don't want to say that I grew out of it; I hope this is not so. It was not dilettantism that made this small-scale replica out of me, but modesty: I wanted to know all these things, so as not to bypass any out of ignorance, and to assimilate some parts, no matter how small, of each domain that was to be given up.

At present, I begin to understand many things about Van Gogh. I develop more and more confidence in him, partly because of his letters of which I own a selection. He was able to reach deep, very deep into his own heart.

It cannot be easy, in fact, for anyone to hurry by such a landmark, for the historical clock moves more harshly in the present than in the meditation of art history. It never stops though; it only seems to, on foggy days.

Perhaps he did not say all he had to, so that a few others might still be called upon to complete the revelation?

It is particularly tempting to view Van Gogh in historical retrospect—how he came without a break from Impressionism and yet created novelty.

His line is new and yet very old, and happily not a purely European affair. It is more a question of reform than of revolution.

The realization that there exists a line that benefits from Impressionism and at the same time conquers it has a truly electrifying effect on me. "Progress possible in the line!"

The possibility ripened in me of harmonizing my swarming scribbles with firmly restraining linear boundaries. And this will bear for me a further fruit: the line that eats and digests scribbles. Assimilation. The spaces still look a bit empty, but not for much longer!

In lucid moments, I now have a clear view of twelve years of the history of my inner self. First the cramped self, that self with the big blinkers, then the disappearance of the blinkers and the self, now gradually the reëmergence of a self without blinkers.

It is good that one didn't know this in advance.

SUMMER

900. We spent the summer in Switzerland. It was hot, very hot; I can recall some hot summers, but none so hot as this. They were much cooler, even though they too were extremely hot. This far hotter summer even burned my brow (clear through the roof). Often it was the real South. The absolutely unadulterated South. Only the water of the old Aare was cool, like mother glacier, like mother glacier.

It had already begun in Munich and one went daily to bathe in Würm, to bathe daily in Würm, day after day to bathe in Würm. Roses were blooming there, which one swam by, the blooming roses swam by.

Sadly, we bathed our last and took our leave from the blooming roses, . . . ming roses. Never again will you bathe in this still far hotter summer, far hotter summer. You will forget what little you know about swimming, and you will crumble, crumble into sweat and dust.

CANDIDE, CHAP. 7, 1911, 63

The dust in Bern is white, white as flour. And the water is pure melted ice. Even from the train I saw the floury lines of the streets of Bern and the waters of mother glacier sparkling icily below.

Someone in the train said: "I know someone, I know someone who's going to dive into the Aare before the day is over." Close to despair, in the throes of fever, I still managed to engender admiration, a full dose of admiration, for this hero!

And as the excessive heat continued, another hero was born. And I trekked to the "Buber," like so many heroes, so many heroes, trekked there daily, there where the waters of mother glacier rushed.

"Oh! It's hot today! 120 degrees!" And even Professor Lotmar became a hero and swam like a seal (I wrote it to my wife).

Later she came too and also joined the ranks of the heroes. Variety was brought to the daily routine (the repetitive heroism), by the lakes of Thun

and Biel. The Sinners too were heroes and so was godfather "Mólié," also known as Uncle "Lui." Heroes along with us.

A day on the island (Schanschaagrousseau) was not at all bad. We still were more or less able to walk from Biel to Tüscherz in "the coolness of the morn." Then the older members of the party went on strike, put on their glasses, and scanned the timetable, right in the waiting room.

I was against the timetable, as always, because no train I had ever looked up on it had ever run. My wife giving me hard looks.

Meanwhile, a train sneaked into the station, just the one we needed. However, they had not yet found it on the timetable. And they didn't trust it, black on black; they wanted to see it black on yellow, as stated on the timetable. They were spurred into action by my getting aboard the train, and even more by two shrills of the whistle.

This was even more exciting than the fact that there was no steamer at the landing in Biel.

Do you know the timetable symbol for "Sundays Only," future reader? All aboard then for Ligerz.

When I was in the twelfth grade, I was once in Ligerz with a priest. We had drunk lake wine, and enthusiasm made a genius of me on the church organ. But the church lies somewhat uphill. The priest contemplated the stained-glass windows. I provided a feast for the ear.

That was about the way I passed my graduation exam, shortly afterward. The priest was nice, a real tower of strength. But "Professor Sidler" was even nicer.

This time, I was no longer a candidate for the graduation exam, but a married man. The motorboat took us to the island "Schanschaagg." My wife had to perform acrobatics climbing on and off. A snack rewarded us for all our efforts, then we dug for worms (faster said than done). And papa fished, which took care of him.

Both of us into Mother Green's waves. A good meal rewarded us for all our efforts. But then we decided on a new arrangement: both men fished, and she had to look on as penance.

In return she was allowed to take a dip with me a second time; toward evening. It was beautiful, very beautiful!!

Then the familiar ride to Biel, the city without connections. We saw the

people of Biel strolling along very much the way people do in Rome, along the Corso.

At last on the train; Münchenbuchsee whisked by, where were born famous-men-to-be. Gallop, gallop!

901. Spent two weeks on the gorgeous Beatenberg. Here a skillful Frenchman officiated as chef, formerly cook to His Majesty the King of Siam.

Our craving for water didn't leave us even on these heights and often drove us down to Thunsee. In those circumstances, what did nineteen-hundred feet downhill matter? One could also rush in turn to Merligen, to Sundlauenen, and to Gunten by way of Sigriswil. Sundlauenen provided me with my last swim; this is where I caught a violent cold as the result of a mad day by the water, on the water and in the water. First I fell into it in Uncle Lui's boat house in Gunten; then rowed Lui's boat toward Spiez. Dived for the second time between Spiez and Faulensee, at a Boecklinian spot between cliffs. Then a picnic in grass and grove, in the most tempting place. Kurt and Sascha von Sinner took part in it. Windy return trip across the lake. On the shore of Gunten, hot from rowing, a third swim. Finally on foot back to our Beatenberg, by way of Sigriswil, through the Justustal, the last stage in complete darkness. The fall into the water at Sundlauenen, as already mentioned, closed the watery part of the season.

It rained toward the middle of September for the first time in ages. Lily's grandmother died, and this event dampened our collective enterprising spirits.

After that, I climbed up once again alone, to where, as a boy, I had first become closely acquainted with the mountains, following the familiar path that leads to the Niederhorn by way of Vorsass and Vorsasspitz. On the way back I rediscovered the already forgotten path leading to the huts of upper Burgfeld. Here a heavy shower forced me to stop in a completely abandoned room. I wrote Senno a poetic greeting on his table, exactly the way boys do, and after a while continued homeward: over the lower Burgfeldalp and over the familiar Känzeli back to my hotel, to wife and child.

In the first place, this had been beautiful. Up on the Horn I had seen the bad weather approaching in person. The wind had blown polyphonic tunes

and I had started all sorts of creatures. Kingfishers, among others, which as a child I had found so fairylike.

In the second place, it had been good for my health, as I could actually feel my cold departing through my nose and ears, like an exorcised demon.

On the way back to Bern we again stopped at Uncle Luli's, where we met August Macke and his wife. In the afternoon we rowed and sailed. Felix seemed happy and was very well behaved, a fact to be noted. I risked an ultimate dip; the lake was very cold now, very cold. Felix sat on the floor of the boat and gravely looked at me as I was swimming about. When we left Gunten in the evening, it was already completely dark. The boy carried the lantern. On the train between Thun and Bern he quieted down: sleep seized him violently by his soft collar. Such a terrible, such a poor little fellow.

AUTUMN

902. This summer in Munich a group of young artists gathered into an association that will bear the name "Sema," the "sign." I am one of the founding members, probably through writer Wilhelm Michel's doing. Others who belong are a series of painters, sculptors, and poets. The last group, currently in the minority, are there mostly to make propaganda, I suppose. The art critics Michel and Rohe. Kubin, Oppenheimer, Scharff, Genin, Caspar are the artists whose names come to my mind at this moment.

We had met a few times in a pleasant little club and had agreed about Greco and about the fact that we all had no money.

Now it was decided to publish a portfolio of original graphic works; we were to collect at least one hundred subscribers; thirty had already been found. Then Herr Thannhauser agreed to organize a first exhibition. Caspar put on optimistic airs. And I? Well, it is at least a sign that I was, after all, not to remain isolated in the outside world—a timid initial attempt to join others. I see little connection between this and the inner world. But, as the saying goes, it's worth a try.

903. Uncle Luli (Louis Moilliet) is with us for a few days. He is in a bad mood, the August Mackes hung his hat on the chandelier in a public establishment. He has left his quarters and moved into our vacant maid's room.

Kandinsky, about whom I have often spoken in the past and who lives in the house next to ours, this Kandinsky, whom Luli calls "Schlabinsky," nonetheless continues to exert a strong attraction on him. Luli often goes to visit him, sometimes takes along works of mine and brings back nonobjective pictures without subject by this Russian. Very curious paintings.

Kandinsky wants to organize a new society of artists. Personal acquaintance has given me a somewhat deeper confidence in him. He is somebody and has an exceptionally fine, clear mind.

We met for the first time in a café in town; Amiet and his wife were also present (on their way through Munich). Then, on the trolley that was taking us home, we agreed to meet more often. Then, in the course of the winter, I joined his "Blaue Reiter."

HODLER

904. Great Marées exhibition at Thannhauser's, organized by Meier-Gräfe, 1908/09, and now Ferdinand Hodler at the same gallery; such things are very stimulating, even though I am not altogether for Hodler. For his significance doesn't rest in the purely pictorial, toward which I am striving more and more. He knows well how to characterize gesturing people, this I grant him. But I am worried by all these figures which look as if they can't find peace. Hodler is interested only in spiritually hyperintense beings; or more exactly, only in their image: spiritually hyperintense painting is neglected rather than put to use. These *Dinge-an-sich* become wearisome, especially when there are many of them together, and get on one's nerves.

This is *my* repudiation of the man. But the repudiation by the numerous people who sought to connect him with modern developments remains ridiculous.

1912

905. From my Munich art-letter, which I wrote for Switzerland: "Among the private galleries, it was once again the Thannhauser Gallery that at-

tracted my attention with the (third) exhibition of the new Association and this group's still more radical offshoot called the Blaue Reiter. Limiting myself to the idea, not to the momentary, accidental nature and the merely superficial appurtenance of a number of works, I should like to reassure people who found themselves unable to connect the offerings here with some favorite painting in the museums, were it even a Greco. For these are primitive beginnings in art, such as one usually finds in ethnographic collections or at home in one's nursery. Do not laugh, reader! Children also have artistic ability, and there is wisdom in their having it! The more helpless they are, the more instructive are the examples they furnish us; and they must be preserved free of corruption from an early age. Parallel phenomena are provided by the works of the mentally diseased; neither childish behavior nor madness are insulting words here, as they commonly are. All this is to be taken very seriously, more seriously than all the public galleries, when it comes to reforming today's art. If, as I believe, the currents of yesterday's tradition are really becoming lost in the sand and the so-called unflinching pioneers (liberal gentlemen) display only apparently fresh and healthy faces, but actually, in the light of long-term history, are the very incarnation of exhaustion, then a great moment has arrived, and I hail those who are working toward the impending reformation.

The boldest of them is Kandinsky, who also tries to act by means of the word. (*The Spiritual in Art*, published by Piper.)

906. February. The good Jahn, our beloved musical mentor, has just died in Bern. He was an able, serious, and noble gentleman. An outstanding violin teacher. None of this is exaggerated. From the very beginning of his elementary instruction, he set the loftiest goals. He himself was still constantly striving to improve, and he knew the right way to teach diligence, because in his eyes diligence stood higher than talent. As an artist, he was a shade too intellectual. The authorities in their efforts to relieve him of some of the burden, and perhaps also to replace him, must have made gross errors of late. On a few occasions he had been beside himself with humiliation.

I believe, however, that the errors committed were only errors of form. For the tragedy had always been there. Jahn had always lacked the virtuoso strain

and this led to conflicts with which he could no longer cope as he grew older. As a teacher, he was of the highest eminence.

A stroke paralyzed him suddenly and within a few days he was gone.

907. Ah, the Sezessions! They won't believe it anyway, even if one could prove to them that they have outlived their usefulness. They won't, no matter how suspicious a symptom appears; as now, for instance, when the battle of opinions tends more and more to transfer its arena to the provinces. Here, one lives peacefully in the most beautiful palace, in royal Bavarian style.

And the poor public will have to grow accustomed to something new because it is the fullness of time (once again). And it will be converted when the French manage again to make capital out of the new. And that will be sooner than one dares to think.

"Der Blaue Reiter," so the thing is called. The enterprising "editors" Kandinsky and Marc have already organized a second show this winter, this time a graphic one, in the upstairs rooms of the Goltz Bookshop. This dealer was the first in town to dare to exhibit Cubist art in his display windows; the *badauds* describe it as a typical Schwabing production. Picasso, Derain, Braque, as Schwabing cronies, a nice thought!

908. April. Thanks to these new Schwabing cronies and their works, the idea of having a look at things in Paris once more became very attractive. My wife wanted to come along too, and so we dared and decided. The boy had to be parked at my parents' in Bern, this was obvious, and so I started out on this roundabout route, while my wife went directly and arrived a few hours before me (on April 2d).

909. In Pontarlier I took a local train; in this way I was able to contemplate the crests of the Jura at a very leisurely pace. Many soldiers had boarded the train there. They were still wearing red pants, they twirled their cigarettes and were merry without being too bothersome. The railroad employees were rather unkempt. On their caps it said "P.L.M."

This noble train stopped at every station. Women with snow- and rain-drenched clothes and baskets got on. An unspeakable smell of people spread. And so it went, as far as Dijon.

After a considerable delay, a through train was ready, thank God! The air in the compartment was better now, too. It smelled quite nice. The landscape around Dijon is appealing. Rocky hills and, and in the midst of all this stone, the most beautiful, blooming trees. A blossoming minority among stony complexes. Quite southern in aspect, that is to say French, where north and south melt into each other, instead of being separated by a wall of ice.

Gradually the scenery lost its alien charm and became green, soft, crepuscular. Quiet streams appeared, here and there a grazing horse in the distance.

Somewhere or other, we had to let two express trains pass us. "Ah, *les directes!*" exclaimed a woman, trembling, and "Whamm!" one of those monsters sped by us. Ten minutes later, "Woof!" the second one. Real explosions!

910. 4.2. Arrived at the Gare de Lyon even later than scheduled. Sonderegger and Lily, she already enraptured. To the Hôtel des Mines on the Boul' Mich. Then to Hofer's, to make an appointment.

4.3. Boulevards, Seine, Notre Dame, Grands Boulevards, Opéra, Louvre. In the afternoon, to the Musée du Luxembourg: Degas, Manet, "The Balcony" etc., the Luxembourg Garden.

4.4. Palais-Royal, Tuileries Garden, Place de la Concorde, Champs Elysées. To Hofer's studio. In the afternoon: Salon des Indépendants; in the evening, Moulin de la Galette.

4.5. Forenoon: Pantheon. Afternoon: Louvre—Greco, Delacroix; evening, Panthéon Bar.

4.6. Montmartre, Sacré Coeur, Montmartre cemetery (something for Lily!). At night: Gaité Montparnasse: "Polu chez les cocottes" with the comedian Cambon.

4.7. (Easter). Versailles. In the evening, at the Café de la Paix.

4.8. Notre Dame and Sainte Chapelle. In the evening, at Karl Hofer's.

4.9. Jardin des Plantes. The church of Saint-Germain-l'Auxerrois.

Louvre: Manet (Olympia), Ingres, Delacroix, Daumier's Etruscan collection. In the afternoon: tea at Hermann Haller's. Café Panthéon.

4.10. Museé Cluny, outer Boulevards, the fortifications, Porte Clichy, Café du Dôme (Schwabing-like *milieu*).

4.11. In the morning I visited Delaunay at his studio. In the afternoon, the

HARLEQUINADE, 1912, 84

Louvre, to see Manet's "Déjeuner," Delacroix, Guys. In the evening, Concert Bullier.

4.12. On the tower of Notre Dame. In the afternoon, at Uhde's, Rousseau, Picasso, Braque. Rue de Seine; in the evening, on Hofer's recommendation, saw the coronation of the Emperor of India at the *Cinéma coloré* (English antics!).

4.13. Musée Carnavalet. Then at Kahnweiler's shop. (Derain, Vlaminck, Picasso). In the afternoon: visit to Le Fauconnier. In the evening: ride on the Seine as far as Auteuil and back. Panthéon Bar.

4.14. Père-Lachaise cemetery. In the afternoon: lovely cab ride in the Bois de Boulogne and along the Champs Élysées. Another visit to Haller, to meet his wife. In the evening, at the Cirque Médrano.

4.15. Seine-ride to Saint Cloud, strolled around there (Parc), in the evening to the Opéra: *Rigoletto* and ballet.

4.16. In the morning at Barbizanges (gallery) at Kandinsky's request; in the afternoon, at the apartment of Durand-Ruel, then to Bernheim *jeune*: Matisse, Goya. In the evening, Bal Tabarin.

4.17. At the cursed customs office at Gare de l'Est. Then to Druet. Ob-

served the eclipse of the sun from near the church of the Madeleine. In the evening, signed one hundred lithographs. Lily's departure.

4.18. In the morning, a visit to Herr Sourbeck's. In the afternoon, at Sr., met and impressed Haller, who runs after his sister. At 10 p.m., departure for Bern.

Spent five days there and went back to Munich.

911. We found an excellent guide for Paris in E.X., even though he proved to be a guide primarily through old Paris. He looks skeptically at anything recent, but knows how to tell us the way there. His second wife, a distant relative from Bünden, briskly accompanied us; a white feather nodded at the front of her hat like a signal, sometimes from a great distance, for she had a brisk walk. However, her tempo picked up sharply in front of exceptionally tempting store displays. As a result of this marriage, our friend E. has become a bit *embourgeoisé*, but also a bit sounder, economically speaking.

Inside him, things might at times have looked less affable. We had the unpleasant task of telling him about the last days of his first wife and giving him her not very cheering diary and a "will."

This first wife, born in F., whom he had divorced, had died recently from taking poison. My wife and I had been allowed to look on, as it were, while this human ruin, only thirty years old, completely went to pieces. She almost moved in with us, but thinking no good could come of it, we put her up in a small boardinghouse in Schwabing. She came to our house every day and ate with us, if you could call such a little bit of food eating. This excruciating sight became unendurable in the long run, until I said to myself that this shipwrecked creature had a right to die.

And so she was allowed to do as she pleased. She was sent once again to the doctor (Fritz Lotmar), she was allowed once again to express her fearsome preoccupations and my wife accompanied her in Schubert's "Winterreise" with a terror such as only a truly hideous swan song can provoke.

Then she handed me—naturally!—poems, for publication naturally, and a number of written things for her E. For the last time she caressed a piece of furniture that we had taken over when her household broke up, she almost caressed me as she said good night, and then she left. And naturally it was the eve of her birthday.

During the night she swallowed several poisons collected in small doses, and died undisturbed, in contrast to her suicide attempt some time before, in F. In the morning she was found dead, and I was summoned by a note to take care of everything. The official investigation was going on, a journalistic scavenger was there too; he published in the newspapers, for the payment of a fee, the few explanations I felt I had to give about the suicide. Now the relatives had to be called in from far and wide, from Berlin and from H., etc. All this was done at the expense of time and nervous energy, but it was nothing compared to the effects of her last days.

X's second marriage seems solid. Haller's marriage seems less good. Before her bust, he said: "Now, if only she were as beautiful inside as outside, it would be fine!" About the late X., he said: "She overloaded her cart."

912.　Two dead painters, Brühlmann and Welti (*Totnigi*). The more enjoyable part of Welti's *oeuvre* can be explained by the fact that the man himself is faithfully reflected in it. A good, old craftsman made it with a true heart. I can still see him before me when he came to Solln last fall to take charge of the body of his wife, who had died suddenly. We awaited him with painful apprehension, but the old man, who suffered from a severe heart disease, dispelled our anxiety by the simple, human way in which he bore his fate. The situation rose above the usual unedifying character of burial scenes. It was as if we were reading from an old story book. But even old stories have very jarring notes; and we are simply not figures out of an old story. Translated into a picture, this ancient forefatherly quality tends to become distressing again, by repeated dilution. And he did translate it into a picture—he etched a funeral cortege, showing himself behind the coffin with "Albärt and Ruodi." Then he wrote a sentimental motto beneath, and the schmalzy piece was done.

Hans Brühlmann agreed too much with Meier-Gräfe. He allowed his admiration for Böcklin to be torn away from him by force. It was not an easy victory for Meier, nor was it very nice to see Brühlmann surrender himself. Later, nothing of the sort happened to him again. The nonfantastic artist remained bound to the "new track. Naturally, Marées and Cézannes follow. Hear ye, Brühlmann has become a disciple! He has painted his own portrait as such. No direct light shines out from this man, only reflections.

And yet he still strove to attain the "monumental." Of course, the monumental is never achieved in this way. For either one is monumental or one isn't. Just like Haller and Hofer, who also always want to be monumental and only succeed in being weighed down by the past. But the gentlemen are not disappointed and will never be. Poor happy souls.

913. Again spent the summer in Switzerland. Bern and a while in Hilterfingen, where my little, surviving aunt keeps house in three rooms. In contrast with 1911, the weather was cool and rainy. Autumn smiled somewhat more kindly.

We spent three days, the three of us, at Uncle Lui's in Gunten. In Bern, Arp visited us; he launched the Modern League of Associated Swiss Expressionists and himself along with it. He is quite a lively fellow. Returning his visit, I journeyed back by way of Lucerne–Weggis–Zurich. We had already seen the exhibition in the Kunsthaus at Zurich on our way to Bern, and taken advantage of the opportunity to take a ride across the Lac des Quatre Cantons up to Andermatt. In Weggis there was still Lüthy, an erotic artist, somewhat too gleaming and pearly, and also Helbig, a little tailor from Saxony, and also Sprenger, who can only say "Pikkasso." All of them make brave efforts, and a little Alsatian litterateur beats the drum for them with a certain grace. I was welcomed as if I were already a great man. How relative all ideas are!

914. Having gone back to Munich first without the child, I had a bit more freedom than before. I was able to go out without first having to ask for my little son's permission. And really got very busy.

Goltz is becoming an art dealer and is opening a small, very appetizing gallery on the Odeonsplatz. I even took part in the preparations.

Then Alfred Mayer, nicknamed "Softy," approached me and had a look. He fell so in love with my "Candide" that he went with me to the Georg Müller-Verlag to sign a contract on the basis of this work. But Georg could not make up his mind: I can't think of anything for the moment, he lisped. I mentioned Sterne's *Sentimental Journey*. "Already published, with Chodowiecki's copper engravings, as is *Candide*." I was able to think of still another:

GOOD CONVERSATION, 1913, 84

"Reynard the Fox." Would I think it over and submit sketches? This was tantamount to a polite no, and Mayer almost became sad.

Now Delaunay wrote and sent me an article by himself about himself. From Cologne, Franz Marc wrote several times about his impressions of Paris, about Walden and his *Sturm*, about the Gereon Club in Cologne. I ought to get together a good selection of my works for Cologne and Berlin, which might eventually tour further.

Kubin shows up, Wolfskehl met at Münter's. Then Marc in person, bringing along Walden on another day. The latter remained very quiet, to him I am very much second rate. But since Franz wishes it, he allows a couple of drawings to be slipped in the pocket of his coat for the *Sturm*.

Marc recognizes the value of the "Candiddles," wraps them and takes them to Piper.

Once again, on the following day, little Herwarth Walden was to be seen at the opening of the Futurist show at the Galerie Tannhauser. Lives on cigarettes, gives orders and runs, like a strategist. He is a somebody, but something is lacking. He just doesn't like paintings at all! He just sniffs at them with his good sniffing organ. Carrà, Boccioni, and Severini are good, very good; Russolo is more typical. Herwarth said to me: "These pictures are not up for sale; they are so famous that the people simply can't paint enough." I heard it.

1 9 1 3

915. I also beat the drums; Hans Bloesch in Bern occasionally prints a short piece by me in a small paper he is editing. For instance: "Munich offered a delightful little surprise in the opening of the privately operated Goltz Gallery, which is devoted to new art and is in the best location imaginable, on the Odeonsplatz. The new art has thus acquired a real home, after having depended until now on the hospitality (which involved some concessions) of organizers who did not really share its ideas.

Now at Goltz's, besides the local Blaue Reiter and the local New Association, are the brave Swiss of the Modern League and our allies from Berlin and Paris. For this first mass demonstration, the handsome room is just

large enough to exhibit three or four works by each contributor. To those friendly to the 'new trend' much remains obscure, but one-man shows will follow later."

916. Several guest performances by the Imperial Russian Ballets, with Nijinsky and Karsavina as soloists, bring an unusual novelty into the routine of the opera. I am not saying new life, for what is involved here is an old, probably dying art. Times long since vanished survive in it. The occasional incursion of modern elements does not alter this state of affairs. And one can look with emotion on what is disappearing, never to return. Particularly outstanding is Nijinsky, who dances in the air and on the ground simultaneously. My memory conjures him up in the moment he leaps and in the exquisite turnings of his young, powerful body.

A certain coolness in their reception is surprising. People here scream about the onset of changing times, in particular about the Futurist artists who at least stimulated us with their great talent, yet they remain stiff when the good old days rise up before them. What do they really want? Still nothing but Wagner, Knote, and Feinhals? Fortunately Munich has recently become a place where a good deal is on display, whether Munich wants it or not.

The great talent that I call attention to is Carrà; one needn't trip in crossing this new threshold and may think of Tintoretto or of Delacroix, so related are the sonorities of his color and even the spirit of his execution. With Boccioni and Severini, to be sure, the relation with the old masters is a less happy one. For instance, it says in the Manifesto: "When one opens a window, all the noise of the street, the motions and the substance of things suddenly invade the room," or: "the power of the street, the life, pride, and fear that can be observed in the city, the oppressive feeling caused by noise." Such things, in fact, have been convincingly represented. (Holy Laocoön!!)

So the domain is enriched by a new work. The frenzy of the hot-blooded young people needn't have been misunderstood either; they lavish it on their manifestoes, partly to scare people, but partly to establish their presence proudly and gloriously. The Modern Gallery, which is Herr Thannhauser, has opened its display-room to the Futurists but assumes "no responsibility" (it was amusing, at the opening, to see the usual, highly decent "modernities"

make room and depart). The real organizer is the heroic Walden from the Berlin *Sturm*.

This "no-responsibility" frontal attack is effectively flanked by the Goltz enterprise; not only by the latter, though, but also by another "Salon Schmid-Diezl," where a Nolde show is on view close to the lovely brook of the English Garden, fortunately at some distance from the "Harmless," toward, "of course," Schwabing.

And the measure is still not full!! Even Schönberg is being performed, the mad melodrama *Pierrot Lunaire!*

Burst, you Philistine, methinks your hour has struck!

917. In the course of the winter, all sorts of small new steps forward. Even a few sales, to Köhler in Berlin (just as my wife was suffering from a severe case of influenza), to Miller in Biberist near Solothurn, and so on.

Arp left Weggis. His father's factory went broke; nor does everything seem to be going well with the Modern League. But this concerns me less than the fact that Arp is making efforts in my behalf. Or let us say: in behalf of the good cause. He put me in touch with a new publishing house, "The White Books," in which a Herr Otto Flake, an Alsatian and a poet, is to participate. This fine Alsatian has been won over to me, it is said, and plans to do an edition of Candide with my illustrations. Even if Flake were to withdraw, which might still happen, this wouldn't jeopardize the *Candide.*

918. June. Piper is planning a portfolio of Expressionists and wants a contribution from me . . . A symptom? Until now this publisher has avoided me with marked persistence . . . And Walden is planning an Autumn Salon in Berlin, and Kubin and I are to have a private room for our graphic works there! In addition, Franz Marc discloses that Köhler is giving money and that he himself will exhibit. His velvet eye glows as he imparts this news.

919. Poor E., whose marital troubles have already involved me on several occasions, lately went completely out of his mind. A love correspondence by his wife drew us into the affair, and E. has now broken off his relations with us. A sick fellow, more and more given to contradiction, who senses betrayal behind any opinion that differs from his own, cannot be good com-

SISTERS, 1913, 140

pany in the long run. He had felt called upon several times to try to help me, without success of course, but that, after all, is not what counts. But now, as my career is visibly taking a turn upward and possibilities are beginning to offer themselves, now he thinks I've fallen into bad company and resents my having joined the Blaue Reiter. Moreover, he resents my not having sided with the defeated party in the breakup of X.'s marriage (feels himself in a parallel situation, to his detriment, in his own marital troubles) and my having let A.X. meet her death.

It is a pity for a human being to barricade himself off and shut himself up more and more, but since this thing threatens to lead to intolerably warlike situations, it is all to the good for relations to be broken off.

It is a great relief, and he made it easy for me. Z. wants to go on seeing us. Let her do so. But not much will come of it, for she too has ended by having a bitter taste about her.

920. "Woe is me under the pressure of the returning hour, alone in the midst, in the depths the stealthy worm." (I believe the drawing is good.)

"The death of the old magpie liberates a tiny spirit which escapes with the message" (another drawing).

An idyllic picture of Bern would have to show the following things:
1. The *Zytgloggegügel* [clock cock], which sings "Call you my fa . . ."
2. A drunken foursome of singers who serenade this bird.
3. Two polyps [policemen; cops] in rubber shoes pondering whether they will triumph over the four or succumb in the end.
4. The arcades of Bern, which arch over the scene [double over with amusement].

"A stroke of lightning in the night; the day screams sharply in its sleep. Faster, Mr. Canine, you'll be late for Frau Gfeller's dinner date / where you're invited to a full plate." Suchlike things I am now able to express with a certain precision, and this by line alone, line as absolute spirituality, without analytic accessories, simply taken for granted.

921. Tie small-scale contrasts together compositionally, but also large-scale contrasts; for instance: confront chaos with order, so that both groups, which are separately coherent, become related when they are placed next to or above each other; they enter into the relation of contrast, whereby the characters of both sides are mutually heightened.

Whether I can already accomplish such things is questionable on the positive side—and more than questionable, unfortunately, on the negative side. But the inner urge is there. The technique will develop in time.

922. Sometimes, a long time passes without struggle. Then I turn out "Innocence upon Innocence." A naïve style. The will is under anaesthesia.

1913/162 is a real declaration of love toward art. Abstraction from this world more as a game, less as a failure of the earthly. Somewhere in between. The man in love no longer drinks and eats.

923. December 1913. A Christmas trip to Bern is undertaken. I'm not at all enthusiastic about the idea. Why celebrate two Christmases there? Well, it's difficult to find any objection to it. One knows, after all, that Christmas

THE AFFLICTED POLICEMEN, 1913, 54

at the home of one's parents was indeed beautiful, was blissful, and is still beautiful and remains blissful.

But certain forebodings spoke against it. I kept seeing uncomfortably sharp images from my childhood.

Shortly after the New Year, Felix came down with influenza. I soon followed; from a devilish cold, a highly interesting sinus infection developed. Professor Lindt, an excellent specialist, was called in. I was able to return to Munich only at the end of January. There I still suffered from a lingering bronchitis. Finally it ended and I was fully recovered.

1 9 1 4

924. Mitrinovic, a Serbian, came to Munich and gave a lecture about the new art, Kandinsky, etc. He also approached me. Had me lend him some of my works so he could immerse himself in them. A nice man with a peasant face.

Often comes to our music sessions. Made this classic utterance: "Yes, Bach knew how to write it, you know how to play it, and I know how to listen to it."

Piper is mellowing and exchanges books with me for drawings. The Belly with the Shirtsleeves, the Sour One, certainly musn't hear about it.

Dr. Fritz Burger also takes an interest.

Musical soirées with cellist Barjansky; once I played Schubert's Trio in B major with Barjansky and pianist Sapellnikoff. It is easier to play with such people than with scholars. What partners I have always dragged along with me! Idealists drunk with beauty at the expense of intonation and elegant mountebanks juggling at the expense of honesty. Yes, yes!

925. The great phalanx from Putz to Kandinsky had to be created. Hausenstein and Weisgerber wanted to command it. Who is Weisgerber? This I never did and never shall understand. Hausenstein, indeed! He is witty and doesn't paint mediocre stuff, because he doesn't paint at all.

1913 55 *Die fliehenden Polizisten*

THE FLEEING POLICEMEN, 1913, 55

But they didn't quite carry it off. Putz would not accept majority, and Kandinsky and Marc declined, largely through Marc's doing. Thus the phalanx will stretch from Püttner to Klee, with Caspar in the center. Too bad the vanguard is weakened. It was named the "Neue Sezession."

Trip to Tunisia

926. April 1914. This is how it came about: Louis Moilliet, that Swiss count, had been there once (of course).

This because he had been invited by a doctor from Bern, name of Jäggi, who lived there.

Now, my friend the count is not only impudent about taking advantage of his good fortune, but also willing to share it with people he likes.

And he likes two people, one of them August Macke and the other myself. (He likes a good many young ladies, too.)

Macke has recently taken a place at the Thunersee, and last December the three of us vowed that it should come to be. Louis thinks I deserve this treat, and will advance me money against pictures. Macke can take care of himself, he is selling pretty well.

Bornand, the pharmacist in Bern, agreed to pay my fare, and Dr. "Jegi" was to put up Louis and me. That is how it came about.

926a. Friday, 4.3. Going to Bern; first, to park Felix with his grandparents; second, to pick up the money.

926b. Saturday, 4.4. Bern. Bought French money, a pocketful of beautiful gold pieces, five hundred francs. Some instinct or other made me take coins, although it was slightly more expensive than bills. Natural and right, even though it may not be really necessary.

926c. Sunday, 4.5. 2 o'clock in the morning. On to Geneva and Lyon in a comfortable Swiss railroad-car, through to Marseille. In Lyon the train stopped for quite a while. Beautiful town, houses like those in Paris. The quays along the Rhone very typical. In Geneva, a group of silly youngsters— French or French–Swiss—got on; they danced in the corridors and sang "Puppchen" and other imports from Berlin in French patois. In Lyon they marched through the streets in bands. Probably they knew a good restaurant; we didn't. Nonetheless we had had enough of their company and didn't

follow them. Not for us, these collegians. So we looked and looked, and finally found a place down a side street, where we had a fish from the Rhone; it was very good, although a bit on the small side. Let us call it a Baby Fish. At 12:15 the train went on; I believe the first part of the countryside we passed through is called Dauphiné and then came Provence. A lovely Southern land. The Rhone countryside near Geneva had already been very striking, there where the train turns off toward Aix-les-Bains by crossing the Rhone bridge; it was, in fact, a sight in the grandest style. Then the little trees covered with red blossoms began, and the roofs became orange-terracotta, enchanting, exactly my favorite shade of orange.

In Provence the little women clad in black, Sunday crowds with no savor of unpleasantness about them. Charms that set Count Louis's shark eye going. Avignon—God's residence in France—Arles, and all those other sounding names. Finally the landscape flattened out. The track was protected by trees against wind or some other danger—a flickering that would make one sick. The Swiss carriage was a bit too light.

Approaching Marseille, extremely heavy freight traffic. Handsome railroad station. A big lake, the Lake of Bern. Looks like the sea.

At five in the afternoon, we reached our first goal. Mounted an amusing little hackney with Louis, drove—or rather bounced—through this Southern Paris for a long time and constantly downhill. Let the cabman pick the hotel. Inexpensive, but so beautiful. Beautiful enough to make you stay.

A stroll at twilight along the harbor front. Looked for our ship. Worked up a terrific appetite. Looked for Macke on the quay of the Vieux Port. Finally found him. There he was with his baby face, eating and drinking like a young prince. Didn't see us. It was a sidewalk restaurant with a hedge around it. We crouched down behind the hedge, so that he could see only our heads.

Now he sees us—saw us, blushed slightly, looked quickly away, as though he had seen nothing. Then he greeted us gaily. He is bubbling over about Marseille and environs. Has even been to a bullfight. Almost made him sick.

There was still time to go to a vaudeville show. A young comedian impersonates a Tyrolean girl, the only number in good taste.

926d. Monday, 4.6. In the morning, tramped around Marseille, and out

FLIGHT TO THE RICHT, 1913, 158

beyond the city gates. We felt that we could take quite a good deal of this place. The countryside is tremendous and the colors are new. But Count Louis smiled at the idea of staying on, knowing what still lay in store! A young Turk hears us speaking German on the trolley and strikes up an acquaintance; he says he served under Liman Sanders. In any case, he knows German quite well.

At noon we went aboard our ship. A fine, big vessel of the Compagnie Transatlantique, called the *Carthage*. Pleasant, clean cabins. Little receptacles for vomiting, pretty and promising. The ride through the harbor made an amusing excursion. Out on the breakwater a last group of people waving goodby. Now the real thing as the ship began to roll. The Golfe du Lyon

[*sic*] is known for it. *Il fait beau temps, pourtant.* Try to believe it. I took Gabriele Münter's medicine; the other two were taking big mauve and green pills and smiling at me and my Münter remedy. I distrusted both remedies, the one as much as the other. That's why I began to feel pretty sick, though it was gradual enough. August Macke drew me a little sketch to show what I would look like when I was really sick (he had no faith in Münter). Whereupon I let him give me some of his mauve and green pills. Lo and behold! I felt better. And a bit later I lit my pipe. Whereupon August Macke really became my friend. Until then he had considered me a monster of perfection, and now I was snugly smoking a pipe. He found this irresistible.

This raised our good mood to high spirits, but all the same the deck slanted like a roof and everything began to slide, men, women, deckchairs; there was no little confusion around the rail. This continual slanting to one side and the other brought results: the passengers became fewer. But the three of us remained cheerful, carefree, above it all. Just happy. Desire for food and sleep overcame us. We laid siege to the dining room a half-hour ahead of time. Perhaps the food was nothing special, it seemed to us fit for a king. And how we slept!

926e. Tuesday, 4.7. Woke up within sight of the coast of Sardinia. The colors of water and air are still more intense today than yesterday. The colors are more glowing and rather darker. In the front of the ship (I visit third class frequently) the most colorful scenes are to be observed. The French colonial soldier goes so well with all this. In the afternoon the coast of Africa appeared. Later on, the first Arab town was clearly discernible, Sidi-Bou-Said, a mountain ridge with the shapes of houses growing out of it in strictly rhythmical forms. A fairy tale turned real; not yet within reach, far, quite far away, and still very clear. Our proud steamer left the open sea. The harbor and city of Tunis were behind us, slightly hidden. First, we passed down a long canal. On shore, very close, our first Arabs. The sun has a dark power. The colorful clarity on shore full of promise. Macke too feels it. We both know that we shall work well here.

The docking in the modest, somber harbor very impressive. The first Orientals we saw close up were those on the banks of the canal. But then, though the ship was still moving, incredible characters climbed aboard up

rope ladders. Below, our host Dr. Jäggi, his wife, and his little daughter. And his automobile.

Finally we landed and were submitted to the last test, making our way through the crush of the customs inspection, amidst deafening noise. By car to Dr. Jäggi's and to dinner. Everything continued to sway.

Under his guidance, a nocturnal walk through the Arab town. Reality and dream simultaneously, and my-self makes a third in the party, completely at home here. This will be fine.

Dr. Jäggi, comical, dry, and sober, feels alienated. Only has a feeling for the climate and money. Yearns for Switzerland, is stranger to me than the first Arab beggar. "There's an inn and a church, just like back home." We have to comment on a couple of fiddles that he bought cheap; in our state of enthusiasm, this is a bit trite. We make a few jokes about Stradivarius, take the violins and improvise the most beautiful Arab music. Louis and I as off-pitch fiddlers, August banging out the rhythm on the piano and singing a long, monotonous melody through his nose. I really think we played good music. And our testing of the violins met with everybody's approval.

926f. Wednesday, 4.8. Tunis. My head is full of the impressions of last night's walk. Art—nature—Self. Went to work at once and painted in water-color in the Arab quarter. Began the synthesis of urban architecture and pictorial architecture. Not yet pure, but quite attractive, somewhat too much of the mood, the enthusiasm of traveling in it—the Self, in a word. Things will no doubt get more objective later, once the intoxication has worn off a bit. Bought something in the *souk*. Macke praises the fascination of spending money.

Took a car ride in the vicinity of the city. Jäggi as unlicensed chauffeur. Heavy sirocco wind, clouds, the extremely subtle definition of the colors. Nothing painfully bright, as at home. To the rear, a big lake, which is said to dry up in the summer. A slight feeling of desert, threatening. In our climate sultry weather like this brings showers of rain. Not here, unfortunately, says Dr. Jäggi. Not a drop has fallen since December. We walked a little. First into a park with very peculiar plantings. Green-yellow-terracotta. The sonority of it strikes deep and will remain within me, even though I don't paint on the spot. Then we came upon a funeral. The lamenting women

could be heard from a distance. Louis's legs twitched, he ran ahead. Macke: "Since old Gobat's death, he's got a mania for funerals." A bit nasty, dear August! *"Le divin Gobat,"* as an obituary is supposed to have read. "But, dear August, this funeral strikes me as not uninteresting." And so we followed, August somewhat reluctantly, but he came! The coffin was colored blue and gold. A carriage drawn by six mules. Louis claims it was the Bey. No rain, and the weather was clear by evening.

On the way home Jäggi told us about a real-estate speculation in which he has a share. A hotel was to be built in the park. Would we not execute an enticing poster? August: Of course we will! Dr. Jäggi thought that we might earn some money and fill our travel kitty. Well thought, quickly said. But done? Never, of course!

The meals at Jäggi's are abundant. The cooking is done by a Negro; a surly woman from Aargau cleans the rooms. Our stomachs burn because we overload them. Macke swallows bicarbonate, powders wrapped in wafers. "But there's one thing the girl from Aargau does superbly," says Louis, taking her side: "That's to prepare baths! This she does to perfection."

926g. Thursday, 4.9. Weather completely clear again. But windy. Painting in the harbor. Coal dust in my eyes and in the watercolors. Worked anyway! The men on a French torpedo boat recognized that we were German and mocked us in broken German. August's appearance is a little compromising. He advised us to steal away as unobtrusively as possible. Sometimes he is exaggeratedly afraid. And he doesn't like Louis's jokes, such as: *"Où peut-on acheter une négresse?* etc." In the evening, went to the *Concert arabe*. A bit monotonous, a bit for the tourist. But new to us nonetheless. Very fine belly dances. One doesn't see such things at home. Musically, it is not without the appeal of novelty. The most melancholy melodies!

926h. Good Friday, 4.10. Tunis and St. Germain near Tunis. In the morning, came along in the car to participate in our doctor's driving examination. A very funny affair. He was at the wheel, and next to him the examiner, getting him to do all sorts of tasks. Louis and I were in the car. Dr. Jäggi, who usually doesn't spare the horn, forgot it in his zeal for long stretches. He had to drive up a large mountain in reverse; turning in order

to carry out this order, he drove on the sidewalk. When he was ordered to speed to the outskirts of town, he brought many cries of fear from the absent-minded natives; but all this to-do proved to be just an ordinary part of the show. The examiner combined this phase of the test with a little personal visit and let us wait for him on a lawn. Strolling around, I saw little spring flowers that don't exist at home. The doctor was worried, not about the exam—he was sure he had passed it—but about other matters. Many operated patients were waiting for him at home and in private clinics. Time was pressing, and the examiner was being very leisurely. After lunch, the doctor wanted to take us all, bag and baggage, to his country estate, where it was nice and peaceful. The drive there was adventurous, the car filled to overloading. Hamed, the colored cook, overtook us on his bicycle like a grayhound. He carried a basket on his back with the groceries in it. The country house is beautifully situated close to the sea beach and is built on sand. A sandy garden with artichokes, etc. A little donkey, which belongs to the doctor's daughter. The beast bites. The little girl was overjoyed and rode around on it. In the cellar were wines, pungent and very strong. "Home grown, the pride of Dr. Schegi."

Very hot during the day, but much cooler and a heavy wind in the evening. Laundry is not hung on lines, but simply laid out against a bush. The wind is steady and holds them fast. Found a chameleon in the garden; thin

as an empty purse, jaws gaping; the only effective thing to do for this is to pour water into them.

926i. Saturday, 4.11. St. Germain near Tunis. Some watercolors on the beach and from the balcony. The watercolor of the beach still somewhat European. Could have been painted near Marseille just as well. In the second, I encountered Africa for the first time. (Hausenstein later obtained this work, reproduced it in *Ganymed*.) The heat overhead probably helped. At noon my first swim in the sea. Got undressed upstairs, came down in my coat. Left the coat on the beach. Fine. In the afternoon our host came with his car and took us through a section of the countryside. Intense heat. In the evening, decorated Easter eggs for the children. August created exquisite patterns. Then painted a plaster wall in the dining room. August immediately at home in the large format, a complete scene, donkey and master, etc. I contented myself with two small pictures in the corner, which I completed.

926k. Easter Sunday, 4.12. St. Germain. August remained in bed that morning with a slight case of melancholy. Is so childlike himself and feels nostalgia for his boys. They ought to be here now to go swimming. I went out! To work. The little girl was looking for the eggs. Unfortunately, we had nothing to fix the colors, and part of the magic came off on her tiny fingers; the morning air was humid. St. Germain with the *tricolore* flag. St. Germain with the young palm tree. August didn't swim. Perhaps he was thinking of the legendary sharks? I wouldn't forego the treat. Noon here is too hot. The little girl stood on the shore with a big, heavy coat. The prospect across the water was splendidly beautiful, but not extravagant. Everything has great dignity.

The evening is indescribable. And on top of everything else a full moon came up. Louis urged me to paint it. I said: it will be an exercise at best. Naturally I am not up to this kind of nature. Still, I know a bit more than I did before. I know the disparity between my inadequate resources and nature. This is an internal affair to keep me busy for the next few years. It doesn't trouble me one bit. No use hurrying when you want so much.

The evening is deep inside me forever. Many a blond, northern moon

rise, like a muted reflection, will softly remind me, and remind me again and again. It will be my bride, my alter ego. An incentive to find myself. I myself am the moonrise of the South.

926l. Easter Monday, 4.13. St. Germain-Tunis. Before noon painted and swam. A sacred scarab dung-beetle does his work before me. So I too will work; will test again and again whether it rolls, remove some, measure it time after time. In the end, it will go right. But shall I, like him, move backward with my ball, I mean backward toward the goal?

But the comparison doesn't have to be pushed all the way. A bit of Homer can bring consolation.

Afterward back to lunch in Tunis by car. After lunch an Easter Monday drive in the car to Sidi-Bou-Said, the town that we first saw from the ship. Drove all the way up. Dr. Schegi turned his car around by getting out and lifting the rear. August observed that it was rude not to help, but he went no further than this. I tried to help, but was stopped. Schegi's hat was drenched with perspiration. Some Italians who were passing gave a hand. Now some explorations could be undertaken in good conscience. The town lies so beautifully up there and looks far over the sea, which accompanies us with its deep breathing as we climb. Stopped by a garden gate and began a watercolor sketch. Thalatta!! Then back to the little town. Where Schegi was drinking coffee in front of a cheerful mosque (just like at home, in Aemmetal, "across from the church at Waadtländer's and Greyerzer's").

We were soon to see clearly that Rome's victory over Carthage was absolute. We again climbed into our delightful car and drove down the mountain into the region of Carthage. This site is more beautiful than the place where Tunis is situated. Or what people generally call more beautiful: more open to the sea, with more of a panorama. Of the city, with the exception of a few excavated spots on the ground, there is not a trace. Instead, a new little Italian agglomeration with a mass of people cutting up. A brass band, hoarse and memorably out-of-tune, such as I had never even heard in unmusical Switzerland. Europe's victory over Africa, it now turned out, had been of questionable value! At the entrance of the village some beauty was sitting all dolled up on a dungheap, so the eye might have a treat worthy of the music. These mixed Sicilians are really not handsome at all. Rough

cross-breeds. There is some justification for the contempt of the French *colons*. The reasons for the severe tension between the French and the Italians, however, are different. Tunis is Arab in the first place, Italian in the second, and French only in the third. But the French act as if they were the masters.

Dr. Schegi on this holiday treated us to dinner in a French restaurant where the waiters were a little snooty. This riffraff is international. But the food wasn't bad. (Hamed had made us obese.) Frau Jäggi joined us. The trip home in the evening deserves no particular mention. Darkness is the same everywhere. This varied day ended with travel plans.

926m. Tuesday, 4.14. Tunis-Hammamet. Had an appointment at the railroad station at 6 in the morning with Macke. A small queue in front of the ticketbooth. An old man shouted: "bara! bara!" and makes room for himself. It was so natural. At home we hear this from children. I am in good spirits, in fact exuberant. I mistook someone in the queue for August and sneaked up to him as if I meant to rob him. Before I picked his pockets, I discovered my mistake. Beautiful voyage. Serious forest, even a certain somberness. "The Eifel is beautiful too," August said. The installations of this railroad are very primitive. As a result, progress was slow. But what did it matter? We had no business to transact. Arrived at Hammamet, but it was still a little way to the city. What a day! Birds sang in every hedge. We looked into a garden where a dromedary was working at the cistern. Downright biblical. The setup certainly hasn't changed. One could watch for hours how the camel, led by a girl, sullenly paces up and down, thereby accomplishing the operation of lowering, drawing, hoisting, and emptying the leather bucket. Had I been alone, I would have remained here for a very long time. But Louis maintains that there is, there *exists* so much more to see.

The city is magnificent, right by the sea, full of bends and sharp corners. Now and then I get a look at the ramparts!! In the streets more women are to be seen than in Tunis. Little girls without veils, as at home. Then too, one is allowed to enter the cemeteries here. There is one splendidly situated by the sea. A few animals graze in it. This is fine. I try to paint. The reeds and bushes provide a beautiful rhythm of patches.

Superb gardens in the vicinity. Giant cactuses form walls. A path with cactuses just like the "hohle Gasse."

Painted a good deal and sauntered around. At the cafe in the evening, the blind singer and his boy beating the drum. A rhythm that will stay with me forever!

Spent the night in a place run by a nasty old Frenchwoman. Louis and Macke, wearing only their night shirts, had a pillow fight. She gave us a constipating beef liver and tea. The cooking at the Jäggi's was better!

But the little terrace on the way up to the "hotel" was fine. I did a water-color here, transposing a great deal but remaining completely faithful to nature. Shortly afterward this watercolor was acquired by Dr. Karl Wolfskehl.

High oboe sounds and tambourine beats lured us to the snake charmer and to the scorpion eater: a delightful street show. The donkey watched too.

926n. Wednesday, 4.15. Our aim now was to go to Kairouan and to avoid traveling around too much by train. Consequently, we decided to walk a stretch, as far as the railroad station Bir-bou-rekba. In this way we got ourselves into the position of livening up the scenery of the country road with our European appearance—as incongruously as possible. The scene, which we had already taken in from the train yesterday, was so uniquely timeless that it was a shame to intrude on it with our anachronistic early twentieth-century costumes.

But we were about to provide a really grotesque spectacle, a veritable disgrace to both parties: we as comedians and a group of blind singers as at least tragicomedians.

In the first place, the country road turned out to be sandy. Deep, dry sand, the kind that makes progress difficult, and of course we were late because we both carried our watches in our pockets. And then we ran into the aforementioned society of rhapsodes, who brought us to a dead stop by begging. Our comical haste in the dry sand, where we slithered around and sank at every step, had been noticed long ago by the ones in the troupe who could see, and they made ready not to let us through unshorn.

Louis and August were luckier in this than I, who was brought to a stop by a firm grasp. I paid whatever I happened to have in the pocket of my jacket, but it seems I had been appraised higher. In view of our lateness, this struck me as too much and I tore myself away by retreating.

Now they all ran after me to catch me again; in the process, the fat blind man was swept along by his tambourine boy and leaped into the air in the most comical way. Anyway, I achieved victory through flight, but didn't feel any fresher for it.

At last we reached the railroad track, which we then used as a road. On this slightly harder sand highway (if "highway" isn't an exaggeration) we progressed more easily. The railroad station was already visible, but very small yet.

We still managed to reach it before the train, which was tremendously late. To give our adventure a new comic twist, the clerk behind the ticket window greeted us with reproaches for being ten minutes late, according to the train schedule. This was French pedantry *in folio*. And another ten minutes passed before the thing actually chugged into the station.

Magnificent trip through more and more desert-like country. In Kalaa-srira we changed trains and had lunch at an "Inn by the Station" run by a curiously excited innkeeper. A Negro did the cooking and serving; he wasn't clean, but he knew his business.

How we laughed at the inn of this Don Quixote of a proprietor! Those chickens! (Well, any chickens! If you looked at them through a microscope, you would think they had been transformed into fiery horses, and would grow afraid of being run over and trampled.) Don Quixote's feathery beasts really were quite frightening, even without a microscope. If at least they had been *his* chickens, but actually, as we now learned, they belonged to neighbors. They had no business being in the halls of his inn! And he simply

could not stand for this behavior on their part or his neighbor's part. They were not to feed at his expense nor damage the *table d'hôte* by letting things drop.

At first we laughed at this comedy without giving offense, but soon our laughter became a ticklish affair, because the old fellow began to feel more and more insulted. He interrupted it by hissing "Sh! sh! sh!" but every time he was forced by his work to go back into the "house," his efforts were reduced to nought.

Maybe he once lost a law suit to his neighbor? For he now struck quite a tragic figure. One would have liked to spare him, but comedy is merciless. "Sh! sh!"—it will drive him to destruction. And "Sh! sh!" echoes a saucy Oriental boy, and our sympathy for the unfortunate man's anguish turns again into its opposite.

There were guests nearby who partook of nothing but this extraordinarily well-played drama. They got laughs gratis. This meant that the majority of the sane who were against the pitiful Don Quixote was swollen enormously.

Louis and August became daring and secretly rolled bread balls. The chickens doubled in number, and many chicks came running and almost broke their legs in their eagerness. Don Quixote's nearsightedness gave us courage. But then a giant bread ball fashioned by August rolled leisurely into the midst of the army of chickens. This seemed to arouse Don Quixote's suspicion.

Louis secretly caught a few chicks and let them flutter on the table. Don Quixote didn't see it too well and blamed the little chicks. "Sh! sh!" An Arab, who had controlled himself until then, one of the nonpaying guests, began shaking with laughter. Everyone howled and thrashed about with arms and legs. The noise turned into a hurricane whenever the old man had to go into the house, as he did just then to look after the coffee we had ordered. On this occasion August threw them a piece of cheese, but he was caught in the act by the returning innkeeper. "*Ah! Il ne faut pas leur donner du pain . . . !*" August: "*Pardon, Monsieur, c'est du fromage.*" "*Mais par mégarde! par mégarde!!*" The old slipper-slopper sat down exhausted, this was the end of him.

Luckily for him, our train was now about to leave. "*Trois francs avec le café*" are his last words. An appropriate tip to the Negro, and we are off.

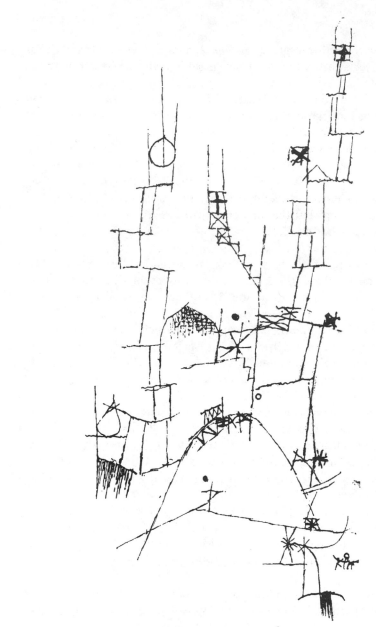

JERUSALEM MY HIGHEST BLISS, 1914, 161

The episode would have provided us with enough memorable things for at least twenty-two stations on the Emmenthal line. But here the new splendor of the land took hold of us again. We dubbed the piece of cheese a "cheese-cube," and then silence reigned.

Akouda, a fabulous town, greets us briefly and temptingly, an image that will last for a lifetime perhaps, and whisks by. At two o'clock, Kairouan. Small French suburb with two hotels. Our thirst for tea is abundantly slaked, so that the discovery of this marvelous Kairouan may be carried through properly.

At first, an overwhelming tumult, culminating that night with the *Mariage arabe*. No single thing, but the total effect. And what a totality it was! The essence of A *Thousand and One Nights*, with a ninety-nine percent reality content. What an aroma, how penetrating, how intoxicating, and at the same time clarifying. Nourishment, the most real and substantial nourishment and delicious drink. Food and intoxication. Scented wood is burning. Home?

926 o. Thursday, 4.16. In the morning, painted outside the city; a gently diffused light falls, at once mild and clear. No fog. Then sketched in town. A stupid guide provided a comic element. August taught him German words, but what words. In the afternoon, he took us to the mosque. The sun darted through, and how! We rode a while on the donkey.

In the evening, through the streets. A café decorated with pictures. Beautiful watercolors. We ransacked the place buying. A street scene around a mouse. Finally someone killed it with a shoe. We landed at a sidewalk café. An evening of colors as tender as they were clear. Virtuosos at checkers. Happy hour. Louis found exquisite color tidbits and I was to catch them, since I am so skillful at it.

I now abandon work. It penetrates so deeply and so gently into me, I feel it and it gives me confidence in myself without effort. Color possesses me. I don't have to pursue it. It will possess me always, I know it. That is the meaning of this happy hour: Color and I are one. I am a painter.

926p. Friday, 4.17. In the morning, again painted outside the town, close to the wall, on a sand hill. Then went on a walk alone because I was so over-

298 / Diary III

flowing, out through a gate, where a few trees stand, rarities and rarity. When I got closer I determined it was a small park. A water basin filled with water plants, frogs, and tortoises.

Back through the dusty gardens before the town, painted a last watercolor while standing. Near the hotel, scenes of people on a roof. Below, an excited woman. A crowd. She defended herself, weeping, her child on her back. Louis was sorry for her. I packed my few things; my train leaves at 11 in the morning. The other two will follow later, on the same afternoon of the next day. Today I had to be alone; what I had experienced was too powerful. I had to leave to regain my senses.

The other two travel with me after all; it seems they too have had their experience. Good lads. Very gifted. Macke facile and brilliant. Moilliet dreamy. In the train they wrestle again, to the astonishment of the natives. An oil merchant, really saturated with it, facing us. Exudes a penetrating odor. Louis moves away, puckering up his nose. I am all eyes.

In Kalaa-srira, again ate at Don Quixote's. Today his mood is elegiac and quite relaxed, quite mild. Perhaps he has just got over a fit. The chickens too stay away. Perhaps locked up, perhaps they have all been poisoned? Dead? One cannot tell.

TUNIS

Upon arriving in Tunis we learn that our medical couple are going out and ask us to come too. The officer's wife will be delighted by our visit and will fry us some eggs, "sunny side up." I decline; today I want to eat in festive style, namely alone. Louis respects decorum and accepts. I let the nurse prepare a fine bath—she is an expert at this—with steaming towels. And then to the best Italian restaurant, the "Chianti." Ate wonderfully and drank Chianti, which prickles like Barbera wine. Then August showed up, smiled genially about my secret debauchery and sang a little paean to the squandering of money.

926q. Saturday, 4.18. Tunis. Louis bought things for his wife. I remembered that I had to do something of the kind myself. We strolled through the

beautiful souks. He bargained hard over an amber necklace. When all was done, a connoisseur nearby declared: *"Ce n'est pas de l'ambre."* But he didn't want us to confront the merchant with his advice. It was amber after all, but, in his opinion, made of powder. Not complete pieces. I am now very wary of these Orientals; the jewelers and perfume merchants are extremely elegant gentlemen indeed, but . . .

I then bought a beautiful knife and leather cushions. Two. Besides, a beautiful amulet, rings, and an old coin.

Light rain, "the first since autumn," fell for a brief hour. Jäggi's little daughter tossed blissfully in the courtyard with her umbrella, which she had received at Christmas and had not been able to use until now.

Louis had made another beautiful purchase: pornographic photographs, which the Italians sell. He smiled happily over his possession.

Jäggi was happy about the rain: "Tonight, the colored folk will certainly all be drunk!" He must go and see his garden in Saint-Germain. Good humoredly, we drove out in his car. He also needed wine.

Arriving there after a rather uninteresting drive, he uttered a "Hey!" Seeing that we had only partly painted his rooms.

In the cellar he uttered still another "Hey!" because August dropped one of his bottles. "What a shame, such good wine!" We smiled skeptically, the wine was too sharp for our taste. We raced back to town because the doctor was expecting literary company in the evening, partly in our honor.

Another comical scene took place at this affair. The Europeans had become a bit excited under the influence of the "good wine," and the conversation, as a result, became a little spicy. Whereupon I whispered to Louis to pass his pornographic photographs around. August heard this and at once fell into a violent laughing fit. The scoundrel contaminated us too, so that the three of us laughed like madmen and couldn't recover for a long time. The fit started all over again, with special violence, whenever a certain officer's wife begged us to tell her why we were laughing so much.

926r. Sunday, 4.19. Departure from Tunis. First, the preparations for the departure. Many watercolors and all sorts of other things. Most of it inside me, deep inside, but I'm so full that it keeps bubbling out.

Paid one dutiful visit to the "museum." A great deal of Roman art. This is the result of the fall of Carthage.

At 5 in the evening, boarded the ship. Ma and Mo stayed a few days more. I felt somewhat restless, my cart was overloaded, I had to set to work. The big hunt was over. Now I had to unravel.

A very mediocre ship, the *Capitaine Pereire*, took me in. The *Navigation mixte*, which is part of my combination ticket, no longer ran. I couldn't be reimbursed there, but only at the place where I purchased my ticket. As a result I had to pay as far as Palermo. And to save money I traveled third class. Luckily I was the only passenger. The men's dormitory was large. It was lit by an oil lamp, one could smell it at once.

Below stood the handsome black car, my host Jäggi who doesn't like people to thank him, his little daughter, and Ma and Mo, who did me the honor of escorting me.

Now I stood above, the others below. They asked how third class is. I said "fine," without really being convinced of it. Ma kept making priceless foolish faces. He was not at all moved by our leave-taking. Offered me closely shaved cheeks to kiss and pretended to be filled with sorrow. In reality, he only meant it as a farce, but I took it seriously and kissed his childlike face. Hadn't I always addressed him with the familiar *du* without formality? He spoke a very broken kind of *Schweizerdeutsch* which one can't take quite seriously; when we spoke High German, I never could bring myself to say *du* to him.

One had to shout in order to be understood below. Therefore I didn't say much any more; after all, we had been together day and night. Oh, it was beautiful, we were good comrades. Our hearts had felt so light that we would have been ready for some youthful escapades, in spite of being married. Be that as it may, I was the oldest.

One time Ma had cast soulful glances toward a balcony where the *"femme" d'un officier* was posing. Immediately she made a sign and disappeared inside. And right after, she appeared downstairs. I felt called upon to give the signal for flight. And the two of them really ran away with me. And so it always remained a joke, which was just as well.

An exceptionally obliging guide took us to one of the bordello alleys. A great scene took place there, because Count Louis couldn't resist smiling

at the sight of a fat French girl in a short child's dress. She flew at the guide with a snappy voice that was in strange contrast with her babyish appearance. *"Tu amènes des gens, sale cochon, qui viennent rigoler devant ma porte!!"*

The native replied in his own brand of French; he trembled like a beast of prey about to leap on its quarry. Louis pointed a forefinger at the fellow's legs. They were really worth looking at, and all because of an old tart at best fit for soldiers!

On one occasion, the only one, we saw a little Arab beauty, and it was incredible how much she resembled August's wife. Mo commented on this fact too, simply because he can't keep anything to himself. Now I again felt pained that the three of us were standing there observing her like this.

As it happened, there were two whores, but the second was not very attractive. Unfortunately, one can do anything to these creatures, except photograph them. You can manage it only once in a great while. The instant they see the camera they flee.

And so we left too. But the creatures reappeared and shouted something after us. Louis answered something drastic in Bernese dialect. The last I saw was a not very proper gesture from the beautiful girl and a vulgar laugh that jarred with an otherwise pretty and delicate vision. Vulgarity even here, then. (But certainly only because of European influence.)

Thus, partly through my doing, partly through circumstances, the merry, brash, lusty young fellows Ma and Mo were successfully kept out of mischief. They never got further than Macke's motto: "Hey, let's go!"

Now, let them do what they please, the two of them. In a very short while I'll be floating toward Italy, and they'll be left to themselves. Who knows. In Trappani, they say, the goats are beautiful; perhaps they will try it that way there.

My ship won't stop in Trappani, so I hear this very minute. Farewell therefore, my two friends of the brush. The noise increases. With blooming voices, we scream a few last trifles at each other, and the wind blows them away. Actually the third-class cabin was pretty bad. I said it was good only because I didn't want them to laugh at my thriftiness. In reality I had already left long ago. Perhaps they too had already stopped thinking about me. They merely wanted to see the ship leave.

From Palermo to Naples, however, I shall again travel in fine style! And if I actually remain the sole passenger, it will be quite all right. I don't like poor quarters. However, I must not forget the sly steward. He is going to bring me my meals, perhaps in a spittoon for seasick people. Perhaps he is better than he looks. He ought to sing a hymn to the *grande nation;* how grotesque that would be!

I won't undress, even if on the next day a few of my hairs are going to stick in my brush again. I . . . but now the ship is about to leave, I go out once again to look one last time at the funny faces peering up. (Don't disturb me, you traveling companion who shared a free laugh in Kalaa-srira, I am now straddling between Africa and Europe! Don't speak to me about the landscape being quite Cubist there!!)

Louis's shark eye seems to be looking for a victim. He stares so fixedly! Where might the victim be among the many people who want to see the boat leave. Seen from where I am, they are just a mass. The second time, when Don Quixote was so mild and so disappointingly wistful, we shouldn't have deprived ourselves of coffee. For, the first time, it cost *"trois francs avec le café"* and the second time, without coffee, *"trois francs, s'il vous plaît."*

At sea. The ship rolls a little. It might be good to have something in my stomach. Now I am really alone, alone like an orphan! The food is mediocre, the bowl not as bad as I had feared. The wine is strong, bluish and foaming. Everything has been cooked together. No plates, just the tin bowl placed before me, the knife and fork, and *"bon appétit."* The steward, too, is better than I thought. But as for going to bed, not too soon.

I lie down somewhere on deck, it is a mild night. And here I experience my dream aboard ship . . .

When at last I begin to feel a bit chilly, in spite of my winter fur coat, I go inside and climb up on my berth. And, in spite of it all, fall sound asleep. And I don't need a cradle to rock me.

926s. Palermo. Monday, 4.20. Woke up early, off the Sicilian coast. Fresh, mountainous scenery; sometimes we steam closely along the coast and one might be tempted to make comparisons with the Lac des Quatre Cantons. Certainly the grandeur of the landscape around Sidi-Bou-Said has gone. I walk up and down on the promenade deck, which is being scrubbed by two sailors.

After a while another passenger comes to pace up and down on the promenade deck (just as I, when I was a second-class passenger, used to snoop about everywhere). I hope he won't draw me into a conversation. I avoid him for a while, then he disappears.

Over there on the dark mountains a train chugs along. How comical. What is it doing up there? And there are hardly any villages to be seen! But a great many beautiful bays! The sea almost smooth.

We are soon due in Palermo, but it is impossible at present to imagine a city. And a large city at that: where is it to spread out, will it climb up the mountain, cover it entirely? At last, here it is. Here then lies the celebrated town! Doesn't seem big. A medium-size harbor (compared to Genoa and Marseille), but beautiful, like all harbors. The red mountain over there certainly has a powerful personality!

We don't put in at the pier, but are taken ashore in a launch. Of course the sailors on the boat quarrel with each other, as usual. There is a peculiar stench on the pier. Arabia is cleaner. The smell of urine!

Very original façades. Now what shall I do with my luggage? Against my will I shall have to entrust it to somebody. Someone reads my thoughts and assures me that the check room is a highly official institution. Under God's protection then, and hope to see you again! I go to Via Roma to rent a cabin on the evening steamer to Naples. Made a mental note of a tea room on Piazza Marina, for the afternoon. After a few hours of strolling about, in the course of which I prepared myself for the eventuality of lunch, I at last found the only restaurant in this big city. Tired and hungry; the weather is hot. Ate very well anyway. Spinach grows here the way pretty girls grow in Saxony. "Roman Restaurant"—two natives are also lunching here. Except for the three of us, all Palermo is probably severely bourgeois and married. After my meal, had a short, carefree nap (sitting).

Then lounged about the harbor again (my hunger gone, but all the thirstier for it). Stretched out my dusty shoes toward a shoeshine artist; soon they were licked into mirror brightness; down under, I was quite the dandy; up in my head, the tea room and a desperate yearning for something to drink.

It turned out all right and was delicious. A very genteel atmosphere, with antique furniture and paintings. The lady who runs the shop speaks a little Swiss. The tea is soon ready, but it seems like an eternity. It is magnificent, as

is the pastry . . . If only the creature would vanish from sight after two seconds, like the beautiful nude photographs that tried me to the heart and reins near the Duomo: exactly two seconds, so that it would not turn into a pleasure—an undischarged one. I stood the test, morally speaking, laughed about the sly vendor, and was able to do without. Drinking tea, however, is more urgent than anything at this moment! Love, or *"amore"* as they say here, applying the word both to the most dissolute and the most beautiful kinds, strikes me as unimportant in comparison.

Restored and completely transformed, I strolled on, trotting by the shoe-shine boy who earlier had made my shoes gleam so dazzlingly. To the ship, to the splendid ship, *Città di Catania,* but one may not board yet.

I lie down *à l'italienne par terre* and wait in this position until twilight comes. Now, at last, one may board ship. I go quickly to the shed where my luggage is checked. Nothing is missing.

Later I discovered that there was at least one little thing missing: my leather case for my name tag.

I was led to a cabin that delighted me. *"Seconda classa?"* I asked, quite amazed. *"No, signor, la prima classa!"* or something like it was the reply. *"Mira!"* ("I have no objection.")

Now. I again go to a good look-out post to watch the preparations for weighing anchor. How beautiful it was, this time, how marvelously beautiful. Gradually the ship was filled; on the pier too the onlookers became more and more numerous. Meanwhile night had begun to fall. And when the ship sailed at 8:30 p.m., how warmly the people shouted perfectly lovely phrases at each other. How short a step it is, here, from reality to poetry. Dear, eloquent people! Choir and soloists!

I was the only one to whom no one shouted anything from below. The thought raised a powerful emotion in me. The last musical phrases of leave-taking sounded more distant; the shouters were no longer able to keep up with the ship's tempo; only the very last ones were still clearly audible, from those who had moved out in time onto the breakwater.

Something shouted in me, shouted a reply to them and could not shout, simply because it could not. And yet all of me cried out in a tearful voice that came from the depths of my being.

The eyes of a young Italian lady met mine soon after. She had probably ob-

served me. I glanced away and looked for a spot where it was pitch dark. Indeed, such eyes have an effect.

Later I went to dinner.

An entire book could be written about this dinner. True, it cost something, whereas the French *transatlantique* included the meals in the price of the fare. It even cost four lire. I assumed from the beginning that there would be much to eat, but to figure on ten courses would have seemed too daring. I put the brakes on at the beginning, but far too little. The spaghetti was so wonderful that I took that course seriously. I began to find the going rough with the boar and pine needles and compote. But I played the game to the end. It was a difficult victory, so difficult that it was impossible at first to think of getting up. For some time I preserved my slightly bent eating position, so as not to injure myself by stretching.

I mention this because I had never been a glutton. I considered it a sacrifice, a sacrifice offered to the god of the palate; from the start I felt in such an extraordinary mood on this ship that even this was bound to happen.

For a long time I sat, until I was able to go to the smoking lounge. Here, a fine Dutch pipe, and no second getting-up at any price!

I finally fell into a deep sleep in my leather chair. When I woke up, almost everyone else had gone. Courage and to bed. My neighbor, an aging gentleman, was already in bed and dreaming sweetly. I got into mine as quickly as possible.

Wonderfully cool linens, blindingly white, good for one who is as hot as an oven.

926t. Naples. Rome. Tuesday, 4.21. In the morning, awakened, but not completely, by my roommate brushing his teeth and rinsing his mouth. After he had left the cabin, the bed felt so delicious that I went back to sleep. Only after this second slumber am I able to go to the window. We are right behind Capri. This excites me. The heavenly bay!

Naples appears; it had enchanted me before, a dozen years ago. It appears out of a slightly veiled atmosphere, the Posilipo showing clearest, and then the whole amphitheater of houses. What a city! It approaches far too quickly, and then I have to go on. For I am not undertaking an Italian journey, this must not be forgotten! I was in the East and now I must remain there. That

music must not be mixed with others. The influences here are too dangerous! And so, onward, onward. The arrival threatening, as it always is. Marvelous climbing down on the light ladder. At a critical spot, a spruce sailor who helps us along. Below, the boatsmen again come close to breaking their oars on each other's heads. But it always works out without bloodshed, just as when children quarrel. I venture on a hackney, inquire about the fare, which comes to a lira and a half. But I had forgotten that the railroad station was close by. Smiling super-politely—perfidiously, methought—the rascal of a cab driver lets me off there. And hands me a silver twenty *centesimi* coin as change, instead of fifty. I notice it right away, threaten him with my finger. Whereat he again lifts up his hat with an eloquent gesture and trots off at a brisk pace. Magnificent display of scenery! Two Roman women—I can tell by the leisurely intonation and the phlegmatic manner and the "sh" in "stupido"— sat opposite me. Both read novels, and from time to time they inform each other of the number of pages they have covered.

Campagna—green! Harsh landscape around Rome. And Rome itself, bright strewn in the distance below, the cathedral standing out clearly!

Rome. Strolled over to the Piazza Colonna. It seems as if I had been there only yesterday! For lunch: *coratella con carcioffli.* Still a real treat! Then to the Fontana Trevi through my old street, the Via dell' Archetto, and, since time was getting short, by trolley to the Ferrovia.

At 2:40 p.m., left for Florence. Umbria, somber region. Then, gradually, Tuscan gayness. The people more light-hearted too. Among them, faces red as wine. Short build, almost as in Vaud. I believe we also passed by Lake Trasimeno, the light soft and dusky. In Florence it was already dark (8:30 p.m.) and I went right on to Milan.

926u. Wednesday, 4.22. Arrived at six a.m. (Milan) and stayed two hours. Breakfasted at the station. Europe certainly began here. Industrial and commercial people. Serious faces. Nothing behind them. At 8:15, off on the Lötschberg train. Frequent stops on Lake Maggiore, not unpleasant. I have a pleasant conversation with this landscape. Beneath me, the wheels are hammering, I hear the irresistible rhythm of the tambourine accompanying the song of the blind man in Hammamet!

Add to this the sight of the doll-like islands. Toys in a washbasin. But

pretty, awfully pretty! Little houses and little trees (Hüsli u Bäumli), bathing. Then we branch off to another little lake, blue with a red shoreline. Not bad! And then the scenery becomes Alpine and slightly somber. Domodossola. Then Simplon, Brig, Lötschberg, Kandersteg, Spiez. The Thunersee sweet as a forget-me-not. Bern at 3 p.m.

And on Saturday, 4.25., traveled on to Munich.

928. In my productive activity, every time a type grows beyond the stage of its genesis, and I have about reached the goal, the intensity gets lost very quickly, and I have to look for new ways. It is precisely the way which is productive—this is the essential thing; becoming is more important than being.

Graphic work as the expressive movement of the hand holding the recording pencil—which is essentially how I practice it—is so fundamentally different from dealing with tone and color that one can use this technique quite well in the dark, even in the blackest night. On the other hand, tone (movement from light to dark) presupposes some light, and color presupposes a great deal of light.

929. If I were a god to whom one prayed, I should be extremely embarrassed, that a supplicant's intonation might somehow sway me. The moment a finer note was sounded, no matter how softly, I would at once say yes, "giving vigor to what is good with a drop of my dew." In this way I would grant a small part, and never more than a small part, for I know full well that the good must be maintained in the first place, but that it cannot live without the evil. In each particular case, therefore, I would order the proportionate weights of the two components, so as to make things to a certain degree bearable. I would tolerate no revolution, but would make one myself at the right time. From this I can see that I am not yet a god.

I would also be easy to deceive—and I am aware of it. I would be quick to dispense a yes; a short, moving tone in the prayer would be enough for me to grant it.

> But then, at once, I would be capable
> Of acting quite capriciously
> And of transforming me

> Into the monstrous thing
> That lies in ambush
> Till whole families weep
> Whenas its poison
> Strikes deep.

I would desire to put on a lot of historical theater: I would loosen periods of time from their epochs; it would make laughable confusion. But many a one would be delighted (if I ever met a knight errant in the field, for instance, I would be overjoyed!).

> I'd make fools of the little folk, so dear,
> I'd put mold in their provender,
> Pain in their pairing,
> Acid in their beer.
> I founded an order and on its banner set
> A merrily dancing tear.

930.
> Why do you cling so toward nightfall?
> "It is dawning!
> But when it fearfully hammers,
> But when it rends apart
> Will you know
> That you have a heart.
> Then its driving desire is enhearsed,
> And it wasn't a mere turn of phrase,
> For the bladder burst."

(The respondent dies.)

931.
> I am armed, I am not here,
> I am in the depths, am far away . . .
> I am far away . . .
> I glow amidst the dead.

932. The creation lives as genesis beneath the visible surface of the work. All intelligent people see this after the fact, but only the creative see it before the fact (in the future).

MEDIEVAL CITY, 1914, 15

933. Invent the *chorus mysticus* that would have to be performed by several hundred children's voices. Whoever knew how to do this, would no longer need to make strenuous exertions. In the long run, the many small works lead to it.

934. Misery.
 Land without ties, new land
 With no warm breath of memory,
 With the smoke of a strange hearth.
 Reinless!
 Where no mother's womb carried me.

Between 934 and 935, war broke out.

935. The big animals sit mournfully around the table and are not filled. But the clever little flies climb upon mountains of bread and live in a city of butter.

936. Only one thing is true: in me, a weight, a little stone.

937. One eye sees, the other feels.

938. Human animal, timepiece built of blood.

939. Seen from a church tower, the activity on the square looks comical. How much more from where I am! (Satyr play, addendum to 931.)

940. The moon / in the railroad station: one of the many lamps
 in the forest: a drop in the beard
 on the mountain: let's hope it won't roll down!
 and that the cactus won't pierce it!
 and that you won't burst your bladder sneezing!

941. Ingres is said to have ordered the motionless; I want to go beyond pathos and order motion. (The new Romanticism.)

942. A: Grandpa rides merry-go-round on the pepper mill. B: A thief? Quick, give the dog its teeth! C: What is it you wish? A glass ball! How big? Perhaps the size of the full moon! (Both parties smile understandingly.) D: Not everyone should guess this thing; otherwise, woe is me, I should be betrayed.

943. Genesis as formal motion is the essential thing in a work.
 In the beginning the motif, insertion of energy, sperm.
 Works as shaping of form in the material sense: the primitive female
 component.
 Works as form-determining sperm: the primitive male component.
 My drawings belong to the male realm.

INSTRUMENT FOR NEW MUSIC, 1914, 10

944. The shaping of form is weak in energy in comparison with the determining of form. The final consequence of both ways of forming is form. From the ways to the end. From activity to the accomplished. From the genuinely living thing to the objective thing.

In the beginning the male speciality, the energetic stimulus. Then the fleshly growth of the egg. Or: first the bright flash of lightning, then the raining cloud.

When is the spirit at its purest? In the beginning.

Here, work that becomes (dual). There, work that is.

945. My crystal-clear soul was at times blurred by vapors, my towers sometimes surrounded by clouds.

Pain settles down by love;

Without yearnings

I cannot live for a long time nor for a short time.

946. Dream: I find my house: empty, the wine drunk, the river diverted, my naked one stolen, the epitaph erased. White on white.

947. Sounds from the distance. A friend early in the morning behind the mountain. Blowing of horns, emeralds.

U. A greeting thought calls me, promising kisses to souls that have presentiments one of the other.

O. A star tied us, its eye found us: two beings who are identical, but more in content than in form. Sacred stones, yesterday; today, no enigma; today, meaning!:

"A friend early in the morning behind the mountain."

948. A kind of stillness glows toward the bottom.
 From the uncertain
 a something shines,
 not from here,
 not from me,
 but from God.
 From God! Were it only an echo,

Were it only God's mirror,
still it would be the nearness of God.
Drops of the deep,
Light-in-itself.
Who ever slept and caught his breath:
he . . .
found his last end in the beginning.

949. Felix writes: "Deer Kopap he send me a pic pickcher book. i and thou millers cow. einmilerschas number 23 [thirty-two]. feliz klee. ot ut wen he is a rascle."

950. 1915. The heart that beat for this world seems mortally wounded in me. As if only memories still tied me to "these" things . . . Am I turning into the crystalline type?

Mozart took refuge (without neglecting his inferno!) on the joyous side, for the most part. Whoever does not understand this might confuse him with the crystalline type.

951. One deserts the realm of the here and now to transfer one's activity into a realm of the yonder where total affirmation is possible.

Abstraction.

The cool Romanticism of this style without pathos is unheard of.

The more horrible this world (as today, for instance), the more abstract our art, whereas a happy world brings forth an art of the here and now.

Today is a transition from yesterday. In the great pit of forms lie broken fragments to some of which we still cling. They provide abstraction with its material. A junkyard of unauthentic elements for the creation of impure crystals.

That is how it is today.

But then: the whole crystal cluster once bled. I thought I was dying, war and death. But how can I die, I who am crystal?

I, crystal.

952. I have long had this war inside me. This is why, interiorly, it means nothing to me.

1915.

'Das Herz, welches für diese Welt schlug ist in mir wie zu Tode getroffen. Als ob mich mit diesen Dingen nur noch Erinnerungen verbänden ... Ob nun der kristallinische Typ aus mir wird? | 950.

Mozart rettete sich (ohne sein Inferno zu verschmähn) ein Grosses Ganzen in die freundige Hälfte hinüber. Wer das nicht ganz begreift, könnte ihn mit dem kristallinischen Typ verwechseln.

*

Man verlässt die diesseitige Gegend und baut dafür hin= | 951.
über in eine jenseitige, die ganz ja sein darf.
Abstraction.
Die kühle Romantik dieses Stils ohne Pathos ist unerhört.

Je schreckenvoller diese Welt (wie gerade heute) desto abstrakter die Kunst, während eine glückliche Welt eine diesseitige Kunst hervorbringt.

*

Heute ist der gestrige-heutige Übergang. In der grosse Form= grube liegen Trümmer, an denen man noch teilweise hängt. Sie liefern den Stoff zur Abstraction.
Ein Bruchteil von unechten Elementen, zur Bildung unreiner Kristalle.
So ist es heute.

*

Aber dann: Einst blühte die Druse. Ich meinte zu sterben, Krieg und Tod. Kann ich den sterben, ich Kristall?

ich KRISTALL

*

Ich habe diesen Krieg in mir längst gehabt. Daher geht er mich | 952
innerlich nichts an.
Um mich aus meinen Trümmern herauszuarbeiten, musste ich fliegen.
Und ich flog.
In jener zertrümmerten Welt weile ich: nur noch in der Erinnerung, wie man zuweilen zurück denkt.
Somit bin ich abstract mit Erinnerungen.'

And to work my way out of my ruins, I had to fly. And I flew. I remain in this ruined world only in memory, as one occasionally does in retrospect.

Thus, I am "abstract with memories."

953. Certain crystalline formations, against which a pathetic lava is ultimately powerless.

954. Dream: I asked the geishas only for a little music and some "of the tea that serves as a manifold substitute for all the geishas of the world."

At the slightest temptation I heard a soft knocking. When I followed the knocking, a small sprite stretched out his tiny hand toward me and led me gently upward into his region.

There, things fell up, not down. A light breakfast, including eggs, was appetizingly laid out on the ceiling.

955. The magnificent, fat Däubler gives me his soft hand. "Yours is a Futurist temperament in Germany. Futurism tied to the traditional culture. I am also a Futurist. It's just that I still use rime."

(Perhaps it is unfortunate that he still rimes?)

956. What the war meant to me was at first something largely physical: that blood flowed near by. That one's own body could be in danger, without which there is no soul! The reservists in Munich, singing foolishly. The wreathed victims. The first sleeve turned up at the elbow, the safety pin on it. The one long leg, clad in Bavarian blue, taking huge strides between two crutches. The actualization of the letter of the history book. The coming to life of the pages of old picture books. Even though no Napoleon appeared, but merely a lot of Napoleonettos. The whole business had as much sense to it as a wad of dung on a shoe heel.

957. Cannot science work its way out of just being receptive?

Between me and Lotmar, for instance, a thick fence. Why can I hardly see his feet, through maybe a loose spot?

A distant voice, before the voice changed, moans in a way that was once pathetic: a fine, good man, at heart.

Leave-taking is not always so very easy.

What a weighty destiny: to be the hinge between this side and the other side, a hinge at the border of yesterday and today.

958. The outward existence of an artist may reveal a number of things about the nature of his work.

My childhood friend Haller loves life with such passion that he practically hunts for shattering emotional experiences, lest he miss something. This worldly drive was only useful to his art for a short time, until his imitative type of statuette, which has its great charm, had been created. But then?

How is he to achieve an active spiritual development now, when in addition a way of life weighs on him that in itself requires a giant's constitution? I once led a restless mode of life, until I acquired a natural base that enabled me to abandon that mode. (One disclaims "the stomach" by granting it neither too little nor too much, for both excite.)

Both of us married; he needed to put the emphasis on "beauty" and thereby overlooked other, more important matters. In consequence his marriage began to founder. Nor did he want to give up the hunt for shattering emotional experiences. The effects on his artistic activity could only be negative.

Then his body aged prematurely, and this jarred with his primitive mentality. It would have been better if he had aged mentally and remained young physically!

In contrast to him, I thus had become a kind of monk, a monk with a broad, natural basis where all the natural functions found a place. I regarded marriage as a sexual cure. I fed my romantic tendencies with the sexual mystery. I found that mystery tied up with monogamy, and that was enough.

Here too I struggled away from memories, down toward the essence, and to a considerable depth, at that.

Kubin is a third case. He fled from this world because he could no longer stand it physically. He remained stuck halfway, yearned for the crystalline, but could not tear himself out of the sticky mud of the world of appearances. His art interprets this world as poison, as breakdown. He has advanced further than Haller, who is a quarter alive; he is half alive, living in a destructive element.

DEATH ON THE BATTLEFIELD, 1914, 172

959. Dr. Hermann Probst owns a few of my watercolors and likes them quite a bit, it seems. On his urging, I had sent Rilke a small selection, which the poet personally brought back to me. His visit gave me really great pleasure. A picturesque, limping lady came with him.

I at once read passages of the *Buch der Bilder* and of *Die Aufzeichnungen des Malte Laurids Brigge.* His sensibility is very close to mine, except that I now press on more toward the center, whereas his preparation tends to be skin-deep. He is still an Impressionist, while I have only memories left in this area. He paid less attention to the graphic work, where I have advanced farthest, than to the domain of color, which is still in the process of maturing.

The perfect elegance of his appearance is an enigma to me. How are such things achieved?

960. I would like to have my *Candide* illustrations back. They are lying at the Verlag der Weissen Bücher, which even before the war put off the publi-

cation in a strange way. Now it would be best if a book of my current graphic work were published first!

961. I was forced to write Franz Marc, who is at the front, at much greater length and much more seriously than I cared to. I expressed my regrets at having got into arguments about the theory of art with his wife. This, I said, had resulted from my efforts to help his wife who had lost her, perhaps only apparent, equilibrium and was opposed to her husband so far as art was concerned. This too was certainly only apparent, for all the while she certainly had his better self in view. It had been unwise, on my part, to let theoretical duels grow out of this, if only because of the difficulty of expressing oneself precisely in this field, which resulted in a falsification of the meaning "to be expressed."

I stressed the works—I mean those already produced, not even referring to those that will come shortly. Frau Marc had also turned against Kandinsky, and I thanked Franz Marc that he remained faithful to Kandinsky's work.

I also protested forcefully against the notion of theory in itself and stigmatized a passage in a letter that spoke of "falsely applied theory."

Then I defended the ego, distinguishing between a self-seeking ego and a divine ago.

This ego, I explained, was the only reliable element in the entire matter of creative art and, I went on, my trust in others rested on the common domain of two egos. To illustrate this point, I used two intersecting circles:

"Your circle and mine, it seemed to me, had a relatively large common area. And I relied blindly on this fact, because I *am* afraid of absolute solitude. For a while I was shaken in this conviction, but now I am again completely reassured."

What was the cause of such useless incidents, worrisome for the brushless painter at the front? The weakness of his wife, who still cannot stand on her

1915. 10.

NAVAL STATION, 1915, 10

own two feet, and the influence of Kaminski, an insinuating prophet who preaches in those parts.

962. Shortly thereafter, Marc got leave and, although he was very tired and visibly thinner, he came to Munich, never ceasing to relate his experiences. The continuous pressure and loss of freedom clearly weighed on him. I now began really to hate the cursed costume, a poorly fitting noncommissioned officer's uniform, with a tassled saber at the side.

To speak more seriously with him, when he had had time to recover, I visited him in Ried near Benediktbeuren, after having walked from Feldafing to Bernried.

The field-gray things hung out in the open to dry, like emptied innards. He himself wore his sports trousers and colored jacket. This was better, indeed, but it was not to last long!

When he had to leave again, his wife accompanied him to Munich, and they came to eat with us. I cooked risotto and he brought some raw ham. We were gay, leave-taking did not seem unbearable to him. He promised to duck

assiduously whenever something dangerous came flying through the air. . . .

The fellow ought to paint again, then his quiet smile would appear, the smile that is simply part of him, simple and simplifying. He is much too far along for the burning ferment he is in. It occurs because his vent is not allowed to function.

He ought to hate the soldier's game more than he does, or even better, it ought to be indifferent to him.

963. We spent this summer in Bern. The sergeant-major who commands the district, a man in a peace-time uniform and with a fiery beard, looked at me sternly through his glasses: "I give you the permission, but you must promise me to return." This I did with a clear conscience, for where else could I live, later, except Germany, where I had just developed a serious following?

In Bern nothing had changed, everything had kept its old shape, nicely bourgeois, forever normal. Shall I never lead any but an inner life; as for outside, shall I always walk my way in discreet, average fashion?

A few excursions gave the illusion of movement. On a Sunday we went out to Kiental, where Lotmar was spending his vacation with his family.

Then we spent a few days with an excited young lady in Fribourg, where we were to meet our Russians, Jawlensky and Werefkin, who came from St. Prex. The Dutch monster was called Frau L. H.

The Russians were, as always, highly talented people. We had to play music and dragged Bach into a Wedekindian milieu. Moilliet too was quickly summoned, for a few anecdotes about this painter made our eager lady's mouth water. He came.

Just after we had played the G-minor Concerto, I went into the neighboring room. There I found the fat Lulu riding on Frau L.'s back, but poor Louis was hard pressed on the floor, gripped by her claws. She would have strangled him, had I not come in. Even so, he needed medical attention, for his larynx was not quite in order. Being annoyed, he left town at soon as possible, and in this way acquired an impartial opinion about the circumstances of L.'s divorce.

Another guest in the house was the weakish son of a painter from Geneva, who seemed to take advantage of L. His good mama sat through it all and

ABSTRACT ARCHITECTS OF THE HEIGHTS, 1915, 232

knitted. With her husband, she had played a great many violin sonatas by "Mosar." She didn't know German.

For the third time, we settled on the Stockhorn. On the first day, we started to climb from Erlenbach and spent the night in the inn beneath the peak. The other nights we spent in a shepherd's hut by the upper lake, on warm grass. It was a wonderful evening. At last we leisurely walked down again. Ate meat again in Erlenbach and drank such merry wine that we almost missed the train. As we were sitting down breathless, a gentle rain slowly began to fall on the land.

Later we spent a few days in Gunten with Uncle Moilliet. His wife was pregnant, and unhappy because he was enjoying himself.

On the whole, social life in Bern was very strenuous as well as monotonous; for much too much music, we received only material compensation. Once I went to Thun, trapped in a quartet of clergymen. We even had to play from the manuscript a composition by one of the gentlemen. Lotmar thought that only important composers should be performed during Joffre's fall offensive. Deep within, I am indifferent to the war, but the soft delusion of the Bernese milieu is not good for me either. I have licked blood in the company of real heads. Däubler must again appear in all his fullness on my threshold. The will-o'-the-wisp Wolfskehl must again flitter through my modest rooms. Kandinsky must at least greet me from the wall. The subtle Rilke must tell us something about Tunis. And Georg Hausmann the searcher had better be there.

964. In November Marc came home on leave as a lieutenant. This time he looked well; being an officer, he was able to take care of his appearance, and he had also assumed the bearing of an officer. His new dress fitted him well—I almost feel like saying "unfortunately." I am not certain whether he was still the same old Marc. I had with me a few variations by Jawlensky and was almost afraid to show them to him.

The last evening he spent with us in Ainmillerstrasse, he was without his wife. She was ill, and he had already taken leave of her. Deep seriousness emanated from him, and he spoke little.

We played Bach, and the variations lay before him on the floor. This was

SPIRITISTIC CATASTROPHE, 1916, 32

just his way of looking at paintings and listening to music. In the past he had often painted in his sketch book while listening to music.

Jawlensky's pictures seemed to mean something to him. He called attention to the reverse of one page obviously discarded by Jawlensky.

1 9 1 6

965. A fateful year. At the end of January, Louis Moilliet's wife died while giving birth to a son, her first child. On March 4th my friend Franz Marc fell at Verdun. On March 11th I was drafted at the age of thirty-five.

Marc and I had not corresponded since his last leave; he had come to know my distaste for theorizing. This abnormal time should be over first, all the more so since I also could expect to be forced any day to abandon paint and brush.

I was willing to exchange ideas, but healthy ideas arising from concrete

cases. I was ready to look for causes with him, but could not indulge in searching for hypothetical, basic presuppositions.

In this state of waiting and hoping, the telegram announcing his death struck me like lightning. It was sent by his wife from Bonn, where she was staying with the widow of August Macke. Ominous urge, on her part, to journey there and breathe the same air.

The telegram called me to Frankfurt; Frau Marc had had other company that far. She could not bear to be alone. On the same day I received the red slip informing me that I would be mustered in on March 11th. That night I decided to clean up things a bit and emptied a number of drawers, thereby disturbing my wife in her sleep. At last I thought of her and went to bed; then the bell rang, shrill and long, the way it rings at night when an urgent telegram is delivered. With a sense of impending disaster, I went—I don't remember how—to the garden gate, and the catastrophe occurred.

On the next morning I left for Frankfurt. Frau Marc was there at the station. She had stayed with a family named Hirschfeld. We came back on the night train and arrived home at nine in the morning.

On the following days more detailed information arrived from the front, as well as Marc's last two letters to his wife. Moreover, people kept coming in and out of our apartment to offer condolences to the widow.

Prepared in this way, I packed my bag and went to the District Command on March 11th.

Now I have a new position in life: I am Infantry Reservist Klee, and my address is: Recruits' Depot Landshut, Section Gabelsbergerhof.

Diary IV

966. Infantry Reservist Klee, Recruits' Depot Landshut, Section Gabels-bergerhof.

Early on the morning of March 11th, I went with my suitcase to the District Command barracks (District Command, Munich I). At least the weather was splendid. After we had been assembled there according to instructions written on blackboards, we had to stand around and wait for quite a while. A kindly major wished us luck on our journey. We were told that we were going to Landshut. And yet I had tried to get permission to remain in Munich. I found it humiliating (it was the last day for a long time on which I was supposed to have an opinion about anything).

At about one in the afternoon, some noncommissioned officers arrived, carrying guns, and escorted us to the railroad station. People celebrating in the streets along the route. Close relatives. Daughters. Tears. Jokes. A special train at the station. During the trip, I snap up a few consoling words. "Consider yourself lucky to be coming to our town. There isn't a better place anywhere."

At about 4:30, arrived in Landshut. Again four by four. We are told to march on the sidewalk. From a schoolhouse, the sound of the ironic laughter of troops at the windows. A halt in the Heissgarten. There, a good deal of calling of roll takes place. Our passports are taken from us. The sections are made up. A sergeant with a good head takes charge of us. Upon reaching our quarters we are divided, according to our height, into five detachments, all the while standing in the street. Night is beginning to fall when at last we get into our quarters, a large room in an inn, with a bowling alley. The corporal apologizes in complicated language about the poor quarters. A dark stable, with rows of straw sacks, on each one a loaf of bread, two plates, and knife and fork. Narrow alleys between the straw pallets. Very hungry. No real dinner. Noncommissioned officers try to cheer us up. A few days later, we will receive permission to sleep in town.

That night at the inn amidst smoke, headache (the last for a long time), sausages, and beer. Then a most sensational night. In the morning we are awakened by a harsh "On your feet!" beginning one of the most memorable Sundays ever.

Sunday, 3.12., awakened at six. Had a little sleep, more the result of sadness than anything else. Marched to breakfast. At first nauseated at the sight of it. Then we marched through the old town, very brave and stiff, four by four, to the Prantlgarten. Under different circumstances the city would be enchanting. At the Glaspalast we're outfitted. Again terribly nauseated by these rags and straps, half civilian, half military, loaded down with gear, having trouble holding onto everything, convulsively, painfully pack-saddled with greasy pieces of uniform, boots, undefinable leather objects, dragging stuff along in the mud, running the gauntlet, convicts exhibited for the curiosity of Sunday strollers, we march back. At our quarters, dress rehearsal. The play promises to be a fine one.

Then, for the first time, going for chow. The food plentiful. Breakfast had already been survived. Delightful. The fat blond pig that dishes out the coffee. His unerring sureness. Ordered around in impossible boots, to our quarters, to bathe—to exchange the boots, a fruitless operation. Finally, the deep melancholy of the prisoner. Dull Sunday afternoon.

967. Monday, 3.13. Today, drill; with my own boots, it would have been a pleasure. As it was, I suffered from the melancholy caused by sore feet. As of tonight, unfortunately, no mail from home. How do they feel without me, I wonder. Are they worried?

I have never been so free of worries. Doing what you are ordered to do is not at all difficult. The cuisine isn't French, but it tastes all right and there is enough of it. What a novelty this hunger and thirst is. Downing a quart of beer without scruple!

968. 3.14. Mail at last! What this means! Only the tone is too subdued. Felix praises Sophie's talent for cooking. Lily wants to try to get me transferred back to Munich. I'll stay in Landshut. I was lucky. We are one of the oldest classes called in. In Munich we might be put together with young men. Here, we are leftovers, second-hand goods. The tone is leisurely. Soon I'll be able to live in town. On Saturdays one can take the train to Munich. But this coming Saturday is doubtful because of the lack of field-gray uniforms.

969. 3.15. A batch of letters from Munich. A noncom named Gröner asks whether my wife feels very lonely. A new lieutenant assigned to us today. He is lively and seems easy-going. Talks particularly to the one-year enlisted men. His rhetoric is rather funny. His name is Buhl. The captain is called Jungwirt. He praises this camp as one of the best. On the train the soldiers escorting our group calmed us with the same comment. In short, this situation was forced upon me, but apart from that I can't complain.

970. 3.16. Today we took our rifles along on our hike. It isn't easy the first time. But after a few drills out in the open, it really does get easier. Only those bottomless abysses called boots. The scraping of the heels. I put on my own shoes again and almost fell down when I took the first step, feeling as if I had lost my feet, but had acquired in their place a head of lead. Someone named Köster is said to have had the luck to be assigned to a Reserve Regiment in Munich. This may make me somewhat thoughtful, for Lily's sake. But the going is stiffer there, and the chances of being sent to the front are greater. This is a good place for such a rest cure.

Sometimes Marc's name comes to mind, I am struck and I see something collapsing.

First evening off, alone. Great apprehension of encountering a superior in rank. Unfortunately we are not allowed to go to Munich next Sunday. I advised my wife to come to Landshut for the time being. My smudgy uniform was one of the reasons.

971. Friday, 3.17. On Saturday I found some enjoyment in the hike. An unrivaled cure. The first mental relaxation in a long time.

I shall show myself coöperative at the beginning; in this way no one will be on my back, and the mood won't go to pieces too quickly.

Gröner, the noncommissioned officer, jokes about my heavy correspondence with my wife. I ask you to try to maintain your military bearing in your postcards. "Herr von Klee, your wife is on the telephone. She says you've got to come home."

My answer: "Sorry, Sir. I don't know how to use the phone."

I knew then that he read my cards.

I have rented a room, five marks per week, right next to the camp. Elegant, sunny, with a fine view. Gas, etc. Actually, I don't need a nice room for my few hours of liberty, but it will be very useful when my family visits me.

972. 3.18. There was no trickery about the cancellation of the first furlough; it was shame at the absence of the gray uniforms. I tell my family to come after all, this Sunday, although my uniform looks like that of a convict. I tell Lily to bring my civilian clothes, so that we may spend four or five happy hours together as usual. We shall make tea and eat cake. As usual. In the afternoon great cleaning up. We are photographed, detachment after detachment.
 3.19. Sunday. Went to church in convict's garb. In the afternoon, Lily and Felix came. Pleasant hours.

973. The swarthy fellow from Dachau, somewhat isolated in this assembly of Munich rascals, attaches himself to me; when I turn toward him and ask him a few questions, his eyes shine. He was taken away from farm work. A cleaning woman, a war widow, has thus been put in a most distressing situation. She will ask for him to be sent back. Now he stands about here and has to stiffen his knees and glue his hands to his sides.

974. 3.20. Drill from 7:30 until 11 o'clock. The sun is burning. Address in real Bavarian by the first lieutenant. Always the same patriotic formulas. Speeches one could and would make oneself if one had to listen to them again a few times.

975. 3.21. Inspection by the Commanding General v. d. Tann. We hiked (in boots!) quite a distance. Got up at 5 o'clock. At 5:30, "grabbed" breakfast. Then, quickly grabbed our rifles. To the Heissgarten, after a long wait, then back to our quarters. There, waited. Then, back to the Heissgarten. Inspection of equipment. Instruction about how to behave during inspection and, possibly, address. Marched off at last at 7:30. Went out at 9 o'clock. Dress rehearsal. Lieutenant Buhl plays the part of His Excellency. After the performance, light drill. Acquired two blisters and bruises on my elbow (the rifle). A hero. Light rain sprinkles us and the dusty road.

I ask that my box of watercolors be sent to me . . . Small hopes—illusions . . .

976. 3.22. The weather is cooler, we have stopped breathing dust. Vaccinated against smallpox; no reaction. Bloesch wanted to look me up in Munich. Goltz asks for black-and-white things. When will he sell the first one?

Drill in marksmanship and the manual of arms. Every day something new. The only problem is marching in these holes that pass as boots. Everything else is accomplished without particular effort.

977. The captain on a docile horse, steering through the fog like a ship. One of the workers, a perfect vagabond type with a rascal's laugh, comes to me and offers to take care of my room. We agree on a *"fulzgerl"* [fifty-pfennig piece].

A few times I let the man from Dachau have some bread, whereupon he decides, without asking me, to clean my boots. A fine man, even in his jester's costume. Torn away from the earth.

978. 3.23. Filled out the passes for Saturday/Sunday. A heavy cold I got the Monday before passed off quickly, but part of it has stuck in my larynx. A slight fever at night.

979. 3.24. The one-year men receive their gray uniforms today at noon. The others are shamelessly allowed to go to Munich in indescribable fatigues. For the first time in many years, my academic education is of some use to me. Unfortunately I have a fever and a mouth infection. But I don't go and see the doctor, otherwise I'd be put to bed, not given leave. Consequence: I perform my duties with a fever. Today, terrain drill, that is, a walk in the rain; then, as the weather brightened up, into the hilly region south of Landshut. Enchanting country, with glimpses of the lovely town.

980. 3.27. "My dear little boy, now I've got it easy. The doctor noticed that I had a fever, and now I am allowed to stay in my nice room at 12/II Gabels-

bergerstrasse. I only show up for meals, and everyone understands. But on Thursday matters become serious again. Then I shall want to be quite healthy again. Farewell, do your work first, then you may play and be happy."

981. 3.27. A slight temperature (100 degrees) impelled the doctor to give me three days of sick leave. He was not at all interested in the kind of infection; he imagined at first that it was caused by my teeth. I protested fairly energetically, because otherwise he might have sent me to the dentist. The whole business of going to the doctor, a new sensation. First, assembly in our quarters, put on our coats because it is still March. And stand around. Then we are led by a private first class to the Heissgarten, where the sick are required to carry back the coffee bucket. One of them, it turned out later, had a 104° fever. Then an assembly of the individual barracks units in the Heissgarten; this meant a great deal of standing around with occasional saluting thrown in. All sorts of talks, all sorts of orders, until we are marched off in fours by a private from the sanitary corps. To get out of the way of a regular marching detachment, we execute a column-right maneuver, the fellow with the 104° fever too, and walk on the sidewalk for a while. At last we reached our goal, the Martin School. Then to the infirmary, to have our temperature taken. What a marvelous infirmary! The air! Fresh air comes in through exactly one window pane, because it is broken, or maybe it's really to allow a sick man to converse with someone standing in the courtyard? Pants down, three by three, we lie down to have our temperatures taken. The fellow with the 104 degrees is discovered and held. Men with less than 104 degrees must go out into the corridor again and line up three by three. We are waiting for a doctor; we have been on our feet since seven, and it is nine when the doctor begins his tour of inspection through the infirmary. Actually this doesn't take long. Those with high temperatures go with the doctor into the consulting room and are examined first. Shortly after, they are taken to the infirmary to breathe the stuffy air for a while. A stiff punishment could be no worse than this. I have reason to feel contented: I am let off with three days in bed. I retire to my quarters (which is more quickly said than done, since all sorts of formalities must be gone through yet) and only leave them twice a day with my two bowls. I continue to receive my pay . . . This is what is called: going to the doctor. Instructive, impressive, and sometimes rewarding.

982. 3.28. From time to time I play the violin. A great fear keeps me from painting. Read Strindberg's *To Damascus.* The usual tune. Slept more soundly that night. Recovery?

3.29. Sale at Walden's for two hundred and sixty marks. The temperature last night slightly higher again, connected with a kind of ending of the thing. Natural exhaustion sets in. I am notified of my admission to my squad. Funny, funny.

983. 3.30. First evening without fever. Played music valiantly. No loss of technique. Tomorrow sick leave will yield to the routine again. But to be well is preferable even here. . . .

984. 3.31. Snow fell early in the morning, and for the first time in a week, I wasn't frozen. I am over it. The swellings in my mouth are healing. To-day, night drill. Sounds serious. And will certainly turn out to be something innocuous. My leave granted. All my energy is back. In the afternoon, took my rifle apart for the first time. It was necessary too.

It was a real soldier's affliction. Really nauseating. During the night drill, the lieutenant staged a little comedy and had us shot at on the railroad track. But no one fell.

I'm to play in the orchestra of the local choral society: Haydn's *Creation.*

We are issued our helmets. Our warlike appearance is accentuated. What helmets!! Taken from the dead and pressed on our heads. But the blood had already been washed off! We would have got accustomed to that too.

4.3. Revaccinated against smallpox. At times something happens in the army, but only after endless fiddling. Plenty of time, plenty of money. No worries. Only civilians are in a hurry.

985. 4.5. Out drilling with helmet for the first time. Heavy heads. To make amends, the newly formed band blew at the head of our column. *Tout Landshout* out to see us, a public celebration.

986. 4.6. Field maneuvers—we are to detect enemy snipers in the distance. Orders to fan out, lie on our bellies, and fire away. The captain poked me

from behind with the point of his sword: "What are you aiming at, friend?"
He was amazed at my correct answer and moved away embarrassed.

987. Singing instructions are no longer given by the clear-voiced sergeant,
but by Corporal Bruckner. A neat man with a slight squint that doesn't
look bad. First we all read the text together, then he sings the first stanza,
fearfully off-key, so that our ears cringe. Then *we* sing it. Today we learned a
horrible piece of trash called "Flag Song," music-hall stuff.

I am living with apes. I realize this seeing them take this unadulterated rub-
bish with such seriousness. And yet, we are all brothers. Everybody wants to
go home. Even the officers.

How Corporal Weidl laughed at the fat, rosy Jew Karlsen because at last
a rich man was caught.

4.7. Announced my absence at the orchestra rehearsal of *Creation* on ac-
count of a long hike.

988. 4.10. Monday mood. Still half in Munich. In the morning, at the bar-
racks, cleaned my equipment a bit. We were to be there one hour before
marching time. Until then we had circumvented the foolish regulation. But
we hadn't managed to do away with it once and for all. I think mostly of the
coming leave for the Easter holidays. On Palm Sunday we have to stay here:
swearing-in ceremony.

Today, rifle practice, during which one doesn't move at all, and the morning
was so very cold! Almost an hour on our bellies, then another half hour of
standing and kneeling in the open. Quick-aiming drill (triangular target).
Then three shots with blank cartridges.

989. 4.11. Radiant day, stood out in the sun; weapon training and other
silly stuff. In the evening, marched until night had fallen. Whither? How far?

Wrote Kubin about the works that Marc had left behind. Went to the post
office, picked up five marks. Gave several hundred salutes on the way and, in
the old town, walked a distance through arcades just like those in Bern.

990. 4.12. Weather suddenly took a change for the worse; there was an icy
draft on the drill ground, and I froze terribly. Corporal Schuster replaces

Kaspar on leave. A distracted, sluggish man. And we stand and shiver like aspen leaves. During the break, we run around like animals about to be fed. Afterward the circus band comes to fetch us. Slim consolation for what we had endured.

991. 4.13. Under sharp wind and icy showers, hiked an hour toward Salzdorf. Drenched to the bone, we formed firing lines in the forest and crawled through the wet moss like salamanders. Waited for a particularly heavy downpour. Then out to look at a trench. The sergeant scrutinizes, criticizes, and explains it. The wind makes us freeze more than it dries us. A sharp glance from the sun and new showers. Hundred-pound slippers made of yellow loam.

Sergeant Pritzlmeier, a teacher of mathematics at the Anna School, often tells about his experiences on the front in intelligent, not unpleasant fashion. But then again he can be quite tough.

992. 4.14. For the first time in ages, followed instruction without having to fight against sleep; the course, given by a little Corporal named Huber, dealt with marksmanship and military conduct. What is the talk of even the brightest lieutenant compared to such homespun "discoursing." And besides, the shrewd mouse face of the little fellow. The climax came when he urged us not to act timid in front of superiors: "They're made of flesh too, they're all made of flesh!"

Instead of Kaspar, we are trained by a delicate, blond little man. He must have had the most frightful experiences at the front. Completely lost in his own thoughts, he forgets in no time the orders received from the lieutenant or the vice–sergeant-major. He dreams away and, at every opportunity, brings up stories about the front. We listen, enjoy ourselves, but learn nothing. No one until now suspects how incapable this blond chap will prove himself on the drillground. He can't find his way out of the real way into this game played on a green meadow. His name is Schuster.

The brothers got wet today. Tomorrow is marksmanship day.

4.15. I first shot twelve, then less; took aim lying down, one hundred and fifty meters.

993. 4.16. Solemn oath-taking shindig. Heard a beautiful mass with music.

Visit from Lily and Felix. At the last minute, changed my room. Now Klötzlmüllerstrasse 16. Lily dissatisfied with the room, a bit annoying—too much of a lady.

994. 4.17. Second marskmanship drill, lying at two hundred meters, hands free. I shot eleven, then eight. At noon, was called to the administration bureau. Had a look at the one-year enlistment blank.

The old slave-dance. Gun-cleaning, slogging in the field, and singing will go on for a few more days, then a week of bliss (Easter leave). And then? Even world wars end.

4.18. They say that one oughtn't to shoot so well. Should I drag along the special sights, as the poor marksmen are forced to do?

We leave very early on Thursday morning by special train. Assembly at six o'clock in the Heissgarten.

995. The Easter leave began for me in high spirits. At six o'clock in the Heissgarten. We march off to the train. Climb aboard cattle cars lined with benches. Instead of doors, a cross-bar. Extremely drafty. To make up, there's no fare to pay. Besides, we get one mark and a half for expenses every day. Also, we continue to receive our regular pay, thirty-three pfennigs a day.

A few days in Munich. Then the gala for the opening of the Weisgerber exhibition. Then a trip to Wiessee for a few days. Ate and slept well. Still, not quite in my normal state. Couldn't help it, and it wasn't so bad after all. Going back after the furlough was quite painful. One had tasted freedom again.

995a. 4.19. Just returned from a rainy and windy night drill. At six o'clock we marched in the direction of Moosburg, toward the enemy, and set up our bivouac in a favorably located farmhouse. We kept watch not far from there. Corporal Schuster had a toothache, which made him a bit tough at times, but after he had found a protected shelter in the roomy woodshed, we were on good terms again and chatted; as usual, he spoke a great deal about the front. Spying the sergeant (this is always the chief job of a look-out), we quickly stationed two guards out in the wind. Then we had visits from patrols, two fellows as tall as trees belonging to the first detachment who admired our

fine quarters with envy. Later, two more came with the lieutenant's order that we return to our field positions at 8:10, "unless express counterorders reached us." From there we went back to base singing.

In the morning, it was biting cold out in the mud-bowl. In the afternoon we learned the glorious song "When the Soldiers March Through Town" in an hour.

4.24. On Saturday afternoon, vaccination. I shall probably miss the 5:14 evening train, but shall certainly catch the express train at 8:22 or the local at 8:36. We shall therefore not see each other until night.

995b. 4.27. Good trip, slept well. Some drilling, really more like calisthenics. Climbed up the pillar of a bridge and down again on the other side. Medical inspection. Instruction.

995c. 5.1. Today we had to carry our packs.

5.2. Our work is now rendered slightly harder by the warm weather and by our load of equipment. This afternoon we shall have a long march with our new gear on our backs. We shall see.

5.3. A seventeen-mile hike with a full load, yesterday—what a grueling test that was! A dozen men in our column collapsed. I saw one of them lying by the side of the road, with a heart attack. This morning, a hike in the hills for less than an hour; then lay about in the forest, with marvelous weather, and took under an hour coming back. I guess things will be all right.

995d. 5.4. I sat yesterday with a few select companions at a nearby inn called *The New World*. A splendid garden and a chance to get a couple of eggs and some rolls. This afternoon we hiked out to the most distant of the drillgrounds, an hour and a quarter's walk with our full load on our backs. Out there we had strenuous drill conducted by the captain. Then the hike back home! In the heat. Now that it's over, I must say it went off all right, but painfully, painfully!

At the first sign of damage, I would quit the game. As it is, it may actually do my body some good.

5.5. Life today was easier because the weather was cooler. In the forest we made our first timid attempts to dig in. The landscape behind Heiligenblut

is superb, everything today seemed as if it had been dropped there by a wizard; again hiked about seven miles.

5.8. Weather cooler, soon the rain will settle in. As a result, had a less painful time of it. Spent four and a half hours on duty in the magnificent forest, during the morning. Unfortunately, couldn't get rid of my pack. But it really was quite manageable.

5.9. Marksmanship competition. Take it easy: this time, I didn't hit anything. At a distance of four hundred yards my slight nearsightedness begins to tell a bit. I talked myself out of it and was allowed not to lug along any special sights. We finally ate at three o'clock. On the rifle range I talked to Schinnerer and—talked to him at great length. He gave me an apple to quiet my hungry stomach.

5.11. At five in the morning we had to hike off to the cavalry drillgrounds. There we took up our places for inspection in the expectation of His Excellency's arrival. Other sections had their turn before us, while our appearance got some extra polishing up. We then had to go through some posture exercises, which went off relatively well. Other drills went all haywire. Splendid May day, not sultry, did its part. No hiking in the afternoon. Tomorrow evening, a night exercise.

5.12. Tomorrow vaccination takes place at 11 in the morning, so that we can probably take the one o'clock train to Munich. But should I have to leave on the 5:14 train—which is not likely—I shall not be able to use the main exit but shall have to get out way over near the Bayerstrasse and, after some frantic crowding, appear near the Kommandantur in the great cross-corridor.

5.15. Arrived safely. It had stopped raining. This morning, did some elementary things in drill period, not requiring too much exertion on account of the weather. In retrospect, I am still delighted with the opera I heard and am very much for repeating this from time to time.

5.18. The final rehearsal of *The Creation* is on Saturday afternoon at 5.30, the performance on Sunday at five o'clock, in the Dominican Church (I play the violin in the orchestra).

5.19. Walden informs me that the watercolors that I had requested back have been returned. He has sold "The Anatomy of Venus," net gain: one hundred and sixty marks. He begs for new material to sell . . . The *Neue*

Sezession has asked leave for me, but the captain is reluctant to grant any before the thirty-first of May, for we are about to have maneuvers, in which everyone must take part.

Yesterday the drill was very easy throughout the day. In the evening we hiked to Klausenberg for a night exercise. We had no packs to carry, and it was a delightful walk through the dusking forest.

5.23. This morning, awakened by pouring rain, half pleased, half apprehensive. But soon the weather cleared again, and it turned very sultry. At least the annoying dust has vanished. Out on the infantry drillground, the usual exercises, then an attack directed by flag signals. Now a short two hours' rest in bed. Hunger and thirst were great, but the remedy for both was available.

996. 5.25. From six o'clock till about twelve, experienced and suffered through a long hike. From one to three o'clock I had a fine sleep in my bed. Weather not sultry, but very hot. We had a half-hour's rest in the forest, moments of deepest bliss.

5.26. . . . You complain and have headaches and are pale. I drag myself about for hours, loaded down, in the bright sun, but I have long since forgotten what those ailments are like. Safely survived the first combat exercise. Safely, because it is over; the field canteen was a very amusing sight; it was like being in a kindergarten.

997. 5.30. Routine drill on the infantry drillgrounds. Unfortunately, had the most varied sorts of sore spots, owing to the antics of the past few days. Then to company formation. The captain wanted to know what the *vernissage* would be like. He grants me leave from the first to the night of the fourth; from the fifth to the eighth, I must be back again. From the ninth to the thirteenth, we'll have Pentecost leave.

Then we'll be divided into companies, and a new batch of recruits will arrive. Promoted a class. I shall be home on the evening of the thirty-first or on the first.

998. Furlough. The captain sent me a pass from the fifth to the eighth without my having applied for it. Now, I assumed that the pass for Pente-

cost (June ninth to thirteenth) would follow automatically. With my civilian mentality, I thought it unnecessary to return to camp on the night of the eighth, in order to leave again with the convoy on the ninth. But when, on the ninth, the pass didn't arrive, I felt like a green recruit and sent a request by wire. The answer came: "Return at once."

999. 6.9. Landshut. How terribly funny the whole sad mess is. The closer I came to Landshut, the gayer I felt; when I stepped off the train, I felt in fine humor and full of fighting spirit. The familiar way into town.

In the Heissgarten I was able to have a word in private with a soldier attached to the administration bureau, who was dusting there. The fellow thinks there will be no trouble. The whole camp really did steam off at six this morning. My exception is therefore an irrefutable argument (civilian's argument), and I hope to convince the company sergeant tomorrow morning at nine-thirty, After all, he's had his fun by making me jump on the train and come back. So let's not get excited! If I am really lucky, I shall take the morning express at 10:40; if not, the 1:21. In that case, I'll send a telegram.

1000. What happened was that a substitute captain, called Daxelhofer, thundered at me, or at least tried to, but was put to shame by my eloquent defense and by my appealing to the authority of Captain Jungwirt. He did not sentence me, but left this to the regular captain. My punishment for the time being shall be the loss of a day. Made out my Pentecost pass and sent me off. The phenomenon of the captain's handing out an unrequested pass was incredible!

1000a. A half a day has passed. On Saturday we rest again. We haven't been mixed in with the new recruits, but all belong to groups trained at the same time. Only the small ones (fourth and fifth section) were sent to Mitterwehr. There was something really disgraceful about these runts. Our platoon now looks very trim. The noncommissioned officers saved my rifle for me, my other things hang nicely all together. Vize Pritzlmeier, the doctor, has remained. A first lieutenant is in charge of us. Company drill today was conducted by a very likeable and able second lieutenant named Feh.

My section-leader is called No Wimmer. At our company exercise, we were about three hundred; it is quite amusing.

A portion of pork-brawn jelly for thirty pfennig is worth noting.

1001. Eighteen minutes of firing at a distance of one hundred and fifty yards, round target. At night, hike with sandbag on our back. The ultimate in the infernally sad existence of the infantryman. Requested pass for Thursday.

6.23. Handed in two passes, an old one and a new one. Had a good trip with two cultivated "gentlemen." Later had beer and pork-brawn jelly with Gruber and Dr. Vize and a company sergeant I didn't know. To bed at twelve. On duty: inspection by the first lieutenant who rode along everywhere with the captain, until the sweat dripped.

1002. 6.27. No leave, I expect my family on Wednesday evening. As an added misfortune, a night exercise is planned, so that I won't be able to pick them up. Fräulein Weidmüller makes tea for them, Lily puts Felix to bed, and when I return, I find her comfortably settled.

1003. 7.1. No furlough, because I got the first watch. Lily and Felix must come on Saturday evening. I'll be free until Sunday noon. Then, sleep at the barracks (Martin School, now infirmary).

1004. 7.4. Letter from Probst, which pleased me. Took care of correspondence with Osthaus-Friess-Piper.

From my sentinel's post, sent a devoted greeting to Lily. Today, shot six, twelve, eleven. In the afternoon, "cleaning-and-sewing hour." At six, long hike, great fun. After the watch I slept so well in my bed that for the first time it was the alarm clock that woke me.

What an affair this guard duty is! Changing of the guard! And yet I survived it quite well. A new monotony is added to the old routine. Unfortunately Lily didn't once open the gate of the infirmary, behind which I stood all day. At night I paced up and down the sidewalk with my rifle on my shoulder and listened to the quarter-hours tolling. Two to four in the after-

WITHOUT TITLE, 1916, 1

noon, eight to ten at night, two to four in the morning, eight to ten in the forenoon. I have the impression that the war is entering its last phase.

1004a. Today, the long hike was made somewhat easier by pleasant weather. The evening and night hikes were more exhausting. In the afternoon, we get going only at about three o'clock, and we usually don't leave the area, except for a bath. My impression is that a change is pending (transfer). An emergency training period is supposed to start in Freising on the twenty-fifth; perhaps, as a "one-year man," I shall go there. Perhaps some day I'll look back on the time spent here as a rosy period.

1005. 7.20. Transferred to Munich. Train trip, waiting, Turk School, waiting, transfer ceremony, a conceited first lieutenant. Talk, then to the Grosse Wirt inn. Then to the Max Classical High School. Second Reserve, Seventh Regiment, First Replacement-(Field)-Company. Permission to sleep at home granted only after making the grade.

MUNICH 1916

1006. 7.20. "My dearest Lily. We are here. For the time being, at the Max High School, Second Reserve Infantry Regiment, First Replacement Company. The others are quartered at the Grosse Wirt, we are in the gym of Max High School. Because of all the waiting time, it has now got to be four-thirty, and the issuing of uniforms is just getting under way very slowly. Exchanging my Landshut rags for gray semi-rags. It may therefore take quite a while before my turn comes. So it is unlikely that I'll still see the two of you today. Sleeping in town is a privilege for which one has to apply to the company commander. Be patient till I come! My quarters are convenient and roomy. Wait, wait, wait. Greetings to all."

1007. Report. Duty wasn't really stiffer than in Landshut. The long hikes a bit harder. The potshots more on target. Serious combat maneuvers. And yet there is still the same great confusion as always. Sergeant Feueregger, at first amusingly haughty. Gradually a certain *bonhomie* developed. Major Ableitner, a ridiculous man full of high-flown phrases: "Be glad that you don't go off on leave, like peasants, but are allowed to drill and learn here instead!" Later, frequent watches instead of night exercises and long hikes.

1008. While I was standing guard over the munitions depot in Fröttmaning, on one of several occasions, a great many thoughts about Marc and his art came to me. Walking in circles around a couple of ammunition storehouses was just the kind of thing to get one lost in thought. During the day magnificent midsummer flora made things unusually colorful, and late at night and before dawn, a firmament unfolded before me that lured my soul into vast expanses.

When I tell what kind of person Franz Marc is, I must at once confess that I shall also be telling what kind of person I am, for much that I participated in belonged also to him.

He is more human, he loves more warmly, is more demonstrative. He responds to animals as if they were human. He raises them to his level. He

does not begin by dissolving himself, becoming merely a part in the whole, so as to place himself on the same level with plants and stones and animals. In Marc, the bond with the earth takes precedence over the bond with the universe (I am not saying that he might not have developed in the direction of the latter, and yet: Why, in that case, did he die?).

The Faustian element in him, the unredeemed. Forever questioning. Is it true? Using the word "heresy." But lacking the calm assurance of faith. Often, toward the end, I was afraid that he might be a completely different man some day.

The changing times oppressed him, he wanted men to change with them. But he himself was still a human being and there was a remnant of inner conflict that bound him. The bourgeois empire, which was the last instance of the good being still a common good, seemed worthy of envy to him.

I only try to relate myself to God, and if I am in harmony with God, I don't fancy that my brothers are not also in harmony with me; but that is their business.

One of Marc's traits was a feminine urge to give everyone some of his treasure. The fact that not everyone followed him filled him with misgivings about his path. I often anxiously surmised that he would return to earthly simplicity, once the ferment was over, that he would not come back in order to rouse the world to some grand vision, but entirely from a human impulse.

My fire is more like that of the dead or of the unborn. No wonder that he found more love. His noble sensuousness with its warmth attracted many people to him. He was still a real member of the human race, not a neutral creature. I recall his smile when my eye overlooked some elements of earth.

Art is like Creation: it holds good on the last day as on the first.

What my art probably lacks, is a kind of passionate humanity. I don't love animals and every sort of creature with an earthly warmth. I don't descend to them or raise them to myself. I tend rather to dissolve into the whole of creation and am then on a footing of brotherliness to my neighbor, to all things earthly. I possess. The earth-idea gives way to the world-idea. My love is distant and religious.

Everything Faustian is alien to me. I place myself at a remote starting point of creation, whence I state *a priori* formulas for men, beasts, plants, stones and the elements, and for all the whirling forces. A thousand questions subside as if they had been solved. Neither orthodoxies nor heresies exist there. The possibilities are too endless, and the belief in them is all that lives creatively in me.

Do I radiate warmth? Coolness?? There is no talk of such things when you have got beyond white heat. And since not too many people reach that state, few will be touched by me. There is no sensuous relationship, not even the noblest, between myself and the many. In my work I do not belong to the species, but am a cosmic point of reference. My earthly eye is too far-sighted and sees through and beyond the most beautiful things. "Why, he doesn't even see the most beautiful things," people then say about me.

Art imitates creation. And neither did God especially bother about current contingencies.

1009. Our company leader is a lieutenant called Deyerl, a serious man, but slightly pedantic. My instinctive way of firing a gun particularly got on his nerves. He had drilling a bit too much in his blood. He was puzzled about why I fired so well one time and missed the target the next. Instead of letting me fire in peace, he fussed around with the way I shouldered my rifle and with my position. The fact that the helmet is bothersome when one fires lying down is a fact noticed by every private, but never by an officer.

1010. When I asked for permission to spend the nights at home, he called this a favor which could only be granted after I had proved myself, after perhaps a couple of weeks. It is inexcusable for an educated man to say such things to another.

1011. The other lieutenant, a handsome businessman from London, was not very serious, but amusing. The peasants liked him, it seemed to me.

I was in no hurry at all about my marksmanship. An instinct bade me to be fatalistic about it.

1012. Gradually I am getting to be popular with the noncoms. The sergeant of the dormitory recognized in me a wild, "ferocious" artist. He was a member of the Artists' Association. I now realized that I was no longer in that God-forsaken, provincial village Landshut. The quartermaster too was very friendly. Gradually the ribbing (though well intentioned) of the company sergeant diminished. The company's chief clerk became intimately friendly with me. I was put on watch whenever a long hike or a night drill was planned. These were my impressions from my lowly estate.

I had long since been spending the nights at home and was beginning to enjoy my new post when suddenly, on the drillgrounds, during a pause in one of the innumerable combat exercises, my name was called. "Here!" Report at once to the battalion medical officer, and before that to the sergeant. At once, I sensed something important. The sergeant was in excellent spirits. "Don't you want to fly?" "Who, me?" "Yes, didn't you request to be put in the air corps?" "Forgive me, Sir, I know nothing about it!" "Well, just so you will understand, I'll tell you that *we* put in the request for you. Now go and see the doctor to find out whether you're fit for it." At the doctor's office a few more men were waiting. One of them asked me whether I was Klee. Introduced himself as Wildermann. First came the doctor's assistant. Did I have anything to say? No! Then came the medical officer. Was I ready to give up my one-year engagement? In reply, I asked: are there no one-year men in the air corps? He shrugged his shoulders slightly.

When I returned to the sergeant I had already been transferred. He congratulated me: "Be glad that you're getting out of the miserable infantry. Now go and eat right away, then get ready. Here are your papers. You'll receive further instructions at the Türkenschule." He shook my hand. "Goodbye, Klee, take care of yourself!" The other noncoms were grinning too. The clerk smiled as he shook my hand.

SCHLEISSHEIM 1916

1013. And so I was no longer an infantry man. What next? First there was the trip with myself in charge (there were four of us): Wildermann and two workers. When we arrived in Schleissheim, a horrible, degraded sentry wearing a felt shako greeted us. This was already a degree worse than what we were accustomed to. After all, there had been decorum in the infantry.

This sentry led us silently to the barracks, a building which, though new, was narrow and small. A sergeant (from the recruits' depot) took charge of us, assigned us to our sections, and sent us around. Passport division, etc. We belonged to the workshop company.

Since we felt safe, we presented ourselves not simply as painters, but as artistic painters. This caused some shaking of heads. Only the company clerk was pleased. We were going to get work, he said, that would enable us to put our art to the test. Now to our quarters: the church warehouse.

The roll calls, Sergeant Poschenrieder. The yard, the work there. Proletarians. Factory workers. Stubenvoll. Three-week leave.

1014. August 12, 1916. From: Engineer Klee, Air Force Reserve Unit, Schleissheim, Workshop Company. To: Frau Lily Klee, Munich, Ainmillerstrasse 32, second floor in the garden pavilion. "What a disappointment that you didn't come. Well, let us hope for Sunday; saw Stubenvoll, promised he'd help. But sleeping outside camp is impossible. Will you find a place? Everything is said to be full to overflowing with pilots. We'll see. They have me varnishing wings. It isn't exactly dangerous. But suddenly to be turned into a factory worker, how adventurous! And the garb! Yours, Paul."

1015. 10.4. "My dear Lily! All my thanks for your last card from Switzerland. But most of all, welcome, both of you, to Munich! Unfortunately I couldn't get leave. I am on guard duty from Wednesday to Thursday, that comes first here. I hope both of you had a good return trip, and that the boy didn't catch a cold."

1016. 10.5. "In spite of your special delivery letter and telegram, I cannot ask for a leave twice in the same week. As if free will still existed! It's not wise to attract attention with small requests. See you Saturday! The train now leaves from here at 6:30 p.m.; so, either seven at the station, or 7:30 at home."

1017. 10.12. "The captain will grant me leave after the slip has been signed by the supervisor at the yard. It will probably be Friday."

1018. 10.23. "Arrived safely. Varnished two wooden fuselages. Corrected old numbers on airplanes, painted on new ones in front with the help of templates. While at work, had the impression that the Saxon foreman was sneaking around in my vicinity. Rumor of a drill spread at four o'clock. Then seized a favorable moment and escaped from the column. Gained a nice chunk of time thereby. What the consequences will be, we'll see. Until now I've been a virtuous recruit, gentle and obedient. All I got for it was a bungled leave. Result: I have ceased being a virtuous recruit. I have started coloring the lithograph for Goltz."

1019. 10.26. "Friday from four to five, fire drill, then off to rollcall. Had a hard time sneaking away. Not in my room before six o'clock. And so now there's a bad boy in the family. Should I have to stand guard on Sunday, I shall have to be back here at 9 a.m."

1020. 11.2. "I send you a warm greeting. Hope to see you again next Saturday. Today was a splendid day. I was kept outdoors for an hour and a half, taking care of trucks while the motors were being unloaded. Not bad for one's health anyway."

1021. 11.10. "Guard duty on Sunday, beginning at noon; I shall have to be back at 9 a.m. Today, had to help clean up the wrecked airplane in which two flyers lost their lives day before yesterday. Badly damaged motor, etc.; really inspiring work. I told Poschenrieder that I am often called on to help Section Two. He promises to stand by me. At least I shall have had the experience of the crashed plane."

1021a. Beginning of November. "Since I had had leave, it was felt in the yard that I ought to be on fire guard this Sunday. I asked the sergeant about it. He said he was sorry about it, but they had put my name on the list out at the yard. It certainly isn't his fault. All day Sunday one is restricted to two rooms in the barracks and to the canteen; it is no use, therefore, to pay me a visit.

Otherwise I am well, still constantly braced against army trickery. But the time for compensation will come again, which will make the Saxon foreman furious. Tonight (Saturday) I will work a little; I have some oil and a warm room."

1022. 11.13. To liven up my monotonous routine, I have been placed in charge of a transport to Cologne. I only regret that I'll have to miss your visit tomorrow, Tuesday, since I am leaving tonight from the freight station at Milbertshofen. But the business is amusing; I have been entrusted with airplanes for Fea Seven. I was given a fine chunk of bacon and money for the journey."

FIRST TRANSPORT

1022a. 11.13. (Monday). At four p.m., walked, loaded with food, to Milbertshofen; found three airplanes there almost loaded. At 10 p.m., left by freight train for Laim.

1023. 11.14. Left Laim at 2 a.m. Breakfasted in Treuchtlingen. In the afternoon, coffee and buns in Würzburg. Reached Aschaffenburg at 9:30 p.m., ate very well at the station. Stayed there until 3:45 a.m. Spent this time on the floor of the guard room, wrapped in a traveling blanket. I show naive enthusiasm, so I'll soon be sent on a transport trip again. I dream about a journey to the Balkans. I sit beside the engineer and often think of Felix and of the fun he would have here, since he is still hesitating between becoming a locomotive engineer and a painter.

350 / Diary IV

1024. 11.15. Left Aschaffenburg in the morning, where I had rested a couple of hours in the waiting room of the station. To Grossgerau, Mainz; pause at Bingen, a very elegant place on the Rhine. A unique mixture of nature and culture. The mountains, the river, the harbor installations, the ships, the terraces. Mainz had made a great impression on me. But there, the artistic element outweighs all the others. If I could only stay for a while in Bingen as an artist! Tonight we'll be in Cologne. Unfortunately I have no money with me, except the twenty-five marks for my expenses.

1025. 11.16. Cologne-Eifeltor, Cologne-Gereon, Cologne-Nippes, Longerich. Delivered airplanes for 249 (Fea Seven). At 4:30 p.m., walked to Bickendorf, took the trolley from there to Cathedral Square, had my hair cut, and then went to the Hotel Kölner Hof. My mission is accomplished. It was a fantastic scherzo mixing the devilish and the luminous. A kind of misty drunkenness still surrounds me. When I was finally free, it was already Thursday evening. I once again spend a civilized night in a nice hotel room. Tomorrow I'll be on my own. Took a wonderful walk in the evening.

1026. 11.17. Slept magnificently at the hotel, after having led a dirty gypsy's life since last Sunday. Cologne is sensational, polished to a smoothness, and large. Particularly impressed by it last night! The affluence in the main streets, those people in uniform! The mad railroad station. Right in front of it, that more-than-lifesize museum piece, the cathedral. The Hohenzollern bridge, totally dark and heavily guarded. The river. The sharp beams of four wily searchlights. Far above the towers of the cathedral, the bright little bar of a Zeppelin, maneuvering gracefully, speared by one of the beams. I had never seen any city put on such a nocturnal spectacle, truly a solemn festival of evil.

Stroll over the bridges. Had coffee for breakfast. Museum: Bosch, Breughel, "Crucifixion" by the Master of the "Life of Mary." Cathedral. Lunched at the Red Cross by the main railroad station, then went to the Artists' Association, then to the Deutsche Ring, as a courtesy to Wildermann, and had a look at his sculptures on the children's playground. Strolled along the Rhine, pastry shop, dinner again at the station, left for Frankfurt at 8 p.m.

11.18. Arrived in Frankfurt-am-Main at night, idyllic welcome with dinner

and quarters for the night at the Hippodrom. Taken there and brought back in a special trolley car.

At eight a.m., left for Munich via Würzburg and Nürnberg. In Munich at 6 a.m. On to Schleissheim at 6:30; since there was no on in the office, I hastened away to save my Sunday leave. Walked home by way of Milbertshofen. Here, met a very pleasant company having tea: Hausmann and Dr. Keller (art dealings).

SECOND TRANSPORT

1026a. To Fighter Squadron 5 with two airplanes, cars 37090 Hanover and 24059 Königsberg, via Cologne-Gereon, staging area. Planes B.F.W. 3054/16 and 3053/16 with spare parts.

11.27. The transport won't begin until tonight, Monday. Perhaps I can get home for a moment from Milbertshofen to catch up on a few things.

11.28. In the morning, I'm off, completely equipped as if I were leaving for the front, including rifle. On arriving in Milbertshofen, I find that the airplanes are not yet ready to leave. The train will not leave until 9 p.m. I deposit my bags with the stationmaster and trot off home, where I am still able to have a comfortable lunch and tea.

11.29. This time I have trouble getting out of Munich. I am stuck in Moosach.

I spend the night on a wooden bench in the waiting room. The line to Laim closed as the result of a minor accident. We have to wait until 3:30 p.m. We must remain on the train, for no one can predict exactly when it will move on. In Laim we wait some more, until 9:30 p.m., when train 1755 is ready at last. Fortunately I took along plenty of food; perhaps it will make getting away easier. The baggage car is relatively comfortable; I set up camp there and had an excellent sleep until Treuchtlingen. Here the baggage car was switched.

11.30. My better preparations come in handy to me. At 5 a.m., made coffee and had breakfast. At 8 a.m., Würzburg. Changed trains again. Then washed, felt fresh. My spirits notably better than at the construction yard. Wrote two postcards, but didn't drop them in the mailbox until Partenstein. My impressions of Spessart again very intense. Heiligenbrücken! Reached

Aschaffenburg at 2 a.m. Again ate extremely well at the restaurant in the station. Went on with train 7509 at 3:20 p.m.; had bread, sausage, and coffee in the baggage car.

12.1. At one in the morning, reached Koblenz, then, very early on Friday morning, arrived in Bonn. Now a long delay, the proximity of the large city can be felt. The worst conditions exist in switchyards. At least I had a sound sleep. Was interrupted only once during the night. Slept on until we reached Cologne-Eifeltor. Breakfasted there at the canteen, and took along with me a big marinated herring. From there, I am not sent on, like a freight parcel, to Gereon, but to the staging area in Hohenbudberg, on train 6263.

12.2. Safely got past Cologne on my way north! Got to the staging area in Hohenbudberg. Unfortunately it turned out to be the wrong place; the connection should have been made in Gereon after all. The traffic manager at Eifeltor District 5, who had assembled train 6263 on December 1st, is a perfect ass in spite of his energetic nature and his sophisticated manners. Only engineer corps freight is shipped to Hohenbudberg. Thus I traveled eighty miles too far. The people here are more than familiar with these mistakes. The welcome is friendly. In Hohenbudberg, you at least find a friendly reception in the military canteen; had the pleasure of eating fried potatoes (fifty pfennigs), thanks to a lady from the Red Cross. Spent the night in a fine room with bed and central heating. 12.2., in the morning, treated in friendly fashion by the sergeant, received a piece of bread and, from his detachment, coffee, sugar, and a piece of butter. Around 12 noon, back to Cologne. Weather clear, milder than in Upper Bavaria. But the people here call it cold; in fact, they even put two l's in the word. I am enjoying this tribe of people more and more. If I lead the transport to its goal, I shall cross Belgium to Maubeuge (Lüttich). I am not counting on its being decided right away. Those great switchyards have got something. They teach you how to wait.

Reached Nippes in six hours; there, coupled to an express train going to Gereon. Reached Gereon at 9 p.m. At the staging area, received leave until next morning at 8:30. Again took a room at the Hotel Kölner Hof. Dinner in a small inn, brought there by a recently drafted field-artillery man, veal stew with potatoes, liverwurst with salad, a loaf of bread, no coupons.

Sunday, 12.3. (Cologne). "The decision has been made. I escort the trans-

port to its final destination. Please send further news to the main postal center in Brussels, since I'll go there on my way back, and perhaps also Hausenstein's exact address?" Got up at seven, repacked, went to the staging area. Here a clerk fills out a return ticket for me and informs me that my mission is completed. I am half disappointed, half relieved. But then the sergeant arrives and laughs at him, hands me a military ticket to Haumont (near Maubeuge) via Aachen and Lüttich, and orders me to turn up with my papers at 2 p.m. on platform sixty-three, to board the train. I make sure at once that my cars are there and that the time of departure is correct, leave my things at the station, and go to have lunch at the station canteen.

On my way to the station, a lieutenant stops me and sends me to a cigar store; I am to tell the salesgirl there that the lieutenant will not come today. In case I was questioned, I was to answer that I had seen the lieutenant at the Deutsche Ring, and that he was already wearing his helmet. For this, he gives me fifty pfennigs. I enter, the cat-faced blonde looks at me for a moment with furious comprehension. A customer present as a witness was more edified. Smiling, he gives me a cigar. From my clumsiness at accepting tips he concludes that I must be from the country: "From Bavaria, eh? Well, here's something good to smoke, a Sunday cigar. Here's a light; see here, this is how its works." I thank him and vanish. The Sunday cigar is poor, the joke all the funnier.

Departure at 2:40 p.m., platform sixty-three, with the military train Gereon-Haumont. Twenty escorts in a fourth-class carriage with benches and stove. Very picturesque, adventurous company. We cross the border beyond Aachen at 10:30 p.m.

Monday, 12.4. Everything comes off according to my wishes. We are deep in Belgium. The French station name Nesseaux. Terrain cut up by trenches; unfortunately it is not daylight. Liége, a magical night picture. Between Liége and Namur, we are forced to halt in the dark of night. Day breaks before Namur. Along the Meuse, where small steamers were struggling to pull scows on narrow canals. Charleroi, artistic mountains of slag, a fabulous place, coal, walls, African, a waking nightmare. Toward Thuin and Lobbes, nature becomes more beautiful again. The gentle tones of France begin softly to sound.

La douce France. What a way to meet again! Shattering. Coming from

the north along a sinister path and not toward the heart! Illegal. Poor, degraded country! The past, a ruthless line drawn under yesterday. A glittering blade striking deeply into the heart's core. Mild, sunny day. Cattle grazing peacefully, black and white cows. Carmine cows.

Zeppelin hangars. Maubeuge at 3:30 p.m. Right after, Haumont. A perfect example of a French provincial town. The poesy of sobriety, everyday life without makeup. Food? Sugar? Oil? Rice? Wool? Rubber? Little, barely more than we have, and already plundered, because it is a military station. Soldiers scouting for goods, hoarding merchants, the speculators! I too would like butter, but not for trading, only for me and my family to eat. The Satan of usury has no strength, he is too much of a bourgeois.

We go to the Soldiers' Home, where a sergeant serves us. My fellow convoy-leaders feel well there. Not one of them senses the fascination of the hopelessness of this French province. Movies are the supreme desire of my heroic colleagues. Some kind spirit separates me from them on the way there. Snow begins to fall thickly. I hurry to the station where I learn that the train will not leave at 11 p.m., as announced, but quite soon. We still have a half hour left. I return quickly to the high hill, night has fallen. At least I would like to get in touch with my colleague from Fighter Squadron 5. This fellow from Konstanz has experience in escorting shipments through enemy territory. But where shall I find the time to get to the movies? Instead, I grab a first-rate apricot tart and dash back to the station. The locomotive and a Belgian freight car defying all description are already on hand. Got the airplanes attached to the train. At 7:30, the mournful convoy leaves.

I manage to find a little place in the warm upper compartment; we sleep sitting, a blanket wrapped around our chilly legs. The hideous one with the ill-smelling dialect from Thuringia, such a hideous one! (Reached St. Quentin at 4 a.m.)

12.5. Somber mood, we are nearing the front. The drama of my journey is probably approaching its climax. St. Quentin. Arrived in total darkness. Barely managed to grope my way to the station commandant. Am told to seek shelter in a *salle à manger*. And who should be there? All my companions, arrived before or after me on the passenger train, among a heap of soldiers from the front. Am glad about my one colleague from the Fighter Squadron 5. There is coffee, sausage, and bread in the somewhat seedy can-

teen. At 8 a.m., waltzed ourselves to the staging area up in town; had a hard time finding it. No one knows exactly where it is. Someone guesses (rightly, as it turned out later) Essigny-le-petit. They end by telephoning the numskull in charge and are told: to Bussigny, and then to Air Base I, at Cambrai. We wonder and wonder: why? And all the traveling to be done only by night! By expending tremendous effort, we order, at the station (how lazy all these employees are!) that new stickers be pasted on and that the orders be changed for our freight. We end by doing the pasting ourselves. Toward noon our negotiations come to a head and we receive a promise that we will be sent on between two and three o'clock on train 7980. This gives us the courage to climb up to town another time and to have a warm meal at one of the soldiers' shelters. Sauerbraten with potatoes, just as in Schleissheim, then we buy loaves of bread and fine liverwurst, return to the station, and wait and wait in the train, which is all ready.

And once again night falls before we move on. No freight cars this time. Traveled with two horses in the compartment. Always just at night, otherwise the trains may be shelled. Took out my fur coat! A slanting board becomes my bed. A precious possession! Otherwise I would have to sleep in the dirt. Wrapped up as well as I could. Froze, but found it bearable. Let's not mention the feet.

12.6. In the morning, arrived at Cambrai-Annex. Pasted on new stickers to Cantimpré, Cambrai's other auxiliary station. Apparently our destination. We again have more time than we need and stroll off to town, a pitifully miserable, hungry village. Pleasant market. Plenty of endives. Lunch at the canteen in the station annex. Then back to the city, into a pastry shop with cakes and fruit. A battalion from the Somme marches up with music, an overwhelming sight. Everything yellow with mud. The unmilitary, matter-of-fact appearance, the steel helmets, the equipment. The trotting step. Nothing heroic, just like beasts of burden, like slaves. Against a background of circus music. The drummer outdoes himself. The worn faces convey only a distorted reflection, if any, of the joy of being replaced and sent off to rest.

Had a look at the airplanes below. Waited for a long time and then at last moved on to a little station. Again waited and waited in the waiting room of the main station, among a group of Saxons (brr!). And finally, moved on to another station, to Cantimpré. Here, out in the street at 3 a.m.

12.7. Nothing darker than such a night. Groped around for the way to the aviation barracks. Barged into a ground-floor room, grabbed a straw sack and lay down on it with all my gear! At dawn, detachments of soldiers in the courtyard of the camp. By and by, we get up, go to the administrative offices (saddlery) and discover that we are at Air Base I. They wire for us to the mysterious Fighter Squadron 5 to find out whether we are to leave our airplanes here or escort them farther. Are told to return at noon. Meanwhile, we are well taken care of and even fed there. Sensations aplenty!

At noon, the reply has not yet come in. We are to return at four. At last: "Escort the planes to Essigny-le-petit, the gasoline to Epéhy (separated from my colleague, who manages a hotel in Konstanz) Kagohl V." So reads the telegram.

I paste on new stickers and receive new freight orders. In the evening, I inquire again at the station, realize that the departure is uncertain, and decide to wait for the only certainty, namely, that the planes leave without me, and sleep another night on the straw sack.

12.8. Slept and breakfasted well; at 8:30, persuaded myself at station Cantimpré that the certainty had materialized at midnight. Calmly, in the rain, I strolled to the main railroad station of Cambrai at 7 o'clock; I at once sighted the airplanes and soon took the train to the annex. Safely returned to the old spot, again retraced the same steps, found a stove made by Russian prisoners ready in the waiting room. Ate at the canteen, had coffee at the Soldiers' Home, where I hear that Bucharest has fallen. The planes are to be shipped on to Bussigny at 8:30 p.m. I smile knowingly. Ate my last dinner at the canteen in the annex, filled my flask with coffee. Take a last nap near the large stove, the pride of the waiting room. Then I find my car next to a shipment of ammunition going to Bussigny. To be sure to leave, I board this car. Nest beside three fellows from northern Germany. A great deal of straw on the floor, candlelight. At first I freeze more than my usual quota, then I put on my waistcoat and sleep and dream until 5 a.m.

12.9. In Bussigny, again the familiar impossibility of obtaining any information about how I am to be shipped on. "Go to your car; in that way, you will know when you will be leaving." True enough. I keep my thoughts to myself and go to the night quarters, where I find a bunch of wild Bavarians. In spite of them, a mild slumber overtakes me. Then slight restlessness drives

me first into the brake cabin of my car, then to the shack reserved for the railroad workers, where I make coffee and jam sandwiches and eat sausage and apples. Now I wait peacefully in the warm room, through the window of which I have a partial view of my train. Outside, fog and storm, the best protection against air attacks.

Toward noon I cover the last portion of this voyage, a few stations beyond St. Quentin. Having reached Essigny-le-petit, I inquire and wander along the track for a few hundred yards, turn right onto the road at the next bridge, walk as far as some large farm installations, inquire and—have reached my destination, drenched by a rainstorm. My goal is attained. I am in the office of Kagohl V.

The reception is warm and friendly; the sergeant brings me immediately to the rustic kitchen, where I am given meat, coffee, bread, and a great deal of butter—wonderful northern French, golden butter. Then a corporal came to inquire about the planes' serial numbers. My mission will be officially over only after they have been unloaded.

I stay in one of the barracks. The stove that they dug in the chimney is my friend. I wash and wait until the men return from work at night.

They are in good spirits. The word "crash" is not a part of their vocabulary. They are from Cologne, Bremen, and Hamburg. Dinner: bread, jam, and again butter. Afterward, they are at first a bit noisy and unbridled; then everybody sits down at the table, around the kerosene lamp. Everyone reads by himself. Quiet and deep peace. They give me at batch of copies of *Motor*, a handsome illustrated sports magazine. I soon feel drawn to a bed with a spread and many blankets.

12.10. The planes are unloaded. Awoke at 7 a.m., went to have coffee. I wipe the table. Then I go up to the track to have a look. Six men for each plane. The weather is clearing. After lunch, I felt like leaving. I inquire about it at the office; my release slip and travel orders are ready, but the lieutenant must come and sign them first. Soon the clerk brings me the papers and I march off contentedly to the station. There a freight train stands waiting, as I had hoped; I hop on and travel to Bussigny in the heated baggage car.

Here I wait for the express train to Brussels, where I arrive at 9:30 a.m. I find a dead metropolis, whose inhabitants are being penalized and must be in bed by 8 p.m.

To a hotel near the Gare du Nord, eat somewhere or other, not badly at all, and go to bed at 11 o'clock.

BRUSSELS

12.11. Lovely mild day. Breakfast at the hotel, at 7.30, many cups of coffee and a few slices of French bread. Then to the cathedral; inside, remarkably colorful stained-glass windows; otherwise, run-of-the-mill. Then to the Royal Palace and to the Palais de Justice, and back by way of an avenue circling behind. Soldiers come along, with fifes. Just as noon strikes I find myself in front of the Soldiers' Home, where a sign saying "Food like Mother Used to Cook" induces me to make a real pause. The food was quite good; in an adjoining room I had coffee and cake. I find the small, old picture gallery closed; only *jeudi*, is the rather unfriendly greeting. I walk away, furious. Down to the Town Hall and the Flower Market, too rich, too bourgeois. Then to the railroad station to buy lard and to the hotel to pack and pay my bill. After that, a buying splurge in the shops and at the market. The officer with the wicker trunk which he drags away himself. Dinner, somewhere or other, is not so good. Hunger doesn't yield an inch. Very attractive nightlife, thoroughly Latin. Tarts with steep hats and thin legs. At the station I had to wait a long time for the train from Antwerp, which arrived considerably late.

12.12. Return trip by way of Namur, Luxemburg at dawn, Metz, Saarburg, Strassburg, Karlsruhe. Here, pretty nursing sisters with weak coffee. Between Karlsruhe and Stuttgart, ugly sisters with excellent coffee and good sausage. In Metz, they wanted to put me off the train because the word "not" had not been struck from my travel papers. I ignored it, pretended to be asleep, and reached Stuttgart. From there on, there were no more controls. Stuttgart, a marvelous city. Unfortunately, night fell; the Alb must be especially beautiful. Via Ulm to Munich, where I arrived at 8 p.m. Home at 8:30 after successfully slipping through the hands of the station commandant. We had heard in Stuttgart about the Kaiser's peace offer.

12.13. to 12.16. Self-granted convalescent furlough in Munich.

1039. 12.18. The stove in my room at Schleissheim smokes. Bought a broom and a shovel. Called a chimney sweep. (Found a rag stuck in the pipe.)

1040. 12.20. My name is down on the Christmas-leave list. I begged the private first-class in charge not to put me on guard duty.

Now that the rag has been removed, my stove is working well. The family can again visit me. Perhaps even in the second half of the Christmas holidays.

SCHLEISSHEIM 1917

1041. 1.2. Arrived safely. Successfully killed the second day of the week. In the evening, talked to Wildermann for a few seconds. Asked about my family. Afterward collected ten marks and fifty pfennigs, earned by being on leave. The army has its pleasant moments.

Started on the Chinese short stories.

1042. 1.4. "Again escorting a transport; it was decided more suddenly than ever before. Nordholz, Naval Land-Based Airplane Division, is my destination. I could have returned to Cambrai, but I preferred the new trip. Impressions of the sea and the possibility of getting to Berlin also influenced my decision. My return-trip orders state: Cuxhaven-Berlin-Hof-Munich. Please send all letters to Walden. My Sunday leave will certainly be replaced in one way or another."

THIRD TRANSPORT JOURNEY

1043. As escort of freight-car Halle 422025, containing B.F.W. 3735/16, to Nordholz, air base near Cuxhaven.

On the eve of my departure, 1.4. At 4 o'clock, walked from Schleissheim to Milbertshofen, where the freight train is scheduled to leave at 9 a.m. Before, found time to buy some food, including some very good liqueur made of herbs. Reached Laim without incident.

1.5. At 3 a.m. left Laim on train No. 1909. Woke up in the Jura mountains of Thüringen, in splendid spring weather. The waters of the Altmühl have flooded the neighboring country. Water in the streets of Dollnstein, water in the furrows, houses like islands on the high seas, water in the carousel with the coupled oxen. A lonely post office, like the farewell gesture of a former age. Later, the Main, clay-green and pink tones. This landscape has a delicate grandeur.

At 7 p.m., reached Gemünden (the home of noble ancestors). With some trouble, the airplane is transferred to a mail train. In the meantime I settle down comfortably in the station restaurant and eat divine potato pancakes with applesauce.

Later, a rapid glimpse from the moving train of a ghostly village, abandoned, phantasmal, dead.

1.6. In Bebra toward 2 a.m. At 4 a.m. on with No. 8439. In Göttingen (8 o'clock), unbelievable news: a policeman killed while fighting with burglars! How terrible, added to all those lost in the war. I go to the Bürgerpark restaurant, eat mediocre bread with meat jelly, drink coffee, and read the local Göttingen paper with the comments of the editorial staff.

At 10:50, back along the Leine. Again, green-pink tones, but not quite the same green as near the Main; besides, a light sprinkling of snow. The floods have transformed the Leine into a mighty river.

Saw Kreiensen again, where I once met with my fiancée and where I changed trains when I was making a trip to Holzminden to meet my wife. Elze, a Hanoverian domain, and Nordstemmen, a castle, perched in genuine literary fashion on a mountain. Read Chinese short stories, father and husband praying together near the body of the girl.

Now the country is becoming flatter, the first windmills appear, and there are signs of a large city soon to come (Hanover).

Like a dream, the great city floats by in the haze, beyond the flooded area. A boastful dome with a gilded knob at the entrance of town and, finally, an old, three-pointed church steeple. In the foreground, a hellish industrial section. Great waste of space everywhere, as also in the installation of the freight station at Seelze.

There isn't enough time to put the plane on the next train to Bremen; it will have to wait until No. 7638 leaves from Depot II at 11:52 p.m. I in-

quire around and discover a charming restaurant where I have beer, soup, roast, potatoes, and Chinese short stories.

1.7. Arrived at the depot in the snow; had to wait a while longer (sleeping) for the train to leave. At 7 a.m. in Bremen, having rested on the bench of a baggage car; it was warmer than the night before, but couldn't stretch my legs.

Actually I am supposed to go on from Bremen only on the following evening. But while I am finishing my sleep on the floor of the depot, a friendly official decides that the train going to Geestemünde should be brought to an unscheduled stop, so that my airplane may be hooked onto it. Meanwhile I am lying in a pleasant, airy, and clean room, dozing while dreams dance gently around me. Unfortunately the train which we are planning to ambush arrives considerably late. I waste a Sunday sitting up there and hardly knowing why all this trouble. The railway official, a delicate blond fellow, speaking with me in excellent German, but talking with the railroad men beneath the window in an incomprehensible mixture of English and Danish.

The train we were planning to ambush arrives at last and takes me to Geestemünde. A soft-hearted station official tells me to be there at 6:45 to catch the passenger train, which will take along the airplane; he warns me repeatedly, in a paternal tone, not to arrive too late. It is 4 o'clock, I stroll to the harbor and look at the wet docks. Then over to the lighthouse (ferried in a nutshell for three pfennig). At the lighthouse and at the radio station, a weird view into the North Sea. There was great misery in this manifestation of nature. Utter hopelessness. A fearful wind, such as can only bring disaster. Deepest, coldest fear assails me. The sailors say that bad weather is approaching. I blame England for it.

Back to a hotel restaurant with a parrot. There I am served pork cutlets, red cabbage, and potatoes, enough to have my hunger satisfied (really satisfied). Responding to the good advice that the traffic manager had given me, I am back at the station in time; it wasn't such an easy matter because of the poor lighting. The passenger train is filled with middle-class people, as if I were in Switzerland; there are also seamen in handsome dress uniforms, returning from Sunday leave. At Nordholz I don't escape the station guard. A sentry, cycling beside me, brings me to my destination, half an hour away. The sergeant and, even more so, the mechanic give me a friendly welcome;

the mechanic supplies me with cigarettes, bed linen (!), and offers me food. I make myself some tea and lie down. Around me, nothing but blond boys. One of them reads aloud a drama which he himself has written—modern subject—in iambs, and is ready to meet any criticism. My worst dreams take a turn for the better. Nice, poor little fellow; should still be in school.

1.8. We are awakened around seven a.m. But nobody pays much attention to it. Later the fellow comes by again, jokes, and pulls away the blankets. Me, he spares as he passes by. Then the sergeant shows up in person to see whether everything is going according to form. About me, he asks: "Who is this gentleman?" "I am the man who escorted the transport!" "Ah?" and he moves on. I am the last to get up; I only discover now how low and crowded the room is. Then I go to fetch honey; it tastes wonderful on bread, with coffee. Later I go along with the detachment assigned to unloading the machines, in a heavy storm; the men work quickly and well, while I self-importantly look on. Walking around I am again frightened by the region. It looks like the scene of doomsday. It is impossible to love something like this, but the godforsaken air of the place has nothing weak about it. If someone is looking for an experience, let him come here. I shall get over it, no doubt. Just the locale for a rabbit-zoo.

One of my next thoughts is Kubin!

The food, served in a pot, tasted good. Afterward I become restless and would like to leave. I go the sergeant's office; a sweet, childlike, blond boy wearing a pretty sailor's uniform is sitting at the typewriter there. The sergeant sends me to the second airplane mechanic. The latter gives me my receipt for the shipment, two cigars, and good advice on how to travel on the express train. The sergeant agreed to the suggestion and made out new travel orders, crossing out the word "not." The blond child had trouble with the receipt.

High time to catch the train! Left in a fearful snowstorm, fortunately the wind was blowing from behind. Like volcanic smoke, wisps of blown snow sweep across the frozen soil.

I board a *rapid* to Cuxhaven. Thorough inspection of my papers. I drink a kind of coffee and am off to Hamburg, via Harburg, on the *rapid*, at 4 p.m. Here I wander about in the snow for a few hours. Bought some food at the Red Cross post near the station. Still had enough time to devour a good deal

of my bread and meat in the waiting room upstairs. At 8:25, took the express train, and reached Berlin four hours later.

1.9. Arrived at Lehrter Station. Night had fallen and I was alone; I steered toward the roof of the Reichstag building and, beyond the Brandenburg Gate, went toward the Potsdamer Platz. Took a room at Hotel Borussia. On my way, gave directions to soldiers and to a lieutenant. Slept well. Awakened at 9 a.m. by a knock on the door. At 10 o'clock, I am ready to leave; as I do, a detective steps out of a neighboring room and looks me over carefully. But I am not the right man.

By 11:30, I am at Walden's. We chat, plan a book, and talk business. At noon I go to have lunch and return to his apartment at one o'clock, to see his private collection. With his help I telephone Köhler and make an appointment with him for 7 o'clock. Then to Aschinger's pastry shop; the coffee isn't bad, but the cakes!

At seven p.m., to Köhler's, Brandenburgstrasse 34. He is a bit late returning from work. In the meantime I look at pretty embroideries based on designs by Macke, Campendonc, and Marc. The best things are a couple of fleeing deer embroidered by Frau Niestlé, reminiscent of Chinese art.

Thereupon, Köhler arrives, greets me amiably, and asks me to stay for dinner. Actually I have already eaten, but it is well known that you just can't eat enough in Berlin these days, and so I hold my own against goose and raw ham.

Afterward we look at the beautiful collection. We recalled our two fallen friends and drank a solemn toast to their memory. When I left, Köhler gave me food to take along; a soldier is easily moved when people care for him. The collection was so fascinating that I telephoned Walden to call off our appointment.

At 10 p.m. I left from Anhalter Station via Leipzig-Hof, sped by Landshut and Schleissheim, feeling strange, and arrived in Munich. Here I slip through the military control by promising to take the next train to Schleissheim. The next train left on Monday, 1.15., before noon.

1050. 1.15. My military experiences are not painful, but full of surprises. Upon returning from my secret furlough, I find that I have been transferred to Flying School 5. This I owe, of course, to the construction yard. But the sergeant promised me to see to my well-being there. Since I shall probably still

leave today, all I may find time for is to clean up my room a bit. My wife will take care of the rest with Sophie, by and by.

1051. 1.16. A transfer that is a real cataclysm. Twelve hours later, I am still shaking my head. Together with some seventy others, I belong to the construction squad. I am to be head painter! Only the staff, to which I do not belong, will remain in Schleissheim. My guardian angel probably knows what he is doing.

We are equipped as if we were going to the front. A special train will get us there early in the morning, at 1:30. One more adventure to prevent the war from becoming too boring.

GERSTHOFEN 1917

1052. "Let's not kid ourselves, at our workshop you won't get ahead. There you'll find advancement," said my sergeant.

All day long we waited and lugged and delivered. At 6 p.m., we were ready. I had a last meal at the Blue Carp and cleaned up in my room.

Roll call at midnight, food and tea for one day handed out. The sergeant shook my hand. But the train left at 3:30 a.m. In Laim, we were stuck; in Munich, more of the same medicine. Reached Augsburg at 3 o'clock, Gablingen by nightfall. Now a memorable march to the construction yard, by the barracks. No sign yet of the Flying School. We are the construction crew.

1.16. Arrived here after an adventurous journey. From my first impressions, quite a God-forsaken land. Our quarters in newly set-up huts, as at the front. But I mustn't forget the difference that the Sunday leave makes. Private quarters? Where? We shall see. An inn?

The place has barely been established, and until things get under way, there'll be fantastic doings here. A soft spot without equal, for entire regiments can sink into oblivion here.

Sergeant Poschenrieder in Schleissheim took leave of me in such exceptionally friendly fashion that I suppose he was trying to do me a favor by transferring me.

"Here, one mustn't even think of getting promoted, let's not waste words

by talking about it. It's stupid, to be sure, but one can't argue against facts. Goodbye, Herr Klee!"

It is certain that the workshop administration disapproved of my frequent absences and wished to see me gone, preferably to the front. I am sorry to have no more of the fine, adventurous transport trips.

Now I shall have to get accustomed to my new situation. And look for new advantages. Time passes swiftly, each passing day brings us a day closer to the end of this insane war.

1054. Until now, we have had little work to do. I am able to read a great deal and am growing more and more Chinese. Li-T'ai-Pe's poems have been translated too playfully. Klabund goes about it somewhat thoughtlessly. The translation of the short stories is not reliable, either. The translator flirts a bit with Europe.

1055. 1.22. Arrived safely and checked in on time. The night was cold, but I pulled my hood over my ears. Crossed Augsburg on the trolley. I didn't see Augsburg, merely a few Augsburgers. That was an impression too. I don't have much time, the train had better not be too late. I was shrouded in frost, like a tree. And my handkerchief froze stiff in my pocket.

1056. 1.26. The railroads are closed for soldiers on leave. I therefore ask for leave to Augsburg from Saturday morning until Sunday night and ask my family to come to visit me in Augsburg. The leaves were granted, but this evening the orders from headquarters arrived. The authorities here cannot help it. Watercolor, "Cheerful Outlook."

1057. 1.29. After the fine hours in Augsburg, checked in without incident. The night was slightly milder and as a result the long walk more pleasant. I brought back enough relaxation to last me for a week, and the powerful impression of the cathedral.

1058. 1.30. I shall try, in spite of the fact that the railroads are closed to us, to take the train to Munich next Sunday, by pretending an emergency has arisen. First, however, I must have in hand the letter I asked Walden to

write. The sunshine has rendered the days somewhat more friendly and the cold more bearable. The skeleton of the first hangar is almost completed. In this way, I learn how to build hangars. Ate all the canned goods; rollmops has turned up at the canteen. When nothing is left, hunger drives me to the village.

Now I am constantly intoxicated by those eight hours spent daily in the winter air; as a result, I no longer feel any wanderlust at night.

1059. 1.31. A new chief arrived today, a certain Captain Moosmair. He makes a pleasant impression. As soon as Walden has come through, I shall see what he is capable of. I ask for nursery rhymes and Russian tales.

1060. 2.3. My family does not have to come to Augsburg, for I was granted a short leave to attend the exhibition of *Der Sturm*. It is better anyway, with this temperature, especially for Felix.

1061. 2.6. Arrived safely. Unfortunately without cans; I left them in the livingroom. The can opener eyed me sarcastically. Just now a package containing salmon arrived, also a parcel from a lady in Munich. Tomorrow our choral society will rehearse.

1061a. 2.9. The new moon brought little change; the air has merely become sharper, as has the color. I need large brushes from home, for the Prussian hangar construction command is leaving us, and we are left without material.

1062. 2.12. Walden sold a few things, among them even a drawing entitled "Dream Aboard Ship" (later I saw it at Lothar Schreyer's). An article by Däubler in the *Börsencourier* was sent to me. The exhibition is deeply impressive, he says, the work has become enormously more profound. In addition, he announces the publication of a longer critical study. Checked in on time. Once the ice has disappeared, it will be easier to walk. I need heavy mittens to work outdoors.

1063. 2.13. "My dear little fellow! Your long-awaited letter has arrived at

last, together with a letter from your Mama and a parcel from Frau von Kaulbach. I just happen to have been on guard, so I shall have all sorts of things to read and to eat. I am still hoping for cake and chocolate, as well as cloth to sew myself some gloves . . . So you had a good trip, except for being cold and hungry. And Fripp did all sorts of mischief. In his place, I would have acted exactly the same way and wouldn't have let blows rob me of my appetite. Especially if they come only long afterward.

I traveled well, on my feet. I cannot say anything about your photograph until someone brings the developed plates back from Augsburg for me, today or tomorrow. The second negative is still in the plate holder, in fact.

Finally, many thanks for the poem. Today, my hands are freezing, but this will pass. I kiss you heartily, yours, Papa."

1064. 2.14. Walden wants six graphic works for his private collection: 1. "Nocturnal Memory of Day," 1916/72. 2. "Small Community" 1916/69. 3. "Constellations over Mean Houses." 4. 1916/8. "Miniature." 5. "The Heavy Heart," drawing. 6. "Light and Shadow."

Without my notebook with the oilcloth cover, I cannot tell what the selling prices for them are, and am unable to evaluate his offer.

1065. 2.19. The delicatessen stores in Augsburg were closed. I asked my wife to send me something instead, also some tea. I cover quite quickly two-thirds of the way to Gersthofen; as a result, I have time to eat at the "Strasserbräu"; in this way, I don't have to make a dent in my food reserves.

1065a. 2.20. "Until now, I always managed to still my hunger in the end. (The eternal theme of the German nation.)

Thawing weather and chocolate quagmires.

I still have my good boots from Schleissheim.

A package arrived from Wiessee; it contained raw carrots and an enormous beet. It also contained a letter addressed to you. There must have been some mistake. Well, I didn't turn down the meat pie and the cake. The vegetables and a package of cream of wheat I shall bring along to Munich. But I probably won't bring the meat pie and the cake."

1066. 2.22. Ordered to work as a clerk at the paymaster's office. What I had anxiously avoided in Schleissheim and gone through a great deal for, happened by itself.

My Berlin exhibition is turning into a financial success. Walden is buying eight hundred marks' worth. In addition, twelve works on paper have been sold for one thousand eight hundred and thirty marks. In all, two thousand six hundred and thirty marks.

2.23. The railroads continue to be forbidden to men on leave. I wired my family to come to Augsburg, since I must remain here next Sunday.

2.26. After this Sunday off, there was a bit more work for me as bookkeeper in charge of subsistence expenses, since I had to catch up on the figures for the day I missed.

I find Augsburg more and more attractive. Today the spring has advanced a little further. Felix is to make photographic copies of a view of a hangar.

1067. 3.1. "My dear Felix, Your letter again gave me much pleasure. Your idea of a double Paris on the Oberwiesenfeld is very funny. I know those two towers well from the drills in which I had to take part there last summer. They are not observation towers, but telegraphic stations to receive wireless messages.

I'll probably have to remain in Augsburg again next Sunday. If your Mama doesn't feel like traveling there, I'll understand very well, after all the efforts made during the week, etc."

1068. 3.19. The most recent sales at Walden's come to five hundred and forty marks; the first sale that he had reported amounted to two hundred and ninety marks; in all, three thousand four hundred and sixty marks. Thank God, we have no money worries on top of everything else!

It was fine to be in Munich, even though so briefly. I had a great deal of work today to make up for it.

1069. 3.22. The road to Gersthofen partly lay under deep snow, especially the last stretch, and I was slightly tired at the end. Yet these weekly marches are enjoyable, after you have been locked up for so long.

Until Monday evening I was the master of the payroll department. The paymaster had gone to a meeting in Schleissheim. I took over the canteen money. They trust me.

The captain gives further instructions for illustrating his album of photographs. If only I knew how one draws a lion holding a Bavarian escutcheon in his paw. The favor of these bigwigs from the airfield is so important that it has to be done to suit his taste.

Today the first airplanes came buzzing in. I hadn't missed the noise of propellers.

1070. March. This time my leave has been changed into a Sunday on guard duty. There is nothing to be done, and since I have never been on Sunday guard duty yet, it seems fair. But it stems nonetheless from some resentment against my frequent leaves. The paymaster is certainly not behind the move. It's divine retribution, because I purloined a fine pork roast, which I had meant to bring to Munich. Now someone else has to take the meat to Munich; the kind tailor Hansi hands over the parcel to the check room at the railroad station and slips the receipt into an envelope which he addresses to my family. He quickly mails the letter; in this way, they will be able to pick up the pork roast.

1071. 4.4. Concerning that *nervus rerum militarificorum*, I mean the matter of furloughs, it must be noted that we are forbidden to use the railroads, or at least greatly restricted. I'll ask for a leave from Saturday evening to Monday night, to "Augsburg." Here I'll change into civilian clothes and in this way I'll easily get to Munich, as I did the other day. The only trouble is that I then won't be able to take the last train back on Easter Monday, because of the extreme risk of being late.

1072. 4.20. The inspection of finances gives us a great deal of work. We are completely buried in papers and know nothing else. We figure and figure. Just like school. Canteen expenses, barracks expenses, barracks expenses, canteen expenses.

. . . Night watch. Horribly boring guard duty at the gasoline cellar. The inspection safely ended.

1072a. The other day there was the sound of a piano in the officers' mess; a warm feeling came over me. But I must be wary and keep myself in check and be unmusical.

At the moment I am training a Fräulein Scheller from Langweid in my branch; after that, I have to do real paymaster's work. A slight shudder at the thought of it! It's nice now outdoors; the airfield is becoming more beautiful, if that word can be applied to airfields. A garden is being laid out.

Today we ate our own fine spinach, a truly excellent meal. As I'm still in charge of subsistence, I still get large portions, but will this continue once I've become a paymaster? Will I still get thanks for looking the other way?

1073. 5.9. Now that I have taught the young lady what I knew, I am beginning to learn the real business of being a paymaster. This is a kind of minor science that keeps one from becoming expendable so easily. A prospect of stabilizing my military career.

1074. 5.23. The wonderful weather does us good. Every evening I go over to my woods and fancy that I am freely spending the time at a good inn, somewhere in the country. How could my daytime duties detract from this feeling? They are easy to bear. At Pentecost I'll probably get leave to Augsburg, where the usual switch of costume will take place. Soon perhaps I'll be able to take eggs home. I am dreaming about a hundred of them! . . .

5.26. Am on night guard duty from Sunday to Monday morning (Pentecost), "because that way I can go on leave Tuesday," says the worthy Sergeant Schurz. I travel to Augsburg, spend the night at Ost's on Ulmer Strasse, and paint in my room. That too is a feast . . .

5.27. A walk through the cathedral again convinced me of the magnificence of this architecture and moved me deeply.

6.3. Traveled safely back from Munich, in soothingly beautiful weather. The long walk, in the clear night, from Oberhausen to the camp was enjoyable. In Augsburg I still found time to quench my thirst. The fish swam. I had bought a second-class ticket. For half the trip, it had still been daylight.

1075. 6.13. Another day passed; my service has become a habit so deeply

rooted that it goes on and on without making any tragic impact. It was quite amusing, in fact. The paymaster greeted me in the best of spirits, and there was as much hearty laughter and gossip about Dr. Schmidt as ever. Toward evening, Head Physician Pickert came to see me and brought me the fifth number of the fourth year of the *Weisse Blätter*, containing a small essay by Adolf Behne about my watercolors. Pickert wanted all sorts of explanations about Expressionism and was exceptionally amiable. The paymaster gaped, the "Doctor" and the young lady stared. How funny that my rising fame should have reached the Fifth Flying School! And so I am no longer an obscure, workaday tool of a dauber, because it says so in the newspaper.

Yesterday I returned to camp safely and in time. The walk was pleasant, the temperature rather brisk, the rain had cleared the dust off the road. And the baggage brought back from leave caused no trouble either. Felix ran alongside the trolley a good way, he is a real greyhound.

1076. 6.20. "Dearest Lily, At last your letter has come limping along; it took from the fifteenth to the nineteenth between Munich and Augsburg! What if it had been something important! I hope you are both well. I am enjoying this heat as if I had always lived in it; I am coming to life down to the very core, even though I'm motionless on the outside, as is fitting in this Southern temperature. Most of the men are cursing.

How enjoyable is the impression of timelessness of a noon like this, this precise equilibrium of being, this standing still, when there is scarcely a breath stirring. All activity here is merely mechanical, a mirage. The only thing real is the long, deep, inward gaze. In the meantime our harvest will probably suffer great damage. My love to you both . . ."

1076a. 6.21. "My dear little fellow, I was very much pleased by your nice letter which arrived yesterday, Wednesday. Yesterday evening storm clouds gathered for the first time, a terrible windstorm wrapped the entire airfield in a great cloud of dust; everything yearned for rain, but not a single drop consented to fall. The wheatfield which I look at all day long is going to ripen prematurely and will only produce meager ears . . . I often read your beautiful book of tales."

1076b. 6.28. . . . tonight I am on guard duty, I wander up and down with shako and rifle.

1077. 7.2. Arrived safely from Munich; a little more pressed for time than usual. As a result, the rag collector's automobile caught up with me even before Gersthofen, and I briskly jumped aboard. It must have rained heavily, for the road was wet, but also firm. The few hours in Munich always do me good; this relative regularity preserves the human being in us. This week I hope to be able to paint a bit for myself again . . . Noticeable shortage of fruit.

1078. 7.4. On Monday evening I painted a watercolor and started another one. Yesterday evening the weather grew beautiful and mild. I strolled through our widespread vegetable garden and finally lay down. The art of yesteryear, this Dostoiewskian Chandala. One work, perhaps the *Brothers Karamazov*, is really sufficient. Instead, one reads fifty such documents of the past, mostly because one is bored, and gaps start to appear very soon! Let's not even speak about gaps in our own time, for here the poets give up! For the time being the plastic arts have jumped into the breach. Our friend Hausmann knows at least how to conjure up perspectives for the poetry of tomorrow. No eggs, a little milk again every day. Received a pound of honey from Fräulein Scheller.

1079. 7.10. I cannot read the Gotthelf book. Sometimes the sermon becomes beautiful, but it never rises to the level where a book begins for me. So it is Homeric: do I read Homer? Why, as a matter of fact, don't we read real trash; at least it is more entertaining. The book of our time has not yet been written.

Yesterday evening I was able to paint well. A watercolor in the manner of the miniature came out of it, nothing new, but a good extension of the series. New work is preparing itself; the demoniacal shall be melted into simultaneity with the celestial, the dualism shall not be treated as such, but in its complementary oneness. The conviction is already present. The demoniacal is already peeking through here and there and can't be kept down. For truth asks that all elements be present at once. It is questionable how far this can

TOWER BY THE SEA, 1917, 160

be achieved in my circumstances, which are only halfway favorable. Yet even the briefest moment, if it is a good one, can produce a document of a new pitch of intensity.

Great drop in temperature, fearful wind, and cool weather. Intestinal pains, on the verge of taking digestive pills. Today we were served fine beans, but those lazy fellows didn't let them boil till they were soft! I now regularly get milk again. As a result, I'm able to give away everything in our ordinary fare that I don't like (and there is quite a lot). Autumn seems to want to come as suddenly as did the summer. Even the seasons are cutting down, maybe to make things go faster.

1080. 7.13. Received two parcels from Munich. From Bern, a postcard. Professor Bürgi intends, supposedly, to try to obtain a furlough abroad for me with a medical certificate. Unfortunately they will be disappointed.

Painted nothing of any value, prepared a few graphic works, as feelers toward the goal, which I hope not to reach too soon, for there can be no more critical situation than to have reached the goal.

1081. July. Thoughts at the open window of the payroll department. That everything is transitory is merely a simile. Everything we see is a proposal, a possibility, an expedient. The real truth, to begin with, remains invisible beneath the surface. The colors that captivate us are not lighting, but light. The graphic universe consists of light and shadow. The diffused clarity of slightly overcast weather is richer in phenomena than a sunny day. A thin stratum of cloud just before the stars break through. It is difficult to catch and represent this, because the moment is so fleeting. It has to penetrate into our soul. The formal has to fuse with the *Weltanschauung*.

Simple motion strikes us as banal. The time element must be eliminated. Yesterday and tomorrow as simultaneous. In music, polyphony helped to some extent to satisfy this need. A quintet as in *Don Giovanni* is closer to us than the epic motion in *Tristan*. Mozart and Bach are more modern than the nineteenth century. If, in music, the time element could be overcome by a retrograde motion that would penetrate consciousness, then a renaissance might still be thinkable.

We investigate the formal for the sake of expression and of the insights into our soul which are thereby provided. Philosophy, so they say, has a taste for art; at the beginning I was amazed at how much they saw. For I had only been thinking about form, the rest of it had followed by itself. An awakened awareness of "the rest of it" has helped me greatly since then and provided me with greater variability in creation. I was even able to become an illustrator of ideas again, now that I had fought my way through formal problems. And now I no longer saw any abstract art. Only abstraction from the transitory remained. The world was my subject, even though it was not the visible world.

Polyphonic painting is superior to music in that, here, the time element becomes a spatial element. The notion of simultaneity stands out even more richly. To illustrate the retrograde motion which I am thinking up for music, I remember the mirror image in the windows of the moving trolley. Delaunay strove to shift the accent in art onto the time element, after the fashion of a fugue, by choosing formats that could not be encompassed in one glance.

1081a. August.

> Because I came, blossoms opened,
> Fullness is about, because I am.
> My ear conjured for my heart
> The nightingale's song.
> I am father to all,
> All on the stars,
> And in the farthest places.
> And
> Because I went, evening came
> And cloud garments
> Robed the light.
> Because I went,
> Nothing threw its shadow
> Over everything.
> O
> You thorn
> In the silver swelling fruit!

1082. 9.9. "My dearest Lily! So, tomorrow evening you will be back in Munich, and it will be easier for us to see each other. Today I couldn't catch the train because I was put on duty; and since my new chief himself informed me of it, there was nothing I could do. I console myself with the thought that, after all, you aren't back in Munich yet. In fact, everything is easy to bear if one doesn't have to account to others, one squares accounts with oneself and that's the end of it. And there are compensations for every unpleasantness—today I was allowed to go out from noon on; the weather was slightly misty, just the way I like the light to be, and I went down to the meadows by the river, toward Landweid, which had consoled me at Pentecost for what I have had to endure. In a very lonely spot I unpacked my watercolors and began to work. By evening I had completed five watercolors, among them three quite exceptional ones, which move even me. The last one, painted in the evening, completely captured the tone of the miracles around me; at the same time it is thoroughly abstract and thoroughly this Lechau region.

In the end, my satisfaction was no worse than on furlough. A few pieces of bread, a package of cigars, and a pound of pears sustained my body.

The time is certainly not an easy one, but filled with revelations. Would my work shoot up as quickly in quiet, day-to-day existence, as in Anno 1916–17? A passionate movement toward transfiguration is no doubt partly the result of a great change in outward life.

I hope your journey will go off well and that you will find everything in order at home. I'll probably come next Saturday, but several days' furlough is incompatible with the state of work in the payroll department right now. Anyway, I'll talk it over with the paymaster, before the chief, First Lieutenant Paul Kremer, decides. My first impressions of the latter are favorable; I believe we were very lucky."

1083. 9.12. "My dearest Lily, I assume you are leaving for Wiessee today, so I am writing you there to tell you that I received your last postcard from Bern and that it has been definitely settled that I meet you in Munich. If I should be prevented from coming, I'll wire you. Love to both of you."

9.18. Arrived safely in Gersthofen. I was glad that I took the earlier train, the long walk out to the camp gave me trouble yesterday because I was indisposed. Today I feel better. The paymaster has gone to Camp Lerchfeld to watch the finance inspection there. I get down to work only very gradually, although there is plenty of it. Sometimes you just don't feel up to it, especially when no superior is present. Magnificent warm weather cheered me up a bit. I got back at a quarter to twelve yesterday and slept well. It was fine, those two days at home; I got some order into my affairs again.

1084. 9.24. Yesterday was a mediocre Sunday. On duty only in the afternoon. I painted at the office, which isn't as fine as out in the open where the scenery stimulates you to start with. Moreover, I was on the *qui vive* because I was substituting for Baumann as photographer and would have had to take the pictures in the event of a crash. This time I was content that nothing happened, no matter how much I am in favor of smashing everything to bits on Sundays. If the new system keeps up, I ought to be back here next Sunday, since my day of leave falls on Tuesday. There will be enough business to be settled to require a leave. The only unpleasant thing is having to report—this is still humiliating.

EMBRYONIC ELEMENTS OF ABSTRACTION,
1917, 119

1085. 10.4. Arrived safely and in time. Found a great deal of work, before inspection. Wildermann wrote that he had mentioned my case in the right quarters (the man in question is a favorite of Stempel, commander of Schleiss-heim—Hans Wildermann, the stage designer, who wanted to intervene to solve my furlough troubles), and that he had been led to expect a favorable issue. It was the work on Sunday that caused these difficulties. We'll see.

10.8. Arrived all right, walked the last third of the way in storm and rain; it was good that I had taken along my overcoat.

1086. 10.8. Today's weather has made me pleasantly tired. Let's hope that some art will come of this; this has often been the case. We are still resting on our laurels after the finance inspection. The office is well heated, very quiet; in fact, the paymaster just returned during the afternoon, through wind and storm, as I did yesterday.

There is always something spiritual about the approach of winter. You retire into your innermost chambers and camp near the small glow you find there. The last reserve of warmth, a small part of the eternal fire. A grain of it suffices for a human life.

1087. 10.10. The storm outside has calmed down; but today we had rainy weather for sure; I'm thinking of working again. In addition, I'm reading Steiner's book. If only he had said it all more briefly! In ten pages. People who write full-length books are becoming more and more mysterious to me. A certain patch of fog that some people harbor in their spirit is probably made to take form; many variations, and even complete works, may be evolved from it.

10.12. All is "well" with me. The rain doesn't reach me, my room is well heated, what more can one ask for? There's no shortage of work, either—on the contrary.

1088. 10.14. This time the trip to Munich fell through. There was too much work for that this morning. This afternoon I could manage to be free, but it's too wet outside to paint. And so I sit in the office and work for myself. Of course, the good, outdoor mood is lacking, as well as the unconscious stimulation that natural colors give.

Theosophy? What makes me particularly suspicious is the description of the visions of color. Even if no fraud is involved, one is self-deceived. The coloration is unsatisfactory, and the allusions to formal composition are downright comical. The numbers are impossible. The simplest equation has more meaning. The psychological aspect of the "schooling" is suspicious too. The instrument is suggestion. But truth does not require a lack of resistance in order to impose itself. Naturally I read only part of the book, because its commonplaces soon made it unpalatable to me.

DRAWING WITH THE FERMATA, 1918, 209

Next door to me is an officer who has been confined to his room for five days because of some affair of honor. He is tortured horribly by boredom. Talks to one and all from the window. Yesterday he shouted through the wall to the doctor who was in our room: "Doctor, I am ill, but you can't help me." "What ails you?" "My noodle; the son of a bitch has locked me up for five days!" At the moment he amuses himself by teasing one of our watchdogs. This makes a terrible racket!

1089. 10.22. Arrived safely here, was glad I took the next to last train. Found much work waiting for me. Paymaster away on a trip. "It must be done and shall be done. We'll manage it."

10.24. Just enough work. The doctor went on leave yesterday, amid much fussing and protracted preparations. I hurry so as to have some free time, since the office is now very peaceful and makes a good studio in the evening.

10.26. I again work more in black and white than in color. Color seems to be a little exhausted just now; new reserves have to accumulate. If it weren't for the duties, this might be a good time to push my plastic experiments further. This is probably the only damage inflicted on me by the war. For whether I'll catch up on it later is questionable; perhaps I shall then stand at a point outside of this domain.

1090. 10.27. No miracle occurred. As the only one present, I had to be on duty and shall have to be on duty again tomorrow morning, since there will be flying. Otherwise I might at least lock the office. Perhaps the weather will be favorable in the afternoon and I'll be able to pay a last visit to the meadows along the Lech, which have become so dear to me, before the end of autumn. I worked yesterday and today as if I were at home; the only difference being that I work in my drawer, which protects me against surprises.

It was a black day for the flying school; in the morning one cadet crashed and broke a number of bones; in the afternoon a lieutenant crashed to his death from a considerable height. *Guten Appetit* for tomorrow's Sunday flying. To be sure, I sit here safe and warm and feel no war within me. The battle of Isonzo, which is becoming a disaster for the Italians, is, moreover, only being fought there so we can return home a bit sooner.

Tagore is not very heavy reading. I prefer to read the excellent futuristic

lansquenet's song about the battle of Pavia or some other good work about this area. I wonder whether civilians can still travel unhampered or whether they need a pass? This is also very important.

1091. 10.29. Went for a walk in the afternoon. It was impossible to paint outdoors; the weather was too cold. I request that my civilian clothes, complete with summer coat, collar, necktie, sleeve buttons, hat, and shoes, be sent at once to Herr Ludwig Ost, Hotel, Augsburg, Ulmer Strasse, on account of the orders forbidding soldiers on leave to use the railroads.

1092. 11.15. Time races on, and I am aghast to see the scanty information I give about myself. This comes from the fact that I am really working all the time. The news that Hausenstein is critic and editor of the art section of the *Münchner Neueste Nachrichten*—a miracle! Dr. Probst writes me a long business letter. Campendonc writes me a very friendly letter! I had felt the premonitory urge to write him.

1093. 11.26. Arrived safely; the night was very clear, and the inner life wasn't able, therefore, to assert itself very much during the long walk. (The professional artist was keeping his eye peeled.) Also, I was still thinking vividly about the perfectly exquisite potato dumplings I had enjoyed. So not a trace of the spirit.

Today a private in the engineer corps brought me a fine sausage for one mark and sixty pfennigs, which I accepted with joy. I had warned him that one of the sergeants was plotting a blow against "personal" uniform coats, and caused him to use the opportunity on Saturday of taking his property home, where it would be safe. The carpenters solved this problem in an expert manner by making a secret table drawer. Secret, because no table in the entire group of barracks has a drawer.

1094. 11.28. Here life goes on as usual from day to day. Quieter this week, as always after the 20th. On December 1st, the rush will start anew.

The new circle is called the "Dresden Association," in Hanover it calls itself the "Kestner Association," in Frankfurt, the "New Association," in Munich, "The Empire." Everywhere, the same mushrooms of the modern

shoot up. Let's suppose that a real basis exists for this. In any event, what happens is the opposite of what Germany's obscurantists [Dunkelmänner] expected from the war. Just as the perspicacious Kandinsky had predicted at the time in Rorschach. I derive one satisfaction, at any rate, from it: complete financial independence. Not that all obstacles will now disappear. As a matter of fact, the spirit needs them!

1095. 12.3. Arrived all right, but didn't check in on time, because the 8:15 train has been dropped and the 9:15 only arrived at 10:45. By exerting myself to the fullest, I managed to get into the inn, which Ost had just closed, to change clothes in a flash, and then to put on my seven-league boots and check in at 12:25. The man on guard, a surly noncom, completely unknown to me, wrote a report on my lateness . . . In the morning I talked to the sergeant's right-hand man, urging him to suppress the report. As of this evening, I haven't yet been ordered to report to my company commander, so the matter seems to have been settled. It's sad but I'll have to take the 5:45 local train in Munich. All in all, a nerve-tickling little adventure.

1096. 12.5. Last night, singing rehearsal at the home of the head teacher of Stettenhofen for the school's Christmas celebration. The quartermaster, a figure straight out of an operetta, is in charge of the affair. It wasn't beautiful, but that doesn't matter; what counts is service rendered, which will be rewarded with a leave. After the rehearsal we went to the tavern by the lower bridge on the Lech, where we ate good sweet and sour liver. It was a cold winter night.

Next time I must take along a quilt. My lateness in checking-in caused no trouble. The man on guard had to make an entry to the effect that he had made a mistake. I enjoy some respect here, after all.

1097. 12.12. As of January 1, 1918, I am on record at Headquarters as eligible to become paymaster. The medical officer had to give a certificate. I am good for service in the field on the basis of L 1. It usually takes a year before this goes into effect. Between now and then a lot of things will happen.

12.13. The graphics exhibition of the *Neue Sezession* comes at the right moment, because it will enable them to ask for a furlough for me.

BIRDPLANES, 1918, 210

12.14. I took along the blanket yesterday, thank God!

12.21. If I had fewer duties, I would have got two weeks without trouble. The chief was all for it.

GERSTHOFEN 1918

1098. 1.3. Arrived safely. The train left Munich an hour late and did not arrive in Augsburg until nine o'clock. A few passengers left the train in desperation; as a result, I was able to sit down. Sitting, you can take a lot more; besides, you can nap. Augsburg quite pretty and friendly. A fine dish of lung and potatoes at Ost's did its share. On my way, had a sense of total contentment about the past ten beautiful days.

Outside of Augsburg some more serious thoughts came to me, evoked by the horrible snowy wastes and the chaotic darkness. This mood became even more marked in the countryside as time passed, and *Kyrie eleison* became my dominant theme. The village of Gersthofen brought a measure of relief for a quarter of an hour; then a fierce snowstorm started. The crucifix stood on my right, black and forbidding. At camp I threw myself on the straw pallet without a word, realizing that I would be faced with a heavily loaded desk tomorrow.

I have still not reached the point of loving England our enemy and of including it in my prayers. Perhaps I'll find peace once I have learned to do so.

1099. 1.10. Since yesterday we've been completely snowed under, and mail connections have been severed. Also, we moved to a barracks with a larger room, but far less comfortable.

1.12. The storm played the most fantastic tricks on the camp. The barracks have become partly invisible. The snow was blown against one side and started accumulating again on the other side. Besides, the moving.

Now we are settled again.

Carpenters, plumbers, electricians, and whatever the whole crew of them is called, climb about on our heads. And we work without a doctor and without

auxiliary help. Masses of snow have cut us off. Trains filled with mail stand frozen on their tracks. No sign of newspapers. Peace might have been declared and we wouldn't know about it.

1100. 1.14. The mails are moving again. It's no use guessing about whether we'll have peace. No one knows anything. But it is coming to that point with Russia, because both parties need it. What kind of a peace will it be, we don't care, since we don't play the game of politics.

Our absence from home: a stanza in the epic. Later, we'll smile softly about it, as we smile now about sufferings in the past. Art looks beyond these things.

1.17. A cheerful message from Däubler; I'll be glad to collaborate on a book with him. On Saturday I shall be in Munich.

1.21. Got in without a hitch. The small company of visitors that I found at home had a fairy-tale effect on me. The jump from the dirty barracks to an attractive little circle. Däubler's *Sickle* I had already read on the train; it's a delightful provincial epic.

1.22. The paymaster was gone for two days; this enabled me to do quite a few things of my own. Unfortunately I didn't feel in a very creative mood. Besides Däubler, I read marvelous Chinese stories, which are profoundly stirring. Then I started Flaubert's *Tentation de Saint Antoine*. Somewhat too much on Ahriman's side. No simultaneity of good and evil.

My main desire is for apples.

1101. 1.27. His Majesty's birthday reminds me of the hours spent together in Augsburg a year ago. I hope I'll be able to sneak to Munich next Saturday. This time there is too much work to be done.

I am now doing the job of a real paymaster. The doctor has taken over the clothing department; I am mostly concerned with taking care of reports and balancing the account books. Now I must try to remain quietly in this desert for another quarter of a year or so, until I have learned enough to risk a transfer. Then I ought to go after something that might resemble an improvement. Fate has revealed now what its plans for me are. The specter of the trenches doesn't have to be feared anymore. Paymaster or quartermaster.

The *Tentation de Saint Antoine* doesn't altogether please me. What do I care about *that* hell now?

1102. 1.28. The head doctor is reading Hausenstein's book: *Die bildende Kunst der Gegenwart* ("Contemporary Painting.")

Yesterday afternoon I took a nice walk. The scene was drenched in a sulphur yellow, only the water was a turquoise blue—blue to deepest ultramarine. The sap colors the meadows in yellow, carmine, and violet. I walked about in the river bed, and since I was wearing boots, I was able to wade through the water in many places. I found the most beautiful polished stones. I took along a few washed-out tiles. It is just a short step from this to plastic form.

Suddenly I was surprised by extremely dense fog and I hastened back in the direction of the air base, since I am not well acquainted with this region even in clear daylight. I took a familiar path; and soon got into the vicinity of Langweid and strolled on toward the left, below the highway to Stettenhofen, where the fog grew lighter; the Lech was at some distance. The soil's tender, warm tones came through. I went to the old familiar inn and had two helpings of *hors d'oeuvres* and immediately felt quite warm again.

1103. 1.31. Got leave to go to Augsburg. I hope the switch to civilian clothes will work again. We are threatened with a change of commander, just at the time when we had come to know each other a bit. Kremer was suddenly summoned to the front by telegram.

In the office a Lieutenant Oesterreicher, whom I have liked for some time, approached me. Wanted to see something I had done, but I could only show him the "Nightingales" in the art magazine. He was rather baffled, begged me for explanations. When we began to speak about ways of looking at the world, he showed himself to be quite a well-informed person. He then steered the conversation toward religious problems and toward the war, looked at in a metaphysical way, as the breakdown of Europe. Quite surprising on the part of a flier and technical officer.

1104. January–February. In the State Gallery, a first glance at things that were already there in the year 1906. My pleasure verges on irony.

Owing to the absence of the paymaster, whose wife is critically ill, I am the uncontested master of the office every evening, which allows me to work there at my ease. Everything vanishes around me, and works are born as if out

of the void. Ripe, graphic fruits fall off. My hand has become the obedient instrument of a remote will. I must have friends there, bright ones, and also dark ones. But I find them all very "generous."

1105. 2.4. Everything went off smoothly, the whole adventurous masquerade. Then I again put on my ragged field-gray disguise, which makes me look so ridiculous, and the long, long carnival was in motion again. The weather was enormously foggy, but I didn't want to have anything to do with ghosts. The fireworks of the will o' the wisps were to be seen again, but I fought off any emotional crescendo. The chapel stations along the way and various crosses weren't weird at all, nothing sensational, as they say in carnival talk. My brief role as a guest at home was the only one I really enjoyed.

2.7. Next Sunday, no leave. The paymaster goes to visit his wife. Someone has to protect the funds.

2.13. Last Sunday I painted energetically and again created something worthwhile. The spring outside reawakens my inner color sense. Soft tones become firmer.

2.19. Short leaves are good, longer ones are poison. The night was slightly warmer, a giant halo surrounded the moon, so large that you forgot what it belonged to. Yes, you get to know the night, when you are constantly locked up during the day. It was beautiful, but I had too much of Rudolf Steiner. I remain alone, a spiritual bachelor. Münter might tell us where Kandinsky is? The devil knows all the things that may yet happen in Russia!

1106. 2.21. Yesterday the golden wedding anniversary of Their Majesties, we were on duty, with the usual crash. Tonight the entire camp is without light. Went to bed with the chickens. Nothing more consoling in sight.

2.21. This week we had three fatal casualties; one man was smashed by the propeller, the other two crashed from the air! Yesterday, a fourth came ploughing with a loud bang into the roof of the workshop. Had been flying too low, caught on a telephone pole, bounced on the roof of the factory, turned a somersault, and collapsed upside down in a heap of wreckage. People came running from all sides; in a second the roof was black with mechanics in working clothes. Stretchers, ladders. The photographer. A human being pulled out of the debris and carried away unconscious. Loud cursing at the by-

standers. First-rate movie effect. This is how a royal regiment celebrated a golden wedding. In addition, three smashed airplanes are lying about in the vicinity today. It was a fine show.

1107. 2.25. Another Sunday in camp! Paymaster suddenly forced to go on leave. I worked a lot, at least. Painted and drew and ended by forgetting completely where I was. In amazement, I caught sight of the horrible warrior's boots on my feet.

Had a good trip yesterday; in Augsburg, changed over to the train to Donauwörth and got off in Gablingen. Then, in a quarter of an hour, made the pilgrimage to the Stettenhofen Inn to eat pancakes. Then back to the camp in twenty minutes—which wound up the whole marching performance. Found a card from Mama waiting for me. In faultless handwriting, she describes her "cerebral attack."

1108. 3.9. Fritz Lotmar came to visit me in Augsburg, and we had a happy reunion at the railroad station. First we went to Ost's, where I changed clothes so as to feel more at ease. Then we strolled through the old town, to the cathedral, etc. Then we drank coffee at the Königsbau. Finally had veal collops at Ost's.

Things were quite amusing, at first. I was a private and he a doctor with the rank of captain. At first I slipped up quite a bit. The situation was new to me. How was I to greet him? Thank him? Then too, he is accustomed to walk on my left. It was also comical that this suddenly just didn't go any more. In short, it was high time for me to change clothes; from then on, it was like old times. There was one other incident; I saluted a major, my hand up against my black felt hat, my eyes turned left. Five minutes before leaving camp to meet Lotmar, a letter came from my sister with a precise description of the episode of my mother's illness. I was then able to discuss it with Fritz.

1109. 3.19. At the station in Augsburg I bought the newspaper and came upon Hausenstein's review of the graphic section of the *Neue Sezession*. The miracle of someone appreciating my work has taken place.

It was nice in Munich. But the scrambled eggs at Ost's weren't bad either.

DEPARTURE, 1918, 207

1110. 3.20. After the paymaster had been forced to go to Munich again at the request of his family, his wife's condition being anything but stable, I had to take his place and will naturally remain on duty until he returns. This makes my next leave doubtful. Perhaps one of the coming weekdays instead of Sunday. This time I have also taken over the responsibility for the funds and have to spend the night in the adjoining room.

1111. 3.20. Made a private first-class. Went to ask for leave today; am hoping for four days; in any case, I'll be in Munich on Saturday evening, perhaps even earlier. I couldn't make it sooner, because I was acting as deputy paymaster until last night. If you leave earlier, you have to be back earlier.

3.21. Inspection again today. Result: continuing fitness for auxiliary service. I have climbed the first step toward the rank of general. Unfortunately my chief received bad news again, and I have a great deal of work, and especially matters that I haven't mastered completely.

3.26. I now have a good opportunity in the evenings to work on one or more important pieces. Easter leave and return of the chief, probably beginning tomorrow.

1112. 4.5. Today, once again lay in the sun on the airfield. I hope my family is having a nice vacation. But poor "Katzenfritzi," the cat, is to be pitied. At Richter's a new magazine is said to be mushrooming. On Däubler's recommendation, he asked me to contribute, and in flattering terms (as a sort of substitute for payment). At the same time enlargement of my exhibition there. (Possible pretext for a little furlough.)

4.8. Not a bad Sunday yesterday. In the morning I took care of personal correspondence.

In the afternoon I wandered around the beautiful country near the Lech; in the evening I went to two inns hunting for food. On Sundays and holidays the so-called evening meal is distributed at noon and eaten right away as dessert. As a result, you have to run around for food in the evening.

1113. 4.11. Received leave for Sunday and Monday. Today and tomorrow I am replacing my chief who has gone to settle the affairs of his deceased wife. I hope he will be back on Friday evening. As boss of the entire business, I'm

able to do more of my own work, but I have to accomplish a great deal more while on duty in order to get away.

Rain at last, it feels good. Not good news for our offensive, though. All is fate.

1114. 4.17. Tonight I am definitely starting on the drawing for Däubler. It has to be done, even though it may cost me many a bitter tear, as always when I can't abandon myself freely to my own fancy.

Engert wants to get some of my graphic work into the State Collection. Prices: one hundred marks for drawings; for etchings (all of these would then be returned to me), forty marks, with the exception of "Virgin in the Tree," which is priced at fifty to sixty marks.

1115. 4.20. A great deal of work, but I am gradually getting the hang of it. In between, many gay moments, while others are getting fearfully excited, and for what? So long as the physical self keeps its head more or less above the water, nothing, after all, can really happen. My psyche belongs entirely to me and no one is capable of taking part of it away.

I think I'll be going on Saturday. I tried a new method, because I don't want to keep putting in formal requests for those twenty-four hours and make myself conspicuous by showing up so regularly. I have the paymaster sign a slip stating that my services aren't needed. This slip I take to the sergeant. The latter orders furlough papers to be made out, which my chief then signs without looking at them. If it succeeds, I'll be proud of my clever invention.

1116. 4.21. The weather lately makes me sad. Add to this the painful progress of the offensive in the West, on the success of which so much depends.

Oh, that one had become no more than a man—half lowly servant and only half god! A richly tragic, a profound destiny. May its full content take form some day and lie open before me like a document. Then I shall be able to face the black-empty moment calmly.

Outwardly, this is what happened: worked through a report and balanced the cashbook. We ate too much bread. That is all.

1117. 4.29. Arrived safely, managed to grab the last seat. Near Nannhofen we passed through a magnificent hailstorm. I traveled on to Gablingen, ate a modest meal there, and slept without a dream until seven in the morning.

1118. 5.1. The finance inspection is over, it was quite amusing. All sorts of things again happened to the doctor, who is in charge of the account books.

I did very little of my own work. The sultry weather is tiring and office hours long enough.

The two drawings for Richter's review have arrived safely there. If only they can be reproduced well.

5.5. Arrived safely. It was hot in the train, but I was able to sit down. Another Sunday is over, this time more relaxing, because there was less work to do.

1119. 5.6. I will turn in a leave slip saying "Agreed: Paymaster Renner" for Sunday and Monday. A woman from the auxiliary service may be there on Monday to decorate the office. The doctor, who isn't in my wife's good graces just now, left today for eight days with the usual to-do. It's questionable whether I'll be able to make it to Munich; it is more likely that I'll get leave to go to Augsburg. I shall then travel to Munich more riskily in civilian clothes. If it is to go wrong, it will go wrong, that's all there is to it. On Monday I'll try to catch the afternoon train. In case it's too crowded, I shall certainly make it with the following train. A pretty picture, should no one turn up on Tuesday! . . . But let's be brave and try it!!

5.7. Splendid weather these days cheers me up, as much as this is possible. Under my very eyes, people are plowing all day long, and from my desk I can see the most beautiful scenes of nature. Moreover, all the apple trees are beginning to bloom. Spring again, the second out here! And another? . . . one day it will all have to end, after all, whether they want it or not. The phonograph is plaguing the barracks again. Poisoned sausages are of no avail: it won't eat them.

1120. 5.21. Everything seems to have come off well. The eight o'clock train didn't run, but I simply took the 9:20 local, since I didn't have to be back

at an appointed time. Got leave in the guise of an official trip to Schleissheim. I was back at 11.30 p.m., slept very well after the long walk through the moonlit night. Had a look at the cashier's office before going to sleep, found some harsh comments about my work.

Kubin wrote with great warmth and kindness; Walden sold three watercolors: "Constellation over the City" for three hundred marks, "Composition with Four Cupolas," two hundred and fifty marks, and "The Temple of the Sect of the Green Crescent," three hundred marks.

5.23. "My dear Felix, I thank you for your short greeting of today, which, to my surprise, really arrived. How are you? It is probably too hot for you? For me, it is just right, since I am a man of the South in some ways. I remember fondly the days in Munich and the brisk walk with you to Schleissheim. Yours, Papa."

1121. 5.27. Arrived safely. At first it seemed as if I would have to stand, but I eventually found a seat. The walk was quite pleasant, a sociable man kept me company.

5.28. Received the report of the two sergeants, went quickly through it, up to May 17th. Feel as if I had no brain left. This is now a kind of battalion report. Each sergeant is supposed to keep his company report. But since none of them are capable of it, it turns out that I am writing three reports.

In the evening I stretched out on the airfield with my Goethe. The episode with the Baron and Hilarion reads very well. An artistic bit, brought off with the aid of the German language. Of course it isn't music. The words are really at quite a remove from the essential mystery; tone and color in themselves *are* the mystery. What a fascinating fate it is to master painting today (as it once was to master music).

While I am thinking about this, the phonograph grinds tirelessly. Heads grin around it, devilish masks peer in through the window. The beasts are enjoying themselves. There must be some reason for the fact that there is always a piece of hell near me. This one is at least quite mild. Only a reflection of the real one.

5.30. This afternoon I again lay in the green thickets for a few hours, all by myself. I may have made some progress by doing so.

1122. 6.3. Arrived safely, found a second-class seat at the last moment.

Die Zeitschrift 1918, published by Richter, has come. The reproductions are good facsimiles. The rest of the makeup tends to show the influence of the war. Däubler's essay is short; he tries to build on my musicality and also spreads my international fame as a violin virtuoso. Engagements by leading concert societies will follow shortly. But I shall cable back: prevented by field-gray.

6.4. Discussed my furlough. Ten consecutive days are impossible around the middle of the month. I think it will be four days first, the rest at the end of the month. I hope to hear and to play music then. But not with Kristeller, time being so brief! They gorge themselves on Brahms; only what grips the entrails is worthwhile in my estimation. There should be magnificent ancient things, folk music, dances, troubadour songs. Or, if only I might hear again the wonderful duo of the two Tunisian beggars in the quiet, white alley at noon, in front of the locked door! Where the one answered the other and the voices joined for a few measures, and at the end, fell away together in such a peculiar, surprising fashion. And right afterward, the door opened slightly, one surmised a figure there and saw a delicate hand holding out a few coins.

1123. 6.6. I am getting a head start on the accounts, so that I may leave later with a good conscience. I believe it will be on the evening of the 11th. If I have my way—and will power does a great deal—I shall probably be able to count on a week. I shall of course be here next Sunday, in that case.

6.8. Now I am convinced that I will finish in time!

1124. 6.28. Two days have already passed again. This is the main thing: that as many days as possible go down as quickly as possible. There are little pleasures, too. Being in a good mood, I painted a few watercolors in red yesterday, and also read two beautiful pieces from the *Wanderjahre*. . . . Not too much work at present. My leave has had the good after-effect of filling me with art. My awareness has again deepened by repeatedly playing Bach. Never yet have I experienced Bach with such intensity, never yet felt so at one with him. What concentration, what a solitary peak of achievement!

LOST IN THOUGHT (SELF-PORTRAIT), 1919, 113

1125. 7.3. The time passes easily, that's the main thing. Currently our work has reached the high-pressure point. On Monday I was a bit afraid that the paymaster had become ill. For he withdrew in the middle of pay-day, and I had to pay all the officers. But it was only the aftermath of a Sunday excursion. The fat Schurz, Sergeant Schmidt, the paymaster, and Siegling, the company clerk, had gone on an outing with our two auxiliary ladies. After the ladies had not enjoyed themselves very much, the four men set out alone. Schurz has to stay in bed for two days, the paymaster fell from his bicycle, only the two others got off without injuries. There was a sarcastic poem on the paymaster's desk today.

It has just stopped raining. The storm on the wheat fields was captivating; I'll paint a ship sailing on waves of rye. Now it has cleared up, but everything is heavily varnished.

The larks have become silent; here and there swallows glide swiftly like shadows over the ground.

1126. 7.8. Had a very good trip and got out in Augsburg as early as ten o'clock. The train was not as crowded as usual, because an extra train had preceded it. But one can never rely on that.

7.18. "My beloved Lily, I'm glad that you have decided to take the trip to Ried; I hope you will have a beautiful, refreshing stay! At what time, on Saturday, do you think your train will get to Munich? My leave has already been granted, namely from Saturday noon until Tuesday at midnight. And then Fritzi and I shall be lonely for a long time! (My family's journey to Bern.) You will suffer least from it, but the cat's heart will break! In the meantime everything passes, even world wars. Many greetings, also to Frau Marc! Yours, Paul."

7.24. The train arrived slightly late. The ride in the express train was very exciting; gray steam all around, a satanic speed in places, rifts in the sky, everything torn to rags. Afterward, when you are forced to walk, you imagine yourself incapable of ever reaching the goal, until the familiar inner life nimbly awakens and time and place are degraded to unconscious mechanisms. Now and then, someone chummily addressed me with *du*; it was very sultry.

1126a. 7.25. "I might tell you, to ease your mind, that I have to remain here on Sunday. Paymaster gone for three days, I substitute for him. So you are hoping to leave for Switzerland tomorrow; I hope everything will go well. I plan to use my free time to paint. Maybe I'll set up my tent out in the bushes, use it as a fine outdoor studio, and borrow some spicy saps from 'nature.'

It was fine that my last leave worked out at the right time so well and that the change-over next Sunday won't hit me so hard, since you will be away. The lonesome time will pass too, like all time. Right now it seems easy to me, but it has only been a few days.

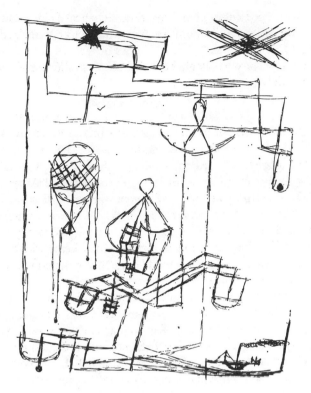

TRAVEL PICTURE, 1919, 132

Well, have a good vacation and enjoy the relief of being on neutral soil."

7.28. Today we had a real rainy Sunday, which completely tied me to my room. I was able to complete a whole series of works begun earlier, so that another ten or so new works are ready to be mounted, among them a few inspired by Däubler's *Sickle*.

8.1. "You've been in Switzerland now nearly eight days, without any news whatsoever reaching me. Otherwise I am well; I hope to be in Munich on Saturday evening, perhaps to find some news there, mount my watercolors, and so on. I'll bring along one or more roosters. Today I bartered some cigarettes for a couple of fried eggs."

8.3. "Yesterday, at last, the first postcard from Rorschach arrived, etc."

8.5. "Returning to camp today, at the end of my Sunday leave, the first two cards from Bern were lying on my desk. Of course, you have had no news of me either.

I had a good Sunday. The evening before, Fritzi was missing. I found the tomatoes, all in good condition except one. Many thanks for your parting words. And yes, a cucumber looked at me, fresh and gay. After a while I saw a light downstairs and went to bring Fritzi up.

Since there was a great deal to eat (new potatoes, tomatoes, cucumbers, two roosters), I asked Madeleine to have lunch with me. She arrived punctually at one o'clock 'in the brown silk dress' and lavished praise on my vegetarian chicken as well as on the rest. Finally, hunted for coffee, but only found some malt and half a quart of milk. Fritzi bravely took part in the festivities and, immediately after, lay down on the bed. He had spent the night on me.

In the morning I mounted watercolors. In the afternoon, I finished painting a few things. In the evening I ate cold leftovers. And last of all, I was in a great hurry. I was at the station at twenty to nine and was soon racing at top speed through the dusky countryside, unless it was speeding by me. And now you know exactly what took place, etc.!"

8.7. More things have been sold at Richter's—two hundred and twenty-five marks net. Walden wants fifty prints from an engraving for the *de luxe* edition of his *Kunstwende*. If he is willing to pay, I'll give him "The Garden of Agony." The lithograph for the Sezession is also becoming urgent. What I need is another eight days off!

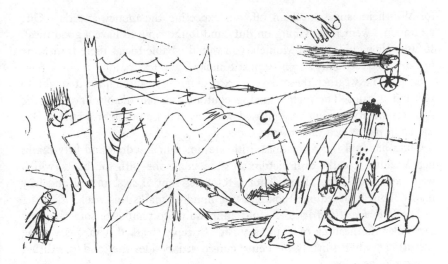

TWO TIMES FOURTEEN, 1918, 49

8.11. Sunday leave in Munich, alone.

8.12. Received the entire printing of "Little World" (for Westheim) to be signed. Beautiful, in some ways gorgeous, Japan paper!

8.19. Yesterday I was in Munich, worked on a watercolor that I had started the evening before. Found everything in order at home. Fritzi very fat and debauched. Madeleine brought him up around 11 p.m., with all his belongings. Hausenstein's essay, no matter how flattering to me, has aroused me to opposition, and I painted a severely organic piece called "The Dream" on coarse linen paper with a plaster base. At once put a white frame around it and hung it. Was still preoccupied with it all the way back to camp.

I am expecting to have a few good days; of course, I'll have to remain here next Sunday, in view of the chief's intention to go on furlough, but this will enable me to do my own work every evening in his room without being disturbed.

8.21. "Earned a few hundred marks, thanks to Goltz. Signed the engravings

for Westheim and sent them off, am expecting the money any day. One afternoon I went to Augsburg on duty and found time to have a good meal. If Ost only had his inn in Munich, you would be able to eat there from time to time. Will certainly stay here next Sunday."

8.24. "The weather these days is exceedingly hot and sultry; it ought to rain but it can't. The nights, on the contrary, are remarkably fine, just the right temperature. I am very pleased with my handsome night quarters. But the lamp by my bed didn't work today.

Goltz has sold the 'Christmas Still-Life' for four hundred and fifty marks net; Walden sold the oval picture and the small one with the boats, which were exhibited at the "Reich," for a total net sum of six hundred and fifty marks. Thus I earned one thousand one hundred marks this week.

The *Leipziger Illustrierte*, the old aunt, wants to reproduce something by me under the heading of Expressionism. In reply, I asked who was writing the article, what artists were being considered besides me, and whether I would receive a fee.

I believe we can face the future now with confidence. And we'll hire a maid too and pay fitting wages.

If only the country's chances were as good as mine!

The *Kunstblatt* brought out a Swiss issue. Not a word in it about me, although people like Neitzel and Dr. Entente, who were to be seen from time to time at Genin's, have contributed.

But this accords with what I've always sought: not to be a local man.

Enjoy yourselves. Think of me when you eat chocolate and risotto."

8.29. The *Illustrierte Zeitung* will get a contribution from me—Westheim is writing the article.

I am expecting my office chief to be back tomorrow and I hope to go to Munich again on Saturday. A roasted rooster flew in from Munich; this I made into a very stimulating meal, and out of *that*, a very colorful watercolor, between ten and twelve at night.

9.4. "I received an invitation from my *Gymnasium* class to come to a reunion of the class of 1898, one day in September. I'll probably have to beg to be excused on the grounds that I am still suffering a bit from the great European sickness. Let them wait another five years, and perhaps it will be possible again.

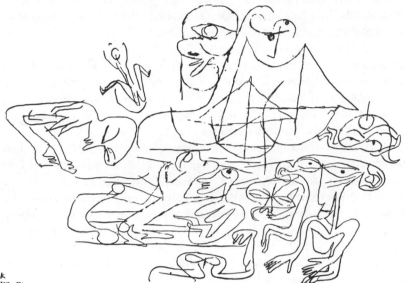

k
148 189

THE UNREDEEMED, 1918, 189

I'm delighted that you will be returning on September 14th, but I won't be able to get a lengthier furlough for a week, because of current bookkeeping operations there is no permission before the 18th."

1127. 9.19. The paymaster is sick in bed. The medical officer should have him taken to the hospital; but, out of consideration for the service and for me, he is waiting a while to see how it will develop. Subjectively, he isn't feeling too bad; objectively, he is all turmoil with dysentery. So farewell, furlough! I was never more chained up!

Somber mood and much work! Nothing is quite in order. Everywhere there are tiny inconsistencies. When I don't see the error right away, I let it go. One questions the chief as little as possible.

Now the other doctor is coming too, secretly, and prescribes the usual minuscule homeopathic doses. He takes both remedies. Comedy, as everywhere else.

Into this situation a publication of Walden's, *Die Kunstwende*, drops out of the blue. To a large extent this is warmed-over stuff, both the pictures and the text. The museum edition is to include an original engraving by me, "The Garden of Agony." I have long since ordered a printing of fifty copies of it from Wetterroth, but he takes an awful time for this small edition.

The first draft of my essay for Edschmidt is already finished. Now I shall have to reconsider and bring order into the thoughts I have jotted down. Some things strike me as repetitions of a thought in a different form.

9.23. The brief interruption in Munich did me good. Sundays here in camp can be so dreary! Especially when you don't have your painting kit handy! The chief is getting up again.

Tonight, no electric light. To bed with the chickens! Mannheim wants to exhibit the puppets. Declined.

9.24. The paymaster gets up from time to time and is beginning to work, thank God. Everything ended relatively well, except for the furlough, which fell through! In the *Kunstwende* yearbook, the excellent essay by Kandinsky ranks high above everything else, with its combination of simplicity and intelligence. Perfectly designed to persuade, sheerest clarity. And people are screaming for clarification! A phrase like "the work of art becomes the subject" says it all. And the whole course of the argument is so gentle and calm.

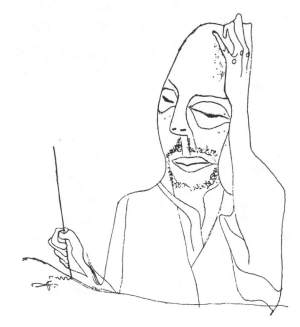

PICTURE OF THE ARTIST (SELF-PORTRAIT), 1919, 260

Perhaps I'll soon manage to have a room for myself, even when I am not on duty, where I can spend my free time without disturbance. The barracks are gradually being occupied.

9.26. As keeper of the cash-box, I have to live next to it. Very favorable to off-duty activity! I am moving out of my drawer!

1128. 10.2. The time is strange, one doesn't like to speak of it. There are days when the craziest things happen, and one has "nothing to report." The main thing now is that I have my own room. No check, no turning off the light! No routing-out of bed, nothing military, except the noble costume. The paymaster has lunch with me at a separate table. We have a tablecloth,

even though it isn't clean. The doctor and the ladies eat in the office next door.

I have a lot of space and a fine big wardrobe all to myself.

So, all ready for work! The shining light of a hundred candles!

Come, holy spirit!

The war happenings are all too worldly! One thinks about the Bulgarians, who hold the war's issue in their hands, and whether the Turks will now be smashed? Will the Western front soon fall back to the Rhine?

Then we shall go home, a theme worthy of a hymn! But now total collapse must actually occur. No one must be allowed to recover. The psychological moment has come.

1129. Had a good trip, found a seat at the last minute. The trip and the walk seemed very short to me; I must have been busy thinking. Actually I slept on the train, and heard a couple of Austrians, as if from far off, telling of dreamlike things on the Italian front, as in my dream.

10.27. Arrived safely by the local train. In Augsburg I felt tired and was loaded down with baggage, so I went to a hotel there. I asked to be awakened at 5:30, after six hours of sound sleep, and took the workers' train with its heavy air of sadness to the air field. I reached the camp at seven a.m., without complaints against me and well rested. Saturday passed, and today I spent my Sunday painting as I had wished, without interruption. Two or three more feeling pieces were, so to speak, completed, and I made preparations for a number of others in case I should be seized by another urge like this soon.

The paymaster is still here; he has heard no more about a change. But I don't altogether trust him. It's a good thing that I was just away, as all furloughs are canceled until November 4th.

I am enjoying the advantages of my new abode. Today at least the food wasn't bad, and tonight, instead of going out, I roasted some potatoes on the office stove. The whole set-up has something monastic about it, not to say hotel-like. At noon, as a break, I read passages of *Robinson Crusoe*; the book is most suitable in my circumstances. This fiction and my reality touch at many points.

1919 133

OPPRESSED LITTLE GENTLEMAN, 1919, 133

1130. 10.30. Austria and the Turks are acting as they should. I am filled with high spirits. I only hope the tension will end soon, because all this world history makes you too worldly.

I mounted my watercolors, six of them, right here, and in so doing used up my cardboard (and my official government paste).

Finished *Robinson*; it grows less inspired as the action rises. But still very good.

What a moment this is—the Reich stands all alone now, armed to the teeth and yet so hopeless! Will my hope also be shattered that inner dignity will be preserved and that the idea of destiny will keep the upper hand over common atheism? We would now have an opportunity to be an example of how a people should endure its downfall. But if the masses go into action, what then? Then the usual things will happen, blood will flow, and still worse, there will be trials! How banal!

At the moment everything still seems peaceful.

1131. 11.3. "My dear Felix, I thank you for the nice letter. Unfortunately I wasn't able to come this time, not even on the sly. All furloughs have been canceled, even to Augsburg. For how long, I don't know, and the reasons are never given, of course. Perhaps the grippe, perhaps travel is being restricted to prevent the revolutionary spirit from spreading. Now, one can no longer reckon in terms of business as usual. Besides, the old idea of martial glory will certainly come to an end soon, and anyone who has returned home safe may consider himself lucky. The paymaster's transfer too is beginning to look as if it's in earnest; only a replacement for him is lacking. Everything really cries out for the end.

On Friday afternoon I was again able to do well with my own work, and the result was two new watercolors. The essay about graphic art, which I am writing for a book, is likewise almost finished now. You can tell your Mama that Walden has sent to the bank the money for the works sold in the "Reich" and for the thirty engravings; and would she please pay the bill for the engravings as well as the previous bill for the frames right away, so that debts won't accumulate. I also wrote to the Verlag Müller (Curth Korinth, Potsdamer Platz), which asked me for illustrations. Love to you and to your mother, your Father.

BATHING LIFE, 1919, 28

P.S. Today, I am eating a chicken, which was meant for you; it is being roasted at the officers' mess by the chef of the Three Moors Hotel in Augsburg. So at least I have some consolation. I'll send some bread by mail."

11.5. Felix wrote another most historical letter filled with revolutionary spirit. I read it aloud in the cashier's office. The ban on furloughs seems to have been lifted. Therefore, Saturday! In the nick of time: no tobacco.

1132. 11.14. I had a definite attack of the grippe, had a fever, and coughed the day before yesterday. But a fancy-filled night cured me. It was too obvious that the illness wanted to break out but couldn't.

After the enormous confusion that went with the collapse, when nobody did anything but curse, our duties have resumed as usual. Various units from the front are announced, and also the entire Flying School 2, Speyerdorf (Pfalz). Flying squadrons from the front, Bogohls, etc. It will be quite a mess, but exciting.

11.19. Had a very good trip on the 7:45 express (morning), ate a big, warm breakfast in Augsburg, then calmly put on my disguise again and set out for the walk through the sunny countryside, which was covered with a light layer of snow. Here, brisk activity on account of the arriving flying divisions from the front. Hair-raising stories about the debâcle, out there. My little room now seems twice as peaceful in all this chaos.

The military commission is adding three marks a day to our pay. It is impossible to spend anything, so we become rich.

1133. 12.2. Had a good trip, ate a pig's knuckle at Riegele's. Then caught sight of the school truck and drove back on it. I shall be busy for a while with the work commissioned by the Müllerverlag. Request No. 1 (it won't be the last). New sections are sent back from the front; this creates a lot of trouble and much specific work for the paymasters. Strange paymasters come in and out, read the absurd new official lists, curse, borrow money from us, etc.

1134. 12.10. Arrived safely as usual, had the customary breakfast in Augsburg. Then I drove to Gersthofen on a horse cart and walked the last half hour to the air field. Continued reading Hoffmann. Duties now performed in a purely mechanical way. I won't be able to take it much longer. I could

KAISER WILHELM RAGING, 1920, 206

use a nice edition of *Des Knaben Wunderhorn*. In art, vision is not so essential as making visible.

12.12. Today I feel even less like working, if that's possible.

12.16. "My dearest Lily. Arrived safely; this time, walked all the way, but in this mild, clear weather it doesn't matter at all. Today I was shown an order from headquarters requesting that the payroll personnel be kept in the army for the time being. But that doesn't change my plans at all. I am acting on my inner urge; for now every man must ruthlessly take care of himself; I visualize with great interest the results of the paymaster's and my leaving here. The doctor will miss us. The auxiliary lasses will weep. But this time it will pay to obey my inner voice, I know it. After all, fate has delivered its verdict, and in the midst of this gigantic collapse, there is no sense in remaining loyal at one's little post. But I want to do this gracefully, and not just rudely run away. Modestly accept my Christmas furlough from the hands of the gentlemen on the commission and then . . . *à la* Leporello . . . Yours, Paul."

"The soldier of Bavarian Flying School 5 begs to be released as soon as possible from the army and to be replaced by a substitute paymaster. (Class of 1879). The said soldier would incur great damage by being retained any

longer in the army, owing to the fact that the employment which he is await-
ing as teacher at an art school in Berlin and as artistic adviser of a modern
theater in Munich could not materialize, in the event his military service
continues. In his position as head of a family, he feels it his duty to call the
attention of the military commission to these circumstances and to ask them
to solve this difficulty by replacing him, as soon as possible, by a substitute
paymaster. Private first-class Paul Klee."

In his fourth diary Paul Klee reports his military transport duty in the West. From time to time
in describing this undertaking, he refers to the same events in abridged form by quoting letters to
his wife. So as not to take the reader twice through an account that is in part similar in wording
and that deals with the same subject, the Publisher and Editor again agreed to preserve unity and
avoid duplication. The travel notes have therefore been condensed so as to give only the important
and essential parts.—Editor's note.

Genealogy

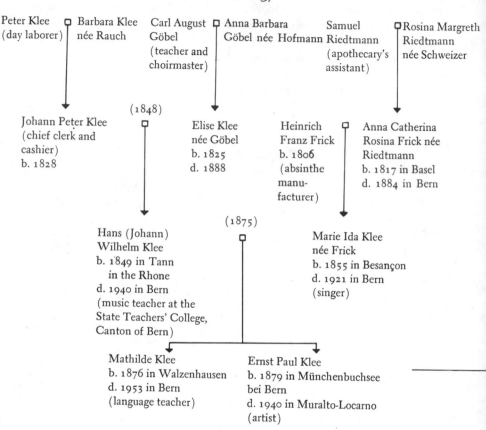

Peter Klee (day laborer) — Barbara Klee née Rauch

Carl August Göbel (teacher and choirmaster) — Anna Barbara Göbel née Hofmann

Samuel Riedtmann (apothecary's assistant) — Rosina Margreth Riedtmann née Schweizer

(1848)

Johann Peter Klee (chief clerk and cashier) b. 1828 — Elise Klee née Göbel b. 1825 d. 1888

Heinrich Franz Frick b. 1806 (absinthe manufacturer) — Anna Catherina Rosina Frick née Riedtmann b. 1817 in Basel d. 1884 in Bern

(1875)

Hans (Johann) Wilhelm Klee b. 1849 in Tann in the Rhone d. 1940 in Bern (music teacher at the State Teachers' College, Canton of Bern) — Marie Ida Klee née Frick b. 1855 in Besançon d. 1921 in Bern (singer)

Mathilde Klee b. 1876 in Walzenhausen d. 1953 in Bern (language teacher)

Ernst Paul Klee b. 1879 in Münchenbuchsee bei Bern d. 1940 in Muralto-Locarno (artist)

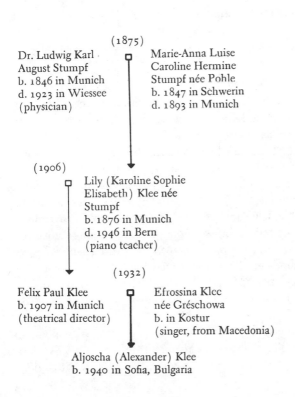

(1875)

Dr. Ludwig Karl
August Stumpf
b. 1846 in Munich
d. 1923 in Wiessee
(physician)

Marie-Anna Luise
Caroline Hermine
Stumpf née Pohle
b. 1847 in Schwerin
d. 1893 in Munich

(1906)

Lily (Karoline Sophie
Elisabeth) Klee née
Stumpf
b. 1876 in Munich
d. 1946 in Bern
(piano teacher)

(1932)

Felix Paul Klee
b. 1907 in Munich
(theatrical director)

Efrossina Klee
née Gréschowa
b. in Kostur
(singer, from Macedonia)

Aljoscha (Alexander) Klee
b. 1940 in Sofia, Bulgaria

Recollections
by Felix Klee:

The editor of the four notebooks of Paul Klee would prefer not to end the history of his life with the year 1918. By using the various biographical works about my father the reader would be able to trace his life to its conclusion. Nonetheless, it seems preferable to close this book by giving a sketch of the course of my father's life from the year 1918 to his death in 1940, and to draw upon my own intimate and subjective ties for details. So as to survey these remaining years to better effect, I shall divide them into five periods:

A. 1918–1921: Munich;
B. 1921–1926: Weimar;
C. 1926–1933: Dessau;
D. 1933: Düsseldorf;
E. 1933–1940: Bern.

A. I remember as if it had happened only a short time ago the December of 1918 when my father returned home in a field-gray uniform at Christmas time to our small, modest, dark apartment in Schwabing. Christmas is a matter of great importance to a child. My mother shut herself up mysteriously in the music room where she made a suspicious rustling over the Christmas packages, and my father was happy to be released from all other duties and to be able to celebrate his thirty-ninth birthday and Christmas peacefully with his family. On the low-hanging gas chandelier the red neckerchief, which he used when playing the violin, was hung up as a warning signal; my mother, blissfully beaming, sat at the piano, flanked by two ball-shaped gasoline lamps; my father unlimbered his violin, tuned the instrument with the piano and the two of them played some Bach and Mozart sonatas to celebrate freedom and the holiday. The only auditor was myself—and the giant tiger-cat, Fritzi.

In the spring of 1919 the revolutionary tension reached its high point in Munich, but all the turmoil of events could not disturb my father's peace of mind. He was preparing his own revolution and in order to see it through

414

to a conclusion had rented a large room for a studio in the small late-baroque castle named "Suresnes" at Werneckstrasse. The surroundings of this dilapidated palace with its even shabbier park had a special appeal for my father: here he could finally concentrate on his glorious new works, and so intensely that he did not observe at all that Ernst Toller had been kept in hiding by Hans Reichel for a whole week right next door in order to protect him from the victorious White Bavarian Soldateska. Wrapped up in a world all his own, Klee lived only for his art, serving it from the earliest hours in the morning until midnight. Old and new friends of the family met together in our home, and when my father wasn't involved in playing music, he kept drawing one beautiful page after another in the midst of all the turmoil. The asthmatic gas lamp was replaced by a glaring, hissing, and spitting carbide lamp. During this bustling time exhibitions were arranged, pictures were sold, and three books about Klee were in preparation. Naturally my father was delighted about this success, but it didn't go to his head in the least. Paul Klee remained instead the same simple, modest, contented—and among the family, extremely good-humored—person who was fanatically devoted to one thing alone, namely, his art.

The holidays, which for the first time we didn't spend in Bern, but instead in a rented apartment in Possenhofen, were a glorious time for us. Besides painting and cooking, my father kept himself very busy with fishing. With infinite patience he caught chub, redeye, perch, and even tench from the lake. The big ones were for us, the little ones for Fritzi. On Sundays we often fled from all sorts of unannounced visits from people in Munich into the solitary marshy area around the Maisenger See, and we marveled at the myriad wild orchids growing there.

B. In the autumn of 1920 I was living by myself in our apartment in Munich. My parents were visiting at the time their Russian friends Alexei von Jawlensky and Marianne von Werefkin in Ascona. There I received the wire that appointed my father a teacher at the state Bauhaus in Weimar. Klee welcomed this honor all the more after a proposed professorship at the Stuttgart Academy had miscarried because of opposition to him by the painters. Because he could not find a suitable apartment in Weimar just then, my father spent two weeks of each month at his new place of work. He was given two

excellent rooms on the third floor of the Bauhaus for his studio. Here he had to an extraordinary degree a sense of being engaged in a common work with kindred spirits. His artistic development moved into significant, new paths here. Like his father Hans, Paul Klee showed a very definite pedagogical ability which he exercised to good effect during thirteen years of teaching. In the fall of 1921 we moved into our new four-room apartment: Am Horn 53, second floor. At various times and in all seasons, the two of us, Klee the master and Klee the apprentice would make our way each day through the romantic park from home to our places of work and back again. How fascinating my father made these walks with his observations about nature. The world of birds and flowers had especially bewitched him. Every day we marched along the meanderings of the gently flowing Ilm, passing by the Dessau stone and the Serpent monument or the log cabin, by Goethe's garden house and Euphrosyne's stone. After the beloved metropolis of Munich, we led an almost cloistered and rather irksome existence in the little town of Weimar; but even though we were shunned and ridiculed by the townspeople, we enjoyed a great deal of intellectual stimulation in the many castles, museums, and the national theater. Hitler's first wave in the spring of 1925 swept the Bauhaus from the city with the single stroke of a pen. We tied up our belongings and moved on to the next place.

C. My father once jokingly asked us the question: What is the enharmonic mistaken identity of "Dessau" [D-flat–sow]? "Cisschwein" [C-sharp–swine] came his answer, with a smirk. In the midst of gloomy industrial sites (sugar, gas, Agfa, Junkers), this little capital city drowsed like Sleeping Beauty. A courageous city father managed to transport the entire Weimar Bauhaus there, produced a magnificent school for these revolutionaries of art, and lent each master, besides, an atelier and eight rooms. In July 1926 we moved into "our" house at Burgkühnerallee 7, which was delightfully situated in a grove of pine trees. In the transition period my father lived as a subtenant at the Kandinskys so that he could teach at the new Bauhaus every other half month, as before. We were never able to accustom ourselves to the city; our only consolation besides the Bauhaus, now grown a bit more mannerly, was the aspiring picture gallery and the tradition-conscious and lively Friedrich Theater, as well as the splendid surroundings of the city with its two mighty rivers and

many park areas. Only a half hour away, we discovered a real marvel of land-scape gardening: Wörlitz. The Old Dessauer [Leopold I of Anhalt-Dessau] had planned the park and not a month passed without Klee's going for a stroll between the Temple of Flora, the climbing rock, and the artificial Vesuvius. My father felt that he was very fortunate between his four big walls, living right next door to his friend Kandinsky. Here he could pursue intensely the further development of his abilities to their ultimate fulfilment under ideally competitive conditions. I should not fail to mention Klee's trip to Egypt in December of 1928. It played a very important part, next after his trip to Tunis, in the rich thematic repertory of the world of his pictures. My father looked forward with pleasure to an appointment as a professor at the Düsseldorf Academy. The continual repetition of his teaching at the Bauhaus finally began to bore my father. He longed more for the "peacefulness" of working at the Academy where he would have about him only a group of master students. So he ended his connection with the Bauhaus, traveled between Dessau and Düsseldorf, again spending alternate bi-weekly periods in each city, and since he had two magnificent work rooms in each city, he delighted in the half-finished "children" that awaited him each time in whichever studio he was away from. Klee enormously enjoyed the lovely and vital city on the Rhine with its pulsing western life. He found it as fascinating as Paris, and the piquant atmosphere stirred him to paint in a free, un-weighted style. The only difficulty was the irksome business of finding a place to live. He kept vacillating about making this decision. Very late, namely on May 1, 1933, my parents moved into a seven-room house at Heinrich-strasse 36.

D. The rest of our stay in Düsseldorf, with the whole family together, was entirely under the shadow of the events of the Nazi "seizure of power." A humiliating search of the house in Dessau by Storm Troopers and his dismissal without notice from the Academy were motive enough for Klee to withdraw into a little work room of his new home. How right my mother was to persuade my father to move out of the country to Bern. But the preparation for getting out went forward more slowly than expected. It was only a short time before Christmas that Klee emigrated to his own native homeland as he had chosen to do. He was never again to return to his once beloved

Germany. But we would do better to let my father comment on these last hours from a letter of his:

"Schadowkeller, December 22, 1933

Dear Felix and Phroska,

Now everything has been moved out of the house. Tomorrow night I shall most likely leave this place. Then the beautiful days of Christmas will come, with bells ringing in every foolish head. I've got a little older these last few weeks. But I won't vent gall, or I'll do it with humor anyway. This is easy for men to do. Women usually weep at such times. . . ."

E. At first Klee took refuge with his father at the old family place in Obstberg, then rented for the time being a furnished apartment on Kollerweg, and in the spring of 1934 took a spacious three-room apartment in Elfenau at Kistlerweg 6. Once again my father had to live in tiny quarters as when he began at Munich. He situated his studio in a medium-sized room—with a window facing south and a door to a balcony facing east. And now life began to take shape quite pleasantly in the free atmosphere of Switzerland. Klee painted, cooked, and played music according to a precise daily schedule. His pictures showed a stronger impulse than they had earlier until a treacherous skin disease shot home the bolt on his creative forces in the year 1935. Klee was never to recover from this sclerodermia which remained after he had got over a case of measles. A bodily struggle that lasted five years, and was only lingered out by the iron determination of his spirit, had only a slight influence upon the ever more intense and vehement production of his works. His physician forbade him to play the violin and to smoke, and Klee became more and more obsessed with the demon of toil, but the decay of his body finally prevailed. At the beginning of May 1940 my father sought treatment at a sanatorium at Ticino, but his strength was visibly failing and he was never again to return from that place. In the early morning hours of June 29th he went gently slumbering into a more distant kingdom. In the crematorium at Lugano his mortal remains were committed to the fire.

Whenever we walk on a beautiful fall day like today to the grave of our parents, I recall in the rural peace of the Schosshalden cemetery the completely happy time of my own childhood. Yellow and white asters, begonias, and roses are planted around my father's urn. And we decipher the epitaph on the big stone slab:

HERE RESTS THE PAINTER
PAUL KLEE
BORN ON DECEMBER 18, 1879
DIED ON JUNE 29, 1940

I CANNOT BE GRASPED IN THE HERE AND NOW
FOR I LIVE JUST AS WELL WITH THE DEAD
AS WITH THE UNBORN
SOMEWHAT CLOSER TO THE HEART
 OF CREATION THAN USUAL
BUT FAR FROM CLOSE ENOUGH

Felix
Calendar

[The Felix Calendar, which consisted of diary entries about the child during the first two years of his life, has been abridged by the editor, removed from its place among the numbered diary entries, and gathered together here. But it was thought that these notes should not be entirely deleted, because they give a deep insight into the personal characteristics of Paul Klee. He had the job of watching over and tending to the infant Felix while his wife Lily earned a living for the family by giving piano lessons.—Editor's note.]

1908

Felix' weight at birth on November 30, 1907, 7 lb. 1 oz.
Weight on January 3, 8 lb. 9 oz.
Weight on January 10, 8 lb. 12 oz.
Weight on January 17, 9 lb. 3 oz.
Weight on January 24, 9 lb. 9 oz.
Weight on January 31, 9 lb. 10 oz.
Weight on February 3, 9 lb. 13 oz.
Weight on February 10, 10 lb.
February 12. Photo made, Felix with Lily.
February 16. Lively talk from 6 to 8 o'clock.
Weight on February 18, 10 lb. 5 oz.
February 19. Makes faces while biting his hands.
February 21. Bites and screeches. Begins to be able to hold his head up.
February 22. Screams from 6 in the morning till 7:30 (Russian ball).
Weight on February 25, 10 lb. 6 oz.
February 26. Screams from 6 o'clock and extorts a meal. Lily has a case of nerves.
February 27. I am rejected by the League of Graphic Artists.

March 1. 10 lb. 7 oz.
March 7. Responds to humor, wishes me good morning.

March 9. 10 lb. 11 oz. Two lower front teeth can be seen in the gums.
March 11, 12. Cries a great deal, no doubt from the teeth.
March 13. Speech exercise: *w w w* and *pf*. Wildly happy crowing.
March 14. Speech exercise: *ch* (guttural), *f*, and *pf*.
March 16. 10 lb. 14 oz.
March 22. Upper eye-teeth.
March 24. 11 lb.
March 26. Colic, we are frightened by his behaving as if he had convulsions. I get the doctor (Trumpp), who quiets him down, calls him a thoroughbred dachshund, and prescribes an enema and wet packs.
March 27. Improvement. The excessive flow of milk has decreased. (This was our first fright.)
March 30. Felix entirely all right again (digestion). 11 lb. 1 oz.

May 4. Photo taken in the afternoon on the balcony.
May 6. Grasps. 11 lb. 11 oz.
May 8. Turns up his nose.
May 10. Pulls himself into a sitting position by grasping two fingers held out to him and laughs at his success.

May 13. 11 lb. 13 oz.

May 16. Smacks with his tongue and has trouble with his teeth.

May 20. 11 lb. 15 oz. Two lower front teeth break through. Intensive efforts to raise himself up (contortions).

May 25. Plays with the doll, says *pa wa wa*, feels and touches everything, holds objects in his hand.

May 27. 12 lb. 1 oz.

May 28. Beginnings of "mischievousness," definitely demands company. Demands to sit up. Props himself firmly with his legs, kicks ecstatically, and smiles in satisfaction about the whole thing.

June 3. 12 lb. 3 oz. Consciously imitates me when I smack with my tongue.

June 8. Says *pö pö* or *pay pay* and *ha-pa-wa*.

June 10. 12 lb. The lower right eye-tooth can be seen in the gum.

June 14. Shakes his rattle to hear it jingling, investigates rings on his finger.

June 25. Hides. Hits himself on his head repeatedly and laughs with glee.

June 26. 13 lb. Several times says *pa-pa* and *pa-pa-pa*.

June 28. Bad, very bad temper.

July 3. 13 lb. 4 oz.

July 4. Says: *day, a-day, n-day, da-a-da-da, yay, ya-ya, tay, gai, gai-gai, gay, tai.*

July 8. Says: *dayi-da*; screams: *day-dayi-da.* This is the way he demands his breakfast in the morning. Between speaking and tears: *dayi-dayi-day-deh-dayi-dayi.* Length, 26.4 inches.

July 13. *Eyah! Eyah!* (Will growing more forceful.)

July 14. *Ma-ma.* Stands so firmly that it's only necessary to balance him, not to support him. This delights him.

July 25. 14 lb. 5 oz.

September 1. Says: *heh-puay.* Deliberately throws his bear from the table time and again.

September 3. Eight teeth.

September 6. Pulls his toy up and down on the ribbon.

September 7. Imitates various things, *sh-sh* (in and out), shaking the head, etc.

September 13. 17 lb. 15 oz.

September 25. Attempts to stand. Rears himself up, lies back down unwillingly; laughs when he is able to stand up.

October 3. Plays dexterously with his bracelet.

October 4. Plays for the first time at hiding behind his curtain.

October 7. Tries to copy snapping the fingers with his thumb and index finger.

October 8. Wants to stand all day long. We find him lying prone in his carriage. Difficulties in getting to sleep.

October 10. Shouts: *Gegge!* (Gritli!)

October 11. Christened at St. John's church in Bern.

October 15. Observes the shadow of his toy and compares it with the original.

October 20. Says: *ladn-tadn, ladn-tadn,* and *mohpm.*

October 21. Shakes his carriage. New stroller.

October 28. Says: *dohdl-dohdl-gogg! Togge-doh! Doh-tay-doh! Stogodoh! Doh-doh!*

November 2. Says: *oli-yoli-yoli, togedo, togay-dodo, toh dyay-doh!* (are irrita-

tion from teeth and learning to speak somehow connected?)

November 5. Rubs his forehead on velvet and laughs.

November 12. The first steps in his stroller.

November 14. Stretches a string in order to pluck at it.

November 19. Falls out of the bed.

November 20. Speaks: *ohdli-gehdli-dool E-dyoo-dool.*

November 23. Tries to loosen the hand that holds him so as to be able to move freely.

1909.

January 4. Says: *Yah, bibi, baybué*; waves farewell when he sees me in my hat and coat.

January 8. Defeats me in a pushing contest. Shakes with laughter over his victory. Knows what I call "or" [ear].

January 13. Can already whistle. Says: *topúte, topétop, nápeh-top-top.*

January 25. The playpen is here—draws himself up to a standing position on it. Knows that I have two ears. New teeth: one eye-tooth on the lower left, one on the lower right. A new game played very carefully and economically:

two/three oranges from the bowl are thrown on the table and are returned to the bowl. Makes marks with the pencil after he has been shown how. If two bits of bread are placed in front of him, he always seizes and eats the smaller one first. Recognizes some wedges for the playpen that were delivered later as new additions. Furious about being left hanging without attempting to help him down.

February 1. Tries to pile one orange on top of another.

February 3. Is eating soup again; moves more freely in his pen; turns his back to the support; twists the support backwards.

February 9. Lets himself down in a sitting position and stands up again.

February 11. Says: Nono, nono; gogel, gugel, gegogo; gogel, gugel, gugel, gogel, gogel, gugel.

February 20. Distinguishes the nose and ear, discovers the face of the doll and makes comparisons, grapples a plate toward him with a hook. Whistles notes in different pitches. The next comment on speech in April: ya ballya, ballya, ballya! Yammai, yammai, hammai!

March 1:	101.1°	. . .	103.0°
March 2:	100.4°	102.4°	104.0° pneumonia
March 3:	103.1°	104.4°	104.4°
March 4:	99.9°	101.7°	102.6°
March 5:	100.0°	101.8°	103.3°
March 6:	98.4°	. . .	102.6°
March 7:	100.0°	104.2°	. . . pleurisy
March 8:	104.7°	103.5°	105.0°
March 9:	104.7°	. . .	100.0°
March 10:	103.5°	103.3°	105.0°
March 11:	104.7°	98.6°	104.0°
March 12:	104.5°	103.8°	105.8° weakness
			continues 104.7°

March 13:	104.7°	104.9°	101.3°
March 14:	105.4° weak	104.7°	103.3° nurse comes in
March 15:	102.7° moved to Uncle Homberger's	103.1° electric bath	97.2°
March 16:	104.2° electric bath	104.5° sun lamp	103.6° sun lamp 103.6°
March 17:	104.4°; 105.4° aspirin	101.0°; 105.4° aspirin	103.5° camphor injection

Second consultation with Pfaundler; aspiration; no fluid.

[*During the lengthy illness of his son Felix, Paul Klee recorded temperatures each day as shown above. The operation on the child took place on May 7, 1909. Numbers 854 and 855 of the* Diaries *refer directly to this difficult time. Editor's note.*]

June to October 1909, in Bern

Felix at age one and a half reached the following stage. Everything that oscillated or made a sound like a moving pendulum is called *ti-ta*. This is a noun. He finds something to which it pertains just anywhere—in a horse's tail, in the leather hand-strap on the street car, in a carriage-roof, in electric lights on cords (when he knocks it in the parlor), the dangling keys on the chest of drawers, pendulum-clocks and those without pendulums. He holds clocks to his ear and laughs with pleasure. Others have to listen to it and then allow him to listen again.

He eats bread, preferably from both hands. If he's given only one piece, he demands more, by saying *da da*. If he isn't successful he tries to make the one piece do by breaking it. Others have to taste his bread, and this is great fun. He is quite willing to help slip his arms into his sleeves. He loves to have his hands washed and watches the foam from close up. (Several months later he rubs his hands together.) He enjoys having his nails cut.

During these procedures, if he is told to "take your bread in your other hand," he does it with a joyous *Ho!* (Later he shouts the same thing when slipping his arm through his sleeve.)

He won't sit on his training stool and will only be held over it. It's called *sss.* . . . He accepts it only when there is urgent need, but always with some resistance. He often soils his pants, or his diapers in bed.

When a note is sounded he makes one of the same pitch. He has a passion for ringing the dinner-bell. He is often receptive to advice about the right and wrong way to handle it.

He runs after children, and dogs too, but especially cats. He knows many animals, also from pictures, and names them on the book pages in his musical language. He imitates rotating objects onomatopoetically by *woo-woo-woo*; dogs by *hoo! hoo! hoo!*; horses by *co! co! co!*—with his tongue clicked against the hard palate; ducks: *heh! heh! heh!* hoarsely in the back of his throat. He makes this sound seeing a quiet pond, and even when "ducky" is pronounced to him.

Cow (earlier, *co*): *moo*—very characteristic.

Donkey (at Beatenberg): *ee-ah.*
Bird: *bibi.* Trill: *fr;* imitated my "flying."
Doves: *go-go-go!*
Goats: *mhay-hay-hay!*
"Gritli" is at first called *ti-ti,* then *ga-ga,* then *geh-geh,* then *gri-gri.*
In the course of the summer he said *papa* and *mama* with consciousness of their meaning.
He shouts *bai!* [herbei] meaning "towards me"; he begs by saying *da-da!* "Goodbye" is *de-de!,* used repeatedly, for example, as he continues walking after stopping at something that attracted his interest, as when someone goes out of the door or puts on his hat.
He tries to put on shoes, pastes them on, so to speak (improves later).
He dexterously takes apart a box and its lid without thinking of putting them together.
Rushing water, rain, and the flight of birds he expresses by a sound between *Sch* and *F.* He does the same for mist and smoke and also imitates their movement with his hand. If you point to something with a finger, he always wants the object. When there is nothing there, the pointing finger he has seized upon has to produce something by magic. The smallest thing doesn't escape him. He isn't afraid of any insect (junebug). Gradually he stops plucking flowers to pieces. He turns the pages of books skillfully and doesn't vandalize them. But if one shows a little damage he destroys it completely. He also destroys book-marks.
He agilely makes himself go in his walker; gets up on his feet with a certain amount of struggling and sits down cautiously and cleverly. At corners he twists himself with his back to the outside and his hand reaching behind him. Often he remains standing like this and leans as if he is on crutches. If one hand isn't free, he squeezes his elbow over the handrail. He frequently forgets himself and topples over, especially if he is in bad temper.
If he wants someone to take him, he stretches his hands toward the person and entreats him: *m-m-m!* When he's being driven fast, he makes see-saw movements to spur it on. In the streetcar or train, he stands at the window and peers out. Stirring in his cup gives him boundless pleasure; he drums it with *ü-ü-ü!*
He likes to eat sugar and bites down on it cracking it with his teeth.
Since the month of May he has been blowing musical instruments.
The train is his greatest thrill; he copies its sound with a *tsch! tsch! tsch!* and waves goodbye with his hand at the same time.
First steps without support on August 27. Felix's language in August:
ent [eins], *vay* [zwei], *fia* [vier]—while climbing the steps.
Nit! [of forks]; *na!* [of his bead-counter]
Ko [cow], *balli* [ball], *päli* [horse]
Tic-tac (also, *tic-cac*)
Tutu-dada (in September, *cucu*)
Bite-bite Sitz [please-please sit]—every time he changes his position.
Bam (Baum) [tree]; *bein* [leg] (sticks his leg out horizontally); *dak* [thanks], said when he gives or receives something; in September, he correctly says *Danke.* (In this month especially his pronunciation radically improved.)
He eats noodles and macaroni with his fingers. Spoons are his enemy. He jokes by squinting and wiping his mouth and by wanting to whistle and not being able to because he is laughing. If no one laughs, he invites it by extravagant laughter for that purpose. Play-acts.

Index

425

426 / *Index*

Brack, Max, 60, 75 f., 82, 157 f., 161 ff., 191;
excursions with Klee, 151, 153
Brahms, Johannes, 14, 16, 47, 70, 130 f., 133,
135, 139, 149, 161, 165, 191, 197, 207 f.,
214, 231, 394
Brakl [Brackl], Franz Josef, 224, 256–258
Braque, Georges, 267, 269
Breuer, 159
Breughel, Pieter, 350
Bréval, Fräulein, 183
Broderson, 210, 225
Bruckner, Corporal, 334
Bruckner, Anton, 138, 148, 224
Brühlmann, Hans, 157, 271–272
Brüstlein, Eliane and Gilonne, 110 f.
Brun, Fritz, 167
Brussels (Belgium), 358
Bürgi, Professor, 373
Buhl, Lieutenant, 329 f.
Burckhardt, Jacob, 69 f., 79, 100
Burger, Dr. Fritz, 280
Burghausen, Germany, 26–27
Busch, Wilhelm, 225
Busoni, 137, 208
Byron, George Gordon Byron, 149, 154, 207,
210

Calderon de la Barca, Pedro, 151
Campendonc, Heinrich, 363, 381
Capet, Lucien, 145, 197
Capitoline Museum (Rome), 76
Cappella Medici (Florence), 112
Cardinaux, Aemilius, 157, 191, 212
Carelli, Emma, 95 f., 104
Carpeaux, Jean Baptiste, 180
Carrà, Carlo, 274 f.
Carrière, Eugène, 181, 198
Casals, Pablo, 165–167
Caspar, 93, 96, 100–101, 102–103, 106, 264,
282
Caspar, Karl and Maria, 254
Cassirer, 189, 192, 213
Castella, Jean de, 44, 47, 76, 105, 108–114
passim, 132, 161
Cathedral-Museum Santa Maria del Fiore
(Florence), 112
Cecilia Society, 139
Cervantes, Miguel de, 204

Cézanne, Paul, 237, 271
Chabrier, (Alexis) Emmanuel, 148
Chardin, Jean Baptiste Simeon, 181
Charey, 153
Charpentier, Gustave, 180, 182
Chekov, Anton, 204
Chodowiecki, Daniel Nicolas, 272
Chopin, Frederic François, 81, 134, 137, 197,
212
Cologne (Germany), 350
Colombi, 130
Comédie Française (Paris), 180
Concert arabe, 288
Concert Bullier, 269
Conrad-Ramlo, 136
Convent dello Scaleo (Florence), 112
Corinth, Lovis, 202, 215
Cornelius, Peter, 188
Corot, Jean-Baptiste Camille, 157, 180 f.
Couperin, François, 129
Courbet, Gustave, 181, 211
Courvoisier, 153
Cousin, Herr, 135
Cranach, Lucas, 109, 113

D'Albert, 137, 207, 212, 225
Dalcroze-Faliero, Frau, 134
Däubler, Theodor, 315, 322, 366, 385, 390 f.,
394, 398
Daumier, Honoré, 216, 219, 268
David, 88
Daxelhofer, Captain, 340
Debschitz School, 213, 225
Debussy, Claude, 234
Defoe, Daniel, 404
Degas, Hilaire Germain Edgar, 198, 268
Delacroix, Ferdinand Victor Eugene, 181,
268 f.
Delaunay, Robert, 268, 274, 374
Dellacasa, 162–163
Delmas, 183
Derain, André, 267, 269
Dessau (Germany), 416–417
Deutsch, 165
Deutsche Ring, 350
Deutsches Theater, 159
Deyerl, Lieutenant, 345
Donatello, 112